Praise for *A Crisis of Brilliance*

'What gives David Boyd Haycock's book its freshness is that, through skilful use of letters and memoirs left by his five subjects, he injects it with the anxiety, ambition, self-doubt and jealousy that possessors of youth and talent are fated to feel'

John Carey, *Sunday Times*

'Haycock's narrative of this entangled, war-defined group is so strong that it often has the force of a novel, hard to put down . . . We should call for a joint exhibition of their work, to complement the moving portrayal of their lives in this engrossing and enjoyable book'

Jenny Uglow, *Guardian*

'An extraordinary book. I read it avidly . . . The familiar cast is handled in a quite new and original way. They have been made fresh and vulnerable once more, and their work re-evaluated – made new to us'

Ronald Blythe

'Truly fascinating from every angle – almost a work of art in itself' *Books Quarterly*

'Haycock wears his learning lightly and has an enviably fluent and assured style of writing: you pick this book up and simply start reading. Rarely has art history seemed so agreeable' *The Art Newspaper*

'A sad tale, wonderfully told ... Haycock fades the many different narratives in and out with ease' *Country Life*

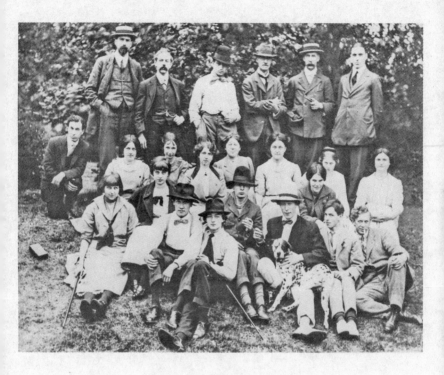

The Slade Picnic, 1912

Seated in the front row (from the left) are Dora Carrington, Barbara Hiles, Richard Nevinson, Mark Gertler, Edward Wadsworth, Adrian Allinson (with dog) and Stanley Spencer. Dorothy Brett sits behind Gertler and Nevinson. Kneeling to the left of the group is Isaac Rosenberg, whilst the man in shirtsleeves in the back row is David Bomberg. Standing to his left, arms crossed, is Professor Fred Brown.

A CRISIS OF BRILLIANCE

FIVE YOUNG BRITISH ARTISTS
AND THE GREAT WAR

DAVID BOYD HAYCOCK

First published in the United Kingdom in 2009 by
Old Street Publishing Ltd,
40 Bowling Green Lane, London EC1R 0NE
www.oldstreetpublishing.co.uk

This paperback edition published 2010
ISBN-13: 978-1-906964-32-0

10 9 8 7 6

Printed in the United Kingdom

To Susannah and Nathaniel

Contents

List of Illustrations

Front cover image

Paul Nash, *Ruined Country: Old Battlefield, Vimy, near La Folie Wood*, 1918:
Imperial War Museum.

Frontispiece

The Slade Picnic, 1912, photograph: Tate Gallery.

Colour Plates (Section 1)

Gertler, *Still Life with Melon*, 1912, oil on canvas: private collection (Bridgeman)

Gertler, *Allegory*, c.1910: private collection (Bridgeman).

John Currie, *Some Later Primitives and Madame Tisceron*, c. 1910: Stoke on Trent
Art Gallery.

Spencer, *John Donne Arriving in Heaven*, 1911, oil on canvas: private collection.

Nevinson, *Self-Portrait*, 1911, oil on panel: Tate Gallery.

Carrington, *Female Figure Lying on her Back*, 1912, oil on canvas: Strang Print
Room, UCL.

Gertler, *The Fruit Sorters*, 1914, oil on canvas: New Walk Museum, Leicester
City Museum Service.

Spencer, *The Apple Gatherers*, 1912, oil on canvas: Tate Gallery.

Gertler, *The Rabbi and his Grandchild*, 1913, oil on canvas: Southampton City
Art Gallery.

Nash, *Wittenham Clumps*, c.1913, watercolour, ink and chalk on paper: Tullie
House Museum and Art Gallery, Carlisle.

Spencer, *Self-Portrait* (1914), red chalk on paper: Williamson Art Gallery and
Museum, Birkenhead.

Gertler, *Dora Carrington*, 1912, gouache on paper: Edgar Astaire collection.

Spencer, *The Centurion's Servant*, 1914, oil on canvas: Tate Gallery.

Colour Plates (Section 2)

Gertler, *The Merry-Go Round*, 1916, oil on canvas: Tate Gallery.

Nevinson, *La Mitrailleuse*, 1916, oil on canvas: Tate Gallery.

Carrington, *Giles Lytton Strachey*, 1916, oil on panel: NPG.

Gertler, *Gilbert Cannan and his Mill,* 1916, oil on canvas: The Ashmolean Museum, Oxford.

Carrington, *The Mill House at Tidmarsh, Berkshire*, 1918, oil on canvas: private collection.

Nash, *Wire*, 1918, ink, watercolour and chalk on paper: IWM.

Nevinson, *Paths of Glory,* 1917, oil on canvas: IWM.

Nash, *The Mule Track*, 1918, oil on canvas: IWM.

Spencer, *Travoys Arriving with Wounded at a Dressing-Station at Smol, Macedonia, September 1916*, 1919, oil on canvas: IWM.

Spencer, *Swan Upping at Cookham*, 1915–19, oil on canvas: Tate Gallery.

Nash, *The Menin Road*, 1918–19, oil on canvas: IWM

Monochrome images in body of text

'Ties of Friendship'

Breathless, we flung us on the windy hill,
Laughed in the sun, and kissed the lovely grass.
You said, "Through glory and ecstasy we pass;
Wind, sun, and earth remain, the birds sing still,
When we are old, are old..." "And when we die
All's over that is ours; and life burns on
Through other lovers, other lips," said I,
– "Heart of my heart, our heaven is now, is won!"
"We are Earth's best, that learnt her lesson here.
Life is our cry. We have kept the faith!" we said;
"We shall go down with unreluctant tread
Rose-crowned into the darkness!" ... Proud we were,
And laughed, that had such brave true things to say.
– And then you suddenly cried, and turned away.

'The Hill', Rupert Brooke

Plenty of artists, it has been observed, 'have tolerably easy, successful lives'. In 1943, however, Randolph Schwabe looked back some forty years to his student days at the Slade School of Drawing, Painting, and Sculpture in London, and reflected that there were many amongst those he had known then who had died 'before the full growth and flowering

that might have been expected from their talents'. It was impossible, he concluded, 'to avoid some insistence of tragedy. Suicide, madness, disease and war exacted a heavy toll on them... Much talent and some genius were born into their generation, and their loss, even for those who were not bound to them by ties of friendship, is deplorable in its tale of waste and unfulfilment.'[1]

What 'change in character', Schwabe wondered, 'might have resulted in the English School' if all those young Slade students had lived out their natural lives?[2] Yet it might also be asked: how was the early twentieth-century English School forged by the very intensity of those events, experiences and personalities? Certainly there were those who were lost too young; but there were also those who – through the stimulation and tribulation of the tremendous events of the years prior to 1919 – rose to greater heights than they might otherwise have achieved. It is, perhaps, the paradox of those times.

The men and women who passed through the doors of the Slade between 1890 and 1910 included such famous (and now not-so-famous) names as Adrian Allinson, Vanessa Bell, David Bomberg, Dorothy Brett, Dora Carrington, John Currie, Mark Gertler, Duncan Grant, Spencer Gore, Gwen and Augustus John, Henry Lamb, Wyndham Lewis, Maxwell Gordon Lightfoot, Ambrose McEvoy, Paul Nash, Richard Nevinson, Ben Nicholson, William Orpen, William Roberts, Isaac Rosenberg, Stanley Spencer and Edward Wadsworth. Together, these men and women helped to make the Slade the foremost art school in England. In the opinion of the critic Frank Rutter, the Slade had eclipsed the Royal Academy in terms of its fertility in producing significant artists.

Whilst the Academy had 'constantly bolstered up the pretensions of British painters', Rutter wrote in 1922, the Slade's professors and pupils 'have always kept their eyes on what was being done at Paris' – and it was Paris more than anywhere else that was at the centre of what was new

and important in Western art in the last few decades of the nineteenth century and the first of the twentieth.[3]

The friends and contemporaries of these Slade artists – men and women who helped them to open their eyes to a wider world that transcended the conservativeness of Victorian and Edwardian England – numbered some of the most influential and famous writers, artists and intellectuals of the time. To offer another long list of eminent names, they included Clive Bell, Rupert Brooke, Gilbert Cannan, Jacob Epstein, Roger Fry, Henri Gaudier-Brzeska, T.E. Hulme, Aldous Huxley, John Maynard Keynes, D.H. Lawrence, Katherine Mansfield, Edward Marsh, F.T. Marinetti, Lady Ottoline Morrell, John Middleton Murry, Siegfried Sassoon, Lytton Strachey and Leonard and Virginia Woolf. Those of the Slade artists who ventured further afield, to Paris, numbered Picasso, Modigliani and Lenin among their acquaintances.

All these names appear within the pages of this book, and what follows is a part of all their stories. But it is told through the experiences of five of the most closely linked and most successful of these young Slade students: Dora Carrington, Mark Gertler, Paul Nash, Richard Nevinson and Stanley Spencer. All five have been written about before, but perhaps not with such detailed analysis of the most formative years of their lives, or with such close attention to the relationships that acted between them.

As I hope to show, these five – more particularly than any of their other contemporaries – were closely, even intimately, inter-connected. All five were a part of what their Professor of Drawing, the irascible Henry Tonks, later described as the School's second and last 'crisis of brilliance'.* Together, they provide a remarkably clear insight into the period, and into the youthful experiences and struggles that help to create an artist – any artist.

* The first had been the earlier generation that included Augustus John, Ambrose McEvoy, William Orpen and Wyndham Lewis.

Between 1910 and 1919 these five, together with their wider circle of contemporaries, loved, talked, and fought; they advised, admired, conspired, and sometimes disparaged each other's artistic ambitions and creations. The Bloomsbury critic and sometime Slade lecturer Roger Fry dubbed them 'les jeunes': they were the Young British Artists of their day. They participated in the newest movements – the Neo-Primitives, the Futurists, the Vorticists, the Bloomsbury Group, the Omega Workshop – and brought havoc with their fights and fanfares in London's Soho and Mayfair. They frequented (and sometimes redecorated) the capital's most stylish cafés and restaurants, and founded their own nightclubs; they led the way in fashion with their avant-garde clothes, haircuts and unconventional, Bohemian lifestyles; they slept with models, with prostitutes, and with each other; on occasion their tempestuous love affairs descended into obsession, murder, and suicide.

This wide circle of artists and writers fought – and some of them died – in the War to end all Wars; or they turned their faces away from that awful carnage, and resisted it in the only way they knew how – with words, and with paint. The Great War is the culmination of this book for, as Paul Nash later reflected, the period after 1914 'was another life, another world'.[4]

But their story starts in quieter times: at Cookham, on the banks of the River Thames.

Chapter 1

Stanley Spencer

The Berkshire village of Cookham lies in a crook of the Thames a few miles upstream from Maidenhead and twenty-five miles west of London. In the last years of Queen Victoria's reign, in winter and spring it was a tranquil place, frequently cut off when the surrounding commons and water meadows flooded. But in summer the river sprang to life, thronging with pleasure seekers in punts, rowing boats, skiffs and paddle steamers. July saw the ancient ceremony of Swan Upping, when the Vintners' and Dyers' Companies claimed ownership of the swans between Blackfriars Bridge and Henley, gathering them in to mark their beaks: once for the Vintners, twice for the Dyers, and those left unmarked for the Queen. And in September there was Cookham Regatta, when the village was decorated with flags, and the trees decked with bunting and Chinese lanterns. Brass bands played, and the river filled with all manner of floating vessels.

It was these pleasures of the Thames that Jerome K. Jerome captured in 1889 in his comic novel, *Three Men in a Boat*:

> We went through Maidenhead quickly, and then eased up,
> and took leisurely that grand reach beyond Boulter's and
> Cookham locks. Cliveden Woods still wore their dainty dress
> of spring, and rose up, from the water's edge, in one long

harmony of blended shades of fairy green. In its unbroken
loveliness this is, perhaps, the sweetest stretch of all the river,
and lingeringly we slowly drew our little boat away from its
deep peace.[1]

Had Jerome and his friends lingered longer in Cookham, perhaps to
gather supplies from the village shop or pause for refreshments at the
Old Ship Inn or the Bel and the Dragon Hotel, they would have passed
on the High Street two tall, semi-detached Victorian brick villas. Fernlea
and Belmont were the homes of two brothers and their families, and had
been built by Cookham's master builder – their father, Julius Spencer. In
Cookham, everyone knew everyone else, and many local families were
related: courtships and romances started as early as the village school,
and Julius's grandchildren could claim over seventy relatives in the
neighbourhood.

Mirror images of each other, Fernlea and Belmont could be
distinguished by the brass plate on the former's front gate: 'W. Spencer:
Professor of Piano'. In the year Jerome's novel was published William
Spencer was forty-four years old and, as local church organist and resident
music teacher, was a familiar sight around the village, out in all weather on
his lady's bicycle, music case slung over the handlebars, reciting aloud the
works of his adored hero, the art critic and social reformer John Ruskin.
William Spencer was an excitable, pious man with a sense of wonder
that expressed itself in his fondness for music, poetry and astronomy,
and in his intimate observations of nature: 'I crossed London Bridge
on Tuesday and could have stood for hours watching the flight of the
seagulls – surely the acme of graceful motion', he told one of his sons.
'And yet the people passed by without a glance'.[2]

'Par' Spencer's family was large, talented and musical; his greatest
ambition was the success of his eldest son and namesake. A child prodigy,
William junior could play preludes and fugues from memory on the family

piano. Even before he could reach the pedals he was performing before the Duke of Westminster at Cliveden, the large country house across the Thames. Guests included the Prince of Wales (the future King Edward VII), who presented the young virtuoso with a piano of his own. When he grew older Will progressed to the Royal College of Music in London, and gave evening recitals at Maidenhead, the family dressing up to hear him play. The Spencers were doing well: Par travelled regularly to London to serve as organist at St Jude's, Whitechapel, and to give piano lessons to wealthy West Enders. There were concerts, servants and a nurse to look after the five children: what one of them later called 'all the trappings of position'.[3]

Par did everything he could to further his eldest son's musical success. In fact, with overbearing Victorian discipline, he did too much. Long hours of endless practice, together with Par's ban on outdoor sports that might damage his son's precious fingers, combined to undermine Will's health, and he suffered a nervous breakdown. But again, only the best would satisfy Par – Will was sent to Thomas Holloway's 'Sanatorium for Curable Cases of Mental Disease' at Virginia Water. This eventually proved too much for Mrs Spencer, however. Seeing that the hospital was nothing more than 'a club for rich dilettantes with a turn for discussion and a belief that they had been reprieved from facing life outside',[4] she brought Will home to Cookham. Though she had saved her eldest son from a life of idle infirmity, the family's fortunes were already broken. Financially spent, his ambitions shattered, according to his youngest son, Par Spencer 'never quite got over the failure of his highest hopes, and buried himself and his disappointment more and more in his books.'[5]

It was into this 'confusion of ambitions, high endeavour, disappointments and partial recovery' that Mar and Par's last children were delivered.[6] Stanley Spencer was born in Cookham on 30 June 1891 and Gilbert in August the following year. With the money for a nanny eaten away by Will's hospital fees, their teenage sister Annie took

charge of the boys. Theirs would be a simple, unrestricted upbringing, as Gilbert later recalled, and the brothers were preciously close. Stanley later remembered how he once hit his younger brother, 'not very hard', but 'Gil bellowed like a bull & then of course I cried. If Gil cried I cried & if I cried Gil cried. Mar comes rushing into the room, "What is it", "I've hit him I have, I hit him I have, oh Gil", "Oh Stan", "Oh Gil", "Oh Stan".'

And Stanley recalled another time when he and his brother sat in their high chairs: 'we were talking over things in general when Gil says very mysteriously "Stan, what are Angels?", "Ow" says I very knowing and wise "Great big white birds wot pecks". Gil after digesting this peered about for a white bird wot pecks'. His eyes fell on Annie: 'so Gil outs with it "Is she an Angel?", "No" says I very contemptibly "Not great big squashed fat things like her".'[7]

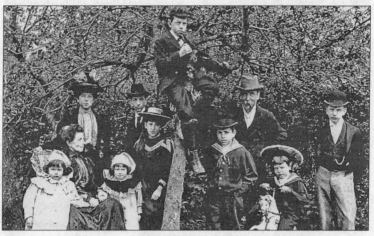

The Spencer family, about 1894: Stanley and Gilbert stand by their mother.

On wet days the boys made their own entertainment indoors: they had only a few toys — an old jigsaw puzzle, a box of buttons, later some wooden bricks. They cut up pieces of paper to make figures to play with, opened with wonder huge old books of wallpaper samples, inhabiting their private imaginative world. Though they preferred to

8

amuse themselves in the nursery, on fine days their sister took them on meandering walks round the village, which began to fascinate and entrance them. Sneaking into the mysterious garden of some grand old house, climbing trees and 'swinging high into other lands', Gilbert would long after recall how 'the thrill of seeing bits of Cookham cropping up in strange places so unexpectedly never lost its charm for us.'[8]

As they grew older the brothers swam in the river, played football and cricket on the common, or hid unnoticed in dark corners of the village, watching their little world revolve around them. Their love of Cookham and its varied inhabitants meant everything to them – Gilbert swore that the villagers could be distinguished by the different sounds their shoes made on the road.[9] And at the centre of it all was the church, where their brother William performed Bach on the organ – a sound like the joy of angels, said Stanley – and in whose graveyard they played among the tumbling tombstones of Cookham's ancestral dead.[10]

Such was their love of home that a visit to another brother in Maidenhead left them miserable. Gilbert thought this fierce love of Cookham was inherited from their father: 'With so much of his life now in the past, it was all he had to give us, but it was all we needed, or for that matter ever wanted.'[11] When Par made £10 from a published edition of his poems (*Verses, Grave and Gay*), he invested the money in a range of 'Everyman' classics and established a lending library in Fernlea's front room, employing Stan and Gil to paste labels in the books. It was opened to the public with expectant excitement – but nobody came. Such schemes were vivid illustrations of what Gilbert called Par's 'odd excitability and lack of control'.[12] But he galvanised the young boys with his love of existence: 'With him, there could be no excuse for idleness', wrote Gilbert much later. 'Father lived his life whole, and we too if we wished could follow his example out in the "world" – which for us and for him was still Cookham.'[13]

Mar was the rock on which the family stood, 'strong willed and strong minded', taking everything calmly in her stride – but it was Par the boys kissed goodnight.[14] Returning home from London, he brought them presents – one penny 'Books for the Bairns': *Brer Rabbit, Snow White, Don Quixote, Gulliver's Travels, Pilgrim's Progress.* After Annie had put them to bed she practised her viola in their room whilst downstairs Par continued his piano lessons. Melodies of Handel, Beethoven, Schubert and Mozart floated up through the house, with occasionally an exasperated cry of criticism from Par: 'You play the piano like one of your father's cart horses!'[15]

This lively family life seemed to provide for everything. Meal times were an animated riot of discussion – passionate arguments about poetry, music or football whirling round the dining room. And, under Par's critical eye, everyone played the piano, the focus of family occasions. Another focal point was religion. At first, Mar took her two youngest boys to the Wesleyan chapel – a fervent, emotional experience. Chapel was followed by prayer meetings, which could reach such a zealous pitch that Stanley felt close to breaking down. In a 'wretched, clammy atmosphere', the meetings ended with a man whispering, 'Is there any poor wandering soul here tonight who has not heard the call of Jesus? He is passing by, passing by...'[16]

The feeling that Christ and his disciples wandered the neighbourhood was emphasised by Par's Bible readings. He spoke with such conviction, Stanley later recalled, that it seemed as if the New Testament's miraculous stories had happened in Cookham's familiar streets.[17] Their village became more than simply their home; it was, almost literally, their corner of Heaven.

When the chapel closed and the congregation moved to a new building in more distant Cookham Rise, Mar and the boys started worshipping at the Anglican church by the river. Stanley would later tell his brother that 'through his pictures it was "Cookham Church at one end and Cookham Chapel at the other".'[18] It would be no surprise that religion became the all-encompassing theme of his life and art.

• • •

As Stanley and Gilbert grew older, the thorny question of their education arose. Par could not afford the cost of private school, and Mother held 'snobbish objections' to the local state school, where they would have mixed with the children of their lower-class neighbours. Par found a practical solution by opening his own school in the tin shed down next-door's garden. A few other children from the 'poorer élite' of the village joined them, and for a while Par taught them himself. When this became too much he passed the children's' education on to two sisters in the village. Then, when they emigrated, Annie and another sister, Florence, became their teachers.

Though their education was rudimentary, it left the brothers free to develop much as they pleased. In fact, Gilbert thought it was the making of them. He firmly believed that a proper schooling would have ruined Stanley's emerging imagination, his individuality, and his creative drive.

These were now manifesting themselves in drawing – a talent then largely unfamiliar to the musically orientated Spencer household.* There were almost no art books in the house, and his earliest inspiration were the illustrations in his children's books, particularly those by Arthur Rackham, an artist with a vivid imagination for landscape scenes peopled with diaphanous fairies, luscious nymphs and dreadful monsters. Rackham's illustrations for *Gulliver's Travels*, *Peter Pan* and *Alice in Wonderland* remain amongst the finest in English children's illustrations. Stanley made copies, and told Gilbert that one day he would like to draw like Rackham.[19]

On their walks around Cookham with Annie, at the fringes of Odney Common or by the moor, the boys sometimes encountered William Bailey,

* Whilst at the Royal College of Music Will had made drawings of the staff and students, which were so well thought of it was suggested to Par that he might do even better as an artist. But nothing ever came of this, and Gilbert wrote that before Stanley there was no strong interest shown in pictures at Fernlea.

a local builder and talented 'Sunday artist' who painted atmospheric oils of local scenes and talked mysteriously about the 'lost-and-foundness of things'.[20] His daughter Dorothy was a painter and designer, and she gave them their first lessons in watercolours in her house across the road from Fernlea, where they saw more of Mr Bailey's Cookham pictures.

William Bailey's love of local scenes left an indelible mark on the young Spencer brothers. Stanley soon discovered that drawing things in Cookham – its buildings, its animals, its people, the river – somehow connected him even more closely to his beloved home. He first experienced this revelation when he discovered a dead thrush in the garden, the bird's body limp but still warm. He spread out its wings and made a drawing. Though it was poorly done, 'I felt a new kind of contact with life had been made: the Thrush had lived in our garden, had been in all sorts of ungetable places in our Pear tree, our Walnut tree, our Yew tree & all the places we weren't allowed to go into next door's gardens. I was drawing something that was to do with all those places.'[21] This memory, as recalled in the 1930s, was of a discovery of enormous impact. It was the realisation that drawing could bring him even deeper into the almost mystical experience of his everyday surroundings. Through drawing, he could capture or recreate the feelings and experiences and emotions of his village life.

And this could be done not only by drawing the things he saw in Cookham, he discovered, but also by the things he imagined might happen there. An early drawing depicted Cookham's Fire Brigade in their helmets and uniforms riding on the backs of snails along the cobbled stones outside the Bel and the Dragon Hotel. Done in black and red ink, Gilbert described it as 'a miracle' – and seriously intended, too. 'Even at this early date, without perhaps being very aware of it, he had, I think, joined issue with his destiny.'[22]

For Gilbert, so aware of the great expectations their father had held for William, it was ironic that in their very midst, unnoticed, another

talent was developing unfettered: 'Will's sacrifice on the altar of my father's Victorian theories and rigid training of the young was not in vain if Stanley's genius was left free.'[23]

• • •

Conscious that he must to do something serious about his youngest sons' education or abandon them to a future of menial labouring jobs, Par finally decided to send Gilbert to a co-educational school in Maidenhead. He was less sure about what to do with Stanley, however, who was developing into a solitary, undersized young teenager prone to long walks, but with a heightening passion for drawing. Par was close friends with a local gentleman, Lord Boston, whose wife had studied at the Slade School of Art in London. Par showed her some of Stanley's drawings, and although Lady Boston was not especially enthusiastic about the boy's work, she invited him to come and draw with her twice a week. As Stanley's work slowly improved, in 1907 she arranged for him to attend the Technical Institute in Maidenhead. Here for the first time he studied under professional guidance, making detailed copies from casts of antique sculpture. Stanley's future was now clear: he would be an artist.

After a year's schooling at Maidenhead Tech, Par considered sending Stanley to the radical new art school at Newlyn in Cornwall, founded by the painter Stanhope Forbes in 1899. Forbes encouraged painting out of doors, and had made his name with scenes from everyday French and English village life. It sounded an ideal place for Stanley. But it would have meant leaving Cookham, and most Spencers suffered excruciating homesickness. So Lady Boston suggested her old school instead: Stanley could catch the 8.50 morning train to London, and by catching the 5.08 from Paddington after lessons he could still be home in time for tea. It sounded perfect. But would the Slade take him?

The Slade School of Art had been founded in 1871 by a series of endowments made by the will of the collector and antiquary Felix Slade.

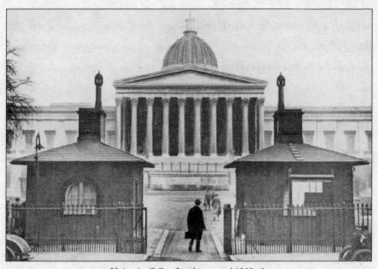

University College, London, around 1910: the
Slade's buildings are just to the left of this picture

As well as establishing Slade Professorships at the Universities of Oxford
and Cambridge, a substantial amount of money was left to found a
similar Chair of Fine Arts and six scholarships at University College,
London. The new School was situated in the attractive front quadrangle
of UCL's neo-classical building on Gower Street, Bloomsbury, about
half a mile north of the British Museum. The first two London Slade
Professors quickly established a tradition of fine draughtsmanship at the
School, demanding that students draw from life models as well as from
antique sculpture. The third Slade Professor, appointed in 1893, was
Fred Brown, himself a former student of the School. An energetic man
who at times happily walked all the way home from Gower Street to his
home in Richmond, a student recalled his 'general manner' as 'gruff and,
superficially, discouraging'.[24]

As a young painter Brown had kept abreast of artistic developments
in France, and was particularly influenced by French Impressionism. In
1886, along with a number of friends who had also studied in Paris, he
founded the New English Art Club. Modelled on the Parisian Salon des

Refusés, up to 1914 the NEAC was one of the few institutions for those British artists who wanted to exhibit their work outside the stuffier confines of the Royal Academy. Though by the turn of the century it had established itself as the new orthodoxy, it was here that many of Brown's students would first display their work for public scrutiny.

On his appointment at the Slade Brown had invited one of his pupils, a gifted young doctor and anatomist with a predilection for art named Henry Tonks, to join him as Professor of Drawing. Another friend, the highly talented but painfully taciturn Philip Wilson Steer, he appointed as Professor of Painting. Then in 1895 Walter Russell, another of Brown's former pupils, was appointed Assistant Professor. Together, these four men formed a close-knit company of friends, advocating realism in both drawing and painting. By 1907 a number of important British artists had passed through their tutelage; these talents included Augustus John, William Orpen, Wyndham Lewis and Spencer Gore. For a young student looking to learn to draw – and to draw well – it was *the* place in England to study. As an historian of the School has written, in the first years of the twentieth century, 'The emphasis on the Slade tradition of draughtsmanship was uppermost: nothing more. In these conditions, and subject to whim or belief, students could be called neither good nor bad. They were either encouraged or discouraged'.[25]

In 1908 Par Spencer took a selection of his son's drawings to show Brown and Tonks. They immediately saw the boy's potential. In fact, they were so impressed that they waived the usual written entrance exam – which, given the poor state of his formal education, Stanley would probably have failed. Lady Boston generously paid the £10 termly fees, and his future now lay in London.

But Gilbert was apprehensive: 'To be trained and yet not guided or steered was going to be the problem for my brother'. Fortunately at the Slade 'this great danger in the period of training, which could disturb any young student, was avoided, since between the staff and the students there was compatibility.

The Slade held a mirror in front of him, the like of which did not exist at home, and he saw himself among the forebears of his art in all their glory. It must have been a revelation to him, although in mood he had been prepared for this moment at home, in his experience of music and literature.'[26]

For Stanley, London was a revelation. Though he hated the daily train journey, he later recalled that his experience of studying at the Slade was

> similar to me to what I imagine it would be if it were possible to get into a book one was reading. The sounds coming in at the open upstairs windows of the long corridor outside the Antique Room, sounds that were coming from the somewhat removed streets, sounds of a barrel-organ playing something which I had heard a cousin playing... It seemed that I and that music was a part of the contents of a book on the cousin's shelf in their house next door. I was so much in the 'Life-Room' that I can't think of any of the students as people one could see in the street anywhere... I liked the girls' paint-covered frocks and walls plastered with palette-knife dabs.[27]

Though they lay on the same river, how could London be more different from Cookham-on-Thames for the young Stanley Spencer? For his brother Gilbert, the two were worlds apart. In 1910 he followed Stanley into an artistic career: he had long been entertaining himself at home making farm animals and toy carts from wood and old pieces of leather. Now he went to study carving at the Camberwell School of Art and Crafts, lodging in south London with another of their many brothers:

> I was quick to realize that here in Brixton we were in the heart of the struggle for survival. The red glare of the London skies killed the starry heavens shining over Cookham, but not the night life of the Brixton Road. Those were the days

before cold storage, and it was a desperate time to walk down the Atlantic Road late at night, when the lean and hungry ones timed their visits to perfection. They knew the butcher's dilemma, as with each passing minute, they eyed his tumbling prices. By midnight the road was in uproar with high pressure bargaining. It was a cut-throat business, though no throats were cut. There was nothing sinister or sordid about it, just a spirit that was London's, with the evening shoppers swarming round barrows illumined by paraffin flares, and floating on a sea of indescribable litter, and the barrowmen themselves shouting their wares, and offering goods of little value to an intelligent and informed clientele.[28]

This was London in the last days of the Edwardian era, the world's largest city and hub of the greatest Empire history had ever known. For some, London simply was England; but for those born and brought up in the countryside in the early years of the twentieth century, before suburban sprawl or the mass ownership of motorcars, before television or radio, London seemed like another country. Here could be found electric lighting, horse-drawn trams, fast-moving motorcars and underground trains, music halls and cinemas showing motion pictures, smoke-belching factories and City banks with their endless stream of clerks and businessmen, the multiform bustle of hundreds of thousands of people streaming back and forth, a 'slick and snappy city' living the new century's modern life at speed.

But the pleasures of West End cinemas and hotels, smart restaurants and expensive cafés, were pleasures for the wealthy. London was also home to the cripplingly poor, the hungry, the homeless, and a magnet for immigrants and abject refugees escaping political and economic hardships or religious intolerance in Ireland and Eastern Europe. London

seemed to suck them in. At the British Museum, only a few minutes' walk from the Slade, the exiled German revolutionary Karl Marx had sat and written his great work, *Das Kapital*. Here he had laid out his grand critique of the iniquities of Capitalism, a system which meant that whilst a few prospered, millions laboured and starved; whilst a few grew rich and enjoyed the luxury of town squares and country houses, the masses inhabited the squalor of 'the abyss' – the East End slums of Whitechapel, Shoreditch and Bethnal Green, the opium dens, sweatshops and ghettos, the pubs, penny gaffs and brothels, the tenements, rookeries and anarchists' clubs of what was dubbed 'the city of endless night'.

In 1894 in his *Tales of Mean Streets*, Arthur Morrison wrote, 'There is no need to say in the East End of what. The East End is a vast city, as famous in its way as any the hand of man has made. But who knows the East End?'[29] Certainly not the village boys Stanley and Gilbert Spencer. The East End's many gloomy enclaves were the place for outsiders: Huguenots had made it their home in the seventeenth and eighteenth centuries, and now the Irish and continental refugees were doing the same.

Here, somewhere among the cramped ghettos inhabited by the 100,000 or so Jewish immigrants, lived another of the promising new students who arrived fresh-faced at the Slade in October 1908: the talented, handsome and wildly ambitious Mark Gertler.

Chapter 2

Mark Gertler and Henry Tonks

Mark Gertler's upbringing could hardly have been more different from Stanley Spencer's. Yet it would leave him with the same passionate and deeply personal attachment to home and family. Whilst the Spencers had known comparative wealth before falling into lower middle-class want, the Gertlers had only very slowly clawed their way out of desperate destitution in London's overcrowded ghetto.

Mark's immigrant parents, Louis and Golda, were from Przemysl, a small cathedral city in Galicia, that uncertain border country lying between Russia, Austria and Poland, and which in the late nineteenth century formed part of the sprawling Austro-Hungarian Empire. In an attempt to escape poverty and anti-Semitism the Gertlers and their four young children emigrated to London in 1891, renting two rooms in a slum lodging-house in Gun Street, Spitalfields. There, on 9 December 1891, 'Max' was born (only later would his name be anglicized to 'Mark'). He was their last child, and the youngest by seven years.

Like many impoverished exiles, Louis Gertler did not prosper in London. Before long the family and their young child were back in Przemysl, their repatriation financed by an English Jewish charity. However, Louis's attempts to run an inn met with failure: he exchanged the inn for a bag of old boots, and the boots for buttons. He sold nothing, and fled alone to the United States, promising Golda that he would send for her and the family when he had found employment there.

For four years Golda cared for their five children alone, taking odd jobs in restaurants and feeding the family on scraps. Finally, in 1898, Louis wrote from London: 'I have prospects. Come, we shall meet in England. I know what to do there and if what I do there is not good we shall go to America where I know still better what to do.'[1]

Mark's earliest memory was not of the rough, tightly-packed, cattle-boat journey across the North Sea, but of their arrival: of England approaching, the voyage up the Thames to London docks, and his mother's anxiety when their feckless father failed to appear. 'Everybody is pushing and shoving', Mark later recalled. 'It doesn't feel friendly – all is chaos, selfish and straining – I am being pushed and hustled, some women are screaming and men shouting roughly.'[2] His recollection of arrival echoes the observation of the same scenes made two years earlier by the philanthropist Charles Booth:

> There are few relations and friends awaiting the arrival of the small boats filled with immigrants: but the crowds gathered in and about the gin-shop overlooking the narrow entrance of the landing-stage are dock loungers of the lowest type and professional 'runners'. These latter individuals, usually of the Hebrew race, are among the most repulsive of East London parasites; boat after boat touches the landing stage, they push forward, seize hold of bundles or baskets of the new-comers, offer bogus tickets to those who wish to travel forward to America, promise guidance and free loading to those who hold in their hands addresses of acquaintances in Whitechapel, or who are absolutely friendless... For a few moments it is a scene of indescribable confusion; cries and counter-cries; the hoarse laughter of the dock loungers at the strange garb and broken accent of the poverty-stricken foreigners; the rough swearing of the boatmen of passengers

unable to pay the fee for landing. In another ten minutes eighty of the hundred new-comers are dispersed in the back slums of Whitechapel; in another few days, the majority of these, robbed of the little money they possess, are turned out of the 'free lodgings' destitute and friendless.[3]

The Gertlers were lucky: their father had not deserted them. He sent an old Przemysl friend, Louis Weinig, to meet them. He led them to Liverpool Street, the railway station on the edge of the City and Whitechapel, only a stone's throw from Gun Street, where banking wealth rubbed uncomfortable shoulders with destitution.

Here the Gertlers waited, like a gang of gypsies, little Mark in his long Hungarian coat of orange leather, a brother straining under his load of feather beds. Finally their father appeared, and they followed him through the streets of London. As Mark later recalled:

Yes, this was London! For some people it may be England my England, but for me it is London, my London. Yes, although I was born in it, I saw London – experienced London – for the first time when I was six and my only language was Yiddish! ...Yes, there was a moment in my life when I was actually fresh to London – London where I have lived for so long, experienced so much, London that has become part of me to such an extent that I can almost imagine life more easily without the people I have known than its own embodiment and peculiarity. And it is here then, in London, and at the age of six and in 1898, that my true history commenced – my own life as I have known it and suffered it.[4]

At first there was much suffering. Their early weeks back in London were spent with Louis Weinig and his family in a damp tenement in

Shoreditch, all seven of them sharing a single room. On his first night Mark woke in the darkness, his family around him asleep beneath sacks, and his heart was filled 'with overwhelming sadness. I cried, but quietly, not to awaken my mother, and that is the first real fit of depression I remember experiencing.'[5]

Louis Gertler worked hard to improve the family's situation, and friends helped him out. In Spitalfields and Whitechapel the Jewish community, though often desperately poor and living in overcrowded conditions, suffering from disease, malnutrition and intolerance, worked hard to support one another. Here there were fellow speakers of Yiddish (Mark's mother would never learn much English), shops selling kosher food, and on Brick Lane the Machzikei Hadath Synagogue (a converted Huguenot church built in the 1740s) as well as Schveik's Russian Vapour Baths, where the Orthodox bathed on Fridays. Though the conditions of life were dreadful, though they were alien and isolated, their small corner of the East End offered solidarity to the Jewish immigrant community.

Mark's father was a distant figure: Golda described him (albeit affectionately) as a *tuttalla*, a 'simpleton', holding him responsible for the family's failures – her parents had told her never to marry him. Golda is the clearest figure in Gertler's accounts of his early life. She was devoted to her children, 'completely self-sacrificing', but Mark, the youngest, was her darling.[6]

Despite his failings, Louis eventually found a job sandpapering walking sticks. The family took lodgings with a Jewish bootmaker who ran a small sweatshop in the same building. Here four or five young men and women toiled hour after hour in a dirty, airless little room. One of them went quietly mad with the stress of overwork and one day was found pacing the back yard, spinning gold sovereigns in the air, 'and murmuring as each piece clinked to ground, "What is money, what is money?"'[7]

This is what the East End could do: it seemed almost to spawn a different race of people – pale, undersized, weak of limb, unsound of mind.

As James Cantlie, Fellow of the Royal College of Surgeons, suggested in a lecture delivered in 1885, 'Degeneration Amongst Londoners', there was a new disease distinct to the late nineteenth century: urbo-morbus, 'city disease'. 'It is sad to contemplate', Cantlie observed, 'that now-a-days honest labour brings with it of necessity illness and misery, instead of health and comfort – that the close confinement and the foul air of our cities are shortening the life of the individual, and raising up a puny and ill-developed race.' The East End sweatshop workers were stunted, 'prematurely old', with 'grave and sorrowful countenances' betraying bodies and minds at variance with nature. 'Being an abstemious class they continue, it may be, to a third generation; but they are more machines than active livers, and, on the face of it, it is improbable that out of such a class a healthy person could spring.'[8]

It was a harsh environment in which to bring up a young child, offering little hope either of escape or of a long or prosperous life. Its impression would govern the rest of Mark Gertler's life.

• • •

Mark was sent to Maida, the Jewish school where he learnt Hebrew from the Rabbi's monotonous intonation of the Torah. Later, when the school inspectors tracked him down, he was sent to a board school in nearby Settles Street, and then another at Deal Street, both just east of Brick Lane. A friend later recalled that their school 'was in a very poor slum area... very dark and frightening, with frequent screams and drunken fights, and homeless people asleep in corners or on steps.'[9] These were the streets where, only ten years before, Jack the Ripper had prowled, eviscerating his female victims and fuelling fear and ethnic prejudice. As the serial killer had scrawled on a wall after committing one of his atrocities: 'The Juwes are The men That Will not be Blamed for nothing.'[10]

Racial and religious animosity meant that East End schools were effectively segregated, but alongside other Jewish children Gertler learnt English, and received the rudiments of an English education. It was here,

too, that his first name was anglicised: 'Max' became 'Mark', and so he would remain.

Unsurprisingly given such an upbringing, Gertler later described himself as 'a very nervous, highly strung, and emotional child, somewhat undersized, thin and pale'. Though much younger than the rest of the family, his mother kept him up late as friends visited and talked long past midnight, and the pressure started to show. As he later recalled: 'I shall always remember the awful mixture of exhaustion and despair I felt every morning when I had to make myself get up in time for school, for I was very conscientious and terrified of losing a mark, and every morning the strain made me weep and cry as I dressed, "It is late already, I shall be late."'[11]

It was drawing that offered Mark a way of escaping this world of poverty and anxiety. Though 'utterly ignorant of everything connected with art', he 'longed to draw and paint, right from the very beginning.' He admired the pavement artists who made pictures in chalk for money, and the brightly-coloured tin adverts in the smoke-blackened streets, whilst the shops 'full of the brilliant colours of meat and fish, vegetables and fruit, were a continual joy, and my mother would sometimes get things for me, which I would paint.' As Golda cooked, Mark sat in the warmth of her kitchen with a school friend, Cyril Ross, and they drew and painted. Cyril later recalled how Mark's drawing 'always seemed extraordinary to me, so accurate, clean and perfect; it was correct from the very start. We would spend hours working on the floor in the dim gaslight, while his mother washed clothes in the cement copper in the corner.'[12]

Mark's discovery in a local second-hand bookshop of a copy of the Victorian artist William Powell Frith's *Reminiscences* sealed his ambition. Frith had risen from childhood poverty to study at the Royal Academy Schools and paint the portraits of royalty. If Frith had done it, why couldn't Gertler? By the time he left school at fourteen, and though he had never been to

a public art gallery or had any contact with the artistic world, Mark knew without any doubt that he wanted to be an artist. But this only perplexed his father, who arranged a clerkship for him at a timber yard instead. A family member recalled that Louis 'didn't understand what an artist was. To him a Jew could not be an artist; he thought everyone should learn a trade.'[13] But the family situation had started to improve. Though still living in the heart of the East End, they had moved out of the slums and into the relative prosperity of Leman Street, from where Louis ran a furrier's business with his two older sons. There was a little money to spare and, with help from a Scottish friend of his father's, Mark was enrolled at the Regent Street Polytechnic, one of the best technical schools in London. Once he was presented with this opportunity, the privations of his background motivated him even harder to succeed.

The aspiring artist: Mark Gertler aged about 15.

Though the Polytechnic was originally intended as a Christian Institute, its head, G. Percival Gaskell, a graduate of the Royal College of Art, soon befriended the young Jewish boy. Recognising his talent and dedication, but also his limited education, Gaskell took Gertler on his first visit to the National Gallery. There he introduced him to the works of Velázquez, Fantin-Latour and the eighteenth-century still life painter Jean-Siméon Chardin. Mark, who was already keenly painting the everyday objects he found around his mother's kitchen – pots and pans, or the fruit and vegetables and fish Golda bought at the local markets – was fascinated by the realist still lifes of the Dutch masters. He was soon trying to emulate them.

At the end of his first year he did reasonably well in his examinations, though not brilliantly. As Louis was finding the Polytechnic's fees a burden he applied to a charity, the Jewish Educational Aid Society, for assistance. They replied unhelpfully: was the young boy really worth investing in? They told Louis, 'It will be necessary for us to take a further opinion before we can come to a definite decision'.[14] So Mark would have to start paying his own way. In December 1907 a position was found for him as trainee illustrator at Clayton & Bell, a prestigious manufacturer of stained-glass windows, whose factory was next door to the Polytechnic. Working there by day, repetitiously copying out endless designs of the Virgin Mary and John the Baptist, by night he continued his art classes.

If Mark was working hard, he was still able to enjoy himself. He returned home to Whitechapel and entertained Golda with stories of the people he encountered in the West End. He brilliantly mimicked the people he saw around him: 'the mincing ladies and the lordly shopwalkers, the tittering girls and the men working in the streets', reproducing for Golda, who never ventured from the ghetto, 'the whirl, the glitter, the roar, the splendour of London'.[15]

At the same time he discovered other social and educational opportunities. In 1901 the Whitechapel Art Gallery and Library had opened as a venue for promoting culture and personal improvement amongst the East Enders. Gertler started spending spare evenings there, and befriended a number of other young Jewish artists, among them the equally ambitious David Bomberg. Another new friend was the Oxford-educated Quaker Thomas Harvey. Harvey was Warden of nearby Toynbee Hall, a Christian establishment set up in the 1880s as a place where Oxford students could come to experience the East End's social problems first hand, and bring moral and instructive improvements to the slums. The Hall itself was much like an Oxbridge College, and with its ivy-clad porch, turreted library, dovecote and clock tower stood out oddly amongst its shabbier surroundings. Like Gaskell at the Polytechnic,

Harvey, who was then in his early thirties, provided cultural guidance and encouragement to the young Gertler.

And then there were the music halls. As Peter Ackroyd records in his biography of the city, 'the East End harboured more music halls than any other part of London – Gilbert's in Whitechapel, the Eastern and the Apollo in Bethnal Green, the Cambridge in Shoreditch, Wilton's in Wellclose Square, the Queen's in Poplar, the Eagle in the Mile End Road, and of course the Empire in Hackney'. These, along with many others, 'became as characteristic of the East End as the sweatshops or the church missions'.[16] Here could be found every variety of performer, from singers of comic songs to acrobats, from strong men to conjurors. They provided local entertainment for Cockney audiences, and Gertler loved it. He regularly headed the queue for the cheap seats in the gods when Sabbath ended on Saturday afternoon.

Though he had not done brilliantly in his Polytechnic examinations, in the summer of 1908 his precocious oil painting *Still Life with Melon* won a Bronze Medal in the National Art Competition. This was run by the Board of Examination, with 15,000 young artists contending from around the country, so a medal represented a major – and well-deserved – success. A renewed application to the Jewish Educational Aid Society now warranted further consideration. Mark's work was shown to Solomon Joseph Solomon, a successful painter who had recently become only the second Jew appointed a Royal Academician. Solomon sought the opinion of another prominent Jewish artist, William Rothenstein. Thirty-six years old and with a large house and family in the well-to-do London suburb of Highgate, Rothenstein was the son of a wealthy German wool merchant. Brought up and educated in Bradford, he had studied at the Slade and at the prestigious Académie Julian in Paris, where he had known Degas, Pissarro and Toulouse-Lautrec. A friend of Oscar Wilde's, he had co-founded the Carfax Gallery in St James's – one of the most enterprising in London for showing the works of contemporary painters. Rothenstein was

proving himself an influential patron for young artists, Jews and gentiles alike. He had even encouraged Augustus John – the Slade's most exciting former-student – to hold his first solo show at the Carfax.

So one day with the help of one of his brothers, Mark carried some of his paintings to Highgate, and rang the front bell. The door was opened by Rothenstein's young son John, who recalled seeing a nervous, sullen-faced boy 'with apricot-coloured skin and a dense mop of dark brown hair so stiff that it stood on end. I took him for a barrow boy, but he said he had been sent to see my father.'[17]

The sixteen-year-old East Ender shuffled shyly in to present his pictures. As Rothenstein wrote to Louis Gertler the next day:

> It is never easy to prophesy regarding the future of an artist but I do sincerely believe that your son has gifts of a high order, and that if he will cultivate them with love and care, that you will one day have reason to be proud of him. I believe that a good artist is a very noble man, and it is worth while giving up many things which men consider very important, for others which we think still more so. From the little I could see of the character of your son, I have faith in him and I hope and believe he will make the best possible use of the opportunities I gather you are going to be generous enough to give him.[18]

Gertler's parents were so moved by this letter that they framed it and hung it on their wall – to Rothenstein's amazement when he later came to visit. If Louis had harboured any doubts about his son's future, they were now dismissed.

Using his connections and his conviction of the boy's potential, Rothenstein immediately secured a place for Mark at the Slade. The Jewish Educational Aid Society agreed to pay his fees, together with

some extra money for travel and expenses, and Mark was released from his position at Clayton & Bell. As the secretary of the JEAS wrote to inform him: 'You are to become a student at the Slade School of Art, and Mr. Rothenstein has very kindly agreed to personally look after your studies. This will include the valuable privilege of occasionally working at his studio. So I think you ought to consider yourself very lucky and determine to make the most of the opportunity now offered you – as I am sure you will.'[19]

• • •

As new students at the Slade in the autumn of 1908, Spencer and Gertler's first destination was the Antique Room. There they mixed with the rest of the year's fresh intake, both male and female, to draw all day from plaster casts of Greek, Roman and Renaissance sculpture under the watchful eye of Professor Henry Tonks. Only with Tonks's permission could they move on full-time to the Life Room – and praise from Tonks was a rare commodity, eagerly sought.

Tonks himself was a 'towering, dominating figure', well over six feet tall, 'lean and ascetic looking, with large, hooded eyes, a nose dropping vertically from the bridge like an eagle's beak and a quivering, camel-like mouth. There was about him an aura of incorruptible nobility of purpose and he was... respected by all the students and feared by many.'[20] He lived for art: 'never was a man more anxious to learn and to teach than Tonks', a friend would write in 1924. 'He read everything that was written about drawing; he listened to all that his friends had to say; he thought about drawing, and he practised drawing, praying that the secret might be vouchsafed to him, for art has become Tonks's religion.'[21]

At the Slade, his hands clutching the lapels of his suit jacket, Tonks moved from student to student, quietly disseminating his theory of drawing with a few well-chosen words. Gilbert Spencer, who would follow his brother to the Slade in 1912, later wrote how Tonks 'talked of dedication, the privilege of being an artist, that to do a bad drawing was

like living with a lie, and he proceeded to implant these ideals by ruthless and withering criticism. I remember once coming home and feeling like flinging myself under a train, and Stan telling me not to mind as he did it to everyone'.[22] Another student recalled that a 'typical beginning, in a slow, horrified voice, would be like this: "What is it? ...what is it? ...Horrible... Horrible! ...is it an insect?"'[23]

Tonks's dedication and demeanour derived partly from insecurity (he was not a naturally gifted draughtsman), and partly from the roundabout route he took to becoming an artist – what he himself called 'a strangely devious one'. Born in Birmingham in 1862, he was the victim of an English public school: after nine years' education at Clifton, near Bristol, he left having learnt little. Though already in love with the idea of being an artist, he imagined these curious creatures somehow emerged fully formed and readily capable of producing masterpieces, 'so my position seemed hopeless'. Instead he decided to become a doctor. At a teaching hospital in Brighton he met a fellow student who shared his interest in art, and who encouraged him to practice. When Tonks moved on to a hospital in London he utilized his developing artistic talent by demonstrating at anatomy classes, and he drew the patients whenever he could. If patients were unavailable to model, he used cadavers instead, bribing the post-mortem porter to fix a corpse on a table for him, 'which I could then draw at my ease.'[24]

Drawing gradually became Tonks's 'absorbing passion': what he lacked in natural talent he made up for with dedication and practice. On ward rounds 'each patient had a double interest, that of the disease which brought him there, and his possibilities as a model and how I would express them.' He discovered another doctor with a similar interest and they found more curious methods of obtaining models. On free evenings they wandered the red light districts until they found a girl who interested them, and then accompanied her to her lodgings where they made their sketches as the girl posed nude. 'This worked quite successfully,' Tonks later recalled.[25]

Tonks, like Gertler after him, was inspired to become an artist by reading the life of a Victorian artist, Randolph Caldecott, who progressed from a Manchester bank clerk to become an artist and illustrator in London. Thus in 1888, the same year he was appointed Senior Medical Officer at London's Royal Free Hospital, Tonks began studying part-time with Fred Brown at the Westminster Art School. Brown was so impressed by Tonks's draughtsmanship and dedication that when he was offered the Slade Professorship he invited Tonks to become his drawing master. Tonks's father 'expressed his extreme displeasure' at his son taking the position and abandoning his medical career. But Tonks believed he owed to Brown 'the great happiness of my life.'

Like many strict teachers, Tonks loved his work and his students. He later wondered why it was that he had been called upon to help so many in their first steps to becoming artists. 'I certainly cannot draw, though I have a passion for drawing; I am uncertain about the direction of lines; I have no skill of hand, and to express myself at all I have the greatest difficulty. Perhaps it is that being so deficient myself, I have enough honesty to urge my students to strengthen themselves where I am weak.'[26] Or perhaps it was his great skill as an anatomist, which allowed him to see almost inside the human body: 'in fact I have often wondered since what the figure looks like to anyone who has not this knowledge.'[27]

Imbued in and devoted to the art of the High Renaissance, Tonks encouraged a style that drew on the great European tradition of meticulous observation and flawless drawing. Titian, Rubens, Velázquez and Ingres were his paragons: 'The atmosphere that prevailed in the school', wrote one student, 'was one of high-minded devotion to Art, untainted by the breath of Commerce.'[28] Despite his withering criticism, these ideals meant that many pupils idealised him – though others came to fear and loathe him. And like many great teachers, Tonks showed favouritism, particularly to his female students (of which there were

many: the ratio of women to men at the Slade was roughly three to one). Though a life-long bachelor, Tonks was intrigued by women – an interest first kindled, he claimed, when as a young medical student in Brighton he had seen the nurses at their Christmas concert 'sitting in rows one above the other, varying in age, some as young as sixteen... For the first time I seemed to understand the beauty of women, set off, as it was, by their neat hospital uniform. The change in my life was complete.'[29]

His attitude to feminine beauty is apparent in Tonks's oil paintings of young Victorian ladies portrayed in drawing rooms and country gardens, twee and slightly syrupy in their English Impressionism. They reveal a different, more sentimental side to the stern face he presented to his students. And his interest in women was often reciprocated in a strange hero worship. William Rothenstein observed that though young ladies 'of the best families were known to weep at Tonks's acid comments on their works', they still 'flocked to the Slade to throw themselves before Tonks's Jaganath progress through the life rooms. There was a time when poor Tonks had to walk the streets not daring to go home, lest ladies be found at his door awaiting his arrival with drawings in their hands, whose easels had been passed by, and in whose hearts was despair.'[30]

• • •

This, then, was the uncompromising environment in which Spencer and Gertler found themselves. The first East End Jew to win a place at the School, Gertler was horribly aware of his rough accent and low social class. Feeling unable to speak without betraying his background, for the first term he worked in silence, listening carefully to the other students' educated pronunciation and intonation, which he then practised to himself as he walked home. Such apparent aloofness, combined with class prejudice and tints of anti-Semitism, meant he was at first unpopular. One student recalled that Gertler was 'smallish, delicately made, pretty in an almost girlish fashion', and 'though tolerated and respected he was not much liked.' Another admitted that he had initially snubbed Gertler because he was Jewish.[31]

Spencer, with his bad teeth and coxcomb of unbrushed hair, his dirty Eton collar and Norfolk jacket, standing only five feet two inches tall and looking like a scruffy schoolboy, was equally vulnerable. He escaped any withering comments from Tonks, however. Tonks had already recognised the extraordinary power of concentration shown in Spencer's early drawings, telling a friend that the main danger facing this young student 'was an overcrowding of ideas'.[32] Tonks had little need to criticise Spencer, and by and large he did not.

Nevertheless, Spencer still had to sit in the Antique Room, making drawings from casts. It was only for the last hour of the day that new students were allowed to work from life, making rapid-fire sketches as the model changed position every fifteen minutes. Here, for reasons of decorum, male and female students were divided into separate rooms, it being considered improper for them to be together in the presence of a naked human. The Men's Life Room was a large, smoke-filled chamber at the heart of the School, where, one female student was told, a net surrounded the model's 'throne', 'to catch any female model who might faint, so that no male hands could touch her.'[33]

The men might be unable to touch, but they were of course expected to look, and for most this was their first sight of a naked woman. One student recollected his first glimpse of a nude model, with her 'pink and soft flesh, breathing and ever so slightly swaying'. Only her eyes were in motion: they roved round the room, 'and her glance as it rested on one or other of the men seemed to share dark and unholy secrets with them.'[34]

Spencer missed these final life classes, however, to catch his train home. Inevitably this, together with his odd appearance and childish manner, made him a figure of fun. When in his second term he received Tonks's permission to graduate from the Antique class and he entered the Men's Life Room for the first time, it was rest period, and the other students were standing around smoking and drinking tea. Seeing this diminutive

newcomer arrive, another new student with a public school accent came up an introduced himself. In his Berkshire brogue, Spencer informed him that he came from Cookham. That, and Stanley's willingness to talk to anyone at length about his home, led the public schoolboy to christen him with a lasting nickname: for the rest of his time at the Slade he would be known simply as 'Cookham' – and he took happily to using it himself. Then the new boy directed Spencer's attention ominously to some marks on the floor. These, he explained, were all that was left of a number of previous students who had melted.

This amusingly menacing young man – later characterised by another student as the school bully, though 'in a playful sort of way, on a mental, rather than a physical, plane'[35] – was Christopher Richard Wynne Nevinson – Richard or 'Chips' Nevinson, as he was known to his friends. He and 'Cookham' would make uneasy companions.

Chapter 3

Richard Nevinson

'It is a terrible thing to be a mother,' Richard Nevinson's mother recalled in her autobiography, *Life's Fitful Fever*, 'and in comparison, all other work and vocations are as child's play. There are too long months of ill-health, sickness and discomfort, the agony and terror of birth, long weeks and months of weariness and loss of sleep... And yet except in time of war how lightly do men think of the work of creation; the English law technically describes wives and mothers as of "no occupation".'[1]

The daughter of a Leicestershire vicar, educated at an Anglican convent school in Oxford and a finishing school in Paris, Margaret Wynne Jones was a forceful woman and a committed Suffragette. Though a devoted parent, her attitude to children was ambivalent. 'A baby is very engrossing,' she observed, 'and for a few years children repay us with a love and devotion that makes earth a paradise. But later, "marriage and death and division make barren our lives," and "remembering happier things," that "sorrow's crown of sorrows," is too often a mother's only compensation for her sufferings and sacrifice.'[2]

Part of Margaret's disdain for motherhood came from its low esteem in Victorian and Edwardian society. By 1926 she observed that many women were starting to reject the role traditionally expected of them. Except among the very poorest in Britain, increasing awareness of birth control possibilities was starting to lower pregnancy rates, allowing some women to pursue 'occupations more lucrative and less scorned'

than bringing up large families. Margaret's youthful ambition had been to become a writer. Instead, in 1882 she received an arts diploma from St Andrew's University and took up the principal career then open to literary young ladies: school teaching.

In 1884, aged twenty-six and heavily pregnant, she married her childhood friend, Henry Woodd Nevinson, a Classics graduate of Christ Church, Oxford. To escape the scandal, they moved to Jena, where Henry pursued his interest in late eighteenth-century German literature whilst Margaret taught English. Margaret would look back on this time as years of struggle, but Henry soon published his first book – a study of the philosopher Johan Gottfried Herder. This was followed by a volume on the poet and dramatist Johann Friedrich von Schiller, a leading figure in the German Romantic *Sturm und Drang* movement. These were the first publications in a writing career that would spawn over a dozen books, as well as a successful life as a leading left-wing journalist. Although her husband was committed to the Suffragette cause, as Henry prospered as a writer, Margaret's ambitions took the back seat conventionally expected of a Victorian mother.

• • •

The Nevinsons' first child, Philippa, was born in 1885. Richard, born on 13 August 1889, would be their second and last. His birth was difficult – enough, perhaps, to put off any woman with a wish to live on her own terms from having further children. But shortly after Richard's birth Margaret caught puerperal fever and almost died: 'One morning, as I lay semi-conscious, I heard the doctor say in the opposite room: "unless her temperature falls I don't think she can last the day," and I laughed to myself in my fever and pain as I thought, "no such luck."' Despite her weakness, she knew she must live. 'I was not one to leave two children to the tender mercies of a cruel world.'[3]

She looked after the children and organised the house and servants – but still found time for political activism. Henry and Margaret shared

a deep-seated Christian Socialist conscience, and on their return to England they settled in the slums of Whitechapel, where Margaret became a teacher in an East End school whilst Henry worked at Toynbee Hall – where some twenty years later Gertler would befriend Thomas Harvey.

When the Nevinson family left Whitechapel it was to move to Hampstead, the hilltop suburb long desirable among wealthier, literary Londoners, situated above the notorious smogs of the capital.* But the Nevinsons had not totally deserted the East End. They continued to take active interest in the social and cultural conditions of the poor: Henry was secretary of the London Playing Fields Commission, encouraging fresh air and healthy exercise, whilst Margaret worked as a manager for the London School Board, campaigning against the iniquities of the Poor Law and the deficiencies of women's education. She devoted her literary talents to the Suffragettes, becoming treasurer of the Women Writers' Suffrage League and founder member, in 1907, of the Women's Freedom League, a splinter group from the more radical Women's Social and Political Union run by the notorious militant campaigner, Emmeline Pankhurst. It was a strong-willed woman or man who joined the Suffrage movement, for their public reception was appalling – insults and physical assault were common, they were spat at and pelted with stones and fruit as they spoke out for their cause. The police did nothing to defend them – in fact, they and the courts did all they could to demean the women. Sentences of six weeks' imprisonment were handed out for such supposed misdemeanours as three Suffragettes 'obstructing' Whitehall. As defence counsel pointed out, 'it was early in the morning, few people were about and three *ladies* do not obstruct Whitehall.'

His protests were ignored, and Margaret recorded how 'to the average lay-mind, brought up to believe in British Justice, it was puzzling to see a

* In 1921 Dora Carrington would write witheringly to her brother of 'that mud-beridden, fog-besmurched, smell-befumed, Boot-bespattered city of London'.[4]

37

magistrate conducting business evidently too deaf to hear evidence, and callous to the great ideal of the women'.[5]

The pressures of political activism played on Margaret's nerves. Emotional and depressive like her husband, she hated London, even Hampstead, complaining of the families packed so closely together, the neighbours with their 'musical practices, pianos, violins, sopranos and other voices, gramophones, barking dogs, and above all screaming babies and fighting children, so that one's highly rated and taxed home become a hell; and there's no redress.'[6] This was hardly Whitechapel, but still London seemed to take its mental toll.

Nor was her hurried marriage a success. When Henry Nevinson became a full-time journalist in 1897 she found his endless absences trying. The papers were set late in the evening, and often he would not return home till long past midnight. 'Nerves get strained and tempers ruffled,' she later wrote, 'and it is to the credit of both husband and wife if they do not take to drink, or drugs, or separation orders, or decrees nisi.' In fact, the Nevinson's relationship *did* break down at this point (if not before). Henry was regularly away, either at the office, or chasing distant war stories overseas, or pursuing relationships with other women, or simply escaping what he described in his diary as his wife's 'nagging ceaseless blast of ill temper' and 'an unhappy woman's unhappiness'.[7]

Margaret again tried to write. But she was terrified that the mental effort would make her ill, and she would burn her efforts 'with bitter tears for the futility of the work of an exhausted body and mind.'[8] One success, however, was her series of short stories, *Workhouse Characters*,

* Many men were also involved in the Suffrage movement. In 1907 Henry Nevinson was one of the founders of the Men's League for Women's Suffrage, and in May 1913 Stanley Spencer attended a Suffragette meeting in London, and wrote to friends: 'You will be amused to hear that Gil & me are Gentlemen in favour of Women's Suffrage. I signed a card (the first to do so I believe) then Gil did... It was fun, we were among the very roughest lot & every time I tried to sign I was bumped & shoved all over the place & called all sorts of names... A lot of these men wanted to chuck us in the Fleet'.[9]

one of which was adapted as a play and performed at the Kingsway Theatre in 1911. Described by the *Evening Standard* as 'this disgusting drama', it nevertheless helped bring about a change in the outdated Poor Law.[10] Margaret later observed that though many adults experience this desire for literary self-expression, it is often defeated by the daily demands of bread-winning and family:

> Unless a way out can be found, the struggle ends in what psychologists call 'frustration', an unwholesome state of mind, leading to cynicism, envy, hatred, and malice towards the more fortunate, and a bitter discontent. The sharpest sting to my mind was the consciousness that the years were passing, that the keen powers of mind and body, the vigour and ambition of youth, do not last for ever. Above all, the brightness of the imagination clouds in the thick mists of age and experience, and the night cometh when no man can work.[11]

It was no doubt from his mother that Richard Nevinson inherited the melancholy, frustration and mistrust that would plague his life, together with his often bitter outlook on the travails of an artist's career.

• • •

Though Margaret's efforts at writing were frequently frustrated by everyday practicalities, the Nevinsons refused to settle into the unquestioning, conformist role expected of the genteel English middle class. They were revolutionaries at heart, keenly aware of the injustices of British society and the many iniquities of its ever-expanding Empire. Henry was well positioned to make his criticisms, travelling the world as a war journalist for the *Daily Chronicle* and the *Manchester Guardian*, reporting on conflicts from South Africa, Russia and Spain to the Balkans and India. Known respectfully to his friends as the 'Grand

Duke', Henry became the most renowned radical journalist and war correspondent of his day.

These were no ordinary parents, then. Indeed, Richard later recalled that by 1910 his father

> had been chucked out of more meetings than any other man in London and had achieved the distinction of being publicly rebuked by Lloyd George at the Albert Hall. My Mother devoted the whole of her life at this period to the under-dog, the scallywag, and the fallen woman and she fought tooth and nail against the smug powers that were. At home I heard little but a lucidly expressed contempt for the grossness of Edwardian days and its worship of all things which were established, be it prostitution or painting. Our house seemed to be a meeting-place for French, Germans, Finns, Russians, Indians, 'Colonials', Professional Irishmen, and Suffragettes, and none of them had any respect for the things that were. It was, indeed, clear to them that England had nothing to be proud of; a belief which was in sharp contrast to the apparent self-righteousness of all other classes. Puritanism, with all its lusts and cruelties, had created a suspicion of beauty and a reverence for commercial success. It did not matter what a man did for the world. What would he leave? A poem? A picture? Nonsense. Look at his will. [How much] had he *made*.[12]

Growing up in such an unconventional household, with such forceful (and, in the case of his father, famous) parents, would make Richard both precocious and insecure. Perhaps unsurprisingly, he became a show-off and a bully. Yet as a child he had been sensitive, introverted and observant. (Margaret recalled that as a baby he had shown 'a very remarkable love of

colour; even at the age of four weeks he would fix his eyes on anything bright'.[12]) As he grew up this inner shyness sometimes showed through, and his adult personality became a battleground between what he was by nature, and what he became by his upbringing in an industrious and literary home – a hothouse of talents similar to the one Spencer experienced. For like Stanley's brother Will, Richard's sister was musically gifted, and she would go on to study at the Royal College of Music.[*]

Also like Spencer, for years Richard lived in a fantastical childhood world of his own creation. As his mother later recalled, imaginary friends included two dogs, Hampstead, 'who acted as his guide, philosopher and friend and advised him in all important questions of life and action', and Herod, who was 'apparently an evil spirit counselling evil, "Him a naughty, wicked dog."'[14] When he grew older Richard became embarrassed by these imaginary companions and washed them away: his godfather asking after them one day received the unexpected rebuff, "Em both dead, 'em never was, 'em wicked lies, the sea-water roared into the cistern at Criccieth and drownded 'em both dead.'[15]

Richard was a melancholy child, easily disturbed by everyday occurrences. When he was five and on a walk with his nanny they passed a lavish Victorian funeral. Perhaps carelessly, his nanny explained to the little boy what was happening, and Margaret remembered her son coming home 'in a state of dreadful agitation, feverish and terrified, clinging to me and crying: "Oh! mother, don't you die, I'll never let them put you in a hole, let us go on here for ever."'[16]

At preparatory school 'the horrors of history and "man's brutality to man" upset him dreadfully.' Sometimes he would arrive home 'with tear-stained face and blurt out historical annals that filled him with disgust: "I hate history, it do be so very poor."'[17] When his parents took him to see an exhibition of Pre-Raphaelite paintings he was particularly

[*] An enjoyment of music ran in the family: Basil Nevinson, Richard's uncle, played cello with Edward Elgar, who in 1899 depicted him as the 12th of his 'Enigma Variations'.

moved by William Holman Hunt's *Isabella and the Pot of Basil*, in which a young woman embraces the ornately decorated cauldron containing her murdered lover's head. It so upset him that he asked to leave the gallery. Of books and pictures with emotional content his sister would counsel wisely, 'Don't tell Richard about them, they are too sad for him.'[18]

School was simply another 'sadness'. He was much more interested in painting and drawing than learning 'the three Rs'. He was miserable at his first school, where beatings were commonplace. A once healthy child now seemed to do nothing but fall ill: measles, whooping cough, mumps, chicken pox, influenza. 'All our school fees for months for both children were paid only for the privilege of infection', wrote Margaret.[19] He was moved to another school, where he was happier, though Henry wrote in his diary in 1901 that Richard was 'growing up all wrong'. Worse, according to his headmaster Richard had 'no exceptional talent'.[20]

But when the boy was about thirteen, Henry noticed for the first time his developing imagination and artistic aptitude: 'I recognised with apprehension that he would become an artist or nothing. With apprehension, because the life of an artist, as of most novelists and poets, is likely to be solitary, self-centred and isolated from mankind. Soon afterwards, most unhappily, I was induced to send him to a Public School for three years, and I might just as well have sent him for three years to hell.'[21]

A middle-ranking public school near Leicester, Uppingham had a long history and a strong emphasis on sport. Richard later claimed that his father showed little interest in him whilst he was there, and that he rarely heard from him. Though they would never really be close, Henry cared much for his son, describing in his diary the day Richard departed for boarding school as one 'of choking sadness to me & us all... It was worse than going to school again myself. Came home in extreme misery.'[22] As it had been for Tonks, so Richard's experience was one of debilitating, depressing pointlessness. As he would later tell Dora Carrington, 'Ever

since I went to a public school I have been fighting with my back to [the] wall suspicious of everyone, trusting no one just one long struggle of harsh dealings & retaliations.'[23]

Uppingham left Richard emotionally scarred, with an enduring hatred of all such English institutions, 'into which fits exactly the national code of snobbery and sport' and the 'façade of tradition'.[24] Thirty years later he would write that public school 'made me aggressive on one hand and too shy on the other hand, and both states are opposites of the same thing. The only things that I ever learned as a youth are those I have spent years trying to forget.'[25] These traits were quite noticeable: a Slade friend would later observe how Nevinson's temperament 'gravitated between easy bursts of laughter... and deep depression.'[26]

• • •

Richard remained at Uppingham till 1907, enduring his unhappiness, learning virtually nothing of use to him. His only escapes were art classes and family holidays to France. But from the 'hell' of Uppingham his parents, recognising his potential, sent him straight to 'heaven': 'St John's Wood School of Art, where I was to train for the Royal Academy Schools.'[27] Prior to the establishment of the Slade, the Academy Schools had been the only place to study fine art in London. In 1907, to aspire to the Academy was to aspire to artistic greatness – but also, as Richard eventually discovered, to convention.

In his first term at 'the Wood' Richard spent his days studying anatomy and making endless chalk drawings from antique casts. Up till then his creative interests had been directed entirely at landscapes and buildings, so he found these obligatory Antique classes 'a tremendous grind'.[28] His favourite artists were the French Impressionist Claude Monet and the great English landscape painter, Joseph Mallord William Turner – especially Turner's late, near-abstract watercolours from the 1840s. But these were highly skilled and gifted artists, particularly interested in colour and shade, the subtle effects of light and tone. To become a professional

painter Nevinson first had to learn to *draw*. As he admitted, it was fortunate that he had not gone straight off to Paris to study, as had been suggested to him, 'because already I was running before I could walk... I was an appallingly bad student'.[29] His teachers reported to Henry that his son had 'no true style', was trying to do things 'every way', and lacked 'concentration'.[30] This would be a problem for some years to come.

Once he had mastered drawing from casts, Richard graduated to life classes. During the day he drew from life at the School, whilst at night he paid a model to come to the 'ghastly little studio' he rented off the Marlborough Road. With all the verve and enthusiasm of youth, he worked and worked. And to have escaped boarding school and be free to explore life and London was a wondrous liberation. Though he later described his colleagues at 'the Wood' as either 'fools or gentlemen', he remembered his days there with fond affection. His shyness went, he spent time with girls for the first time, there were parties and visits to the opera, 'and various excursions with exquisite students, young girls and earnest boys; shouting too much, laughing too often'.[31] It was all 'a strangely beautiful time', he later recalled, especially as he was busy falling in love, 'usually with two or three girls at the same time.'[32]

With fellow students and girlfriends he visited the best restaurants and cafés in London – in particular the bohemian Café Royal on Regent Street, haunt of writers and artists. With its rococo decoration of gilded caryatids, painted ceiling, crimson plush couches and marble-topped tables, its varied clientele included the 'elegant hedonists' who had once surrounded Oscar Wilde, as well as the famous young painter Augustus John and the Satanist Aleister Crowley. 'I felt most beautifully self-conscious as we strutted in,' remembered Nevinson.[33]

Like Gertler, he discovered a love of the music hall. 'The Metropolitan in Edgware Road, the Bedford at Camden Town, the Tivoli, the Oxford, and the Pavilion were visited regularly, while on some nights we strolled in the most *blasé* manner about the promenades of the Alhambra and the

44

Empire'.[34] There he bumped in to friends of his father such as the writer Arthur Symons, an authority on symbolist literature who in the 1890s had produced *The Savoy* magazine with the brilliant but doomed illustrator Aubrey Beardsley. Now perched on the brink of a nervous breakdown ('I was hallucinated, obsessed', he later wrote), Symons stood drinks for the young art student and talked excitedly and inarticulately 'about the beauty of some woman or other'.[35] Intensity of experience – madness, even – seemed to be the very way of the artist.*

Richard's father now took a keener interest in his son's progress, although he considered art to be 'that queer kind of work that seems so unlike work'.[36] He took him to exhibitions, and showed his pictures to influential friends and potential patrons. Richard made a few sales – mostly sketches of the Thames and its wharves, and other townscapes from his holidays in France. Whilst praise came from some quarters, he started to despair of his efforts. He was confused by his influences – moderns such as Monet, and the controversial American James Whistler, jostled alongside northern Renaissance geniuses such as Hans Holbein and Albrecht Dürer: 'I had difficulty in creating realistic pictures of the model or still life, and my work suffered from over-painting. My first shot was always the best one, after it would become glutinous and oily, timid and dead in the handling, and my drawing would go from bad to worse.'[37]

And he discovered that other students were rejecting the stuffy ethos of the Royal Academy. Radicalism was in the air: one older student was

* Symons's nervous breakdown in September 1908 resulted in a fascinating personal account, published in 1930 as *Confessions: A Study in Pathology*. It opens: 'To trace, to retrace, to attempt to define or to divine the way in which one's madness begins, the exact fashion in which it seizes one, is as impossible as to divine why one is sane... Almost every artist lives a double life in which he is for the most part conscious of the illusions of the imagination; aware also of the illusions of the nerves; aware, to his peril, of nights of insomnia, of days of weary waiting, of the sudden shock of some event – that any one of those common disturbances may be enough to jangle the tuneless bells of ones nerves.'

incessantly preaching the ideas of the socialist writer George Bernard Shaw. This same student introduced Nevinson to the work of Augustus John, showing him drawings reproduced in a short book called *The Slade*, which reproduced works by past and present students of the School. A precociously gifted but rebellious artist, John had studied under Tonks in the mid-1890s, and was now exhibiting portraits and landscapes to considerable acclaim – in 1907 *The Times* described him as the favourite artist 'among the admirers of very advanced and modern methods' in England.[38] But at the same time John was scandalising society with his Bohemian appearance and outrageous womanising. It was John who went a long way to popularising in England the twentieth-century idea of the artist as defier of convention, as an outsider – in both dress and in outlandish, over-sexed demeanour.

'These drawings completely upset my apple-cart,' Nevinson later recalled. He took them to show one of his teachers at the Wood, 'who, something to my horror, dismissed them as no good. John was simply a posing charlatan who wore gold earrings, "long hair like Christ" and a Salvation Army jersey'.[39]

In what would become a characteristic experience, another period of doubt descended. For over a year he had been training with a single objective in mind: the Royal Academy. But was this the right choice? What was the Academy if not another Uppingham, a bulwark of tradition and conventionality, a bastion of Englishness upholding all the standards he and his parents were supposedly set on undermining? Did he really want his art to cater solely for rich English industrialists whose tastes were for paintings of 'deeds of daring-do', 'young girls praying' and hunting scenes? The English aesthetic was still firmly embedded in the artistic thrall of high Victoriana.

But Nevinson had travelled to Paris, and it was there that contemporary art was advancing into new and exciting realms. He had visited the artists' studios in Montparnasse and had gazed into the torpid windows of the

clubs and cafés in the Place de Clichy; he had met that 'dwarf in a frock coat' Toulouse Lautrec in a Lower Regent Street art gallery; he was already reading the novels of Tolstoy, Dostoevsky, Zola 'and a host of others whose work shouted for a better appreciation of art.'[40] These were not exactly the tastes or sentiments of a future Royal Academician.

So, when John Singer Sargent, 'the god of St John's Wood', declared that Augustus John 'was the greatest draughtsman since the Renaissance', Richard's mind was made up. It became 'obvious' that John's former school, the Slade, was the only place to study. He 'abandoned any attempt to get into the Royal Academy Schools, a grave step which I took lightly'.[41]

The leaving party from 'the Wood' was a heady affair – Nevinson later claimed it was the first and last time he was drunk. But his father did not hold out great hope. As he told a friend in January 1909: 'No, my son absolutely refuses to go to Oxford. He cares for nothing in the world but "art". It is a dreary prospect.'[42]

Chapter 4

'The Slade Coster Gang'

Arriving at the Slade at the start of the new term in January 1909, Nevinson presented his portfolio to Professor Brown. Since he had already spent a considerable amount of time drawing from antique casts at St John's Wood (and as art was long but life short), Brown allowed him to progress directly to the life class. But Nevinson's entrance into the large, gloomy vault of the Men's Life Room was inopportune: a female model he had known at 'the Wood' recognised him, greeting him 'with embarrassing enthusiasm'. Immediately Nevinson was made 'aware again of that terrible disapproving atmosphere of the public school.'[1] The Slade authorities did not even approve of male and female students talking to one another, and models were strictly off limits.

'Once more shyness and uncertainty came back upon me', he remembered. 'The room seemed to smell like a chapel and I did an awful drawing.'[2] He quickly turned the paper over and started anew before any of the students could come over and rate the new boy. As artists of all levels mixed in the Life class, there were old hands there to comment and criticise, as well as beginners like himself.

Already dressing as the art school Bohemian in the style of Augustus John (a rakish growth of beard on his cheeks, a large bow-tie and waistcoat complimented by socks and handkerchiefs of 'delicate peacock blue'), Nevinson was immediately going to attract attention. Or so he might have hoped. In fact, he found the Life Room filled 'with a crowd of men such

as I have never seen before or since.' Some twenty students surrounded the model's throne, sitting astride 'donkeys' – low-slung stools on which they rested their drawing boards. Two tall Germans were dwarfed by a Pole of even greater height, 'with scowling brows, tight check trousers and whiskers eight inches long.' Then there was Stanley Spencer with his 'cockatoo' crest of hair, 'looking like a boy of thirteen,' and the handsome Mark Gertler, with his curly locks, 'like a Jewish Botticelli.'

And there was the mysterious, dilettantish John Fothergill, who had edited *The Slade*, the book where Nevinson had first seen and admired Augustus John's drawings. Fothergill was one of the older students at the School. A bisexual, he had been friends with Oscar Wilde in the 1890s. Following Wilde's downfall, Fothergill had lived for many years in a curious, quasi-monastic ménage in East Sussex known as the Lewes House Brotherhood, run by the wealthy Massachusetts aesthete Edward Perry Warren, whose impressive art collection included a version of Rodin's statue, *The Kiss*. Each of the eight men in the Brotherhood had their own horse and dogs, as well as a private study. Women were not admitted, and at the drop of a hat a 'Brother' might be sent off to London or Italy in pursuit of a work of art or a manuscript for Warren's collection.[3] Fothergill's friends also included Gertler's patron, William Rothenstein, and together they had established the Carfax Gallery.

On Nevinson's first day at the Slade, Fothergill was in the Men's Life Room, exquisitely dressed 'in dark blue velvet suiting, pale-yellow silk shirt and stock, with a silver pin as large as an egg, and patent court shoes with silver buckles.' Nevinson found the atmosphere 'as solemn as it was uncouth: self-consciousness ruled. In order to attract attention Fothergill developed a fit of temperament and tore up his drawing, then struck several matches which he threw in the air, and departed, I learned later, for his studio in Fitzroy Street. Presently he returned in changed clothes – a black coat, chef trousers and sandals, with a whippet at his heels – and prepared to make a fresh start upon the long road that leads to artistic

achievement.'[4] Sadly for Fothergill, it would never reach that destination; his exotic life would continue haphazardly along its convoluted and curious course.

Nevinson's first encounter with Tonks was nerve-wracking. On entering the Life Room the Professor stopped to converse with a couple of older students – retired majors in white shirt-sleeves and cuffs, 'discussing the vintages at some dinner-party they had attended the night before.' He then came up to Nevinson 'and was not unpleasant. He asked me to define drawing, a thing I was fortunately able to do to his satisfaction, as I neither mentioned tone nor colour in my stammering definition but kept on using the word outline. But he nevertheless managed to shatter my self-confidence, and I was wringing wet by the time he left me to go on to Stanley Spencer.'[5]

For the whole of that first term Nevinson 'felt thoroughly out of it'. He was 'wretched, subdued'. His escape was the weekends, when he could enjoy painting without the technical strictures of endless drawing. Good draughtsmanship was the Slade's defining feature, and Nevinson found it hard-going – and he was lonely. His colleagues from 'the Wood' had mostly gone on to the Royal Academy Schools, and he saw little of them. At first his new pals were not his fellow artists at the Slade (whose atmosphere seemed to reinforce that hated sense of distance and authority he had experienced at Uppingham), but the medical students at University College Hospital across the road. For a while he yearned to become a doctor instead of an artist.[6]

Gradually, however, he made companions at the Slade. Though there were only a handful of young male students, they were an eclectic group from disparate backgrounds. But they shared one thing: a passion for art. His first young companions were two northerners, Edward Wadsworth and Adrian Allinson. Wadsworth was a Yorkshireman whose wealthy father owned a spinning mill; he had studied engineering draughtsmanship in Munich before going to Bradford School of Art. Allinson was

the eldest son of a Lancastrian doctor who had been struck off the Medical Register for his over-vigorous promotion of vegetarianism and contraception; his mother, a German Jew, had studied portrait painting in Berlin.* Allinson, who had been expelled from school on account of his atheism, had started medical training before evening classes at the Regent Street Polytechnic had turned him to his true passion, art. But the closest friendship Nevinson made was with Mark Gertler.

Although some students shunned him, to Nevinson Gertler was 'the genius of the place and besides that the most serious, single-minded artist I have ever come across. His combination of high spirits, shrewd Jewish sense and brilliant conversation are unmatched anywhere... even as a young man he was an outstanding figure.'[7] With his well-connected parents, public-school education and greater experience of the world, Nevinson acted the teacher. He later wrote that he was 'delighted to be able to help Gertler, I hope without patronage, into the wider culture that had been possible for me through my birth and environment. At any rate, I loved it, and his sense of humour prevented me from becoming a prig.'

Together they shared the 'pleasures and enthusiasms' of the print room at the British Museum, the paintings in the National Gallery, the museums of South Kensington – and in the evenings they went to the music halls. Nevinson took Gertler home to Highgate, 'and I am proud and glad to say that both my parents were extremely fond of him.'[8] Gertler felt equally pleased with his 'nice friends amongst the upper classes. They are so much nicer than the rough "East Ends" I am used to,' he informed Rothenstein. 'My chief friend and pal is young Nevinson. I am awfully fond of him. I am so happy when I am out with him. He invites me down to dinners and then we go to Hampstead Heath talking of the future. Oh! so enthusiastically!'[9]

* Allinson wrote that his father 'was considered not only a quack but also a crank.' The ex-doctor's promotion of health foods led to him establishing the bread manufacturer Allinson's.

With Gertler and Nevinson at their head, a group of male students formed themselves into a gang, 'sometimes known in correct Kensington circles as the Slade coster gang' because they mostly wore black jerseys, scarlet mufflers and black caps or hats like the costermongers who sold fruit and vegetables from carts in the street. (Gangs were Nevinson's speciality – at prep school he had founded the Manboya Gang, which evolved into the Red Brotherhood. They met at his parents' house, dressing in elaborate robes made from scarlet Turkey twill and devising elaborate rules and ceremonials.)[10]

The 'Coster Gang' included Spencer, Wadsworth and Allinson, along with fellow Slade students Darsie Japp, Rudolph Ihlee, Maxwell Gordon Lightfoot, David Sassoon and John Currie. 'We were the terror of Soho', wrote Nevinson later, 'and violent participants, for the mere love of a row, at such places as the anti-vivisectionist demonstrations at the "Little Brown Dog" at Battersea. We also fought with the medical students of other hospitals... There is no doubt we behaved abominably and were no examples for placid modern youth. Fortunately we were well known to the police, who in those days treated "college lads" with an amazing tolerance.'[11]

Occasionally other local gangs turned on them, chasing the Coster boys 'up Greek Street and round the Palace Theatre. They were usually actuated by a frenzy of patriotism, as the eccentricity of our clothes proved we were dirty foreigners. Why they should have felt like that in Soho, of all places, heaven only knows.'[12] Gertler's humour was 'a continual delight' to the younger students, in particular 'his exceptional powers of mimicry and burlesque', but his ignorance (the product of his inferior education) could also send the gang into fits of laughter.[13] Gertler was sensitive about his background, but his lowly origins mattered little to his fellow students. Nevinson, for one, knew all about the East End from his parents, and 'Whitechapel had no terrors for me'.

The Coster Gang's favourite hangouts were the Café Royal and the Petit Savoyard in Soho, where they indulged their passions for food and Bohemian company. Sometimes, to their 'wild excitement', Augustus John would appear at the Café Royal, with keen competition ensuing to see whether he would sit with the Slade students or the older 'Camden Town lads' – the loose-knit circle of artists centred on Walter Sickert that included Spencer Gore, Henry Lamb, Harold Gilman, Wyndham Lewis and Lucien Pissarro.*[14] John took an interest in many of the promising young artists, often taking time to chat with them. However, even in the Café Royal fights would break out: one that saw Currie, Gertler and Augustus John assault some bookmakers who had spoken derogatorily of their tatterdemalion dress resulted in the Café banning all young artists – or anyone who even *looked* like an artist.

And the Slade Gang also fought amongst themselves – or at least Nevinson and Spencer fought. Most gangs include at least one outsider, the butt of everyone's jokes. Spencer's diminutive size, his naïve provinciality, his obvious talent that made him the professors' favourite, together with his pious seriousness, consigned him to this luckless role. Stanley knew what it was like to be bullied, for Cookham was a rough-and-tumble rural world (a sign on a house near the village inns read 'All fighting to be over by 10 o'clock').[15] So he knew how to stand up for himself, though on one occasion when he returned home uncharacteristically late and with a bloody nose, he told Gil that the Gang 'had left him upside down in a sack in the boiler house and

* The Camden Town Group officially formed in the spring of 1911, with many of its members having formerly been part of Sickert's equally loose-knit Fitzroy Street Group that had started meeting and exhibiting around 1907. John was, technically, a member of the Camden Town Group – as was (briefly) the talented Maxwell Gordon Lightfoot, who left the Slade in 1909, but who was also numbered amongst the Coster Gang. The Camden Town Group took their name from the fact that some members had studios in this slightly insalubrious region of north London, where railway- and canal-side industrialism mixed with middle-class suburbanism.

"forgot" about him.'[16] Following a conversation about his life at the Slade, Stanley's brother Sydney recorded in his diary: 'Poor chap – he has a bad time of it sometimes'. But Stanley would get his revenge by squeezing a tube of white paint down Nevinson's back.[17]

There were other jokes, too. The Slade Sketch Club ran a monthly competition with a three-guinea prize – a generous sum of money. A specific subject, often on a Biblical theme, would be pinned to the School's notice board and students could submit an appropriate drawing. These would be exhibited anonymously, and Tonks would go through them one by one, remarking on each before the winning artist was revealed and the prize awarded. But, as Adrian Allinson recorded:

> A perverse kink in Spencer's make-up prevented his working to the set subject, so that though month after month his designs earned the highest praise, on account of their failure to illustrate the theme, he never received the award.
>
> It was high time to rectify this lamentable situation, particularly as I knew that a little cash would be very welcome to him. So for the ensuing competition I executed not only my own design but also an imitation Spencer that besides exhibiting all his mannerisms conformed, as regards the subject, to the rules of the competition. When seen on the wall amongst the rest of the drawings, students and professors alike took it to be authentic. The latter in particular were happy in the thought that dear Stanley was coming into his own at last. I had of course to take him into my confidence so that my practical joke should achieve its aim. Alas, our genius, without a glimmer of a smile, said to me, 'Oi think this will affect moy career Oi do, Oi'm going to tell the Pro.,' and promptly ran off to Tonks and blew the gaff.

Shortly afterwards I was invited into the latter's private sanctum, his baleful lack-lustre eyes fixed mine, and his words 'Allinson, you have a very dangerous talent here, beware how you use it,' choked the bubble of laughter in my throat. As [Tonks] was a gifted satirist when he felt so inclined, I had expected that he would enjoy the jest himself. He added that he had intended at the criticism to say he did not consider the work quite up to Mr Spencer's usual standard, which I hardly thought a sporting way out of the predicament.[18]

Stanley Spencer, The Fairy on the Water-Lily, *1909.*

Already Spencer was committed to his art beyond all else. As well as the regular Sketch Club competitions, other Slade rituals included annual prize-givings in the summer (followed by a strawberry tea), an end of term picnic, and in December a fancy-dress dance. But Stanley never went to the dance – he claimed that he did not even know there *was* one: 'I was against anything detracting from the men's life-room... I just somehow did not feel I could bear to rejoice one little bit until I could draw. There was a book at home called *Winning His Spurs*, and I did not feel I could come upstairs and out into the sunshine of the quadrangle, spurless and unsung. When I could draw – up then, on then and out in the heaven of the Strawberry Tea.'[19]

Spencer's first year at the Slade, however, ended with success. Tonks wrote to inform his parents that Stanley 'has shown signs of having the most original mind of anyone we have had here at the Slade'.[20] More importantly, he had been awarded one of the School's two coveted scholarships, with the other going to Stanley's skilled imitator, Adrian Allinson. However, in their initial eagerness to admit Spencer, Tonks and Brown had waived the usual entrance exam. Their largesse now caught up with them. The higher authorities at University College revoked the award because Spencer's 'general education' did not reach the required standard. Angry that his star pupil had been snubbed, Tonks visited the Provost 'and after a battle royal a compromise was reached'. Stanley could receive the scholarship, but only once he had passed a written examination. It would be the first of his life, and he dealt with this novel situation like a young schoolboy, writing a colourful essay all about Cookham, accompanied by pictures.[21]

Inevitably he failed the exam 'utterly'. But by 'a kind of cheating' the rules were once again bent, and he was finally awarded the scholarship that would keep him at the School for another three years. Afterwards Professor Brown came up and shook him angrily, declaring, 'You only got the scholarship by the skin of your teeth.'[22]

Though Philip Wilson Steer, the Professor of Painting, was a highly accomplished artist, Spencer claimed that during his four years at the Slade he spent only about three days painting from life. His first efforts with oils occurred at home in Cookham, and he would be largely self-taught. His earliest surviving effort, probably painted in the spring or summer of 1910, was *Two Girls and a Beehive*. The girls of the title were Dorothy and Emily Wooster, daughters of Cookham's butcher. Innocently naïve, Stanley was in love with Dorothy: everyday he looked out for the sisters as they walked through the village. His painting shows them as they pause to admire the roses growing in a garden at the end of Mill Lane. To their left stands a large beehive, and behind, beyond a long iron fence, the shadowy figure of a cloaked man carrying a staff can just be made out: it is Stanley's representation of Christ. It is a curious juxtaposition, the everyday image of the young women with a religious scene playing out unnoticed behind them. There is a hint here of the eighteenth-century mystical poet and painter William Blake, and Spencer's own vision of Jesus walking 'on England's pleasant pastures'.

Spencer had already discovered that drawing Cookham could bring him closer to his home; now he found that painting religious scenes actually set *in* Cookham could bring him closer to God – and closer to Love. His father's pious respect for nature in all its changing moods had led to his conviction of what Gilbert called 'an earthly paradise.'[23] Now through his painting this belief would be made literal, and Jesus and all the characters of the Bible would appear physically in Stanley's paintings, actually walking through Cookham's streets.

Thus Spencer later recalled that *Two Girls and a Beehive* was painted at a time when he was 'becoming conscious of the rich religious significance of the place I lived in. My feelings for things being holy was very strong'.[24] He was also becoming aware of the sexual attraction of women, and he felt the need to 'marry' these two experiences into one pictorial expression.

Love for a woman was like his love of God: important, mysterious, slightly beyond reach; and this intense desire to combine his various feelings into single pictorial images would come to dominate his art. Another of Stanley's brothers, the bookish and equally religious Sydney, helped him to articulate this realisation, and led him to the novel way of expressing it. Sydney was three years older, and with a more conventional education behind him he was preparing to sit Oxford University's entrance exams. Sydney's ambition was to become a clergyman, and he introduced Stanley to Biblical mysticism and the writings of Shakespeare.

A couple of years later Stanley confessed that he was 'slow at grasping anything & this makes reading a business for me.'[25] But Sydney helped guide and – more importantly – stimulate him. Two seventeenth-century metaphysical writers who particularly captured his imagination were the poet John Donne and the physician Sir Thomas Browne. Late into the night, Stanley and Sydney sat up talking together, and Gilbert, who took little interest in books, found he was losing his former closeness with his brother.

These were times of change in the Spencer household. Will finally escaped Par's influence by heading off for a music career in Germany, where he married a local woman and eventually become piano master at the Cologne Conservatoire. Gilbert, too, was regularly absent in London, pursuing his own artistic training. Stanley, though, was more than happy to remain in Cookham, where Slade friends such as Ihlee and Japp came for visits, spending long summer days swimming and punting. It was an idyllic, innocent, carefree time – and a time in which he would come to produce some of his best-known works.

• • •

Though Spencer and Allinson had won the Slade scholarships, things were also going well for Gertler. Yet he remained anxious about his progress. In May 1909 John Fothergill suggested he should send one of his still lifes to the New English Art Club, and even made a frame

for it. The NEAC was one of the most reputable places to exhibit, and Fothergill was well placed to make such a recommendation. To young Gertler, however, the idea seemed 'absurd'. But if he did not send it, he risked upsetting Fothergill, who possessed a quick temper and might take offence. Gertler wrote to Rothenstein, seeking advice. Rothenstein's reply was encouraging: 'you are doing quite rightly submitting your still-life to the jury of the NEAC.' And he added: 'You must not worry too much about your progress… the great thing is to *care* very much for beautiful things, and to carry a pencil and sketch book about with you always and to live as much with nature as possible. Painting is done in the studio, but inspiration comes from outside'.[26]

The insecure student, who was experiencing wild swings of emotion over the unsteady development of his work, warmly welcomed this fatherly support. He replied that Rothenstein's letter had 'braced me up like the sea an invalid. Reading it, I felt encouragement dancing in the very atmosphere about me... My World is a World of Beauty and Joy, marred only by one thing, "Progress", and if at any time I am encouraged on that point, my world becomes perfect; all is bliss and I am in ecstasies of joy.'[27]

Rothenstein also told Gertler to see something of the countryside: 'you must get away into the fields whenever you get a chance', he advised, and 'spend as much of your time as you can in the open air.'[28] Tonks supported the idea, arranging a summer visit to Hampshire. Familiar only with the smoky streets and parks of London, Gertler found the fields, meadows and streams 'beautiful beyond words'. He enjoyed himself 'immensely', working on his art from ten in the morning until half past eight in the evening when daylight finally failed.[29] These were the first stirrings of his long love affair with the English countryside.

These widening experiences also inspired him to move into different subjects than the still lifes that had preoccupied him till then. Like Spencer, he started looking around him at the everyday goings-on of his family and his immediate environment. This world, like Spencer's, was a deeply

religious one. Louis Gertler enforced a strict Jewish observance on his children. At Synagogue Mark was moved by the 'magnificent old men with their long beards and curly hair, looking like princes in their rugs and praying shawls – swaying, bending, moaning at their prayers, passionate, ecstatic, yet casual and mechanical.'[30] These old Jews – especially the recent Polish and Russian immigrants with their long gabardine coats and big felt hats – became the subject of more paintings. He also painted his family, including his brothers who, though illiterate, were doing quite well running the family furrier business. But it was his mother, Golda, whom Gertler painted most. Mark's portraits of her, rendered in a skilled but conventional style, reveal a well-dressed, stern-looking, middle-aged woman sitting by the front door or in the kitchen, content to stay at home all day.

Whenever Gertler completed a painting, his friend David Berlinski, son of Russian Jewish immigrants, helped carry the canvas onto the roof of their house. David's passion was photography, and he would take a picture of Gertler standing beside his latest achievement. David had a younger sister, May, and now Gertler experienced his first sensations of love. The fifteen-year old girl accepted his invitation to be his model, and they were soon close to one another, though Gertler's relationship, like Spencer's with Dorothy Wooster, was quite chaste. His only sexual experience was with a prostitute, whom his brothers had persuaded him to visit. He found the encounter repellent.[31]

Though he did not win a Slade scholarship that year, Gertler did win prizes for his paintings, and was receiving encouragement from Tonks. 'Besides praising some paintings I have done in the holidays,' he informed Rothenstein, 'he told me that I had made good progress in school and that I can tell my people so.'[32] Even more exciting, by 1910 Gertler was able to afford his own studio, and no longer had to paint in the family kitchen. Though situated on the top floor of a house above a noisy marketplace in the busy Commercial Road, it was 'very comfortable. I am very happy and proud of it indeed', he told Rothenstein, adding:

I am so independent! I sit at one end of the room and look across to the other and say, Look! this is all my own. I can do what I please… It is exactly what I used to look forward to, for what more does one want but a room, materials, and the National Gallery?

On the whole I am awfully pleased with my existence. I live almost spiritually, looking down with a cynical smile at all the petty little worries of mankind, for I feel that I gracefully float above all these, touching only what is beautiful and worthy. When I look at other men and see what are their worries, their ambitions, their outlooks, I feel that they have in life got hold of the 'wrong end of the stick' and that I am really in a way a superman,* for in order to be happy they seek unworthy and impossible things whilst I can go out and thrill with happiness over a tree, a blade of grass, a cloud, a child, an onion, any part of nature's innocent work. Have I not the advantage?[33]

Things were not going so well for Nevinson, however. Henry recorded in his diary in July of 1909 that he had bumped into his son going out to draw, and 'felt very sad about it, perhaps without reason.' Though

* Gertler's term 'superman' (*übermensch*) derived from the writings of the German philosopher Friedrich Nietzsche, and had only recently entered into the English lexicon. Nietzsche's 'superman' was a superior being who through his own 'will to power' evolved from but stood above the normal human. Its use here reflects Gertler's growing interest in Nietzschean philosophy, which appealed to many young artists and intellectuals in the early twentieth century. Whilst declaring that God was dead, Nietzsche seemed to offer a route out of the moral void of modern life; his influence on Gertler's forceful attitude to himself and his work would prove significant. Gertler would declare in defence of his behaviour in a letter of 1913, 'A real artist is "beyond good and evil"', citing the title of one of Nietzsche's most famous books.[35] In 1937 Nevinson would recall that Nietzsche was 'a philosopher who profoundly influenced many of us.'[36]

he considered Tonks to be a 'remarkable man with wide sympathies & knowledge', Henry must have thought that Richard had made the wrong decision in going to art school, as he was receiving little or no encouragement from Tonks.[34] Richard's paintings of industrial scenes around London – railway bridges, canalsides, gasometers – reflected the radical political ideologies of his parents. But like Gertler's portraits they remained largely derivative, displaying an unremarkable English Impressionism. He might be able to dress and act the role of a Bohemian artist, but though he was seeking out his own distinguishing subject matter, he had not yet discovered the personal style necessary for him to become the genuine article.

In August 1910 Nevinson celebrated his twenty-first birthday. His art may not have been progressing as well as Spencer or Gertler's, but he knew how to throw a party. All his friends were invited, old and new. There was the Slade Coster Gang, and former colleagues from 'the Wood'. Augustus John appeared, along with 'a crowd of professionals, singers mostly, men, women and girls. We had a whole dancing troupe to keep the party going, and one of the girls danced naked.' The young art students did their best 'to look like decadent geniuses with a strong tinge of the anti-*bourgeois*... we were tremendously manly and thought ourselves vastly superior beings and lords of creation.'

Nevinson admitted that up to that point the Coster Gang had had little or nothing to do with their fellow female students, and the boys were going all out to enjoy themselves. This was a change from John's time at the Slade, when there had been 'great camaraderie between the sexes.' But Nevinson grandly declared that 'We represented a reaction against the priggishness, posturing, and posing which had been left as a legacy to the Slade from John's generation, and we must have been a sore trial to poor virgin Tonks.'[37] But before long Tonks would be exacting revenge on the worldly, hedonistic and slightly unstable young Nevinson.

Chapter 5

Paul Nash and Dora Carrington

In October 1910 a new set of students arrived at the Slade. They included William Roberts, a gifted but scruffy schoolboy of fifteen, and Paul Nash, a handsome, smartly-dressed young man of twenty-one, who in his suit and spats seemed out of place amongst what he considered the 'eccentric sartorials' of the Slade. Nevinson came up and loudly asked him if he was an engineer. Nash recalled how Nevinson's barbed remark 'got a laugh, and I felt a pariah. It meant that I did not "belong" and, looking round from Gertler with his Swinburne locks and blue shirt to Roberts and Spencer with their uncompromising disregard for appearance, or Nevinson himself with his Quartier Latin tie and naive hat, I was forced to accept the implication.'[1]

The animated, imaginative eldest child of a middle-class family from Kensington, Paul Nash had grown up a reluctant Londoner. His father, a barrister, was from Buckinghamshire, on the eastern fringes of the Chilterns, and Nash's first childhood visit to his grandfather's farm at Langley Marish left deep impressions: 'It was like finding my own home,' he later recalled, 'my true home, for somehow it was far more convincing than our so-called home in London. I realised, without expressing the thought, that I belonged to the country. The mere sight of it disturbed my senses. Its scenes, and sounds, and smells intoxicated me anew.'[2]

A short childhood stay with an aunt and uncle at Yately, in Hampshire, awoke a love of winter landscapes – 'the brittle ice pools with their dark thin rushes on the common, the rich weather stains and bruises on the dripping trees in the deep lanes which led up to the Flats, the colour of faded, rotting paling in the pure distilled beam of the winter sun – these I absorbed'.[3] Thus early in his life Nash developed an acute sensitivity to landscape, and the particular, mysterious ambiance of certain places. This sensitivity to place and nature would become one of the defining characteristics of his personality.

Eventually the Nash family, which included Paul's younger siblings John and Barbara, left London for Wood Lane House in Iver Heath, Buckinghamshire. One reason for the move was the fragile mental state of Mrs Nash. Recalling his childhood, Paul would remember his mother as seeming 'always delicate, subject to headaches and so obviously worried.' She would sit silently, scarcely noticing the shadows of evening drawing in as her sons played. 'Her mouth would be parted rather sadly', Paul later recalled. 'The shades thickened in the corners of the room; the conservatory, now emptied of light, became a ghost-house; only the fire kept the darkness away until my mother shook off her reverie and rang for the lamp.'[4] Country life, however, offered no improvement. It was not long before Mrs Nash's health collapsed completely, and she was sent away to an institution. Though he would make few explicit references to it, his mother's mental instability would have a permanent effect on Paul's own inner life.

Living at home in a small village meant that Nash, like Spencer, travelled into London daily by train. But although he was two years older than Spencer, he came to the Slade two years later, for his artistic impulse had come relatively late. Nash's mother's family had been naval people, and he had originally been intended for a navy career – though a more inappropriate profession could hardly be thought of for their sensitive child. He hated the crammer school he was sent to in Greenwich, and

failed his entrance exams. An architectural career was suggested, but his incompetence at mathematics again let him down.[5]

So he left school feeling a complete failure, wondering what on earth he should do with himself. Family friends unhelpfully suggested a career in banking, but in 1906 his father accepted his son's proposal that he should become 'a black and white artist or illustrator of some kind'.

This idea came rather out of the blue. Though the Victorian landscape painter and nonsense poet Edward Lear had once been in love with Nash's Aunt Bethell, whose drawing-room 'was full of his dry, luminous water-colours', and the artist Eric Kennington had been an older boy at his London school, Nash had had little other exposure to the art world. In fact, he had shown little interest in the subject, and had no especial gift for drawing. But his father – preoccupied, perhaps, with his sick wife – accepted Paul's proposal, and he was launched into this precarious vocation.

In December 1906 the seventeen-year-old started taking the train to classes at Chelsea Polytechnic; then in autumn 1908 he began evening classes at the London County Council's School of Photo-Engraving and Lithography in Bolt Court, Fleet Street. This was Samuel Johnson's old house where, as Nash eagerly noted, the genial dictionary-writer had 'supported his human menagerie.' But it was now 'given over to easels, "donkeys", naked models and eager students... The whole purpose of the school was avowedly practical. You were there to equip yourself for making a living. It suited me.'[6]

Nash later wrote that the urgency he felt for making money early in his artistic career could be explained by this late start. 'Had I been able to begin studying at a proper age I might have made another thing of life, but to begin at eighteen with no apparent *natural* talent beyond an ability to compose out of my imagination was not encouraging, especially as I realised that, somehow, within the next few years a living must be quarried from this dubious field. Such prospects might well have depressed me, had I not been of a rather careless and sanguine temperament.'

In fact, he felt 'stimulated rather than cast down' by his uncertain prospects. 'To be my own master, free to make my own way as I chose seemed everything.'[7]

He soon made a life-changing discovery. Though the training at Bolt Court was for a professional design career as an illustrator of posters, show-cards and other such commercial works, Nash fell upon 'the disintegrating charm of the Pre-Raphaelites', and Dante Gabriel Rossetti in particular.[8] In 1910 he wrote that he would rather see one of Rossetti's paintings 'than that of any other artist. Whatever sense of beauty or line I may have or may develop I seem to owe to him. And I have only to look at his designs to feel a burning desire to create something beautiful.'[9]

Under the influence of Rossetti and the pseudo-medieval romanticism of William Morris, Nash began to write poetry and plays. Cycling home to Iver Heath from the railway station he crossed over a river, and there seemed to hear voices: 'Henceforth, my world became inhabited by images of a face encircled with blue-black hair, with eyes wide-set and luminous, and a mouth, like an immature flower, about to unfold.' This distant figure was 'lit only by some other radiance which poured out of the eyes in their steady gaze – unaware of the mundane world; certainly unaware of me.'[10]

Then, almost inevitably, he discovered William Blake and then the work of Blake's young friend, Samuel Palmer, whose own 'monstrous moons' and 'exuberance of stars' hanging in the night sky above English pastoral scenes soon found their place in Nash's work.[11] Suddenly his world seemed filled with fantasy and wonder. 'Do you believe in Fairies?' he teasingly asked his close friend, the free-spirited, 'gypsy-like' Mercia Oakley, in 1909. 'I'd never speak to you again if you didn't.'[12]

Reading Blake's poetry inspired him to open his eyes and look around, 'above all, to look up, to search the skies.' He formed the habit of what he called 'visual expansion' into Blake's 'regions of air': 'I believed that by a process of what I can only describe as inward dilation of the

eyes I could increase my actual vision. I seemed to develop a power of interpenetration which disclosed strange phenomena. I persuaded myself I was seeing visions. These often took the form of faces and figures in the night sky.'[13]

These experiences inspired some of his earliest, mystical works, such as *Our Lady of Inspiration* and *Vision at Evening*, whose Pre-Raphaelite influence is immediately apparent. Though he had been writing unrequited letters to a young cousin, Nell Bethell, and was in love with another young woman, Sybil Fountain, it was his mother's death in a mental asylum on Valentine's Day 1910 that had the strongest psychological influence on these enigmatic drawings of female faces.[14] He would later write of how, when thinking of his 'dark, Beautiful but delicate Mother', he was 'overwhelmed with misery and anxious distress as at the reminder of something dreaded.'[15] Both Nash brothers would have troubled marital relationships and repetitive affairs – a legacy, perhaps, of their uneasy childhood connection with their distant, depressive and doomed parent.

Under these new, Romantic influences, Nash's still quite juvenile but highly imaginative work received significant recognition. The most long-lasting of these early admirers, as well as an important friend and correspondent for the rest of Nash's life, was the poet and playwright Gordon Bottomley. Born in Yorkshire in 1874, Bottomley was an invalid from his late teens. In an attempt to improve his health he had moved to the Lancashire coast, where he wrote verse and plays influenced by Rossetti and William Morris. In 1910 a neighbour lent Nash a limited-edition copy of Bottomley's one-act play, *The Crier by Night*, published eight years previously. It reminded him of his own imaginative experiences and visions. Inspired by the play, Nash made a few drawings in the pages of the book. Impressed, the neighbour sent it back to Bottomley, who thought the pictures 'remarkable for a nascent but already powerful imagination and an interesting originality of technique.'[16]

A friendly correspondence quickly developed between author and artist. Nash was soon complaining to Bottomley of how his drawing was 'rotten bad': 'You see the gods have given me a head full of golden pictures and precious little natural ability to carry them out – and the impatience of a fire horse!'[17] Bottomley wrote back, encouraging Nash to persevere – and he suggested the Slade as the ideal place for Paul to improve his draughtsmanship. 'I think you are going to do the real thing, if you work faithfully', Bottomley told him, 'and someday I am going to be happy that I was one of the first to see it in you.'[18]

Bottomley's encouragement was complemented by recognition from other quarters. In January 1910 Selwyn Image, soon to become Slade Professor of Fine Art at Oxford University, was invited to an exhibition of students' work at Bolt Court. He was an acolyte of Ruskin and, in Nash's opinion, 'the last conspicuous pre-Raphaelite before the second advent in the person of Stanley Spencer.'[19] Image picked out for particular praise a pen and ink drawing illustrating Rossetti's poem *The Staff and Scrip*. It was one of Nash's. He invited the young artist to tea, which marked Nash's first entry 'into another world' – the home of an aesthete. Image's house was filled with the 'austere craftsmen-like designs' of William Morris's 'Arts and Crafts' movement.

Gertler's patron, William Rothenstein, was also admiring Nash's work. Like Bottomley, he recommended the Slade. When Nash explained that he could not expect his father (who had, like Spencer's, been financially crippled by asylum expenses) to pay for the classes, Rothenstein declared, 'Well, then, why not make them for yourself?'[20] Nash was understandably excited at the prospect of going to the Slade: 'I have met some interesting people', he wrote and told Mercia Oakley, '& there are men who hold the keys into the select circles where I long to move one day. I am to be introduced to many artists & writers & I am glad to have this chance because it is an opportunity to get known. So far I have got to know men because they have seen my

work which is more creditable than by [the] patronising introductions of friends.'[21]

He set about designing bookplates and illustrations to earn his fees. This led to a meeting with William Butler Yeats, whose poems *The Wind Among the Reeds* Nash hoped to illustrate. He visited Yeats at his London home with a collection of his visionary drawings, finding the Irish poet 'sitting over a small dying fire'. He 'probed me with a few languid questions, peering at the drawings the while and smiling at me with an amused air which I found disconcerting.' 'Did you really see these things?' asked Yeats. In the presence of 'the master of visions', Nash declared that yes, he had. 'But I did not feel he was convinced, or, if he was, that he was interested enough.' After this strange encounter he was 'rather glad to get into the narrow street again'.[22] But Yeats's publishers were not favourable to the proposition, and the project was never realised.

Despite this failure, by October 1910 Nash had earned enough money to cover a year's fees. He was duly enrolled at the Slade, 'and one morning at the beginning of term I approached that inscrutable building along the curving asphalt path which flows like a grey stream between the bright green lawns.'[23] Nash was as ambitious as any of the other Slade's young students. He had the self-belief and was determined to succeed. But he was certainly the least technically gifted – and thus, it must have seemed, the least likely to prosper.

• • •

Nash's early experience at the Slade was not good, as an early encounter with Tonks revealed:

> As a new student I sought an interview and confidently
> displayed my drawings, secure in the good opinion of at
> least two authorities and already beginning to be collected.
> But Tonks cared nothing for other authorities and he
> disliked self-satisfied young men, perhaps even more than

self-satisfied young women, if any such could be found in his vicinity. His surgical eye raked my immature designs. With hooded stare and sardonic mouth, he hung in the air above me, like a tall question mark, backwards and bent over from the neck, a question mark, moreover, of a derisive, rather than an inquisitive order. In cold discouraging tones he welcomed me to the Slade. It was evident he considered that neither the Slade, nor I, was likely to derive much benefit.[24]

Nash was alarmed to discover just how 'backward' his draughtsmanship was. Eventually, however, he found Tonks to be a good teacher. In November he told Bottomley 'one learns a great deal from him but until one gets used to it, his manner & sarcastic comments rather damp hope. He never praises and can find more faults in five minutes than another man could think of in a fortnight.'[25] But he learnt more in his first two weeks at the Slade than he had in the previous four years, and after Christmas enjoyed 'a great triumph' when Tonks congratulated him on a picture which had 'created a little stir' amongst the other students.[26]

But rather than the 'temple of art' he had hoped for, Nash's initial experience of the Slade was the same as Nevinson's: it was 'more like a typical English Public School seen in a nightmare, with several irrational characters mingled with the conventional specimens.'[27]

It took Nash a while to settle in, but eventually he was making friends. The first was a short, strongly built teenager with the physical poise suggestive of an athlete. His face was 'remarkable' and 'vaguely familiar' to Nash: 'I felt sure I had seen someone like him recently.' He overheard a lady at a private view remark to her companion, 'Tell me, my dear, who is that young man with the three-cornered head?' As Paul stood talking with this odd-looking student, Gertler wandered up 'and in his imitation Oxford accent, one of the best of his clever repertoire, said, "Oh, Nicholson, how does your father paint those *marvellous* black

backgrounds?'"[28] This, Nash now realised, was Ben Nicholson, son of the artist William Nicholson, one of the major British painters and illustrators of the day. As Nash wrote, William's work 'had an air of easy mastery and good quality, like something hall-marked and immaculate.'[29] Ben, though, would go on to achieve even greater fame than his father, becoming between the wars the leading British proponent of painterly abstraction (wherein he painted some marvellous *white* backgrounds).

Nicholson, like Nash, would only attend the Slade for a year – though he spent little time actually at the School. He was a reluctant student who had been enrolled largely because his parents believed that, as their child, he simply *ought* to be artistic. He later recalled how he was 'in the painting world & trying to get out' whilst Nash was 'out & trying to get in'.[30] Eventually, instead of attending lessons, Nicholson would sign himself into the school register in the morning before going off to lunch with Nash, and then pass his afternoons playing billiards. There the abstract formality of the green baize and the constantly changing relationships of the balls were, he later claimed, of more appeal to his aesthetic sense than 'the fustiness of the classrooms at the Slade'.[31]

Though Nicholson was only sixteen (some five years younger than Nash) they became good friends. Like Nash, Ben was a poor draughtsman, and their mutual difficulties in Tonks's drawing classes made them natural allies. Paul 'made the Slade possible'[32] for Ben, and he was soon invited round to the Nicholsons' home in nearby Mecklenburgh Square. Nash was impressed and fascinated by the fashionable interior of the house, its blue ceilings, black mirrors and maps on the walls. At Easter 1911 Ben invited Paul down to his parents' rural retreat at Rottingdean, East Sussex, where this 'amusing family taste' in interior design was also to be found: 'Everything was bright and gay and calendared.'[33] The family was away, and the two young men had the house to themselves; they talked endlessly and lived simply, feasting on blancmange and jam.[34]

Back at the Slade after the vacation, Nash fell in love, bashfully admiring from afar another student in the new intake. As men and women at the School were not permitted to mix, the only place in which all the students came officially together was the Antique Room. As Nash sat amongst the plaster casts, drawing, he stole covert glances at an 'attractive chattering flapper in a check overall' with turned-in toes, delicate complexion, fine forget-me-not-blue eyes and a thick crown of golden hair.[35] He became inflamed with a desire to know her.

Eventually he won her regard by lending her his braces for a fancy dress dance: 'We were riding on the top of a bus and she wanted them then and there.'[36] He admired her work, too, writing enthusiastically about a drawing that he had seen at the Slade, 'Oh I am sure you have created a marvellous thing, tremendously alive and strong, simple and full of great feeling, and beside all this as fine a piece of decoration as can be desired by any eyes. You'll think I exaggerate but this is about half what I am feeling.'[37]

• • •

The daring, talented girl with a stutter was Dora de Houghton Carrington – or Carrington, as she preferred to be called. In Nash's opinion she was 'both clever and good-looking to an unusual degree.'[38] Nash and Carrington quickly discovered they shared a passion for Blake and Rossetti. She lent him a copy of Blake's collected poems, which included many pieces Nash had never seen before. 'My dear Carrington I thank you exceedingly,' he wrote. 'I expect you love Blake as I do. His verse is the most purely touching and inspiring that I know – it moves me in the same way that all sweet & simple actions in life & all wonderful and clear effects of Nature, move me. And at the same time what immense mystery it contains! The Tiger – isn't it startling? It would shake the mind of even the most material & prosaic city man if he would read it twice.'[39]

Carrington was only seventeen when she arrived at the Slade. She was the artistically precocious daughter of Samuel Carrington, an engineer who had gone out to build railways for the East India Company, arriving

there in 1857 at the height of the Mutiny. (His youngest son later wrote that Samuel had been 'close enough to the fighting and butchery to be affected for life', becoming 'by conviction and religion a man of peace.'[40]) By the time he returned to England and married Charlotte Houghton, governess to one of his nieces' children, Samuel was fifty-five, and some twenty years older than his spinsterish wife. They had five children: two daughters and three sons, of whom Dora and Noel were the youngest and closest. Samuel was sixty-one when Dora was born in 1893, and she doted on her father, regarding him as an Odyssean figure, resting in retirement from adventures in foreign lands.

Yet she would later declare that she had 'an awful childhood.'[41] This she blamed on her mother, a stern woman and a strict regimentarian with a Victorian sense of probity. In Dora's eyes her father had once been carefree and unconventional, but her mother 'tamed' him, 'regarding all his independence, & wildness as "peculiarities" – and just making out he was a sentimental good husband.'[42] For this alone Dora could never forgive her, and through her life she would avoid at all costs any similar attempts to tame her.

The family home in Bedford was thus a place of strict manners and formality, but with a strong sense of ambivalence, of a powerful paternal force for the unorthodox kept firmly in check by stern maternal authority. Noel Carrington later recalled that their mother's anxiety over conformity and convention took two forms: 'The first was extreme prudishness. Any mention of sex or the common bodily functions was unthinkable. We were not even expected to know that a woman was pregnant. Even a word like "confined" was kept to a whisper. The second was church going and behaviour on Sunday. We all came to hate the whole atmosphere of a Sunday morning... I believe [Dora] would have refused point-blank to bend the knee had it not been that it would have bitterly grieved our father.'[43] In 1920 Carrington would declare, 'You must know I hate my Mother. It is a dull & bare fact. Her name is poison to me'.[44]

The worst impact of this prudishness was on Dora's sexual development. A plump child who won the nickname 'Dumpty' from her siblings, she was horrified when she started menstruating. She would call her periods 'the Fiend', declaring that they filled her with 'disgust & agitation'.[45] She grew up to dislike both sex and her physical appearance. In 1925 she would write, 'I have always hated being a woman... I am continually depressed by my effeminacy'.[46] This self-loathing and sexual ambivalence (she would write of an internal struggle 'between two characters'[47]) would mar all her adult relationships: none would ever be uncomplicated.

However, for all Dora's demonising of her mother, it was she who influenced and encouraged her artistic interests. Charlotte Carrington had been a pupil at Lambeth Art School in her youth, and it was she who hung reproductions of the works of artists such as Velázquez, Millais and Alma-Tadema on the walls. Muddled amongst these was the assortment of curiosities her husband had collected on his foreign travels. For Noel, this 'formal tribute' paid to art was an uncommon upbringing, 'something I cannot recall observing in the homes of my friends. At no stage of her family life did Dora encounter opposition to her desire to become an artist.'[48] But in Bedford the Carringtons were removed from more modern cultural and social influences. Though Dora made annual visits with her mother to the Royal Academy's Summer Exhibition, Noel wrote that Bedford might as well have been a thousand miles from London rather than fifty 'for all the cultural influence then exercised on it by the metropolis'.[49]

Whilst Charlotte Carrington sowed the seeds of her daughter's artistic spirit, their tastes soon diverged. In 1926 Carrington wrote with despair at her obligatory visits home: 'Here I am plunged in the middle of Benares brass life, and Japanese screens... I am too depressed by the hideousness of this house, and the bric à bracs.'[50]

Carrington's chief early interest was portraiture, and from a young age she produced masterly images of family and friends. In this she

differed considerably from Paul Nash, who never grasped the difficult art of capturing a likeness. Carrington would only develop a keen interest in Nash's speciality – landscape – later on in her short life, partly through the encouragement of Paul's equally artistic brother, John. And though she introduced Paul to the further wonders of Blake's extensive poetry, she claimed to have been little educated. At school the only subjects in which she showed any distinction were art and natural history. In the former, she excelled. In 1905 she won First Class from the Royal Drawing Society of Great Britain and Ireland for two pen and ink works, and over the next five years continued to win prizes and certificates. Then in 1908 Carrington's beloved father suffered a paralysing stroke. Though he lived on until 1918, her mother took over full control of both house and husband, to Carrington's frustration.

Carrington, self-portrait, *around 1910.*

In order to get her own way and to exert at least some control over her life, Carrington became secretive and deceptive. An already confused girl grew even more disturbed. By seventeen she had found she 'couldn't speak the truth' even if she wanted to: 'I had acquired such an art of self protection.'[51] She became unpredictable and unreliable – traits she carried into adulthood. But when the Slade accepted her, not only could she continue her training at one of the finest art schools in England, for the first time she could escape the stultifying atmosphere of home.

Carrington found accommodation in a hostel for female students near Gordon Square, only a few minutes walk from the Slade. She soon

made friends. The closest and most long lasting were Barbara Hiles and the Honourable Dorothy Brett. Hiles, the daughter of a Liverpool businessman who had retired to Paris to pursue his passion for the arts, had already studied at art school in the French capital. A little older than Carrington, she was confidant and out-going. Brett, in turn, was nearly ten years older. She was the daughter of Lord Esher, who as a royal courtier had been close to Queen Victoria, and who served on the boards of the British Museum, the Wallace Collection and the Imperial College of Science. These were a different class of friend to any she might have had in Bedford, and they helped Carrington throw off some of those formal family bonds and restrictions – though like her mother, she remained something of a snob. Her first move was to drop what she called 'the sentimental lower class English name Dora': from now on she insisted on being known solely by her surname, as men mostly were then.[52] Carrington she became, and Carrington she would remain.

The newly refashioned artist now embarked on what Noel called 'her long odyssey in self-education'.[53] This included expanding her reading, which broadened considerably to include such works as Mary Wollstonecraft's *Vindication of the Rights of Woman*, Laurence Sterne's *Tristram Shandy*, and Tolstoy's epic Russian novels – works her better-educated younger brother confessed to having never heard of.

As he had done with all the students before her, Tonks splintered her artistic self-confidence. She temporarily abandoned painting until she had truly mastered draughtsmanship. Earlier pieces, once admired, were now destroyed or hidden away, and she called again on her family and friends to pose for her. But she was ambitious – and so were her new girl friends, as Noel immediately saw: 'All were entirely serious about their art and their intention to be the equal of men.'[54]

Carrington's future lay with her new companions in the capital's fashionable artistic circles. It was an exciting time to arrive in London,

as she was soon to discover. For the most important art exhibition in early twentieth-century England was just about to open – and all through the efforts of the Slade's very own lecturer on Renaissance Art and Old Masters: the brilliant, compulsive and erratic artist and critic, Roger Fry.

Chapter 6

Roger Fry and the Post-Impressionists

Roger Fry had arrived at the Slade at the beginning of the autumn term of 1910. At forty-four years old, his credentials were impressive: in 1905 he had helped to launch the highbrow art journal *The Burlington Magazine*, and had subsequently become curator of paintings and then European buyer for the Metropolitan Museum of Art in New York. Yet despite his clear suitability to teach the Slade students in art history – and Fry was an excellent lecturer – he was a man of contradictions.

From a Quaker family that had made a fortune in chocolate, in the mid-1880s as an undergraduate at King's College, Cambridge, Fry had studied natural sciences, not art history. But he took a keen interest in the writings of Ruskin, and developed excellent skills as a draughtsman. Though he took a double first and applied, unsuccessfully, for a College fellowship in science, he 'had begun to think of art as somehow my only possible job.'[1] On abandoning academia Fry trained as an artist in London. In 1891 he made his first trip to Italy, and studied briefly at the Académie Julian in Paris, where he discovered the Impressionists and fell for the work of Monet.

But Fry absorbed ideas and influences when and where he found them, and regularly changed his style. When Paul Nash's friend Robert Trevelyan showed him his small but eclectic collection of paintings in 1913, Nash was amazed to be told that they were *all* by the same man:

'Impossible,' Nash cried, 'what is his name?'

'Roger Fry,' Trevelyan exclaimed.

In Trevelyan's opinion, 'Fry was without doubt *the* high priest of art of the day, and could and did make artistic reputations overnight.'[2] However, it was not till around the time that he took up his Slade lectureship that Fry began to win such influence.

It was then, in early 1910, that Fry made some important new friends. It started with a chance meeting with the painter Vanessa Bell and her husband, the art critic Clive Bell. Vanessa was the daughter of the scholar and critic Sir Leslie Stephen, and had trained at the Royal Academy Schools and briefly, in 1905, at the Slade – though she had soon quit when she tired of Tonks's acid criticism. She had first met Fry in 1906, the year after she had founded the Friday Club, an exclusive meeting-point for young artists which included a number of former Slade students. Like Fry, Clive Bell was a Cambridge graduate, and had also spent time in Paris, where he had discovered the work of Matisse and Gauguin. When Vanessa first introduced her husband to Fry in 1910, the two men immediately discussed the idea of staging an exhibition in London of the latest French painters. Clive liked the idea, but thought it was so fantastic, that the chances of pulling it off seemed slim.[3]

So, whilst the exhibition idea was temporarily shelved, Fry was introduced to the Bells' wider circle, which congregated in their Bloomsbury home at 46 Gordon Square. The group of friends included the painter Duncan Grant (who had also studied in Paris), the writers Leonard Woolf, Lytton Strachey and E.M. Forster, the economist John Maynard Keynes and the philosopher Bertrand Russell. These young Cambridge graduates were hugely impressed by Fry's remarkable erudition and intense personality. Vanessa's younger sister, Virginia, was particularly captivated. 'He had more knowledge and experience than the rest of us put together', she later wrote (though William Rothenstein, by contrast, told Henry Nevinson that he considered Fry 'a bit crazy').[4]

Mark Gertler, Still Life with Melon, *1908*

Mark Gertler, Allegory, *c.1910*

John Currie, Some Later Primitives and Madame Tisceron, *1912: Currie's vision of the Neo-Primitives with (from left) Currie, Mark Gertler, Richard Nevinson, Edward Wadsworth and Adrian Allinson, with the proprietor of the Petit Savoyard Café, Soho*

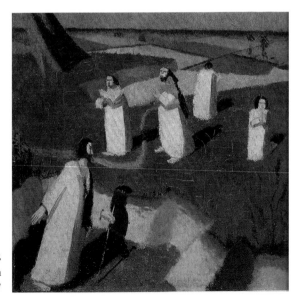

Stanley Spencer, John Donne Arriving in Heaven, *1911*

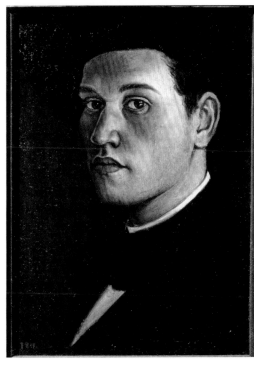

Richard Nevinson,
Self-Portrait, *1911*

Dora Carrington,
Female Figure
Lying on her
Back, *1912*

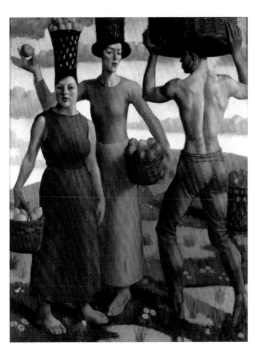

Mark Gertler,
The Fruit Sorters, *1914*

Stanley Spencer, The Apple Gatherers, *1912*

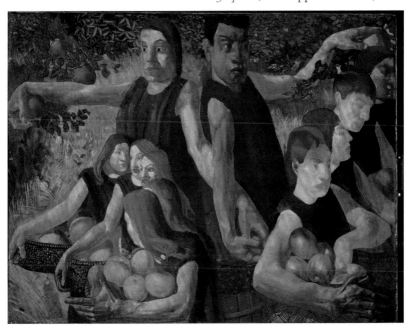

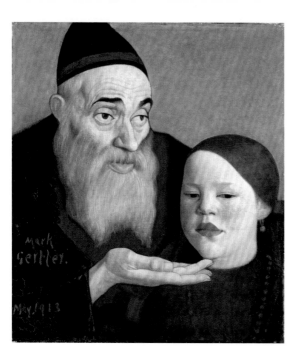

Mark Gertler, The Rabbi and his Grandchild, *1913*

Opposite page:
Stanley Spencer, Self-Portrait, *1914*

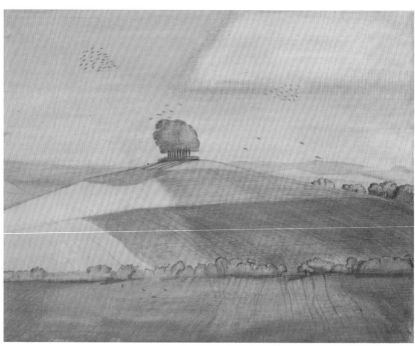

Paul Nash, Wittenham Clumps, *c.1913*

Mark Gertler, Dora Carrington
1912

*Stanley
Spencer,* The
Centurion's
Servant, *1914*

Two years after Fry's appearance, Virginia Stephen married Leonard Woolf, and thirty years later, as Virginia Woolf, she would publish the first biography of Roger Fry. With his arrival the famous Bloomsbury Group was now virtually complete, and Fry put 'flesh and blood' on what Woolf considered the skeleton of their more rudimentary discussions of art and beauty. With Fry there was 'always some new idea afoot', Woolf would write, 'always some new picture standing on a chair to be looked at, some new poet fished out of obscurity and stood in the light of day'.[5] It was a thrilling moment, the coming together of a circle of glittering talents who would help to refashion England's literary and artistic culture for the next forty years, dragging it all too reluctantly into the voguish world of the Modern.[*]

By 1910, Fry's artistic interests were ranging beyond the Old Masters. Like a number of avant-garde artists and critics, he began taking interest in the pictorial and sculptural works of what were usually considered more backward civilisations. In the spring of that year he reviewed a book on drawings by African Bushmen for the *Burlington Magazine*, admiring their sharpness of perception and intelligence of design.[6] These, he felt, could in no way be considered primitive works, though they clearly differed strongly from Western painterly traditions. Fry was opening up his awareness to a wider sphere of artistic expression, though it was not one that would win him many friends. Henry Tonks told the critic Robert Ross, 'I say, don't you think Fry might find something more interesting to write about than Bushmen, Bushmen!!'[7]

[*] In 1932 Carrington would ponder the 'quintessence' of the Bloomsbury Group. She concluded: 'It was a marvellous combination of the Highest intelligence, & appreciation of Literature combined with a lean humour & tremendous affection. They gave it backwards and forwards to each other like shuttlecocks only the shuttlecocks multiplied as they flew in the air.'[8] Others were not so charmed, and John Rothenstein would later remark on the dark shadow that the group's 'malevolence and intrigue' cast over the lives of a number of early twentieth-century British artists. He added that one artist had told him shortly before his death that this shadow 'had ruined his life and that, had he known what it would be like, he would have been most careful not to antagonize them'. This man might well have been Nevinson.[9]

Then in the summer of 1910 there was an exhibition at the Public Art Galleries in Brighton of modern French artists. It included works by Derain, Signac, Gauguin, Cézanne and Matisse. Fry attended, and though the reviews were largely hostile, the idea he had outlined to the Bells was rekindled. With his friend, the journalist and literary critic Desmond MacCarthy, he headed off to Paris. Together with Clive Bell they visited the Parisian dealers and private collectors, arranging an assortment of paintings to exhibit at the Grafton Galleries in Mayfair. Fry did not have an exact idea of which artists or works he wanted to exhibit, nor high hopes that their show would be a success. Nonetheless, MacCarthy later recalled Fry's 'raptures' as they looked through the pictures that had been generously put at their disposal in Paris. 'He would sit in front of them with his hands on his knees groaning repeatedly, "Wonderful, wonderful".'[10]

Fry was spellbound. Virginia Woolf described him at the Grafton Galleries gazing at the paintings, 'plunging his eyes into them as if he were a humming-bird Hawkmoth hanging over a flower, quivering yet still. And then drawing a deep breath of satisfaction, he would turn to whoever it might be, eager for sympathy.'[11] Manet, Cézanne, Gauguin, Van Gogh, and Matisse would dominate the London show, which included such now-famous works as Matisse's *Fille aux Yeux Verts*, Manet's *Un Bar aux Folies-Bergères*, and Van Gogh's *Wheatfield with Crows*. There was also a work by Picasso, *Portrait of Clovis Sagot*.

Although some of these paintings were already twenty or even thirty years old – and four of the five major artists represented were dead – they were new to most Londoners. The show was going to be an eye-opener for an insular audience that had been brought up on the realism of the classical tradition – a tradition exemplified by contemporary British painters such as John Singer Sargent, William Rothenstein, William Nicholson and Augustus John. Fry's 'new' continental paintings were not, by and large, 'about' anything – they did not have a narrative or a

literary inspiration in the way that most Pre-Raphaelite and Symbolist paintings did. They were portraits, or landscapes, or still lifes, painted with a distinctive, idiosyncratic eye. They were anti-narrative, anti-naturalistic: form and style dominated. Only Walter Sickert and, before him, Whistler seemed to be offering anything akin to this modern art being painted on the other side of the Channel. Fry knew there would be trouble: 'I am preparing for a huge campaign of outraged British Philistinism', he told a friend in October.[12]

The exhibition opened to the public on 8 November 1910 under the title *Manet and the Post-Impressionists*, a collective phrase Fry coined especially for the show. It met with immediate derision. The critic for the *Pall Mall Gazette* described the paintings as 'the output of a lunatic asylum',[13] whilst Robert Ross, writing in the *Morning Post*, pointed out that Van Gogh *had* been 'a lunatic', and that the 'emotions of these painters… are of no interest except to the student of pathology and the specialist in abnormality.' Given the fate of Fry's schizophrenic wife (she had recently been committed to an asylum), these accusations must have been particularly hurtful. The exhibition, Ross declared, revealed 'a widespread plot to destroy the whole fabric of European painting'.[14] Paul Nash recalled that one critic, Sir Claude Phillips of *The Telegraph*, 'the most honest and uncompromising of them all,' on leaving the show 'threw down his catalogue upon the threshold of the Grafton Galleries and stamped on it.'[15] The reviewer from *The Times* observed that such work 'throws away all that the long-developed skills of past artists had acquired and bequeathed. It begins all over again – and stops where a child would stop.'[16]

Though a similar process of reinvention and experimentation was also occurring in contemporary music and literature, this was not going to endear Fry's show to an older, conservative audience. The venerable painter Sir William Blake Richmond wrote of his 'fierce feeling of terror lest the youth of England, young promising fellows, might be

contaminated' by 'this unmanly show'.[17] The aged hedonist and writer Wilfrid Scawen Blunt rejected claims that the show paralleled the response to the Pre-Raphaelites' first appearance at the Royal Academy in the late 1850s: 'these are not works of art at all,' he wrote in his diary, 'unless throwing a handful of mud against a wall may be called one. They are works of idleness and impotent stupidity, a pornographic show.'[18]

Of course, the hostile response of the older critics and public must be set not just against the ongoing revolution in the arts, but also against the wider contexts of contemporary Britain. Socially and politically speaking, these were years of crisis and anxiety. The decade before 1914 is often seen, nostalgically, as a period of innocence and tranquillity. Yet in 1910 Edwardian England was not wholly at ease with itself. The previous year had seen the fraught divisions caused by the Liberal government's 'People's Budget'. Whilst this was a major first step towards the creation of a modern welfare state, it had enraged the landed class, which Prime Minister Asquith and his Chancellor, Lloyd George, expected to fund it. The House of Lords had unsuccessfully opposed the Budget – indeed, the government had questioned the Lords' continued existence, and in 1910 an Act of Parliament seriously curtailed their powers. The old Tory order, it seemed, was on the brink of collapse.

At the same time, in Wales and north-west England the labour unions, with their links to socialist, Marxist and anarchist movements, were in full and militant action, demanding radical social as well as political change. On 8 November, the same day Fry's exhibition opened to the public, there was a riot in Tonypandy, with shops looted and a miner killed. The Home Secretary, Winston Churchill, was forced to send policemen and soldiers from London in an effort to restore order. But the disquiet continued to simmer and occasionally boil over through the rest of the year and on into the long, unusually hot summer of 1911. In Ireland, meanwhile, calls for Home Rule and Independence were getting louder, and civil war looked ever more threatening; and in London the Suffragettes were

becoming more vocal and forceful in their demands – and meeting even stronger opposition. On 18 November, only a few days after Wilfrid Blunt visited the Gratfton Galleries and described the exhibition there as 'pornographic', truncheon-wielding policemen in Parliament Square broke up a vocal crowd of protesters demanding Votes for Women. On what became known as 'bloody Friday', some two hundred and eighty protesters were arrested.

Did the press reaction to Post-Impressionism reflect these social upheavals? Fry was surprised that the 'accusation of anarchism was constantly made' against the 'new' artistic movement. He believed that from an aesthetic point of view 'this was, of course, the exact opposite of the truth, and I was for long puzzled to find the explanation of so paradoxical an opinion and so violent an enemy.' Fry thought that the opposition arose from class and snobbery. To become an authority on Chinese porcelain or Renaissance painting demanded education, erudition and time devoted to study, 'but to admire a Matisse required only a certain sensibility. One could feel fairly sure that one's maid could not rival one in the former case, but might by a mere haphazard gift of Providence surpass one in the second.'[19] This, perhaps, was true – but Fry seems to have missed the bigger picture.

These foreign artists, with their seemingly crude style and gaudy colours, challenged the conventional notion of Western Europe as a civilized, sensible and pacific society – exactly the same challenge Socialism and the Suffragettes were making. But once Victorian scientists had accepted Charles Darwin's theory of evolution by natural selection, the portent of its obverse face, degeneration, had appalled them. Survival of the human species seemed to hang on the twin principles of strength and fitness, yet at the same time civilisation and industrialisation was producing its fair crop of the ill, the malformed, the vicious, the decadent, the discontented, the insane and the anarchic. This was a Janus-faced world in which respectability was only skin-deep – as Robert

Louis Stevenson revealed in his dark 1886 novella, *The Strange Case of Dr Jekyll and Mr Hyde*, and as Sigmund Freud was soon exposing in the new discipline of psychoanalysis.

The *fin-de-siècle* mood, characterized in England by Oscar Wilde's circle of aesthetes and homosexuals, still cast its shadow across the new century. One Slade student who visited the Post-Impressionist exhibition wondered if in some 'of the most successful exhibits, the emotion expressed was somewhat feeble or morbid, or decadent?'[20] In an extraordinary book published in 1895, *Degeneration*, the German sexologist Max Nordau had described decadence and the *fin-de-siècle* mood as 'the impotent despair of a sick man, who feels himself dying by inches in the midst of an eternally living nature blooming insolently forever.' To Nordau, death, decay and insanity appeared to characterise the modern art and literature being spawned in the corrupted cities of Europe: 'We stand now in the midst of a severe mental epidemic,' he declared, 'a sort of black death of degeneration and hysteria, and it is natural that we should ask anxiously on all sides: "What is to come next?"'[21]

For such critics, new conceptions in art, music and literature were bought at dangerous expense. For many intellectuals and politicians, something had to be done to counter what was seen as an increasingly menacing threat. Karl Pearson, who in 1911 would become UCL's Professor of Eugenics, had recently declared: 'The time is coming when we must consciously carry out that purification of the state and race which has hitherto been the work of the unconscious cosmic process. The higher patriotism and the pride of race must come to our aid in stemming deterioration... To produce a nation healthy alike in mind and body must become a fixed idea'.[22] Artworks of the seemingly insane had no place in such a world, as J. Comyns Carr, art critic and director of London's New Gallery, recognized. For Carr, Fry's movement appeared 'to indicate a wave of disease, even of absolute madness; for the whole product seems to breathe not ineptitude merely but corruption – especially

marked in a sort of combined endeavour to degrade and discredit all forms of feminine beauty.'[23]

This was an attitude to modernity that would culminate in the 1930s with the burning of 'degenerate' books and paintings by the Nazis – acts that terminated with the Holocaust. That would be the true madness of the twentieth century. But in its first years there was a real sense of instability, danger and uncertainty about modern civilisation. To be avant-garde was to challenge the very social order.

• • •

Heavily morally and culturally loaded, *Manet and the Post-Impressionists* was some exhibition. Back at the Slade, Henry Tonks was having none of it. As Nash observed, his fellow students were 'by no means a docile crowd and the virus of the new art was working in them uncomfortably. Suppose they all began to draw like Matisse?'[24] Tonks gathered them together and called on their 'sporting instincts', explaining that whilst he could not prevent them visiting the Grafton Galleries, he could tell them 'how very much better pleased he would be if we did not risk contamination but stayed away.'[25]

In private Tonks was equally hostile. Whilst Brown and Steer aired their concern that if the Slade did not adopt the new, modern style into its teaching it would lose out to other London art schools, Tonks declared, 'I cannot teach what I don't believe in. I shall resign if this talk about Cubism does not cease; it is killing me.'[26] He would come to view Post-Impressionism as 'an evil thing' that 'seduced the most gifted of the Slade students' away from the English tradition represented by Turner, Gainsborough, Constable, Millais and Holman Hunt.[27] 'I don't believe', he would confess to a friend, that 'I really like any modern development.'[28]

Nash ignored Tonks's request to stay away from the first Post-Impressionist exhibition. But he left it 'untouched', writing long afterwards, 'I remained at the point I had reached and continued to make my monochrome drawings of "visions".'[29] The responses of his

colleagues were (at this stage) equally cool. Richard Nevinson, who had already spent some time in Paris and knew of the 'Post-Impressionist' artists long before 1910, went with Gertler to what was being called this 'ultra-modernist' exhibition.[30] It made a limited impact on their art, however. Like Nash, they would not yet join the ranks of the European avant-garde.

Indeed, to one anonymous Slade student writing in the College magazine, Post-Impressionism was really nothing new: 'The principles advanced in the catalogue of the Exhibition at the Grafton Galleries were certainly interesting, but surely more as a revival than as an innovation. They express nothing more than has been the aim of artists from time immemorial.'[31] Others saw it as significant, but with little immediate impact. William Rothenstein told Fry that he considered the exhibition to have been 'a brilliant and gallant charge of the light brigade – a glorious episode, but leaving things very much where they were before.'[32] This seems to have been true, at least at first, for the young Slade students. But some of their immediate elders – among them Vanessa Bell, Duncan Grant and the Fitzroy Street painters such as Spencer Gore – were soon displaying the influence of Post-Impressionism in one form or another.

For the moment, however, Nevinson, Gertler, Spencer and some of their Slade colleagues were still finding more influence in the National Gallery's collection of Renaissance paintings than in the Post-Impressionists at Grafton Street. In 1910 Augustus John had made his first visit to northern Italy, where he had seen the works of such Italian 'primitives' as Signorelli at Orvieto and Giotto at Padua. Their influence had quickly appeared in his paintings, which were exhibited on his return to England, and the young Slade artists appear to have followed John's lead.[*]

Nevinson later recalled that 'By this time I was largely under the influence of Gertler and was doing highly finished heads in the Botticelli

[*] The critic Laurence Binyon, writing in the *Saturday Review*, considered John's works better than the Gauguins on show at the Post-Impressionist exhibition.[33]

manner.'[34] His beautifully finished self-portrait of 1911 certainly shows the influence of the Florentine painter, and it was John who had introduced Gertler to tempera. Indeed, by that year the Slade Coster Gang had renamed themselves 'the Neo-Primitives' (or so Nevinson later claimed), drawing artistic influence directly from the Italian early to mid Renaissance – artists that included Duccio, Cimabue, Giotto, Masaccio, Fra Angelico, Piero della Francesca and Botticelli.[35]

Thus Gertler declared in an interview with the *Jewish Chronicle* in February 1912 that Piero della Francesca's *Nativity* in the National Gallery was 'assuredly one of the finest pictures in the world', filled with 'music and rhythm' of colour. He added that it was Botticelli who had 'helped me a great deal to see clearly in that direction.' He doubted whether the Old Masters would ever be equalled in this respect: 'There is too much visualism, and not enough brain, in modern art', he complained. 'People do not think enough before they put brush to canvas, and then we are not such keen craftsmen as they were in the old days.'[36] When the reporter asked him what he thought of modern art, Gertler explained: 'I say this, that until we begin to paint in the same sincere spirit that they did, we have no chance of approaching them as painters.' Augustus John was the only modern artist he spoke of by name as 'really great'.[37] Nevinson also rated Piero della Francesca highly, though he held that it was Whistler who was 'undoubtedly our last Artist', and that 'John is useless compared to him emotionally'.[38]

The apotheosis of this 'primitive' spirit was Gertler's *Allegory* and then a group portrait that John Currie painted in 1912. It portrayed the artist alongside Gertler, Nevinson, Wadsworth, Allinson and the proprietress of the Petit Savoyard café in Soho. With a deftly Renaissance style and an Italianate backdrop (a critic would soon speak of the 'Florentine lucidity' of Currie's figures[39]), he titled this unusual tempera scene *Some Later Primitives and Madame Tisceron*. It was well received when exhibited at the NEAC – but it could not be called modern in terms of what was

going on across the Channel, or indeed in terms of what was going on in Bloomsbury or Camden Town. Even in August 1913 Gertler was telling Brett to study 'Giotto! & at once – He is tremendous!!! Study also Dürer – *the* draughtsman. These men are a constant cause of inspiration to me. It will never do, unless we too, express ourselves with such knowledge & emotion.'[40]

When Nevinson, Gertler and Currie exhibited at the Chenil Gallery in Chelsea in December 1913 alongside paintings by Augustus John, the critic for *The Observer* perceived that 'when their modernity is closely investigated it seems to belong more to the fifteenth century than to the twentieth century. Indeed the most "advanced" of the exhibits take us back to the days of Giotto.'[41] But by then the 'Neo-Primitives' were already breaking up. Nevinson had warned Carrington in July of his fear that Currie and Gertler were becoming too 'early Italian & costumy', telling her that 'we must guard against raking up the past'. He felt that such 'academic art' was 'second hand & therefore lifeless.' Though he looked to the past, he wanted 'to paint this present age', and soon Gertler and Currie were following suit.[42]

It was Stanley Spencer who would be most influenced by the early Renaissance Italians. There is no evidence that he ever visited the first Post-Impressionist show, and he later denied having been influenced by *any* form of contemporary art (though this was clearly untrue).[43] In 1911 his fellow Slade student Gwen Darwin (six years Spencer's senior and a grand-daughter of Charles Darwin) gave him a copy of Ruskin's *Giotto and his Works at Padua*. The illustrations there were supplemented by those he saw in a series of little art books published by Gowans & Gray – available for a shilling apiece – and Spencer was soon returning to Cookham with editions on the Old Masters stuffed in his pockets. He was reading widely and avidly, and discovering how the medieval and early Renaissance artists he so admired had worked as craftsmen, celebrating God with their manual skills. It was an idea that appealed greatly. He later

earned Gertler's wrath by answering the question of what he thought of Picasso with the reply: 'I haven't got past Piero della Francesca yet'.[44] Gertler and Nevinson soon moved beyond their interest in the so-called Primitives; Spencer, however, did not.

Indeed Spencer – like Gertler and Nevinson – eventually became fed up with 'thinking' about art, and the endless discussions the Slade students engaged in. They all had their own theories on how great art could be produced, with Maxwell Lightfoot and Edward Wadsworth amongst the most fervent in advancing their ideas and advising their peers. Not that Spencer minded Lightfoot's encouragement: though he came from a working-class Liverpool family with little interest in art, Lightfoot was precociously talented and had recently been invited to join the select circle of Walter Sickert's Camden Town Group. But in 1914 Spencer explained to Gwen Darwin that whilst at the Slade he would go 'for ages every day, to lunch with Nevinson & Wadsworth, & Wadsworth used to get me to study the anatomy of his "thoughts" upon art & how to paint & draw in a *practical* way, mind. This sort of thing went on for what seemed to me years until at last one day Wadsworth came in absolutely desperate'. Wadsworth didn't think Spencer knew enough about 'Art', and so advised him to give it up altogether, explaining: '"I have had experience; you have not. I have passed through all the stages an artist can go through; Rembrandt & all the rest". He went on like this & Nevinson looked very glum. It is extraordinary, but on this occasion I was silent. I thought perhaps he was ragging, until one day I asked Nevinson & he said Wadsworth was doing the same thing to him; delivering these lectures. I thought when I heard Wadsworth going on, "If you had not interfered you would never have got yourself into a muddle" for Wadsworth is a horrible man to me. You understand I only tell you this to show you that it was more or less through listening to these people's rubbish that made me so prejudiced against thought in every way... I agree with you that my work has suffered on account of this prejudice'.[45]

It was Carrington who was the most immediately influenced by the Post-Impressionist exhibition. She returned to Bedford after her first term at the Slade a changed woman. Her brother Noel recalled how her new opinions on art 'deflated all our previous conceptions; those revered elders, Lord Leighton, Alma-Tadema, Herkomer and company were brushed aside as fit only for the dustbin. Who were we to look to, then? Why, Sickert, Steer, John, [Ambrose] McEvoy: names unknown to Bedford, and even these were not to be mentioned in the same

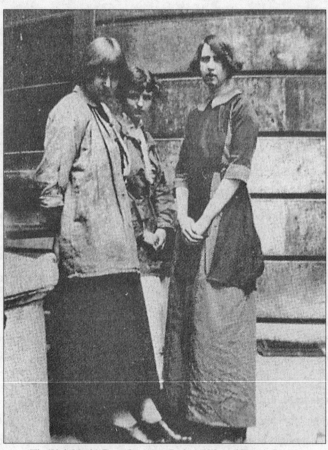

The 'Slade Maids': Dora Carrington, Barbara Hiles and Dorothy Brett
outside the Slade in their fashionable new haircuts, 1911.

breath as Cézanne.' For Carrington's art-loving mother this was all 'rather humiliating', and she 'now hardly dared to talk on the subject for fear of mispronouncing these strange names.'[46]

This, though, was as nothing compared to Carrington's corresponding change in appearance. When she had arrived at the Slade she was quite conventional-looking. But in 1911, in a defiant, defeminising act, she cut her long locks of golden hair in to a short, boyish bob. Hiles and Brett followed her example. They became known as 'the Slade cropheads', and set a trend for young female art students. Copying their dress designs from Augustus John's gypsy drawings, these 'Slade maids', relaxing under UCL's quadrangle limes between classes with their 'half done' hair and frocks like nighties, were soon being both admired and parodied in the College magazine.*

Whilst Carrington's old acquaintances in Bedford hardly recognised her, in London she was suddenly being noticed. It was this radical change in her appearance that really brought the nineteen-year-old student to her male peers' attention. 'You girls are so sensitive & I am so rough – I don't know how to handle you,' Gertler would soon be telling Brett. 'Please know, that I never want to annoy you three – because I love you all, as friends – You are so much better than my men friends & so much more intelligent than the other women I know.'[48] But of the three it was Carrington, with her good looks, charm, vitality, intelligence and independence of spirit, who would soon be threatening Gertler and Nevinson's cherished friendship.

* As a poem in a 1912 edition of the University College student magazine addressed to 'The Slade Maid' joked: 'Oh (S)lady, you force my attention … For your garb, and your hats, I might mention … Your hair's but half done … I think … You ought to be Slayed.'[47]

Chapter 7

'This Anarchic & Egoistical Condition'

In February 1911 Nevinson, Gertler, Allinson, Ihlee and Lightfoot exhibited with Vanessa Bell's select group of painters, The Friday Club. Gilbert Spencer recalled Stanley coming home with reports of this 'most obscure body... the very inner circle of mystery.' Unsure if his brother was even ever a member, he observed that the fact the Club 'held their meetings in the evenings would have been a severe barrier to Stan's taking much part in it. He hated not getting home to tea, and still seemed perfectly happy to develop his ideas in the front bedroom at home.'[1] Nevinson would have laughed at such provinciality: rubbing shoulders with the Bloomsbury Group – and, better still, exhibiting his work publicly alongside theirs – meant everything.

The *Sunday Times'* review of the Friday Club's winter show, held at the Alpine Club Gallery in Mill Street, Mayfair, heralded the young Slade students as 'The Rising Generation', with Gertler and Maxwell Lightfoot picked out for particular praise.[*] Then in November 1911 one of Gertler's portraits was included in the NEAC's winter exhibition, hanging alongside paintings by Tonks, John, Sickert and Sargent. This was a success Nevinson

* The *Sunday Times* wrote of Gertler's painting *Jews Arguing*: '[It] is more remarkable, for its vigorous and incisive rendering of form than for its colour, though this is brave and strong, and if, as I hear, Mr Gertler is only eighteen years of age [in fact, he had just turned nineteen], he has plenty of time in which to acquire distinction in colour and quality in pigment, and he shows a capacity, which, sooner or later, will force him to choose between being either a popular Academy exhibitor or a superior person in the New English Art Club.'[2]

was yet to emulate. But there was no rivalry between Gertler and Nevinson – not yet, at least. They simply loved to talk endlessly together about art. In December Henry Nevinson took his son for a private audience with Roger Fry. The Bloomsbury artist gave them 'a good criticism' of Richard's work, advising against 'having to draw' and emphasising his belief 'that if the passion is there the expression will come'.[3]

It was Carrington, not art, that drove a wedge between Gertler and

Nevinson, Factories, *1913*.

Nevinson. Nevinson made her acquaintance first, in early 1912, during his final year at the Slade. Their friendship, which quickly blossomed, was a godsend to him. Two paintings he had exhibited to some acclaim with the Allied Artists' Association at the Albert Hall in 1911 had respectively been titled *Carting Manure* and *Cement Works*.* Other favourite subjects included gasometers, canals, gloomy factories and smoky railway bridges,

and suicides, all painted in pseudo-Impressionist style. A reviewer for the *Sunday Times* described him around this time as 'a painter who sees beauty in what the crowd condemns as ugly', and Nevinson admitted the irony that 'I, who was born for Oxford and the Army in a hotbed of intellectualism, religion, and the classics, found refreshment in ugliness and the uncouth.'[4] And whilst Spencer, Gertler and Nash were relatively

* The critic Frank Rutter and the painter Walter Sickert had established the Allied Artists' Association in 1908 as an English equivalent of the Paris 'Independents'. Anyone who paid the guinea subscription could exhibit up to four of their works. The annual Albert Hall shows thus soon consisted of thousands of pictures, forcing Rutter to use a bicycle to ride around supervising the hanging.

chaste in their youthful romances, Nevinson was boasting of encounters with prostitutes and impassioned love affairs – though he later declared himself mystified at his attractiveness to women: 'I was always fat, ugly, indifferent and promiscuous, with a terribly roving eye'. His only explanation was that this 'most unpleasant creature' was redeemed by 'a real love of beauty, the effrontery of a shy man, and a mind more than half-feminine in seeing their point of view'.[5]

Adrian Allinson had remarked how the naked female models at the Slade with their wandering glances 'seemed to share dark and unholy secrets' with the young artists. Nevinson was quite prepared to search out those secrets for further scrutiny: as he later confessed to Carrington, before he had met her, he was 'always going about... with men that lead much filthier lives than myself [and] I lost sight of decency altogether.'[6] Indeed, at one point in 1911 he felt obliged to propose to one of the Slade's models who had become pregnant – not necessarily by him, though he was clearly a contender (as was Tonks, rather improbably). But he received 'a very rude refusal'.[7] It was alleged, however, that the subsequent child bore a striking resemblance to him, and he told Carrington that he was ever alert for a telegram arriving 'announcing a death & birth with a child left for me to look after or every letter I was terrified might be from that busybody Tonks or some blackmailer.'[8]

Models usually provided the main focus for male artists' sexual attention. They were presumed to be of loose morals and, naked or dressed, set the students' pulses racing. Allinson, still a virgin at twenty-two, was fed up at being unable to join Nevinson and Wadsworth in their comparisons of libidinous adventures. He used the new-found wealth from his Slade scholarship to procure one of the prostitutes who promenaded outside the Alhambra Theatre. He caught a venereal infection, but the escapade impressed his companions, and he now considered himself 'a man of the world'.[9]

It was from this dissolute life that the naive but unconventional Carrington rescued Nevinson. 'I owe you everything', he told her melodramatically in May 1912. 'I have no doubt but for the sudden appearance of you, I would now be a dissipated criminal of the most carnal description. I would [have] lost money, reputation & my very soul.'[10]

This was not simply youthful hyperbole. One night in September 1911 Maxwell Lightfoot cut his throat with a razorblade in his Fitzroy Road lodgings. Gilbert Spencer recalled Stanley coming home stunned at the news, and relating the story 'with an almost pre-Raphaelite attention to detail. His death was a great loss; he had been a leading light among the band of desperadoes who had dedicated themselves to their art at all costs'.[10] According to Adrian Allinson, Lightfoot's fiancée, an artists' model he had met the previous year, was 'notoriously promiscuous', but his love for her had blinded him to what was 'common knowledge to us all'. The realisation of the truth, on the eve of his wedding, 'drove him to the extreme of suicide. We were all deeply shocked by the loss both to ourselves and to Art.'[13] An obituary in *The Times* affirmed that 'All artists and critics… were united in believing that Lightfoot would enjoy a most distinguished career in the highest rank of painting.'[12] Nevinson was struck by the callous attitude of his friend's bereaved fiancée: 'I felt bewildered when I witnessed the natural pride of the woman because a man had died for her.'*[14]

Nevinson's letters to Carrington in the spring following Lightfoot's suicide chart his growing infatuation. She was unlike any other woman he had met: she was a 'gorgeously egotistical, impulsive, unsettled youth',[16] and he revelled in her correspondence. Her letters were quite different

* According to an account of the inquest in the *Daily Mail* (30 September 1911), Lightfoot had only been engaged for a few days, but his family had advised him to wait before marrying, and this had greatly upset him. He was due to travel to Liverpool with his fiancée the next morning. The contemporary collector Michael Sadler considered Lightfoot's early death 'a disaster to art in England'.[15]

from the 'four sheets of prosaic balderdash' he had received from other girls, and filled him with trembling anticipation.[17]

A hot topic of their correspondence was Carrington's bid for a Slade scholarship, without which she would be unable to continue at the School. That would mean returning permanently to Bedford and the loathsome dullness of her family life. Being at home during the Easter vacation was bad enough, but a seemingly immutable return was too horrible to imagine. Four years older than her, and artistically more experienced, Nevinson felt he could advise her on her work, and so help her win the scholarship. He told her that she needed to 'fairly knock off compositions, landscapes, heads & figures in pencil, charcoal, oil, watercolour, tempera & pastel & if you can do any sculpture do a bit of that, I can absolutely guarantee that quantity & versatility are the two qualities that really move Old Brown out [of] his senile sleep.' And he already feared losing his new friend: 'I am leading the most profoundly "dull life"', he complained at the end of March, so she simply had to get the prize. 'I will really turn my face to the wall & die if you miss it.'[18]

His correspondence would be filled with advice and encouragement, as well as hints of his romantic interest. He was particularly aware – no doubt through his mother's experiences with the Suffragette movement – of the disadvantages Carrington, talented though she was, would face. He warned her, 'as you happen to be aiming high you have quite simply a bloody struggle in front of you of course not only with your actual self-expression but that vile dead wall of prejudice & hatred against a woman'.[19] Noel Carrington believed Nevinson and his family had an important influence on his sister. Though uncertain as to whether or not she actually became a Suffragette, he thought this new friendship 'marked the beginning of her later dislike for feminine weakness and for the restrictions which custom then imposed upon women... It was almost certainly at the Nevinsons' house in Hampstead that she began to acquire the feeling that a woman's role in life must not be one of subservience.'[20]

Richard also advised her on the current artistic controversies, and the divisions between the traditionalism of the Royal Academy and Bloomsbury's Post-Impressionism. Despite his audience with Fry, he was not wholeheartedly married to the latter, and told her he was

> convinced there is something in you if only you can find your right track & others do not send you off into wrong ones & now that Art is in this Anarchic & egoistical condition with absolutely no two standards of taste alike in a little time you will probably find yourself hopelessly lost, I know how Gertler & I are always getting muddled & finding new discoveries...

In such times of change, it was hard for young artists to find their own way. Perhaps Tonks, after all, had been right in encouraging them to stay away from Grafton Street? Nevinson certainly advised her, 'above all don't get into this post-impressionist cleverness of pretending to be a great[er] fool than you are & paint your own time & the life about you.'[21]

He also shared with her his intimate feelings, self-doubts and frustrations: 'You cannot think how frightfully keen I am to get on & be appreciated sometimes, yet my brain always is telling me how silly & futile it is of me as I know only too well I have not a single touch of genius, yet I still have this mania to do at least one really good picture in [the] course of my lifetime & as a secondary ambition I would love some day to get hung in the New English.' But he added laconically, 'I have an inward conviction or second-sight I will never get in to the New English & Allinson always will.'[22]

He partly blamed Tonks, who was on the NEAC's judging panel, for his failure to get exhibited there. Indeed, in his autobiography Nevinson claimed that towards the end of his third year at the Slade, just when he seemed to be making progress, 'Tonks advised me to abandon art as a

career'.[23] He was devastated, but briefly heeded his professor's advice, and during the summer of 1911 considered a career as a journalist like his father, or embracing his parents' Christian socialism. Looking inside himself, he told Carrington that he thought there was a danger of him 'becoming a "simple little Christian"'. But he believed his 'salvation' would ultimately come 'not through Christ but draughtsmanship. If I could only just get an understanding of drawing I might feel more at peace within myself.'

He hoped that by the start of the next term 'I will have done something better than I was thought capable of. Oh I would love to prove I could draw; I think I would shoot myself to prevent any deterioration'.[24] Nevinson did return to the Slade, but it was clear that Tonks had no great hopes for his artistic future. The Professor of Drawing became Nevinson's *bête noir*, and his name recurs with bitterness throughout his correspondence with Carrington.

• • •

By April 1912 Carrington's animated letters were giving Nevinson the impression that, romantically, she was almost as keen as he was. As he replied to a lost letter of hers, 'I am flattered, I believe you really love me. If I should happen to be in a fools' paradise don't tell me. I infinitely prefer it to a wise man's purgatory.'[25] He knew Carrington was popular with the male students, so was right to be cautious. It was Nash who had got to know her first, and though he had left the Slade the previous year, he was still in touch with Carrington. For some reason, Nevinson was asked to forward one of Nash's letters. Nevinson obliged, but queried: 'I do not want to get cut out but I heroically enclose my rival's letter, by the way who is this Paul Nash? I do not seem to remember him though in a way his name seems familiar to me.'[26]

Given such competition, Nevinson should have thought twice before taking Carrington to meet Gertler. He had left the Slade at the end of 1911, but had noticed Carrington there – though he had not been

particularly impressed: 'The first time I saw you,' he later told her, 'you only just looked attractive enough for me to look back. I looked back, saw a long plait and *turned in* toes; no good, I thought, and forgot all about it!'[25] Now, at his studio on Commercial Road, he saw something more: her radically short haircut, and the impressive breadth of her reading, that distinguished her from many the more conventional middle-class women of her age. Gertler was impressed, and smitten.[28]

He contacted her almost immediately, inviting her to visit his studio alone for tea, and to model for him. As it was the Easter vacation he wrote to her at home in Bedford. His interest was clear, as either he or Carrington described this first contact as a 'passionate love letter'.[29] But Gertler was unaware that Nevinson was equally attracted to Carrington – indeed, even she thought he was keeping his interest secret. Nevinson defended himself: 'I am not ashamed of really liking you (I have even carried that basket of yours) but I am rather secretive not by nature but experience.' Emphasising their difference in age he joked, 'You must remember I am now middle aged.'[30] In May he ended a letter with a clear declaration of his feelings: 'I do so love you Carrington & I am absolutely yours.'[31]

Whilst she maintained a close relationship with Nevinson, Gertler intrigued Carrington. Noel thought that it appealed to his sister's 'sense of romance' that Gertler was 'a poor Jewish boy from the East End, was good-looking and witty, and like her was educating himself in art and poetry.'[32] Gertler was also doing extremely well as an artist – much more so than Nevinson. He had recently won a British Institute scholarship worth a handsome £100, and as he told Carrington in July, he had sold one of his early paintings for £35.* Most impressively of all, Professor Brown had written to ask him if he would like to have his name put down for election to the NEAC. 'I am so happy! It is such things that make me think for a *moment* that my ambition to become a true artist may yet be realized.'[33]

* These figures (like the rest in this book) can be very roughly translated into their modern equivalent by multiplying them by seventy.

Equally, Gertler was pleased by the access to higher society provided by his new friendships with Carrington and Brett. In May he was invited to join them at a social function in Mayfair: he promised that he would come 'in REAL Evening dress!!! No you must promise not to laugh'. A friend had lent him the suit, but the trousers were a little short. Gertler recalled the incident on the bus when Carrington had accosted Nash to help her adjust her fancy dress costume: 'with *your* experience of Braces you will know that with a little manipulation that fault can easily be mended – No one need know. The upper part of me will be perfect! I shall be able to look Aristocracy straight in the face.'[34] Still, he felt inferior. 'You are the lady and I am the East End boy,' he would eventually tell her, adding in an envious reference to Nevinson, 'Alas! or had I even been to a Public School like the gentleman of Hampstead'.[35]

Gertler's artistic successes would never quite make up for his lack of 'breeding' – and he knew it. Though he would often attempt to hide his lowly origins behind a forceful ego and sheer strength of character, underneath he would always be the poor Jew, the East Ender, the outsider. At other times, by contrast, he played up this poor background; but always it was a form of disguise, or part of an attempt to be 'real' that plagued him throughout his life. In December 1912 he would tell Carrington, in a sentiment that recurs through this period, 'my isolation is extraordinary... if only, like my brothers, I was an ordinary workman, as I should have been... By my ambitions I am cut off from my own family and class and by them I have been raised to be equal to a class I hate! They do not understand me nor I them. So I am an outcast.'[36]

Noel Carrington was intrigued by his sister's relationship with Gertler. But he was more wary of Nevinson, describing him as 'something of a loner, introspective and suspicious of society.' He felt Nevinson had 'fastened on to Carrington as a sympathetic innocent who was worth coaching in the facts of life and art... His advice was sound enough, but he seems to have expected too much in return.'[37]

Over the following months the three students spent a great deal of time together – the photograph of a Slade picnic, with Gertler resting his arm affectionately on Nevinson, probably dates from this period. Sometimes Gertler and Carrington went to the National Gallery together, where they stood rapt in fascination before their favourite paintings, and bought postcards of them to take home and copy. Gertler's passion for Carrington ran high, and soon he was seeking a more physical relationship. Such were his feelings that only two months after their first meeting, and seemingly still unaware of Nevinson's love for her (though aware that she had some affection for another man), he went so far as proposing marriage.

On 19 June 1912 he wrote and told her that he had 'come to the conclusion that I love you far too much for us to be merely friends. Therefore, unless you agree to marry me, or in some other way be more than friends, I am afraid we must part for always.' He listed five 'advantages' she would enjoy by marrying him:

1. I am a very promising artist – one who is likely to make a lot of money.
2. I am an intelligent companion.
3. You would not have to *rely* upon your people.
4. I could help you in your *art* career.
5. You would have absolute freedom and a nice studio of your *own*.

He then added, wistfully, 'I know of course that you would not agree to this.'[38]

This was the case, and Carrington immediately tried breaking off her relationship with *both* men. Her letter to Nevinson announcing this came as 'a horrible surprise'. He could not 'guess what has happened to make you wish to do without me as a friend next term.' He thought that

perhaps he had gone too far in expressing his own feelings, and swore 'I will never speak a word to you as a lover... I promise you I will be a great friend of yours nothing more & nothing less & if you want to get simple again I am only too willing to do the same.' He added plaintively, 'you & Gertler & Wadsworth & mother are the only friends I have ever known'.[39]

Likewise Gertler was soon trying to retrieve their friendship, though he found it difficult to maintain it on a platonic level. She was horrified when he attempted to kiss her, and her threat not to see him again resulted in a remarkable plea:

> My Dearest Carrington,
>
> If you want to *Kill* me you can part from me, but if you want me to live *don't*.
>
> I love you *more* than I *ever* did & I did not think you would mind what we did yesterday. I did it with the *Purest* intention just as I kiss a flower, a kitten or your letters. Just as I could kiss [Augustus] John because he is an artist. In fact it is only now that I feel you as a *real real friend*.
>
> Any how I *beg* of you to see me on Monday. *Please* Carrington or I shall kill myself... Let us be friends for *Arts* sake. Think what we could do together... If I don't see [you] I can't *exist* or *paint*.[41]

* Nevinson's loneliness was periodic, and his mother's autobiography paints a lighter picture in which Richard had numerous friends and visitors: 'Many of the young artists of the Slade used to come to our house, the brilliant but ill-fated Lightfoot, and John Currie whose end was yet more tragic; Wadsworth, the Spencers, Wyndham Lewis, Gertler, Allinson, Ethelbert White, Odle, the Nashes, the Carlines, McKnight-Kauffer, Gaudier Brzeska... Nina Hamnett, and afterwards, John, Sickert, Epstein, Ginner, the late Robert Bevan and Harold Gilman... They all danced and "ragged" with the delightful *abandon* of the artistic temperament; there was never a dull moment.'[40]

Then, when Carrington told Gertler of her feelings for Nevinson, his jealousy was indescribable, and he decided to break off that friendship, too. On 2 July he told her:

> I have suddenly begun to think that you simply use me as a help to your work and for myself you don't care a scrap. Your affections are given completely to Nevinson. I must have been a fool to stand it as long as I have, without seeing through you. I have written to Nevinson telling him that we, he and I, are no longer friends.
>
> I have just had a letter from a Jewish girl I once knew. A girl that is simple and beautiful, who is, thank God, not '*arty*' and of my own class. She will not torment my life.[42]

From now on, the whole three-way relationship dominated their letters, with rejections, denials and apologies flying back and forth through the post. The fact that in the summer of 1912 Carrington actually *won* the Slade scholarship she had worked so hard for (not to mention the Slade's Melville Nettleship Prize for Figure Composition and second prize for Figure Painting as well) went unremarked. The boys were fighting not just for a good friend or lover, but for a potentially great artist, too. Gertler finally wrote to Nevinson, telling him 'that our friendship must end from now.' His 'sole reason', he explained, was that he was in love with Carrington,

> & I have reason to believe that you are so too. Therefore, as much as I have tried to overlook it, I have come to the conclusion that we are rivals, & rivals in love cannot be friends. You must know, that ever since you brought Carrington to my studio, my love for her has been steadily increasing... When ever you told me that you had been kissing her, you

could have knocked me down with a feather, so faint was I. Whenever you saw me depressed of late, when we were all out together, it wasn't boredom as I pretended, but *love*... Rivals we are destined to be & rivals we must remain. We must be rivals openly, really rivals dramatically & theatrically & not friends. I am sorry but that is how it must be.[43]

He tried to explain the reasons for his passionate jealousy to Carrington. Gertler knew she was innocent of matters to do with sex – the legacy of her prudish mother – and on 7 July he tried setting the record straight:

In order to make you understand let me tell you for once always. You are no doubt extremely ignorant that way. Nature, forcibly takes hold of a man, places him on a road where she knows his ideal will pass. She passes: He loves her: madly, horribly, and uncontrollably. Not content with this, nature implants him with a desire (no doubt for the sake of the preservation of the next generations) to wholly and absolutely honour that woman. This causes him to be jealous of everything she does with other people... Of course it is absurd to ask me to try and be friends with Nevinson, so you think I am made of stone? That I should be friends with a man who kisses my girl...[44]

Despite Gertler's declarations, and although Carrington liked both men, she was not ready to commit to either. Inexperienced, unschooled in the ways of the world, she was battling with her own troubled thoughts on her sexuality. But she appreciated their interest, and in particular their keenness to guide her artistic development, and she did her best to reconcile them. Gertler, however, told her that he had 'lost interest' in

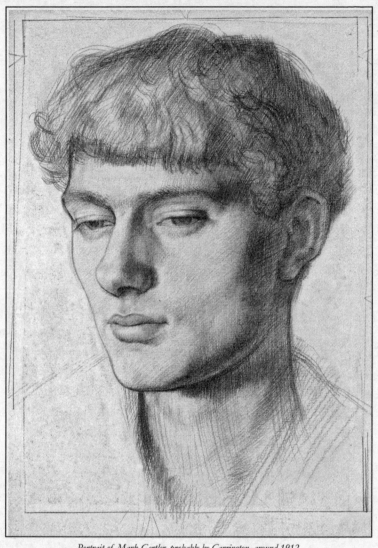

Portrait of Mark Gertler, probably by Carrington, around 1912.

Nevinson, and John Currie was 'now my *greatest* friend and Currie would consider it rather funny if I said tomorrow night I shall go out with Nevinson! It wouldn't be fair on Currie.' Their split, he insinuated, had nothing to do with his feelings for Carrington. Nevinson, he declared,

would soon forget him: 'I shall soon pass out of his life, as he has passed out of mine.'[45]

But Gertler was wrong. Nevinson refused to accept that their friendship was over. At the beginning of July he told Carrington how much he missed Gertler's companionship, their conversations on art and their work, '& our talks in general. God how fond of him I am, I never realised it so thoroughly till now I have lost him yet I cannot give you up, you have put a reason into my life & I am through you slowly winning back my self respect'.[46] But Nevinson feared that Gertler was interested in Carrington merely for her beauty (Gertler would describe her to Augustus John as 'a beautiful flower encased in a form of gold').[47] He warned her that Gertler 'will always prefer your looks & all that concerns your looks over *everything* else.' He was prepared to accept Carrington's more qualified feelings for him, promising not to get as carried away as Gertler had.[48] But to his friends he was less charitable, and the rumour soon reached Carrington that he had called her 'an ill-bred shop girl'.[49] He denied it, though the snideness of the remark rings true to Nevinson's bullying nature.

Nevinson also wrote to Gertler, telling him how lonely and depressed he felt. Gertler confessed to Carrington: 'His letter has made me wretchedly miserable. I shall have to do my best to be friends with him too.'[50] Seeing all the pain she was causing, Carrington again tried to break off her friendship, declaring that it was spoiling Gertler's life and work. 'You are *wrong, wrong,*' he replied. 'Friends like ourselves cannot afford to part.'[51]

But their traumatic relationship was throwing her into a depression, and along with her own artistic ambitions and difficult family life she confessed to finding life difficult. 'Dear Carrington,' he wrote, 'Don't be unhappy, as life is very inspiring and beautiful. That it is hard, is true. But isn't there something grand about it being hard? Isn't there something grand to try and bear up and give to the world all we can?'

This, he suggested, was the price that *all* great artists had to pay for their art.[52]

In Noel Carrington's opinion, this was the embodiment of his sister's relationship with Gertler. Apart from the undoubted artistic guidance and encouragement she received from him, 'there was in their relationship something which for her reached far deeper. This, I am sure, was the revelation of the spiritual travail that an artist must go through even to the point of physical exhaustion. Such states of exaltation are constantly reflected in Gertler's letters to her, and it was this communion of spirit which drew her back to him after so many dissensions.' Noel also noted the bitter disillusion Nevinson experienced when he found Carrington preferred his rival: 'he regarded Gertler as his own friend, and wanted to retain a special place with both. Gertler was having none of that and Carrington was forced to choose between them.'[53] In the end, reluctantly, she chose Gertler.

Nevinson seemed resigned to the decision, and regretted that he could not be 'so madly & heroically in love with you as Gertler'.[54] But there is no doubt that he *was* in love with Carrington: 'it seems so natural to me for a girl to prefer Gertler', he told her in July, 'that I am always prepared to take a second place purely from a matter of good taste on the girl's side. If only Gertler was of bigger stature, he would be absolutely superman with that highly sensitive brain'.[55]

Certainly Gertler had already become a notable figure on London's art scene. Nina Hamnett, a flamboyant young artist, recorded meeting him with Carrington around this time:

> She had fair hair which was cut like an Italian page. She was one of the first women in England to cut off her hair and was very much stared at as she never wore a hat. I invited them both to tea and felt rather as if I had invited a god and goddess. Carrington appeared in one red shoe and one

blue. We talked about Art and the future, and I preserved Gertler's tea-cup intact and unwashed on the mantelpiece. It remained there for about a month; I felt that it ought to be given to a museum.[56]

By mid-July Nevinson, cynical of his former friends' actions and emotions, was distancing himself from the whole affair. He begged Carrington,

> may I in future be kept absolutely outside all your future lapses & quarrels & depressions? Your acquaintance with Gertler I don't think can affect my old friendship with him as I feel there is not much hope of it being regained. I have managed to exist this week without it so I presume next month it will still be possible.[57]

Though feeling 'this loss of Gertler more intensely that I thought possible',[58] for Nevinson the whole business was now over, though he felt Carrington had enjoyed his attention. In July he told her: 'Oscar Wilde says a woman never knows when the third & last act has arrived but waits for the fourth, tenth & twentieth scenes of anti-climaxes. Well try not to be a woman as much as you are able & realise a thing finished when it is even though it may not have a nice musical-comedy happy ending.'[59]

He then escaped to Paris on a three-week holiday, whilst Carrington went to Bradford to stay with her friend Ruth Humphries. For a while Gertler was left to himself in London, to catch his breath, and reflect on both what he had gained, and what he had lost.

Chapter 8

'That Awful Ghost Tonks.'

In July Gertler had told Carrington that John Currie was now his *'greatest* friend', and with Nevinson and Carrington gone it was with Currie that he spent much of his time. Seven years older than Gertler, Currie was the illegitimate child of Irish Catholic immigrants. His father had been a navvy on the North Staffordshire railway, and it was his mother who brought him up. Currie worked for a while painting ceramics in the Staffordshire Potteries before his obvious talent led him to the Royal College of Art in 1905. Then in the summer of 1910 he briefly attended the Slade. There he quickly made friends with Gertler, Nevinson and the other 'Neo-Primitives', whose group portrait he painted with such loving attention to detail. As an ambitious outsider attempting to escape an impoverished background, Currie had natural affinities with Gertler. Both shared a single-minded artistic drive. One collector wrote of Currie's 'burning eyes', 'uncouth speech', rough manner and self confidence: 'he was simple and absorbed in his work – conscious of genius without being conceited, full of himself but not egoistic'.[1]

Like Gertler, Currie was dark-haired, but ruggedly handsome rather than pretty. Perhaps importantly for Gertler, Currie would not be a competitor for Carrington's attentions, as he was married with a young son; or, at least, he had been married, to a woman he had met whilst working in the potteries. But the previous year Currie had met Dorothy

Henry, a tall, attractive seventeen-year-old who modelled dresses at a Regent Street department store. According to one of Currie's friends, Dolly 'was of flower-like loveliness, but lascivious and possessive to the last degrees. Her lure for men was irresistible, and Currie was of course utterly enslaved to her physical attraction, a fact of which she was well aware.'[2]

When Currie's wife discovered the affair in August 1911 he abandoned his family, moving with Dolly into a flat in a decaying Victorian terrace in Primrose Hill. They were indifferent to public opinion – an independence of mind that impressed the young Gertler. But it was a hopelessly doomed relationship. Dolly was poorly educated, unintelligent, and had no interest in art. She resented Currie's absorption in his work, and attempted to make herself the centre of his life. As a friend later recalled, Dolly used the power of her beauty and sexuality 'to goad him from abject desire to baffled fury and then, suddenly complaisant, to win him back again. This dangerous cruelty led to violent quarrels and... blows.'[3]

Dolly and Currie welcomed Gertler as a friend. In July he accompanied them on a seaside holiday to Ostend, writing to Carrington excitedly, 'This place is like one huge Soho!'[4] But despite their frolics – holiday photos show the three of them dressed in bathing costumes and fooling around with a toy donkey – there was clearly a darker, brutal side to Currie's nature, as Nevinson recognised. He thought that Currie suffered from 'a Napoleonic complex' and that his love of Nietzsche had left him amoral.[5] Indeed, Adrian Allinson blamed Currie, not Dolly, for the discord that all saw in their relationship: 'Violent jealousy continually drove Currie to threats of murder', whilst Dolly's 'beauty, and pity for her lot, aroused in more than one painter the desire to replace the Irishman, so that Currie's jealousy, originally groundless, in time created the conditions for its own justification.'[6]

Another friend likened Currie to the character Raskolnikov in Dostoevsky's novel *Crime and Punishment*, who 'killed an old woman for

the sake of three thousand roubles.'[7] An art collector who visited Currie in London found him reading Dostoevsky to Dolly: 'He was blazing with genius', he later recalled. 'All his nature was aflame.'[8] Currie drank neat whisky and recited poetry out loud; if he saw something he wanted, he simply took it, be it a book from a shop or silver spoons off the table of a wealthy patron. Stanley Spencer wrote simply, 'I cannot bear him.'[9]

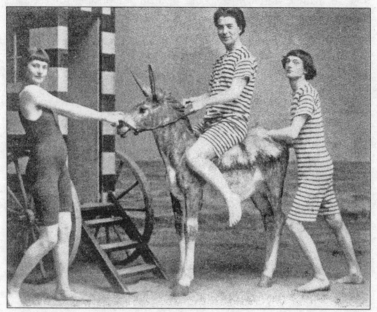

'This place is like one huge Soho!' Dolly Henry, John Currie and Mark Gertler, Ostend, July 1912.

Nevinson was in no position to be moralising about Gertler's new friend, however, as his own past was catching up with him. The Slade model he had proposed to had had her baby, and Tonks was collecting money to assist her. Tonks had perhaps heard the rumour that the child was Nevinson's, but the latter claimed that he could not afford to make a contribution to Tonks's charitable fund. In August he told Carrington: 'Tonks has been saying about me that he has never in all his life heard of any man behaving worse than I have done, he little knows how I loathe

not being able to pay for my own misfortune (if it is mine) but as it is by the girl's particular wish not to tell my people I don't see how I can pay Tonks his beastly £10 or whatever it is that he gave the girl.' The episode had, he added, 'blighted the whole of my life, it haunts me day & night'.[10] His greatest fear was that his mother would find out.

And he was amazed to discover that Carrington did not understand how so many different men could be held responsible for the girl's predicament. 'Surely you must know that few women are only for one man', he asked. Her innocence surprised him, and he could not comprehend 'how till lately you have never asked yourself why there were men & women & why they were attracted so enormously to one another & where they differ & why they differed physically.' He advised her 'to put away childish things now & know things as they are. So many mistakes & miseries have been caused through this foolish innocence that girls are compelled to have or pretend to.' He also thought such knowledge would give her 'a much keener insight as to people as they really are & even pictures, books, plays, will mean more to you.' With an understanding of sex, Aubrey Beardsley's drawings would suddenly mean more to her than 'merely bookfuls of patterns & hints to fancy dress'.[11] But she was still too young and naïve to fully understand.

Nevinson had been upset to find, on his return from Paris, that Gertler with his 'tales of woe' had won over most of their old Slade friends. In August he told Carrington angrily that Gertler 'has simply used me as a stepping stone & now that in his estimation I am no more use he is no longer interested in me'. He felt that he had helped Gertler overcome his 'ignorance' and shyness, and that 'it was largely through me that it is possible for him to "move in" decent society that is so horribly strict on small things especially in those that they consider the lower classes.'[12]

Nevinson now abandoned most of his Slade friends – they were 'cads' and 'blackguards'. Indeed, he felt his studies at the School had been a

waste of time and money. Even Augustus John, whose drawings had first drawn him to the Slade, he looked down on. 'I am not very fond of John's work', he told Carrington. 'It strikes me as being by a symbolic Slade man who is a marvellous exponent of Slade teaching, conventions & eccentricities, but somehow not quite art.'[13] With the exceptions of Carrington and Wadsworth, anything to do with the Slade was to be rejected.

In August he headed off to Bradford. There, 'cut entirely away from all artists & the Slade clique', he felt happier than he had for months.[14] The north of England, with its rugged countryside peppered with slag-heaped coalmines, cotton mills and vast, smoke-belching cities, offered a different environment to the less heavily industrialised south.* Nevinson set himself happily to painting the North Country's gloomy industrial landscape. Enjoying his independence, with no one around to 'thrust their opinions down my unwilling throat', he told Carrington, 'my work does not want criticism, it wants doing'.[15]

But Carrington was upset by his attempt to escape his former life. She responded by inquiring why he had not proposed to her, as Gertler had, and why he was no longer romantically interested in her in the way he had been. Once back in London he told her that this letter had

> succeeded in thoroughly chilling me... You wanted to know why men as a whole did everything to avoid marriage before they eventually succumbed to it. Well, why do you object? Because you think you will lose your freedom, your mind, your soul & your ambitions. Well does not that apply to

* When Paul Nash travelled through the region by night train in July 1914 he reported to Carrington how 'we saw the dawn break over the North country – very grey it all looked. Great horrific factories loomed out, the landscape bristled with chimneys, furnaces flamed suddenly'. It was not a subject matter that would ever interest Nash artistically – he added with relief how 'as we ran on into the country the light strengthened and we saw the Trees.'[16]

men, even more so & especially to Artists... I simply say how utterly unbalanced you could be sometimes, & a gleam of commonsense strangely enough came & wiped up that madness I once had for you. Thank God... But poor Gertler was worrying himself silly & if ever I get again like that & am worried I will run away hard & will *never* see you again...

He ended his letter by explaining that Gertler was now 'engrossed in himself & his work & success', and 'naturally has not time for me'.[17]

• • •

In fact, Gertler was *not* enjoying his recent critical success. Where once he had been confident, now he was uncertain. It was almost as if the more artists he met, and the more great art he saw, the more intimidated he became. His intention, he told Brett, was to devote the whole of his life to his work, '& perhaps before I die, I may do *one* thing that people will say – is an *addition* to what has been done.' But at that moment he was, he confessed, 'very doubtful' if he could achieve even that much.[18]

During the summer of 1912 Gertler had met up with Augustus John, brilliant role model for almost every aspiring artist in London. They had had lunch together, 'and got so confidential that we told each other all about our lives. ... We parted great friends', he told Carrington.[19] John introduced him to tempera, a favoured technique of many Renaissance painters. It was a careful, time-consuming process that could produce works of great lucidity, but offering little room for error. Gertler was already a methodical painter, and this new technique reduced his slim output still further. Since leaving the Slade at the end of 1911 he had depended on selling paintings for income; but the more time he spent over his pictures, the less he could expect to earn from them. However, his experiment with tempera did result in his carefully crafted portrait of Carrington, which was painted in this year. With its delicate beauty and sympathy to its subject, it shows why he was now in demand as a society portraitist.

Gertler's other new colleagues included the young Jewish artist Jacob Epstein, who had emigrated from New York and was creating a stir in London with his primitivist sculptures. Epstein took Gertler to the British Museum and showed him the Egyptian art there. He was overawed, writing to tell Carrington, 'my ambition doubles and redoubles! Oh! Carrington, if I am given many years in this world, I think! I think! I shall do great things! Things so great that they will surprise all men!'[20] Yet his artistic spirit seemed to have become entirely intertwined with his love for Carrington. In the same letter he continued, 'You must, you must like me a little... because as soon as I do not hear from you the sun has no rays for me, the flowers no scent, all beauty flies from me and all is blackness! Black as Hell.'[21]

By September 1912 he was insomniac, increasingly depressed and sometimes almost suicidal. 'The more I go on, the more difficult does my art become to me', he told Carrington.[22] His devotion to painting, and achieving greatness in it, was matched only by his dedication to her. In September he wrote, 'I am so interested in my work that I see *nobody* – not even Currie. I live in a sort of beautiful, half melancholy loneliness.'[23]

Coming as it did at such an emotional pitch and mental price, he expected Carrington to respond with equal devotion. But his moods frightened her, and she had her own ambitions to consider. Sometimes in his anger Gertler claimed not to love her at all. Then he would quickly retract such claims, before flying into fierce jealous passions. When he discovered that she had secretly been seeing Nevinson on his return to London he was furious. Her behaviour had been 'outrageously insulting to me ... Your presence was absolutely repulsive to me & I couldn't stand you near me, I was absolutely disillusioned... There are to me only two kinds of actions: – ugly & beautiful. I can forgive murder or any crime as long as it is done "bigly". But anything mean & low I cannot stand. Yours was such & it was therefore ugly.'[24]

It seems hard to believe such intense passions could be continued for long. In early September Nevinson ran into Gertler at the Café Royal, and Gertler told him that he no longer loved Carrington and wanted to end the relationship. Concerned for his old friend, Nevinson wrote to Carrington and asked her not to contact Gertler any more. But only a few days later Gertler was once more pathetically pleading with her: he had *never* said he didn't love her. 'Carrington Dear I can't live without your friendship. Please Carrington have pity on me & don't leave. Give me one more chance Carrington – *I never I swear, I swear* I loved you all along.'[25]

Again she consented. But it did little to assuage Gertler's self-doubt, as a long, melancholy letter written later in September reveals. A woman and her teenage son had recently visited him. The woman thought the boy had artistic talent, and wondered if she should encourage him:

> Oh! Carrington, what could I say? The mother looked at me and envied me! They both thought what a happy man this must be. They were both nervous and 'Sir'd' me. Did they know that, though for so many years I had been studying, studying, working, working, pouring my very brains out into my art, yet there I stood feeling more ignorant than when I first started as a boy of fourteen like the little fellow that was asking my advice at that moment.
>
> 'It's a hard life, it's a hard life,' was all I managed to mutter to the anxious mother. They went away more bewildered than they came. I dropped exhausted into an armchair, thinking, thinking of all my past life! How strange it all seemed! I remembered my childhood in Austria. The great *poverty*. No bread and my poor striving mother... Then I remembered my school days in London with my little urchin friends. They now sell newspapers at the Mansion House. Then came my

Polytechnic days. Then I worked in a designing firm for *a year*! which nearly broke my heart. Then the Slade and that awful ghost Tonks, and here I am now an artist – supposed to be – yes, I thought to myself, 'Be a tailor, anything, my dear boy,' but not an artist. By this time the room was in gloom and my pictures all looked like mocking spectres that were there to laugh at me. I could stand it no longer. So I went out and saw more unfortunate artists. I looked at them talking art, Ancient art, Modern art, Impressionism, Post-Impressionism, Neo-Impressionism, Cubists, Spottists, Futurists, Cave-dwelling, Wyndham Lewis, Duncan Grant, [Frederick] Etchells, Roger Fry! I looked on and laughed to myself... and I walked home disgusted with them *all*, was glad to find my dear simple mother waiting for me with a nice roll, that she knows I like, and a cup of hot coffee. Dear mother, the same mother of all my life, *twenty years*. You, dear mother, I thought, are the only *modern artist*.[26]

• • •

Whilst Gertler was fighting to come to terms with modern art, the struggles with his work and his love for Carrington, Paul Nash was making steady headway, despite initial setbacks. Though he had improved his drawing skills at the Slade, while there he had felt he was making little *real* progress. Tonks told him, 'You are like a man trying to talk who has not learnt the language', but he could not find the solution to his difficulties. After a year at the School he was already suffering from Nevinson's disillusionment. He felt he had seen 'enough of students who, after a full course of instruction, were considered "to have learnt to draw". They had learnt nothing else in all those years and it would be only a matter of time before they themselves would be doing nothing else but teaching another generation to draw.'[27]

Another of their contemporaries at the School, the young Jewish student Isaac Rosenberg, felt much the same way. He complained later that 'the paradox of the Slade' was that the push 'to attain to a completeness of vision' resulted in 'a total sinking of all conscious personality, a complete absorption and forgetfulness in nature'.[28] This was fair criticism, though Nash, like Rosenberg, struggled with figure drawing. Both men left the Slade early, and both needed to discover an artistic vision on their own terms. Rosenberg would eventually find his in poetry, and help was at hand for Nash.

In the summer of 1911, shortly after he had quit the Slade, Nash was advised by Audrey Handcock, a wealthy Iver Heath widow with a professional interest in the arts, that he was too out of touch living at home with his father. He should move to London. So he found a bed-sit at 19 Paulton's Square, Chelsea. Mrs Handcock (who in 1915 would marry Paul's father) then engineered an introduction to her former tutor, Sir William Blake Richmond, who lived nearby in Hammersmith. Richmond's late father was the portrait painter George Richmond who, with Samuel Palmer, had been one of The Ancients, the group of young acolytes and friends of William Blake. Nash found the seventy-year-old artist 'rather convincing' as Blake's namesake: 'Certainly, Blake might have had, as it were, a spiritual hand in his making. He was not unlike the ancient, vigorous old man of the designs.'[29]

No fan of Post-Impressionism, Sir William took an interest in the earnest young student. With his characteristic lisp he advised him, 'Wemember my boy, drwawing, drwawing, drwawing, *always* drwawing.'[30] And it was Sir William who, on one of Nash's visits in the latter days of 1911, recognised his true potential as a landscape painter. In his 'booming, Blake-like voice' he suggested, 'My boy you should go in for Nature.'

Nash had 'only a vague comprehension' of what Sir William meant, but out of curiosity he 'began to consider what Nature offered, as it were, in raw material. How would a picture of, say, three trees in a field look, with no

supernatural inhabitants of the earth or sky, with no human figures, with no story?'[31] During a weekend visit to Buckinghamshire he reflected on Sir William's advice, and walking through winter fields experienced an epiphany:

> I wandered over the stubble. The air was filled with the delicate agonies of the peewits who were wheeling and curvetting about the sky in eccentric flights... In the blue vault above vast cumulus clouds mounted up with slowly changing shape. A full level radiance illumined the scene, articulating all its forms with magical precision. This peculiar clarity had in its essence a sort of mystery. A phrase of Gordon Bottomley's came into my mind. 'The greatest mystery comes of the greatest definiteness.' I had been looking at the 'mystery' latterly, it had for me an increasing significance. There were certain places where it seemed to be concentrated. I now realised that I had been unconsciously studying some of these places which lay near-by, within the distance of an ordinary walk. But it was close at hand that this magic was enshrined and it emanated from here with a potent force.[32]

Although Nash was surprised to find that he quite enjoyed living in London, and realised that it was London that 'held my fortune and my fate', it was the countryside that held the promise of artistic salvation. He began reading Samuel Taylor Coleridge and William Wordsworth, those great Romantic poets who encapsulated in their letters and verse the pleasures and grandeur of nature and the outdoor life. And he started to recapture the sense of wonder with the world he had possessed as a child. On a visit home he wandered the wooded banks of the river where he had once played: 'I remembered the intense excitement of hunting for nests, the breathless moment when the hand torn with thorns reaches out just one more inch to the rim of the nest and how the thrusting, twisting

fingers must then become delicate and sensitive as a moth's antennæ as they feel for the eggs.'[33]

During his hated school days and what he called the 'tortured years' of his mother's long illness and death, Nash had mislaid this childhood innocence. But now, out in nature, he was rediscovering it, as the vivid evocations of his adult writing reveal. A hunting trip with his father and cousins in September of 1912 brought back the memory of a childhood holiday to Dorset when, whilst chasing butterflies, he had suddenly found himself standing alone in a landscape of hedges, trees, downland, birds and the sea: 'I remembered the curious sense of being alone in the wide fields, the spacious scene beyond emphasising a sense of the power I felt in this isolation.'[34]

For Paul, returning to this same world, not as a boy but as an adult and an artist, was a return to the rustic domain of his forebears. But he would have a different quarry than butterflies, hares or partridge. 'What better life could there be – to work in the open air, to go hunting far afield over the wild country, to get my living out of the land as much as my ancestors ever had done.'[35]

Like Gertler with his East End portraits, Nevinson with his industrial landscapes, and Spencer with his visions of Cookham, in nature Nash realised his own subject matter, and his own idiosyncratic way of interpreting it. He now saw that the countryside he loved was theme and subject enough; these magical places could be used to express his sense of the mysterious, his longing for visions, and his private, inner emotions. He embraced the earth, and desperately wanted to share this spiritual love, as an ecstatic letter to Mercia Oakley reveals:

> You are going to be one who will stand with out-stretched hands upon a hill – wind-blown sun-kissed one with the great earth, a dreamer who can dream into my dreams, understand, grip and fall deep. At the same time one who

can talk the sublimest nonsense with me and go mad with
the winds you are to be my sister thro the magical compelling
touch of Nature thro' that touch which thrills in our beings,
which we call sympathy...[36]

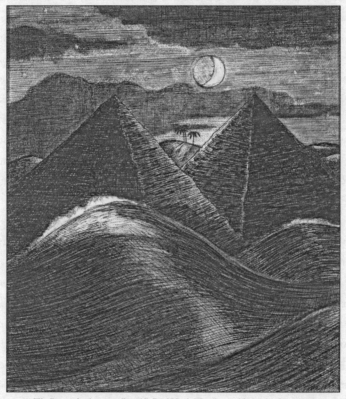

'The Pyramids of my small world': Paul Nash, The Pyramids in the Sea, *1912.*

It was in the natural world, well beyond the fug of the Slade's Life
Room, that he now found inspiration. And trees, with their sensuous but
mysterious personalities, became symbolic substitutes for the human,
female form. Nash had long found consolation and rapture in parks
and gardens and woodland, but now he discovered that he could draw a

springtime oak as he 'felt' it, the 'red swollen buds' on the branches, the round trunk in the sunlight 'as white as paper. I did not find it difficult to draw this tree, as I had found the models at the Slade difficult to draw. An instinctive knowledge seemed to serve me as I drew, enabling my hand to convey my understanding. I could make these branches grow as I could never make the legs and arms of the models move and live.'[37]

Thus by the summer of 1912 Nash could tell Gordon Bottomley that he was trying to paint trees 'as tho they were human beings... because I sincerely love & worship trees & know they *are* people & wonderfully beautiful people'.[38] It was an important breakthrough. 'The last link with Rossetti was broken',[39] and to Bottomley's regret he shed the Pre-Raphaelite figures that had up to then inhabited his drawings. He realised he could follow his own formula, that – as the Post-Impressionists had shown him – in art there are no rules, that in a picture shadows and reflections can go any way you want them to.

'Going in for Nature' meant further experience with what Nash called his 'places'. The most important of those he discovered at this time was Wittenham Clumps, a pair of rounded hills that rise above the flood plains of the Thames valley near Dorchester in Oxfordshire. Prehistoric earthworks top one of the hills, adding to the timeless sense of remote history. In September 1911 he wrote lovingly of these 'Grey hollowed hills crowned by old old trees, Pan-nish places down by the river wonderful to think on, full of strange enchantment... a beautiful legendary country haunted by old gods long forgotten.'[40] To Nash, who had travelled abroad only once (to northern France), they were 'the Pyramids of my small world'.[41] He was soon pinning down subjects, and producing drawings and watercolours of subtle intensity and mystery.

When in May 1912 Nash showed Sir William Blake Richmond the results of these adventures in nature, he was thrilled: "'I knew it," he exclaimed in a rousing bellow and, striking his thigh with a sharp report, "I thought I was right, but I feared it might be some phantasmagorrwia of the brrwain!"'

Nash recalled that 'Whatever "it" was, and I was by no means clear about that, I could not help feeling greatly elated by "Billy's" enthusiasms, and determined to take advantage of this warm expression, if I were given an opportunity.' He added that he heard the old man muttering, 'not a bit like those damned Post-Impressionists'.[42] As Nash wrote to Mercia Oakley: 'Richmond is really roused & thinks I have a mission or something I should hug you if you were here!!! But really Sister aint it awfully good it may mean a very real success if I only do some good things in these coming months.'[43]

Nash's chance came in the autumn, when Sir William arranged a meeting with Arthur Clifton, the shrewd and gifted manager of the Carfax Gallery, near Piccadilly. As one of the most exclusive art venues in London it usually exhibited only Old Masters, the latest work from Paris, or the great contemporary English names such as John and Steer. Though a seemingly severe and melancholy man, Clifton had a reputation for his generous treatment of promising artists, and Nash was both young and hopeful. Rolling out some twenty recent drawings and watercolours, he told Clifton, '"Sir William thinks these are something new." I hardly expected a reply, but Clifton seemed to have become interested in a comatose way, and, as in his sleep, murmured, "Yes, they are something new."'

Clifton agreed to let Nash exhibit his work on one of the back walls of the gallery, and Paul did all he could to make the show a success. It went well, with Paul prominent at the private view in silk top hat, cane, black jacket and white spats. (He never fully succumbed to the Bohemian artist look popularised by Augustus John, though he admitted that by 1913 it would have been hard not to mistake him for an 'artist of some sort'.) Towards the end of the show William Rothenstein appeared and purchased a drawing, to Nash's great gratitude and excitement. A review in *The Times* was respectable, holding out hope for 'this artist's delicate talent'.[44]

Years later Nash recorded with amusement how Clifton informed him on closing day that the show had not brought in much money, but had created 'a good deal of interest for a first exhibition'. Nash expressed his satisfaction, and thanked Clifton for his help:

> He seemed pleased and continued, 'After deducting commission and a few expenses, the Gallery owes you just thirty pounds. How will you take it? Shall I write you a cheque?' 'No,' I said, 'I should like it in gold, if that is possible.' Clifton regarded me over his glasses with widening eyes but a slowly increasing smile. 'Jack', he called out, 'bring up thirty sovereigns.' We parted pleasantly and I carried away my gold in a thick cartridge paper envelope. I was due at a studio tea Carrington was giving in Bloomsbury to a few friends. The check table-cloth was spread on the floor and the check cups and mugs set out when I arrived. Carrington's gold head shone in the candlelight as she sat cross-legged on the floor. I poured out my sovereigns among the teacups.[45]

Chapter 9

'The Din of Happiness'

A few days after his Carfax show closed, Paul Nash ran into two old Slade colleagues. One enquired how the exhibition had gone. Nash, who was 'still rather full of it' after his success, responded enthusiastically. The man asked how many works he had sold.

'Six or seven,' Nash replied.

Without warning, his former colleague's manner changed: 'His white face became contorted with rage. "My Christ!" he broke out. "Look at this bloody tyro. Last year he was at the Slade, now he gets a one-man show and sells his pictures, isn't that bloody nice?" He seemed to suck over his words and spit them out. I looked at his white face. It was darting at me with protruding eyes... It was the first time I had met real hostility in a fellow artist.'[1]

It would not be the last time. The five young Slade artists were accustoming themselves to many new experiences and attitudes. Jealousy of success would be just one of them. Yet there was still no real rivalry between them. Gertler was enjoying the most public recognition – it would later be claimed (improbably) that by the age of nineteen he was earning £1,000 a year painting portraits of London society's elite, and that people would stand up in restaurants to look at him as he came in, the famous young artist in his black sombrero and black curls.[2] But back in Cookham, out of the limelight, Stanley Spencer was quietly experiencing a revolution in his work. He was still attending church every

Sunday and pondering the Resurrection, which was coming to fascinate him. As he wrote half-jokingly in May 1911 to Jacques Raverat, an older friend at the Slade (who had previously studied at Cambridge): 'I rose from the dead last night, it happened like this. I was walking about in the churchyard when I suddenly flopped down among the grave mounds. I wedged myself tightly between these mounds – feet to the East & died. I rose from the dead soon afterwards because of the wet grass. But I did it in a very stately manner.'[3]

This interest in the Resurrection partly reflects the time he was spending with his brother Sydney, who was busy studying for Oxford University's entrance exams. Sydney's ambition was a career in the Church, and together the brothers enjoyed long discussions about art and literature. And Stanley was encouraged to widen his reading by Jacques Raverat's fiancée, Gwen Darwin. She had already drawn his attention to Giotto, and now lent him a volume of John Donne's early seventeenth-century sermons. His imagination was captured by the line, 'As my soul shall not go towards heaven, but go by heaven to heaven, to the heaven of heavens, so the true joy in a good soul in this world is the very joy of heaven.'[4]

Donne seemed to suggest that moments of joy in this life are moments of Heaven, glimpses into the greater glory of God. The words inspired an oil painting, completed in the spring of 1911: *John Donne Arriving in Heaven*.

In Spencer's little picture, Donne turns to see four figures in flowing gowns facing in all directions, praying. As Stanley explained to Gilbert, he had been 'brought up with the notion that heaven was, if not all enveloping, at least straight ahead'. In this picture, he told his brother, 'he had the idea that heaven was to one side: walking along the road he turned his head and looked in to Heaven'[5] – its location in the painting actually being part of Cookham's Widbrook Common. The four figures were facing in all directions because, Stanley explained, 'everywhere is Heaven so to speak'.[6]

Spencer used a simple layout for his naïvely-styled painting. A sparse palette is predominated by the olive green grass and the five flat, ivory-coloured figures, and it represents a break from his earlier influences. Spencer was pleased with his painting, and in May 1911 took it to show Tonks. He, however, was more sceptical, telling Spencer that he liked it less than the preliminary drawing: 'it has no colour,' he claimed, '& is influenced by a certain party at the Grafton Gallery a little while ago'. Stanley was annoyed by this (not inaccurate) reference to Fry's Post-Impressionist exhibition: he claimed not to be influenced by modern art at all, and told Sydney that Tonks was a 'damn liar!'[7] He was pleased, nevertheless, that the Professor had asked to buy the next thing he did.

Spencer usually worked at his paintings on the dining-room table at Fernlea, and was happy to paint with the rest of the family milling around him: Par reading out loud from a book or the newspaper, or a student or brother practising at the piano – or Dorothy Wooster coming in to watch him work. Nor did he seem to be disturbed by his mother sending him out on errands. If he was ever in the way, he simply picked up his painting and moved elsewhere in the house; if he wanted privacy he worked alone in his bedroom, a card table beside him with the latest books he was reading on it, or he went on long, solitary walks around Cookham.

In 1911 Tonks suggested that though Spencer was 'full of ideas', he needed to widen his horizons. So he arranged for him to pass some of the summer vacation at the house of a former Slade pupil who lived at Clayhidon, Devon. Spencer spent a month there painting watercolours – but told the Raverats he was 'convinced' he would 'never do any thing unless I am in Cookham... my Paradise'.*[8]

* Spencer was not completely locked to Cookham, and he recognised that if he was to be successful as an artist he could not be entirely provincial. In another letter from the summer of 1911 he told the Raverats, 'I am quite ambitious, more ambitious than I have ever been before. My life would be an enjoyable one if I spent about 5 months in London a year and the rest in a room in Cookham... I like... my ideas in Cookham. But I must live in London because I want models and must keep in touch with London.'[11]

Seeing the labourers gathering cider apples inspired a drawing for the Slade Sketch Club, however. This evolved into a painting that would win him a £25 Slade composition prize: *The Apple Gatherers* was started at home over Christmas and New Year 1911–12, but it is one of the few paintings from this period *not* set in Cookham, nor directly biblical in its subject matter. Nevertheless, to make it 'work' for him, Spencer still had to link it to somewhere in Cookham. On Odney Common he found a place 'where looking towards a grassy bank towards Mill Lane I had the feeling for that picture.' The fact that there was not actually an orchard there didn't bother him; it was the *feeling* that it created inside him that mattered. So Odney Common, he explained, 'was not in my picture at all; it was the place I thought about because it seemed to bring the thought of this picture in mind. It helped me to the frame of mind to produce this idea.'[9]

Whilst painting *The Apple Gatherers* the Christmas commotion at Fernlea became too much even for him. With eight siblings – some with spouses – returning home for the holiday, he moved into the Ship Inn, which was then standing empty. He later described the painting he completed there as his 'first ambitious work'. In *The Apple Gatherers* he hoped to express in it everything he felt his life was then about: 'I felt a need for my religious experience expressed in earlier paintings to include *all* that was a happy experience for me. One can't, I know, make endearing remarks to a canvas before you begin to paint on it, but I felt I could kiss the canvas all over just as I began to paint my apple picture on it.'[10] Working on it was a joyous experience, a glorious celebration of life: 'I felt moved to some utterance, a sense of almost miraculous power, and arising from the joy of my own circumstances and surroundings. Nothing particularised but all held and living in glory. The sons of God shouted for joy, the din of happiness all around me everywhere.'[12]

In *The Apple Gatherers* Stanley sought to combine the spiritual and loving connections between men and women, and between people and nature.

Though not absorbed in any of the romantic and sexual travails disturbing his Slade friends, he was still intrigued by the *idea* of sex, if not the physical act itself, and by the possibility of parenthood. Up until 1919 Spencer's experiments with sex were quite innocuous – when Gwen Darwin and Jacques Raverat married in June 1911, he sent them a letter of congratulation, declaring enviously: 'As soon as you have more babies than you want you might give me one. Must have a wife before you can have a baby! Rotten I call it! I used to be forced to eat my bread & butter before I could have any cookies, same thing!'[13] It was a confession of innocence: Cookham was a prelapsarian Eden, still unpolluted for Spencer by sex.

Though Spencer continued to work on *Apple Gatherers* through the following year, his next major work was for the Slade Summer Composition Prize in 1912. This annual competition required students to undertake a large oil painting during the long vacation. The theme of 'Nativity' had already been set as a Sketch Club subject, and it was this idea that Spencer now developed into a substantial piece that he painted in a neighbour's barn. His inspiration for the outdoor setting for the birth of Christ (which is, of course, Cookham) probably came from Piero della Francesca's *Nativity* in the National Gallery; other influences possibly came from Botticelli, Rossetti and even Gauguin.[14] His *Nativity* won joint share of the £25 first prize, and was kept by University College.

Gilbert Spencer later recalled how his brother 'read a lot for these pictures', and how Cookham made itself felt in his work:

> On his walks about the village he would be peopling it with his thoughts and ideas... For a possible clue to the mood of so many of the pictures of this period, I am reminded of those early walks with Annie in which so much was hidden or only half-glimpsed through fences or partly opened gates... Stanley nursed his ideas and reared them among his books,

on his walks and searchings, until his excitement, which was concealed from us by his outwardly natural manner, knew no bounds. Then his canvases received these ideas as though it was the end and not the beginning of his journey. They seemed to explode from the canvases.[15]

But there was struggle in this process. As Stanley explained to the Raverats: 'How one's mind does alter continually when doing a picture. I have walked about sometimes in exstacies with nothing but "Yes yes that is it" upon my lips & then a few seconds after "Oh no" & I want to go & see Charley with the cows to take my mind off it.'[16]

In spite of his growing confidence, Spencer was in no hurry to exhibit. Unlike Gertler and Nevinson, he was not involved with the Friday Club, and did not yet submit to the NEAC or the Allied Artists' Association. Indeed, in December 1913 he told the Raverats, 'I shall not think about one man shows until I am fifty & then if I have enough money I shall not have one at all, unless a private one for my own pleasure'.[17] Selling any of his work, paintings or drawings, was a terrible wrench: 'I know that if I had money', he would tell an artist friend in 1915, 'I would buy back every picture I ever sold.'[18] His work was, first and foremost, for his personal benefit. Selling or exhibiting took second place.

• • •

After leaving the Slade in the summer of 1912 Spencer returned infrequently to London. He was happy living a 'hermit' existence in Cookham, taking early-morning swims in the Thames, painting and drawing, playing marbles with the village boys. Yet the first public appearance of his work was a dramatic one, far in advance of anything Gertler or Nevinson had yet achieved. Despite his protest against Tonks's critique of *John Donne Arriving in Heaven*, it showed a clear debt to Post-Impressionism (Gauguin in particular). And there were similarities with Gertler's recent work, such as his *Jewish Family*. An interchange of ideas

between the two artists at some level of consciousness can clearly be seen in their paintings from around this time.[19]

John Donne Arriving in Heaven had caught the attention of Duncan Grant, who was helping Fry select paintings for a second exhibition of Post-Impressionism. This was again held at the Grafton Galleries, between October 1912 and January 1913, under the title 'British, French and Russian Artists'. Spencer's little painting and a couple of his drawings were chosen to hang with works by Picasso, Matisse, Cézanne, and Kandinsky, as well as those by British modernists such as Fry, Grant, Wyndham Lewis, and Spencer Gore. Though Fry had claimed the Post-Impressionists as inheritors of an ancient Byzantine tradition, it was still odd company for a man who claimed his direct influences from Giotto.*

But Spencer's painting was picked out for praise by the critic Lewis Hind, who considered it 'entrancing', and also by the young poet Rupert Brooke, who found it 'remarkable' given the artist's age (Spencer was still only twenty-one). Brooke perceived 'a passion of design and form sadly absent' from many of the other works on exhibit.[20] The *Connoisseur* was more critical, however, advising the young artist 'to cast off the artificial conventions of Post-Impressionism' – advice that he would eventually heed.[21]

According to Paul Nash, with Fry's second Post-Impressionist exhibition 'all the cats were out of the bag. The first demonstration had caused quite enough disturbance one might think. But it was nothing to what followed the second opening. It seemed, literally, to bring about a national upheaval.' In Nash's opinion, it was 'Probably... the relentless distortion of the human figure which was responsible for this'.[23]

* Gilbert Spencer believed that Tonks's anger at Fry for including Stanley's painting in the Second Post-Impressionist exhibition contributed to Fry's departure from the Slade. Another more incongruous English artist included in the Exhibition was the sculptor Eric Gill. His statues were rapturously received by Gertler, who told William Rothenstein afterwards that they 'were most *inspiringly* beautiful... I could have wept for joy! When I went out the world seemed full of pleasure & joy & I was happy all that night. I should love to meet him.'[22]

Nevinson's father certainly thought so. He and Richard visited the show at the beginning of January, and Henry wrote in his diary afterwards that 'about 10' of the paintings were 'comprehensible'. The rest 'were insanity to me,' especially those by Wyndham Lewis, 'who paints everything including women as though made of plate armour. But Roger Fry who was there admires him.'[24]

Fry's second exhibition was not as badly received as the first. The intervening two years had seen a number of avant-garde shows in London, highlighting the work of continental modernism, and the art world was suddenly awash with 'isms'. One movement in particular was starting to be noticed, if not widely applauded: the anarchic 'Futurism' espoused by the Italian poet Filippo Marinetti. So too was the Paris-based Cubist movement of Picasso and Braque. The influences open to a young artist were multiplying, and could prove puzzling. As one Slade student reflected in 1911: 'Not every student can bear with equanimity the burden of dozens of semi-digested principles, the bewilderment of theories innumerable, each claiming for itself superiority over all others.'[25] On top of it all, their Professors were encouraging them to continue looking back to the Old Masters, and to retain their dedication to fine draughtsmanship.

But the Futurists, like Fry, had contributed to a clear shift in the English outlook. Marinetti had first come to England in 1910, and as Margaret Nevinson had explained to the readers of *Vote* (the journal of the Woman's Freedom League), the Futurists 'are young men in revolt at the worship of the past. They are determined to destroy it, and erect upon its ashes the Temple of the future. War seems to be the tenet in the gospel of Futurism: war upon the classical in art, literature and music.'[26] In March 1912 Marinetti and his colleagues returned to London – the vibrant modern metropolis they considered '*the* Futurist city par excellence' (even if they found its inhabitants stultifying).[27] They delivered more lectures on Futurism's outlandish ideals. Marinetti was a brilliant performer:

the art collector and patron Edward Marsh described him as 'beyond doubt an extraordinary man, full of force and fire, with a surprising gift of turgid lucidity, a full and roaring and foaming flood of indubitable half-truths'.[28]

Marinetti's Futurist manifesto was all about modernity, sweeping away the past and destroying museums in order to eulogise the present in the anarchic form of machines, fast-moving electric railways, motorcars and aeroplanes, and a glorification of war. In March 1912 the Futurists held an exhibition at London's Sackville Gallery. Fry was not impressed. What he considered the most 'positive elements' in the Futurist creed – 'their love of speed and mechanism' – had 'failed to produce that lyrical intensity of mood which might alone enable the spectator to share their feelings.'[29] Marinetti rushed around London and the Home Counties in his motorcar, challenging a surprised English journalist to a duel and joining the Women's Movement on demonstrations. As his colleague Boccioni wrote home to Italy, 'I witnessed all the riots of the suffragettes, encouraging and cheering them on when I saw them being arrested'. Boccioni participated in the fighting not out of support for the women's cause – the Futurists were proudly misogynist – but simply out of the love of a good brawl. 'I fought with fists and elbows', he declared.[30]

Whilst both praising and damning the English in public, Marinetti described his surroundings to a friend in Italy: 'London, beautiful, monstrous, elegant, well-fed, well-dressed, but with brains as heavy as steaks. Inside the houses are magnificent: cleanliness, honesty, calm, order, but fundamentally these people are idiots, or semi-idiots.' The English seemed obsessed with manners and neatness: 'What does it matter if some day under the ruins of London raincoats will be excavated intact, and account books without ink spots?'

As much as Marinetti loved London, he declared in a lecture, England was 'a nation of sycophants and snobs, enslaved by old worm-eaten traditions, social conventions and romanticism.' English art, he told his

English audience, meant nothing to him: 'The fact is that your painters live on a nostalgic feeling, longing for a past that is beyond recall, imagining they live in the pastoral age'. The National Gallery's collection of Turners and Pre-Raphaelites should be dragged out into Trafalgar Square and burnt.[31]

When Marinetti tired of London, his next target was New York. The White Star Line's massive new ocean-going liner was shortly to leave Southampton on its maiden voyage, and Marinetti tried booking tickets. But he couldn't get the berths he wanted, the departure was delayed, and his Italian friends did not want to go to America. The *Titanic* sailed without the Futurists. Going down in one of the most tragic expressions of mechanical hubris of the twentieth century might have delighted Marinetti – indeed, a great discussion raged in Paris after the disaster, with people asking, 'Was the *Titanic* a work of art?'[32]

So the Futurists lived on. But for all their outrageous performances they made only one true convert in England. It was Richard Nevinson. His conversion took some time, but when it came, the results would be compelling.

• • •

On leaving the Slade in the summer of 1912 Nevinson had headed for Paris, and then Bradford. But on his return to London the troubled relationship with Gertler and Carrington was still unresolved. He told Carrington that he had been 'practically compelled to make a choice between losing one of you' and that 'naturally' he had wanted to hold on to his friendship with Gertler.[33] 'Gertler must become my friend again,' he told her in September, 'I can't do without him even if he can do without me.'[34] But Gertler remained deeply resentful of Nevinson.

So Nevinson had to get away again. In October he headed back to Paris, but was unhappy there, too. His loneliness resurfaced and he failed to make new friends. This was not wholly Nevinson's fault. Allinson studied in Paris for a while, and experienced similar unhappiness during

his 'obscure existence' there.[35] Augustus John thought the 'atmosphere of Paris, usually so favourable to the artist, ends by defeating him... The people pass in endless procession, animated and purposeful, leaving him to revolve like a foreign body in a back eddy of the stream of life and getting nowhere. The boredom of this is excruciating.'[36]

Nevinson was certainly disappointed. As he complained to Carrington: 'The artists here are swine either Bohemians who slack about all day sitting in the Luxembourg gardens talking to sluts... Americans who are worse... or doodaas from the Slade.' He felt each artist was 'endeavouring to be more incompetent than [his neighbour] in treatment & more eccentric in outlook'. The nightlife was not up to London's standard, either, and French men treated their women appallingly: it was almost impossible for a respectable French woman to go out on her own.[37]

Though England was more conservative in the arts, and the Suffragettes had to fight hard for women's rights, it was advancing socially with greater speed than the rest of Europe. Women could behave independently in England in a manner they never could in France. Nevinson met a young woman who was studying at the Sorbonne and trying 'to live a life *à l'Anglaise*', in the manner of Carrington. But 'the treatment she experienced and the insults which were heaped on her would simply be disbelieved in England. She had ventured down Boulevard St Michel alone and on foot, and as a result of what was said and done she cried the whole way.'[38] Carrington and other Bohemian women might be stared at in the streets of London, and Suffragettes might be attacked, but as individuals they were not abused to this extent. Nevinson invited Carrington to come and visit him in Paris, giving her directions to his lodgings. It never happened. England might be more liberal, but her mother would never have approved of such a trip – and neither would Gertler.

In October Nevinson told Carrington, 'My clearing away to this godforsaken hole has been quite useless.' Even at this distance the drama

with Carrington and Gertler continued. He was concerned for the well-being of his former companion and told her, 'if you intend to be "just friends" with Gertler you may as well know you are his worst enemy... I do hope you will let Gertler either win or lose you & finish this dangling about as he can't stand it.'[39]

Nevinson never really warmed to Paris, though in his autobiography he pictured his times there as ones of great friendships and wonderful adventures. For a short while he studied at the Académie Julian, and his mother visited him, sharing what she called 'his Bohemian lodgings and Bohemian life'. They lived in rooms off the Boulevard Raspail, dining at artists' restaurants and sitting at cafés in Montparnasse where they met 'all the international genius and youthful promise of the century – Paul Fort (the poet), Picasso, Boccioni, Modigliani, Guillaume Apollinaire, Marquet, Marinetti, Severini and many others.'[40]

As most of the avant-garde artists were desperately poor, they lived as cheaply as they could, shoulder to shoulder with the Parisian underclass. With his broad, Slavic face and foreign accent Nevinson was mistaken for a Russian at the Académie Julian, where his name was taken down as 'Nevinski'. This was a fortuitous error: 'A Russian was accorded deference, while a mere English artist was not worth consideration.'[41]

'Nevinski' met many of the refugees and exiles from the abortive revolutions in Tsarist Russia: 'terrorists, anarchists, men hiding from the police of the world... They were endless talkers about Life and the social system; practical, logical, horrifying. The women were either of the most degraded and vicious type, or mistresses of journalists, doctors, and deputies, some of them brilliant, all of them interesting.' Amongst them was Lenin, 'a smallish, yellowish man with a good head', regarded as a 'cranky extremist by most', including his fellow Russians. Nevinson heard Lenin's speeches, and occasionally they discussed politics, 'but he was a one-minded man for all his obvious intelligence.'[42]

At the Louvre Nevinson copied the paintings; Picasso and Matisse were doing the same. For a while he shared a studio with Modigliani: 'He loved women and women loved him.' The artists of the Fauvist school interested Nevinson, and he noted the experimentation of Cubism and the 'colour harmonies' of Kandinsky. To be in Paris was to be at the epicentre of revolutionary artistic ideas. His own thoughts started to move towards abstraction: 'It was a period of intense study, and I must have examined literally hundreds and hundreds of pictures', he later recalled. 'I was like a man in any other walk in life who is struck suddenly by a truth which he has always known to be at the back of his mind, and I was altering my standards accordingly.'[43]

Returning to London, at the beginning of 1913 Nevinson tried to meet Carrington, who was now in her third year at the Slade and enjoying the benefits of her scholarship. Though he was still in touch with Wadsworth, Nevinson felt isolated and depressed.

'Does Gertler own you?' he demanded. 'If so *it is final*. If not I *am* damned why I should not see you. I don't care if Gertler can't stand it, I can't stand this frightful lonely life that *he* has compelled me to live. Why should I not have friends? He is not God Almighty.' He was on the verge of violence; if he did not kill himself, he threatened, then he would kill Gertler.[44]

A few days later he caused a scene in front of Gertler and Carrington. Afterwards he offered 'an absolute apology' for his 'vile behaviour', and felt he would never be able to look Gertler in the face again. He blamed his poor health: 'I have lost all control of myself & my nervous state makes me think all sorts [of] delusions against people & imagine everyone my bitter enemy... no wonder everyone else has dropped me I now see what a little spiteful beast I am.'[45] But their relationship did not improve. On 26 March he wrote again, apologising for a 'loathsome letter' he had written. Yet he was still lost in the pit of depression:

> I am doing no work. I bought a motor bike in the hope
> of preventing myself everlastingly brooding: failure! Like
> everything else I do. God it was a cursed day when I met
> you & Ruth. I admit the only happy times of my life were
> spent with you, but how you have blighted my life since...
> I have spent hours trying to pluck up the necessary half
> second to kill myself but I only sweat & tremble...

He felt like 'a man useless to himself & everyone else.'[46] But he could not follow Lightfoot's example and make the final leap into oblivion.

Nevinson's physical health was failing: he blamed his breakdown on pericarditis and rheumatic fever. By the summer of 1913 he was 'crippled completely'. His parents sent him to a health spa in Buxton, where he was treated by a specialist and slowly recovered. There he met a fashionable young woman who attracted his interest: Kathleen Knowlman, the 'most lovely blonde', was in Buxton tending to her father, who owned a department store in London's Holloway Road. At some point over the next few months Nevinson introduced his new girlfriend to his old Slade friends – in October Mark wrote to Carrington that he had 'skipped' all the way home, 'like Nevinson's Girl.'[47] It promised to be a new beginning.

Chapter 10

'A Most Wonderful Country!'

Nevinson would chart his return from Buxton as the beginning of his life 'as a rebel artist, discussed everywhere, laughed at and reviled by all contemporary critics'.[1] The disgruntled public schoolboy was now in full revolt against the English institutions he so professed to hate. What he wanted most of all was to be *noticed* – by his family ('If my mother does happen to be in for a meal', he complained to Carrington, 'she is engrossed in other things that she hardly hears & certainly never takes in a word I say'[2]), or by society at large. Obsessed by what he considered the world's indifference, he would go out and pound at the doors of success – until he was heard.

He rode his motorbike around London with a Futurist's admiration of speed and machinery: 'Never shall I forget the look of icy disdain when I turned up on my mount, most un-aesthetic, to a general meeting of the New English.'[3] He was exhibiting at the Chenil and Doré Galleries, and had made friends with Severini and the aspiring *enfant terrible* of English art, Percy Wyndham Lewis.

Lewis had been at the Slade in the late 1890s, during its first 'crisis of brilliance', and was now a member of the Camden Town Group. Inspired by the artistic movements across the Channel, Lewis was leading a rebellion against Roger Fry's dominance of the British scene. Early in 1913 the Bloomsbury critic had established the Omega Workshops at 33 Fitzroy Square as a place where modern-minded artists with a dislike

of mass-produced goods could design and make decorated wares for the home – everything from furniture and china to fabrics and wall decorations. Lewis was involved during its first few months, but by the autumn had fallen out with the domineering and conniving Fry: 'a shark in aesthetic waters', he called him.[4] In response, Lewis founded the Rebel Art Centre, with its headquarters at 38 Great Ormond Street. Nevinson, Wadsworth, William Roberts, Bomberg, Epstein and the American poet Ezra Pound all quickly joined: they became known simply as 'the Rebels'.[*]

In Kathleen Knowlman, Nevinson had discovered a replacement for Carrington. Now, in Wyndham Lewis, he found a surrogate for Gertler: Lewis, he later wrote, was 'the most brilliant theorist I had ever met',[5] and the two men revelled in their shared enthusiasm for Futurism.

In October 1913 Nevinson exhibited three drawings and three paintings at the Doré Galleries' *Post-Impressionist and Futurist Exhibition*, organised by *Sunday Times* critic Frank Rutter. Rutter was one of the few who supported Nevinson's new artistic direction, and he used one of his paintings as the cover image for the exhibition's invitation. Rutter's show offered an alternative vision of the English avant-garde to the one being promoted by Fry.[†] English contributors included Sickert, Lewis and Wadsworth, as well as Nevinson, whilst the continental contingent numbered Cézanne, Van Gogh, Matisse, Severini and Picasso.

The show received mixed reviews – not least from Bloomsbury. Clive Bell declared that Nevinson was 'probably cleverer' than most of the other British exhibitors – 'clever enough to pick up someone else's style with

[*] The RAC was largely bankrolled by Lewis's friend, Kate Lechmere. Despite this, at its first meeting Nevinson declared, 'Let's not have any of those damned women' – a sentiment with which Lewis concurred, and (its patron aside) it remained a men-only club. The RAC folded when Lechmere withdrew her funding four months later.[6]

[†] Finding a catch-all definition for the new movements in modern art was proving difficult, and some critics resisted Fry's dominance. In its review of Rutter's show, *The Times* jokingly defined Post-Impressionism as 'any modern picture... which looks as it if will make a Royal Academician angry.'[7]

fatal ease', but 'not clever enough to diagnose the malady and discover a cure'.[8] Henry Nevinson recorded in his diary that whilst his son's works 'were well liked', those by Wadsworth and Lewis 'were horrible: really hideous and I was sorry, for I like the two men.'[9]

Lewis would not have cared – Richard wrote that 'being misunderstood' was one of his new friend's pleasures, for 'to be understood would mean, in his estimation, to be obvious.'[10] The same could be said of Nevinson. He would not be distracted from his new course. In November 1913 he tracked down Marinetti to Brussels and invited him back to London. The Futurists' leader agreed, and a dinner was held in his honour.

Shortly afterwards the Rebels received what was possibly their only commission. The wealthy society hostess Lady Cunard paid Lewis, Wadsworth, Nevinson and a colleague £50 to design small gifts and decorations for a dinner held in honour of the Irish writer George Moore. This commission – together with the early success of the Omega Workshop – reflected the gathering interest in the interior design possibilities of modernism. Indicative of the new mood were the mural panels Nevinson, Wadsworth, Gertler and Allinson painted at the Petit Savoyard café in March 1912, and the decorations Spencer Gore, Charles Ginner, Jacob Epstein and Eric Gill provided for Frida Strindberg's 'Cave of the Golden Calf'.[11*] Strindberg, the Viennese ex-wife of the famous Swedish playwright, had established what was London's first nightclub in a basement room off Regent Street. Wyndham Lewis's huge modernist canvas *Kermesse* was situated prominently in the staircase, and the writer Osbert Sitwell described the Cave as 'hideously but relevantly frescoed'. By the small hours, he recalled, it was like 'a super-heated Vorticist garden of gesticulating figures, dancing and talking, while the rhythm of the primitive forms of ragtime throbbed through the wide room.'[12]

* The central motif of the club, its 'Golden Calf', was Gill's creation, and it was this gilded statue that was amongst his works that Gertler saw and so admired at the Second Post-Impressionist Exhibition.

In April 1914 Augustus John helped launch the Crab-Tree Club in Soho's Greek Street. Whilst the Golden Calf, according to Adrian Allinson, 'catered for the fat purses of well established artists and wealthy hangers on', the Crab-Tree became 'the haunt of the poorer ones', their venue of choice after the Café Royal closed for the night.[13] The club's clientele included artists, poets, musicians, actors, models and boxers.

Paul Nash recorded Augustus appearing at the opening party 'most painfully drunk but alone in his glory', as everyone else was 'very sober and bored'. By the time Nash left, the only women to have appeared were 'three old girls verging on 40 and one very fat female on the right side of 30'.[14] But Gertler told Nash that 'things livened up about 2 o'clock and at 4 John expressed a desire to be married then & there to all the women present'.[15] London, clearly, was changing.

• • •

When not mingling with London's avant-garde, Paul Nash was continuing his quietly successful development as a landscapist. In November 1913 he held a triumphant joint exhibition of drawings and watercolours with his brother John at the Dorien Leigh Gallery in South Kensington. The twenty-year-old John (or 'Jack'), a trainee journalist, was also interested in becoming a professional artist, and Paul had encouraged him – though significantly he advised him against art school. Visitors to the brothers' exhibition included the collectors Charles Rutherston (brother of William Rothenstein) and Michael Sadler; both men bought pictures.

Roger Fry also appeared, and was impressed. Nash talked with him, telling Gordon Bottomley afterwards: 'he was simply delightful. Of course he's the most persuasive and charming person you could ever meet. Dangerous to work with or for but frightfully shrewd and brilliant brain and pleasant as a green meadow. He was obviously *very* pleased with our work & stayed some time talking & inspecting'.[16] Paul heard later that Fry had also seen his drawings at the NEAC's recent exhibition 'and liked them more than anything else there.'[17] It was eminent praise – though

Paul wondered what a fan of Cézanne found to admire in his drawings of trees, and was cautious of Fry's potentially over-pervading influence.

In Nash's opinion, despite Fry's two Post-Impressionist exhibitions by the spring of 1913 'the doctrine and practice' of the New English Art Club continued to represent 'all that was most typical of modern art in England', and there were only three larger than life-size 'personalities' to be found in the London art world: Augustus John, Jacob Epstein and the illustrator and theatre designer Gordon Craig. According to Nash, 'All were constantly in the public mind where all were associated with something romantic, daring, scandalous and brilliant.' Nash felt that Craig possessed imagination 'in a degree far beyond John or Epstein',[18] and it was Craig who would be the greater influence. The sense that Nash's paintings are sometimes more set designs than true evocations of Nature is surely partly due to this early debt to theatrical design.

Yet Paul and his brother continued to be seen as moderns. Soon after their exhibition at the Dorien Leigh Gallery, Paul and Jack were surprised when Spencer Gore asked to show twelve of their paintings at his *Camden Town Group and Others* exhibition at the Brighton Public Art Galleries. Nevinson, Wadsworth, Bomberg and Lewis were among the other Slade artists all exhibiting in a separate 'Cubist Room'. 'This is amusing to us', Paul told William Rothenstein: 'so we're Post Impressionists and Cubists are we?'[19] Their pleased bemusement was understandable: John Nash had been to neither of Fry's Post-Impressionist exhibitions, and there was little yet in their work that was radically modern. But they were enjoying themselves, and were starting to sell.

Another fan was Carrington. During his year at the Slade Paul had introduced her to Jack, and they too had become friends, exchanging regular letters. There had even been talk of Carrington participating in the brothers' Dorien Leigh show. Though she eventually declined, she had written to John asking him 'politely for a landscape of fields and figures from you to put on my walls', and asked him to 'try to coerce Paul

too'.[20] Like most of the young men Carrington met, John fell in love with her – though his courtship would be neither any happier nor any more successful than Nevinson's or Gertler's.

Carrington's career, like the Nash brothers', was progressing. In the winter term of 1912 she received her first artistic commission – it was the start of her third year at the Slade, and her first as a scholarship student. A former pupil, Mary Sargent-Florence, came to lecture on fresco and tempera. She had studied in Paris, but now lived in Marlow, near Cookham (and the following year she would give lessons in fresco to Stanley Spencer). Carrington and her friend Constance (or 'Cooee') Lane became interested in the technique that had produced Giotto's masterpieces in Padua and Florence, and Michelangelo's Sistine Chapel ceiling. In the summer of 1913 they were invited by Lord Brownlow to paint a fresco cycle on the walls of his library at Brownlow Hall, in the rolling Chiltern countryside.

For the duration of the project the two women stayed at Lane's mother's cottage in neighbouring Nettleden. As Carrington wrote to John Nash shortly after their arrival:

> oh but it is a most wonderful country! You and Paul should just see the trees, and green fields like lettuces, you could almost eat them they are so luscious... it is altogether a very happy place. We go up each day to Ashridge, (an ancestoral seat, with a most amazing early Italian garden & trees) to do our fresco... I spend the mornings in fields drawing big heavy elms for it and small village boys come, & pose in the garden in the evening... About six workmen are running about erecting scaffolding and carrying buckets. Lane and me feel like great masters controlling this band of men and having the big wall to cover with our works of art. Frescoe painting is awfully hard all this afternoon I have been struggling to

learn. But the best time is after it is all over at seven o'clock in the evening, when I can trudge home wearily across the fields, with the black sheep and the woods on the slope, and the little deer and big deer hopping and running.[21]

Carrington and Lane brought this inspiring landscape into their design. One scene has men and women working in a flower-lined cottage garden surrounded by fields and woods. The central figure is a woman holding a basket in one hand, the other on her hip, and a small girl clinging to her dress. It is a strong, statuesque and formal pose, reflecting the best of her Slade teaching. She invited John and Paul to come and see the work. Only John, ardently in love, made it, cycling twenty miles through the September lanes. They shared a profound attachment to the English landscape, and John helped to turn Carrington away from the Post-Impressionist goings-on around them: 'how can nature be dull?' he asked her in 1914. 'What is Cubism or anything else to nature?'[22] Indeed, the two students became quite influential upon each other, such that in later years some of Carrington's watercolours would be misattributed to John Nash.

Her summer in the Chilterns – broken by a trip to Scotland with Dorothy Brett and a holiday in Hove with her family – provided Carrington with a welcome escape from the boredom of Bedford. And the frescos were such a success that further commissions were suggested. The following year the idea was proposed of her working with the Nash brothers on a fresco series for a church near Uxbridge. The vicar was keen, as were John and Paul, though they had to convince Carrington that her agnosticism was not an impediment, and they disagreed over subjects. She wanted to paint pigs: John suggested sheep instead, or an entombment: 'Do try... you might very well bring in your little lambs in a baptism.'[23]

In spite of a long exchange of letters between John Nash and Carrington, as well as some time spent taking measurements of the church

and making drawings, the project was ultimately abandoned. Part of the problem was Carrington's anxiety that her designs would not be good enough for such a public space. She increasingly suffered doubts, and this made her reluctant to exhibit work publicly. Indeed, by the end of 1913 she was contemplating an alternative career. Gertler told her, 'You must not talk of becoming a teacher with spectacles or of going back to your people. You are quite capable enough a person to become independent.' Yet he vetoed her thoughts of applying for the Prix de Rome, which would mean three years studying in Italy. 'What an imprisonment it would be', he told her, 'three whole years!!! No! one must always live in cities that have a future, not merely a past – one mustn't be out of things.'[24] His real fear though was not that she would miss the modern influence of London, but that she would be away from *him*.

Carrington continued to string Gertler along. As Nevinson had recognised, in spite of her youth and innocence, she was both secretive and manipulative. On 2 January 1914 Gertler told her: 'There can be no real friendship between us, as long as you allow that Barrier – Sex – to stand between us. If you care so much for my friendship, why not sacrifice, for a few moments, your distaste for Physical contact & satisfy me? *Then* we could be friends. *Then* I could love no one more than my friend – *then* I could share all with you.' He continued: 'I am doing work now, which is real work. Far better than anything I have done before & I would like you to share it with, but as long as that obsession for you sexually is there, I cannot. Remember I tried to fight it for three years, without success. Now it cannot go on any longer'. He knew what Carrington's defence would be, and added in a postscript, 'I am not ashamed of my sexual passion for you. Passion of that sort, in the case of love, is *not* lustful, but Beautiful!!'[25]

Despite Carrington's unwillingness to sleep with Gertler, not all middle-class young women were so sexually reticent. The artist Nina Hamnett, for example, was twenty-two when in 1912 she decided it was

time 'to consider the problem of sex.' 'I was almost completely ignorant', she explained in her memoirs, and 'decided that the next man I met and whom I liked I would hand myself over to.' The 'next man' was a friend of the satanist Aleister Crowley. According to Hamnett, he was 'a most beautiful creature' with 'long green eyes and hands like the Angel in the National Gallery by Filippino Lippi.' Late one night she went to his rooms near Fitzroy Square: 'I arrived and he said, "Will you take your clothes off?" So I did and the deed was done. I did not think very much of it, but the next morning I had a sense of spiritual freedom and that something important had been accomplished.'[26]

Carrington, however, would not be persuaded by Gertler's rhetoric. She was not physically attracted to him – was not sure, in fact, that she was physically attracted to *any* man. She refused to submit to his request.

• • •

Paul Nash, who was unusually shy with women, was also having a difficult time with love. Since 1909 he had lost his heart on at least two occasions: to his cousin Nell Bethell, and to Sybil Fountain. His friendship with 'the gypsy-like' Mercia Oakley, which lasted from about 1909 to 1913, was platonic – tellingly, he often addressed her affectionately as 'Sister' and 'Mother' – and though he later described their relationship as having grown into 'a love affair', it was never physical, and he had felt stronger attraction for Sybil.[27] In March 1912, however, he told Mercia that he had 'broken' the three-year 'dream' that had been his passion for Sybil, and had 'flung the pieces to the wind'. His love for her, he explained, 'at times was all absorbing', but 'at last after struggles innumerable it grew dead & the ice covered it... how I long for the real fire which burns steadily thro a life and dreams'.[28]

The breaking of his relationship with Sybil was followed by a brief affair with a young lady named Veré Suetoni, whom he met through his Slade friend Ivan Wilkinson Brooks (known affectionately as Wilkie). She was 'a Spaniard & a gypsy', Nash told Mercia. Clearly he was drawn to

dark-complexioned, dark-eyed and free-spirited girls, a reflection, perhaps, of his lost mother: 'she knows almost everyone especially artists; she is like a child & an animal wild, simple, unconventional quite unconcerned at anything not caring a damn for anyone, full of moods & whims beautiful artless passionate & simply charming in whatever she does.'[29] Veré was, he claimed, the first woman to say she loved him, and with her outgoing manner helped dispel some of his 'reserve' – though he was not falling completely for her: 'I know what Veré is she has about ten hearts & none of them ever at home!'[30] The role that a woman might play in an artist's life, and whether or not he might wish to marry at all, remained, he later confessed, 'perplexing'.[31]

Then in February 1913, at the Chelsea studio of his Slade friend Rupert Lee, Nash met the dream-girl he had been seeking. Margaret Odeh – 'Bunty' to her friends – was small and slender with large brown eyes, a full mouth and a mass of grape black hair. She and Nash 'got on well from the first.'[32] Margaret's father, an Anglican chaplain, was of Arabic descent, and she had been born in Jerusalem. Educated at Cheltenham Ladies' College, she had read history at St Hilda's College, Oxford. Having abandoned teaching, she now worked for the Suffragette movement, and had taken part in the 'Black Friday' protest. She also worked for women's social welfare, assisting 'fallen women' escape the moral and financial trap of prostitution by helping them train in 'useful' skills and cottage industries.

Margaret was 'an intelligent, sympathetic listener' with a vivid personality. A friend later wrote how she instilled into 'the ordinary events of every day a mysterious – an almost magical – element'. Life with her was 'infused with a sort of transcendental quality'.[33] Soon Nash found that he had fallen in love. But Lee warned him that Bunty was 'a charming little humbug', with many admirers.[34]

Among the quirks that so drew Nash to Margaret was her claim to be psychic (a gift Nevinson's mother also claimed to possess). An interest in the paranormal was fashionable amongst London's intellectual circles: Crowley

'A superlatively elegant dandy.. with a slight air of the man-about-town':
Portrait of Paul Nash *by Rupert Lee, 1913.*

represented the darker side of the occult movement, but spiritualism and psychic research of the kind practised by W.B. Yeats were popular pursuits. In a room where she felt some strange presence, Margaret would suddenly make outlandish remarks: 'I know something. I feel something very strongly... Time is a continuous stream that curves and crosses and

recrosses itself. To speak of the Past and the Future is only a confusion of thought.' Nash, who found it 'impossible always to take her seriously', regarded this in a rather tongue-in-cheek manner. As a friend explained, when Margaret made 'one of her more astounding statements he would purse his rather full lips and give a high, incredulous exclamation... "Hueh! Bunty is airborne again!"'[35]

But Nash took her involvement with women's suffrage more seriously. Though he had claimed in 1910 that he had once been 'vaguely a Socialist', his politics now leant towards Conservatism.[36] Before he met Margaret he had held no particular opinion on the rights or wrongs of the Women's Movement, but she brought his attention to their struggle: their vociferous protests, their attacks on Post Offices, their plots to kidnap the Prime Minister; the arrests, hunger strikes and force-feedings in prison.

Margaret was private secretary to the organiser of the Tax Resistance League, a Suffrage organisation that helped women who refused to pay their taxes. One activity Margaret organised was the auctions where non-payers were forced to sell off their possessions in lieu of their tax debts. Nash accompanied her to a sale in Tottenham Court Road, and was astounded at what happened. As he later recalled, the women speakers 'stormed and shouted against the hooting crowd,' some of whom threw mud, stones and eggs, whilst 'Government men' stirred up the trouble.

The worst protesters were medical students: 'What you want, sweetheart,' one growled, grinning into Margaret's face, 'is raping'. She struck him across the face with a horsewhip and drew blood. Standing on top of a horse-drawn milk cart, brandishing her whip, Nash likened her to 'a new kind of Boadicea, scattering the enemy hordes.'[37] Like Margaret Nevinson with her axe concealed in a bouquet of flowers, Margaret Odeh was a woman to be reckoned with.

Little more than a month after their first meeting Nash took his new muse to the theatre. As they stood afterwards saying goodnight, he suddenly declared, catching her hand, 'I think I shall marry you some day.'

'Yes, I expect you will,' she replied.

'It was not much to go on,' he later wrote, 'but on an impulse I pulled her into my arms. As we kissed all doubts dissolved and the questions we might have asked ourselves were answered.'[38] Decades later a friend would write, 'One cannot think of Paul without Margaret. He was her life-work, her husband, her lover, and all her children.'[39]

Nash's only sadness was his father's disapproval. It led to rows in the usually happy and open household at Iver Heath. But to Carrington he exclaimed, 'I have fallen somewhat precipitately in love... and I am what the vulgar call engaged.'[40] 'Thank Paul for his wonderful letter', Carrington told his brother: 'I felt, do not tell him, bad pangs of jealousy, that Bunty must have stacks of such letters whilst I have but few!'[41]

Paul was equally excited to report his engagement to Gordon Bottomley: 'She writes, speaks and plays musick & she is going to look after Paul & Paul's going to be all the world he can to her. In fact she is what he has been seeking for & she says he is what she was seeking for too. And there my dear Gordon (forgive the liberty!) you have it, & I am so damn happy I don't know what to do.'

It would have to be a long engagement as they were too poor to marry immediately. But Nash looked forward to a long life together: 'I expect there will be many hard days ahead & big difficulties to surmount but we are both sure & both sound.'[42]

Bottomley replied enthusiastically: 'I was only a year older than you when I became engaged myself. I still walk in the transfigured light of those heavenly days, and I hope you always will too'.[43]

Chapter 11

Eddie Marsh and *Les Jeunes*

Though Nash, Nevinson and Gertler were enjoying some success through their own efforts, Roger Fry felt a personal obligation to assist what he called *les jeunes*, 'the younger and more vigorous' British artists. He told William Rothenstein in 1911 that through his position as adviser to the Grafton Gallery, 'I can give them a chance they never had before of being well seen'.[1]

This was true, and Fry acted upon it, particularly with the establishment of the Omega Workshops, which provided a much-needed regular income for struggling artists. But many of *les jeunes* were suspicious of Fry: he was Nash's 'dangerous to work with' and 'frightfully shrewd', and Wyndham Lewis's 'shark in aesthetic waters'. Even his friend Duncan Grant later observed that Fry had 'applied pictures to his ideas', rather than the other way around.[2]

In fact, the man who emerged as many of *les jeunes*' most valuable patron was not Fry, but the collector Edward Marsh. Like Fry, Marsh at first appeared an unlikely man to emerge as a leading advocate of contemporary British art. Educated at Trinity College, Cambridge, he studied Classics before joining the Colonial Office; in 1905 he became personal secretary to Winston Churchill (who, shortly before Marsh entered the life of the Slade artists, had been appointed First Lord of the Admiralty). To Marsh's fellow civil servants it seemed fitting that this immaculately dressed and monocled gentleman 'should spend his days in

heavily-carpeted rooms, locking and unlocking Cabinet boxes with one of the four keys that dangled from a slim silver chain.'[3]

Marsh was the great-grandson of Spencer Perceval, the only British Prime Minister to be assassinated: a deranged businessman had shot him dead in 1812. The killer was quickly tried and executed, and Parliament voted a handsome pension to Perceval's widow, his twelve children and their descendants. In 1906 Marsh received a share in the remainder of what he called 'the murder money'. He used it to buy paintings.

Specialising in eighteenth- and nineteenth-century English watercolours, by 1911, Marsh had established one of the most important collections in the country. But suddenly, at the end of that year, he took what some of his friends saw as an erratic leap into the contemporary: he purchased *Parrot Tulips*, a distinctly Post-Impressionist painting by Duncan Grant.[*] With this new work hanging on the crowded walls of his apartment at 5 Raymond Buildings, Gray's Inn, Holborn, Marsh turned his attention wholeheartedly to work by living artists, and began courting *les jeunes*. As he later explained, it had seemed 'a sheeplike, soulless conventionalism' simply to buy acknowledged masterpieces from the big Mayfair dealers when it was far more exciting 'to go to the studios and the little galleries, and purchase, wet from the brush, the possible masterpieces of the possible Masters of the future!'[4]

Marsh's keenness for painting was matched only by his passions for poetry and handsome young men. He had already promoted a number of aspiring writers, one of the most promising being the attractive young Cambridge graduate Rupert Brooke, to whom Marsh was particularly close. In December 1912 Marsh published *Georgian Poetry*, his first anthology of contemporary English writers. It included works by Brooke, D.H. Lawrence and Paul Nash's friend, Gordon Bottomley. The most

[*] Painted in 1911 and now at the City Art Gallery, Southampton, this was Grant's sole work shown at the Camden Town Group's exhibition in December 1911, where Marsh saw and purchased it.[5]

notable poem in this well-received collection was Brooke's 'The Old Vicarage, Grantchester', with its now famous concluding couplet:

> Stands the Church clock at ten to three?
> And is there honey still for tea?[6]

In contrast to his careful criticism of poetry and literature, Marsh's response to pictures was intuitive rather than learned. He wrote of 'the Lust of Possession', the 'curious and very pleasant sensation of tingling, or perhaps gooseflesh' he felt in his response to a good painting. The artist Graham Sutherland wrote an entertaining description of Marsh, recalling his 'high, light, slightly lisping, withdrawn, yet infinitely persuasive voice – those extraordinary upturned eyebrows, the quizzical regard and the tensed elegant body.'[7] A homosexual at a time when homosexuality was still a criminal offence, Marsh appeared to Sutherland 'always shy and physically tensed – forearms hugged close to the body and parallel with the ground – delicate hands clenched'. When it came to selecting paintings 'his mind was quickly and clearly made up. The sharply inquisitive nose and eye seemed to lead him by some invisible course to what he wanted.'

'That's the one I want,' he would say, and then disappear.[8]

Nevinson was the first of the young Slade artists to make Marsh's acquaintance. In spring 1913 Marsh and Brooke attended a discussion evening held by the young philosopher and poet T.E. Hulme at his home in Frith Street, Soho. Also present were Ezra Pound, the critic John Middleton Murry – editor of the avant-garde literary magazine *Rhythm* – and three young artists: Wadsworth, Nevinson and the French painter and sculptor Henri Gaudier-Brzeska. As Nevinson wrote of Hulme's regular salons, 'There were journalists, writers, poets, painters, politicians of all sorts, from Conservatives to New Age Socialists, Fabians, Irish yaps, American bums, and Labour leaders'.[9]

A month later, at an exhibition of the Allied Artists' Association at the Albert Hall, Marsh again ran in to Gaudier-Brzeska, who now introduced him to Gertler and Currie. With Brooke heading off on a lengthy tour of North America and the Pacific, Marsh's attentions turned more fully to contemporary art. He invited Gertler (whom he described to Brooke as a 'beautiful little Jew like a Lippo Lippi cherub') and Currie to dinner at Gray's Inn. Currie brought Dolly Henry with him – according to Marsh's description, 'an extremely pretty Irish girl with red hair'. They were all 'tremendous fun', he told Brooke.[10]

Marsh equally impressed Gertler, though he worried that his new friend 'liked *me* more than my art'. As he told Dorothy Brett, 'I do not share his taste in art. He buys everybody's work except my own.'[11] Gertler's uncertainties of the previous year had not been resolved. Still obsessed with Carrington, he wrote to her in June of the 'heavy cloak of depression' that frequently weighed him down and prevented him from painting. 'But *you* make me more happy than *anything*!'[12] At Christmas he would tell her, 'If only you knew how awful and black life would be without your friendship and how much courage you give me to go on with this hard life and what noble ideas and thoughts the sight of you inspires me with!'[13] His love for her was an important motivation, and it helped him with his work.[14]

To add to his troubles that summer of 1913, Gertler was 'very poor' again. He could not afford to pay for models, or to go out in the evenings to the music halls or the restaurants he loved, and was worried about relying on his family again for financial support. Though he had had a successful exhibition at the Chenil Gallery in March, by June he was telling Brett, 'there is no hope of selling anything more, as my work is getting more & more personal, & therefore less & less understood.' It was not the sort of work the 'cultured buyer' looked for: he wanted prettiness, otherwise 'How could his white & scented wife look at it – How could one possibly go on eating asparagus in the same room! My types – they

say, are *Ugly*.'[15] A well-meaning visitor who had seen his new work at the NEAC's summer show had even offered to pay for a visit to an oculist, thinking that there must be something wrong with the artist's eyesight.[16]

Gertler was now revealing the influence of Post-Impressionism, and saw his one artistic hope as lying with Cézanne. 'We have much to thank Cézanne for', he told Brett. 'He was a great, great man.'[17] There was certainly something strikingly modern in his *Family Group*, a portrait of his eldest brother Harry and his wife, painted in 1913 in flat, starkly expressionist colours. The days of the Neo-Primitive were over.

· · ·

At this time of crisis, and despite his initial reluctance to buy his work, Gertler discovered in Marsh an important new patron. On 26 August Marsh wrote excitedly to Rupert Brooke:

> Currie came yesterday. I have conceived a passion for both him and Gertler, they are decidedly two of the most interesting of *les jeunes*, and I can hardly wait till you come back to make their acquaintance. Gertler is by birth an absolute little East End Jew. Directly I can get about I am going to see him in Bishopsgate and be initiated into the Ghetto. He is rather beautiful, and has a funny little shiny black fringe, his mind is deep and simple, and I think he's got the *feu sacré*. He's only 22 – Currie I think a little older, and his pictures proportionately better, he can do what he wants, which Gertler can't quite yet, I think – but he will.[18]

Marsh introduced Gertler to polite society. Once again he was dressing in evening suit, this time to be taken to theatrical opening nights, concerts and the ballet (where he saw Nijinsky perform). But Gertler felt ashamed of his appearance. 'My face looks so dirty in comparison with those well washed gentry', he told Brett. But he did little to help himself: 'I do not

'wash much,' he confessed. 'I think it is a waste of Labour. I only wash when I look dirty.'[19] He did, however, buy a sponge to clean himself up for Carrington's benefit.[20] One consolation was that Gaudier-Brzeska was even dirtier: people actualy refused to sit near the filthy, impoverished Frenchman, who nevertheless charged prices for his sculptures that even Eddie Marsh could not afford.

Whilst Gertler adored his trips with Marsh to hear Wagner, their visits to the theatre sometimes incensed him – in particular a performance of George Bernard Shaw's *The Doctor's Dilemma*, which featured a young artist 'justifying his artistic immorality in Shawese witticisms!' He told Carrington angrily, 'I feel that I should like to excite all the working classes to, one night, break into these theatres and *destroy* all those rich *pleasure seekers!*'[21] Though Carrington actually considered the play to be 'Shaw at his best',[22] Gertler's outburst led her to express regret at belonging to 'the upper middle class'. 'You must not bother yourself,' Gertler consoled, 'you ought to congratulate yourself on being such a wonderful exception'.[23]

Although he moved at the heart of government circles, Marsh was another acceptable exception, even if Gertler felt intimidated by his young Cambridge friends. 'They seem to be clever – very clever', he told Marsh after they had visited the University together. 'They talk well, argue masterly, and yet and yet there is something – something – that makes me dislike them. Some moments I hate them! I stand alone! But if God will help me to put into my work that passion, that inspiration, that profundity of soul that I *know* I possess, I will triumph over those learned Cambridge youths.' He added incredulously, 'One of them argued *down* at me about painting!'[24]

Perhaps they had argued about Cubism and the abstraction of Braque and Picasso, which was now emerging as an important artistic influence upon some of *les jeunes*. It was already showing its influence upon the fractured and increasingly nonfigurative work of Slade

alumni such as Wyndham Lewis, Nevinson, Wadsworth and Bomberg. But Gertler remained firmly wedded to realism, even if it was not the traditional, Victorian realism of the New English Art Club. He admitted to Carrington, 'I don't want to be abstract and cater for a few hyper-intellectual maniacs. An over-intellectual man is as dangerous as an over-sexed man. The artists of today have thought so much about newness and revolution that they have forgotten art.'[25]

Talking art with the Cambridge students had riled Gertler. But he defended his convictions, and refused to apologise to Marsh for admitting his aversion to them. 'Don't be offended with me – never be offended with me – for with my friends I must be frank.'[26] Gertler was equally frank with Brett, counselling her against her upper-class relatives who dismissed the work of Augustus John: 'They lead such soft & uselessly happy lives, that they know nothing about life. Their life is too easy. They have had no hardships. God! They don't know what some experience, here on Earth – the same Earth.'[27]

These encounters with the privileged classes steeled him in his resolve to paint the realities of *his* life, what he called 'the beauty that trembles on the edge of ugliness'.[28] He felt that there was 'something different' about his East End home, 'a greater vitality perhaps: the rich dark-complexioned boys and girls seemed to move and talk with unusual intensity – as if life were fearfully important – momentous.' In contrast to the up-tight West End, Brick Lane 'seemed to vibrate with a quickened pulse and a life of its own.'[29]

The irony, of course, was that it was only the rich and privileged who could afford to buy his work, and to sustain him in his ambition.

• • •

Gertler and Currie now became Marsh's artistic mentors, advising him on what to admire, and who to buy. Amongst the 'Ancients' Gertler recommended Blake and Giotto, and of the continental Moderns Cézanne headed the list. Of the young British artists, Gertler and Currie enthused

about one painter in particular: their old Slade colleague, Stanley Spencer. As Marsh informed Brooke,

> They both admire Cookham more than anyone else. Gertler was to have taken me to see him (at Cookham) tomorrow, but it's had to be put off... I shall be buying some pictures soon! I think I told you I was inheriting £200 from a mad aunt aged 90, it turns out to be nearer four hundred than two! So I'm going to have my rooms done up and go a bust in Gertler, Currie, and Cookham.[30]

Things did not turn out so rosily, however. The reason the Cookham trip had been 'put off' was a heated argument that had flared up between Spencer and Gertler. Spencer was unimpressed at what he considered Gertler's presumptuous attempts to promote his work for him, and he did not share a similar enthusiasm for Gertler's latest paintings. Gertler had moved away from his earlier Neo-Primitivism and was now showing the increasing influence of Bloomsbury and Post-Impressionism. This bothered Spencer. Though he liked Gertler as a man, he did not want him coming down to Cookham acting as some sort of a patron intent on doing him a 'good turn', and he felt uncomfortable that he could not reciprocate his enthusiasm for his work. As Spencer told Gwen and Jacques Raverat, Gertler was 'praising me to everybody... I wonder if he would if he knew what I thought of him.'[31]

Finally he decided that he had to let Gertler know his feelings. He explained to the Raverats that he had written and told Gertler everything:

> I was sorry that you gave up painting in your old way, because while you did these things which were dull, you were in a fair way towards doing something good. Then you seemed to

lose all faith & patience with your work & began trying to paint like Cézanne, & you were incapable of understanding him. Wadsworth was without convictions & that naturally led him to do this kind of thing... but you, you ought to be ashamed of yourself.*

Spencer admitted to the Raverats that this was a 'peculiar letter' to have written, and regretted that he had also expressed in it the opinion that Wadsworth's work reminded him 'of warm Cabbage water'. But he defended himself:

My feelings towards Gertler are not malicious, & I did it intending to do him good. This is how he answered me:

'Dear Spencer, I am not in the habit of being dictated to. I consider your letter was an *outrageous insult*. Remember you are not in the position to criticise other people's work & you have a long time to wait before you ever will be.'

This was all... I expect I have done wrong & yet I cannot see what else I could have done. If I hated Gertler, which I do not, I should simply have told him not to attempt to do anything for me & also not to come to Cookham. But I did once feel rather interested & curious about him. I have written to him

'Dear Gertler: I wrote that letter, because I could not allow you to do me any favours without first letting you know my feelings towards you. If it was insulting, I apologise, but it was not insulting. You owe me an apology. Thank you for

* Spencer did not rate those who claimed to be influenced by Cézanne. In July 1914 he would tell Lady Ottoline Morrell: 'When you see the French pictures, they will help you to understand what an impertinent thing it is for a modern Futurist or [sic] Post-impressionist to call himself a "follower" of such a person as Cezanne.'[32]

any kindness you have done me. Unless you regret sending me that letter, I forbid you to write to me again."*[33]

Gertler was understandably incensed. He told Marsh, who tried to defuse a quarrel which lingered on through October,

> About the 'Kookham' affair, I have finally decided that I cannot forgive the insults he sent me in that letter. His second letter says that it was not meant insultingly – that makes it *worse* – for then, what he wrote, were not insults, but *truths*. In that case I do not want to know a man, who has such ideas about me, as he has. I have more respect for myself than that; no, his Personality interests me no longer. He seems to have already adopted the 'Great Man' attitude – which I loathe like poison – I hate it!!! He has had much praise lately, & he is spoilt. I will have nothing more to do with him. His personality will prejudice me against his work also. I intend dropping the subject now, as I must get on with my work, I have no time for petty Quarrels.[34]

Currie also attempted to mediate, telling Marsh that a 'misunderstanding' between the two artists 'I only really care about' was 'a bit off.' He thought it a shame that Marsh had had to cancel his visit to Cookham, but thought that since Spencer was 'certain to go on doing better things any delay won't matter much just yet.'[35] Gertler, however, was also considering breaking off with Currie. 'In many ways I love

* It was not only Gertler and Wadsworth that Spencer criticised in this honest but tactless manner. He seemed to think it necessary to tell everyone what he thought of their work. In December 1913 he told the Raverats of a recent visit to his Slade friend William Roberts: 'I looked at a picture he was doing & I was disgusted. When I said how meaningless & insincere it was he flew into a passion not because I did not like it, but because I, so he said, could not say if it were sincere or not'.[36]

Currie,' he told Carrington, 'but there is something – something – that worries me and it must end.'[37] 'The atmosphere he lives in stifles me,' he told Brett. 'I want fresh Air. Real Air!'[38]

The problem was not so much Currie (though Gertler had now recognised his friend's darker side), but Dolly Henry, whom Gertler was coming to dislike. 'Friendships are terribly difficult to manage', he complained to Brett in September, '& I don't think they are worth the trouble. Henry is not intelligent at all – that's the trouble. Frankly I prefer to stand alone. I need no great friend at all. Ties are a terrible nuisance and hindrance to an artist'.[39]

Gertler told Marsh that he had written to Currie, letting him know that he wanted to be alone for a while: 'There is a grandeur & dignity in solitude. When I am amongst people of so called intellect, my soul gets torn to bits, my inspiration leaves me, & I get depressed.' But he advised Marsh not to think that Currie would be too bothered: 'I know him far too well for that... he has friends and a woman whom he loves. Remember that I am absolutely alone & I have loved without the slightest success. If anyone will suffer it ought to be me. Perhaps no one of my age has suffered as much as I.'[40] But Currie *was* confused by Gertler's attitude, and later told Marsh, 'Mark's attitude to friends is rather curious – rather like mine to ladies.' He would add ruefully, 'A strange and tormented lot we are.'[41]

Yet Gertler hated the self-imposed solitariness that he considered somehow necessary for an artist. A few months later he told Carrington, 'I am always alone. This makes me feel sometimes that I should like to find a great friend with whom I could live. It would be so nice after being all day alone in the Studio to have somebody always to interchange an idea with. The loneliness of man is appalling!'[42] He had lost Nevinson, and Carrington remained (physically) out of reach. So for the time being he continued to hold on to Currie.

• • •

In October Marsh finally saw Spencer's work for himself, when *The Apple Gatherers* was exhibited at the Contemporary Art Society's summer exhibition at the Goupil Gallery. Struck again by the 'Lust of Possession', Marsh wanted to buy it, and wrote to Spencer directly. Unfortunately another young artist, Henry Lamb, had already bought the painting for £30. Spencer wrote back asking if Marsh would be interested instead in a self-portrait he had recently started work on.

'It is just twice the size of my own head', he explained. 'I fight against it but I cannot avoid it. The next one I do I shall commence by painting it the size of a pin's head.' He also recommended that Marsh take a look at his brother's work. Gilbert, now studying at the Slade (where he was known as 'Cookham Two'), was enjoying some success: 'He is the only person I have any faith in or feelings of interest', Stan confessed.[43] Though Marsh would prove to be Gil's first customer, he was keener to purchase *The Apple Gatherers*. As it turned out, this might still be possible.

Henry Lamb, the painting's new owner, was a former Slade student, a friend of Augustus John's, and (like Tonks) a student doctor turned artist. He had recently moved back to London after some years in France and Ireland, and had also seen and admired *The Apple Gatherers* at the CAS show. But he had been annoyed when Clive Bell had rejected the suggestion that the Society should buy it for £100.* Lamb felt that his friends in the Bloomsbury Group were 'fashion-mongers', lacking a proper appreciation of truly great art, and he had therefore bought the painting himself – though he could barely afford it. His plan (unknown at first to Spencer) was to resell the picture at a higher price, and then to pass the extra money back to the artist.

Early in November, Spencer delivered *The Apple Gatherers* to Lamb's studio in the Vale of Health Hotel, right on the edge of Hampstead Heath. It was an awkward first meeting. Spencer had demanded 'full

* The following year the Contemporary Art Society paid £100 for a work by Stanley's brother Gilbert – an astonishing success for a young man who was still a student at the Slade.

directions as to how I am to get to your place, etc.', confessing to Lamb that he was 'not used to London & get very puzzled sometimes. Japp tells me to "fight against it", but I cannot somehow'.[44] Lamb, who was suffering from 'the hell of a chill', found the naive and nervously talkative young artist trying – he subsequently described Spencer's visit as 'one of the most terrible days of my life'.[45]

Having acquired *Apple Gatherers*, Lamb sent it on to the collector Michael Sadler, the Vice-Chancellor of Leeds University. Like Marsh, Sadler enjoyed 'chancing his arm' on unseasoned, up-and-coming artists, and he had already bought works by Gertler, Currie and both the Nash brothers. He made an offer of £50 for Spencer's painting. Marsh would have to act quickly if he was going to have a chance of securing it for himself.

So, shortly after Sadler's offer had been made, Marsh arranged to have lunch with Spencer at a London restaurant. Spencer had a hard time finding their meeting place, and was disappointed to find that the smartly dressed and monocled collector 'looked exactly like a private Secretary'. He had, he told the Raverats, 'expected something so different.'[46] Marsh, equally, 'was disappointed and at the same time relieved' at Spencer's appearance: he was not quite the country bumpkin with dirty, crooked teeth that he had been led to expect (though he would later express amazement that Spencer almost never wore a hat).

Marsh informed Brooke that Spencer 'has a charming face' and that 'we got on like houses on fire'. After lunch he invited 'Cookham' back to Raymond Buildings to show him his collection, which now included Gertler's painting *A Jewish Family*. And he presented him with a copy of *Georgian Poetry*. Spencer's response to 'The Old Vicarage, Grantchester' was typically idiosyncratic: 'I like Rupert Brooke because he knows what teatime is'.[47] Marsh told Brooke that Spencer 'says that tho' he has had tea at 4.30 in the same house ever since he was born, each teatime has a novelty, a character and a charm of its own.' Marsh added, 'He writes delicious letters.'[48]

In late November 'Par' Spencer wrote to Marsh, formally inviting him to Cookham. 'We are very homely folk', he warned, adding, 'We are very grateful for your kindness to the boy.'[49] In Cookham, Marsh finally sealed the deal for *The Apple Gatherers*, trumping Sadler's £50 with an offer of fifty guineas. Afterwards he wrote an amused letter to a friend, describing his visit to Fernlea: 'The family is a little overwhelming. The father is a remarkable old man, still in early middle age at near 70 – very clever... a tremendous talker and frightfully pleased with himself, his paternity, his bicycling, his opinions, his knowledge, his ignorance (due to the limitations imposed by his fatherhood of 9), his Radicalism, and everything that is.' But Marsh complained that Spencer 'only had about two things to show, he does work slowly.'[50]

Marsh duly paid Lamb the fifty guineas for *The Apple Gatherers* and Lamb, as he had promised, sent the extra money to Spencer. Stanley returned a carefully written out receipt: 'I always write formal receipts', he explained, 'because Tonks says it is right to be businesslike.'[51] Though the money was starting to come in from the sale of his paintings and drawings, Stanley hardly knew what to do with it. The Spencers had little interest in wealth, and Gilbert recorded that he and Stanley 'were the extreme consequences of a family tradition that placed more importance on things that no money could buy. If Fernley could have stamped its own coinage, the currency would have been poetry, music, astronomy and the like.'[52] So the money gradually accumulated in the bank account Stanley was obliged to open when the Post Office refused to accept such wealth into his penny savings book.

As long as he could afford the brushes, paint and canvas he needed to keep working, Stanley was happy. He was more surprised than pleased when people bought his pictures. It was more important to him that he liked the person buying the painting rather than the amount of money they offered. If he had to part with his work, it was better if it was going to a good home.

On 8 December *The Apple Gatherers* arrived back from Leeds, and Marsh hung the painting in his spare bedroom. He wrote to Brooke, 'I have just bought Cookham's great picture of the Apple Gatherers. I can't bring myself really to acquiesce in the false proportions, tho' in every other respect I think it magnificent – I've made great friends with him.'[53] Gertler was interested to hear that Marsh had acquired 'the "Kookham". I would love to see it', he wrote.[54]

Brooke, however, was less enthusiastic: 'I hate you lavishing all your mad aunt's money on these bloody artists'.[55] But Marsh could not help himself. The following year he returned to Cookham and visited another of Spencer's makeshift 'studios', this time in the attic of Wisteria Cottage, a deserted old house a short walk from Fernlea. Marsh was amazed to find its floor bestrewn with apple-peel and brilliant sketches imprinted with hobnailed boots. From amidst the confusion Stanley brought forth the larger-than-life-size self-portrait he had been working on for the past year. To Sydney Spencer the painting was 'nothing short of a masterpiece' with 'the dignity of an old master in it. And he has done the whole of it with penny brushes!'[56]

Marsh, too, recognised that it was 'masterly... glowing with genius'. The 'Lust of Possession' surged up. He asked the price: 'Eighty,' he thought Stanley said, and his heart sank, for he possessed no such sum. After one 'frost-bitten moment', Marsh gave himself another chance.

'How much did you say?'

This time Stanley distinctly answered, 'Eighteen'.

It was a bargain, and Marsh bought the portrait and a landscape of Cookham on the spot. He returned to London triumphantly, a picture under each arm.[57]

Spencer, Gertler and Currie now formed the epicentre of contemporary English art for Marsh – indeed, he soon considered Gertler to be 'the greatest genius of the age'.[58] The other artists amongst *les jeunes* were of no interest to him. Although Marsh knew Roger Fry and

173

loved him 'as a man', he detested him 'as a movement', and when he met Nevinson's 'Rebel' colleague Wyndham Lewis he told a friend: 'He is very magnificent to look at, but I don't think he liked me, and I suspected him of pose, so we shan't make friends. Hoping to strike a chord, I told him I had spent the day with Stanley Spencer and he said, "I don't know him, is he a painter?" which *must* have been put on.'[59]

Knowing Lewis, it quite probably was.

Chapter 12

'Georgian Painters'

In January 1914 Gertler and Currie's applications to join a newly established circle of modern artists, The London Group, were rejected. The Group, which included Nevinson amongst its first members, had formed in November 1913 as a merger of the Camden Town, Cumberland Market and Fitzroy Street Groups; it deliberately excluded those artists closely associated with Bloomsbury. There is nothing to suggest that Nevinson blackballed his old Slade friends, however. In fact, he admitted in his autobiography that the London Group offended 'half the art world by rejecting half the established painters of the day.'[1]

But there was succour for the excluded *jeunes* elsewhere: Stanley Spencer had suggested that Marsh should edit a book, *Georgian Art*, as a companion to his *Georgian Poetry*.[2] The idea was that it would consist of forty or fifty drawings by some twenty young artists, including Gertler, Carrington, Currie, Lightfoot, Roberts, Nevinson, Gaudier-Brzeska, Bomberg, Rosenberg and the Spencer and Nash brothers; the proposed publisher, Howard Hannay, was a friend of Carrington's.[3] Paul Nash was excited at being invited to participate: he told Gordon Bottomley it would be 'a glorious book indeed if it ever appears... How splendid it would be not only for us and our friends but for everyone to be able to see what work is being done. There are to be no older Gods like John, Rothenstein, or others & I do pray they keep to that idea – it is the best ever.'[4] Paul was soon exchanging letters with Marsh with ideas for what became known

simply as 'the Book', and he helped send out copies of the prospectus to potential subscribers.[5]

Paul Nash was a recent addition to Marsh's circle. They had met the previous autumn, when John had invited Marsh over to Iver Heath. Then at the beginning of March 1914 Marsh invited Paul to Raymond Buildings to view his paintings. Paul was immediately impressed: 'The collection... at that time was not predominantly modern,' he later recalled, 'but it was exclusively English... I knew here was a collection of personal taste.' Though still dominated by eighteenth- and nineteenth-century watercolours, every inch of wall was filled, and Nash was intrigued by Marsh's 'excursions' into contemporary art: instead of the usual Johns and Steers, 'I found the work of my Slade colleagues, Gertler and Spencer, and a painting by Duncan Grant. What surprised me most was the number of examples representing the younger men.'[6]

Marsh was the first real collector Nash had met. He thought to himself, 'if all collectors collect in this way we shall all live happily ever afterwards.'[7] The first time he stayed overnight at Marsh's flat, however, he was slightly alarmed by Spencer's *Apple Gatherers*:

> The spare room, being the smallest room in the house, was literally papered with pictures... Groups of dwarfs by Gertler and Spencer seemed to menace me from every wall; while on eye level with the sleeper in bed was a large oil painting by the latter of small men with small heads in the likeness of the Spencer family who were thrusting out their arms in the most realistic manner. With this powerful, but, to me, terrifying picture staring me out of countenance up to the last moment before I put out the light, I sank into an uneasy sleep...[8]

For his part, Marsh found the debonair Nash 'charming', and they soon became friends. But it was some time before the collector bought

one of his drawings – 'and then', as Nash recalled, 'it was at the instigation of Mark Gertler whose advice Eddie was inclined to seek on matters of contemporary art.'[9]

For reasons impossible to foresee early in 1914, *Georgian Painters* would never be published. Nonetheless, with Marsh's patronage the Slade students were gradually being moulded into a distinctive circle of young artists. Spencer's prominent role in all this was perhaps surprising. In December 1913 he had considered exhibiting some of his paintings at the Chenil Gallery with Gertler, Roberts, Currie and what he called 'some other wretched creatures'. It would, he told the Raverats, 'cost me a mere nothing & might look rather interesting to see a number of my works together instead of one here & one there.'[10]

In truth, Spencer did not really want to belong to *any* kind of group. His ideal was a Renaissance one of the journeyman artist. In 1915 he would tell Richard Carline, a young artist friend of his brother's, 'how nice it would be if, instead of all this New English Art Club, London Group, Society of this, that and the other, we each had a studio and in front of the studio a little shop with a window full of all sorts of things, and someone behind the shop door to call "shop" when anyone comes in.'[11]

But with Marsh's influence as a patron, his invitations to breakfast or dinner and weekend stays in his flat, his young artists were forming their own close, if informal, network. Eddie made the spare bedroom – or, if another guest took that, the living-room sofa – freely available, often providing friends with a latchkey to let themselves in and out. Gertler even kept his own pyjamas and slippers at the flat, and Currie used it as a place of refuge when his relationship with Dolly Henry abruptly ended early in 1914. Marsh met Currie for dinner in January and found him horribly distraught. Fed up with his fierce jealousy and devotion to artistic rather than feminine beauty, Dolly had quit their Hampstead cottage. Currie's close friendship with Gertler had not helped the relationship, and there had been ominous tensions. 'Oh, Eddie, it is such peace to be here',

Currie declared when Marsh invited him back to Gray's Inn. He enjoyed what he said was his first night's sleep in a week.[12]

These were testing times for Currie, who was struggling with the break-up of his three-year affair. In March Professor Michael Sadler, the collector who had wanted to buy Spencer's *Apple Gatherers*, invited him to give a lecture at Leeds University. It was a disaster: Currie mislaid his notes, and spoke for only twenty embarrassing minutes. 'Under an appearance of calmness', Sadler wrote afterwards, Currie 'was really nearly out of his mind.' Back in the safety of Sadler's study the two men talked late into the night, Currie explaining the source of his anguish: Dolly's faithlessness, and his fear that his period of artistic genius had passed.

'His life was a hell. But his love for her was intense', wrote Sadler, who had never before seen 'such fiery, consuming' emotion. Currie told him 'that he could hardly keep from suicide. The night before, he had nearly killed himself in our house.'[13]

Though he was, in fact, receiving some critical acclaim, Currie told a friend that 'he had made a great failure of his artistic life and felt like ending it all.'[14] He had also threatened Dolly, once pressing a razor blade against her throat: murder or suicide were real fears. Marsh was worried, telling Gertler, 'I think he will be done for if he doesn't get Dolly out of his head.'[15]

By the end of March Dolly had agreed to return to Currie. An uneasy peace resumed. Currie apologised to Marsh for his behaviour – 'I seem lately to be drifting through a period of awful negation' – and told him he had decided to escape 'the Art group' for a while. He and Dolly were going to Brittany.[16] Before they left, Marsh invited Currie and Gaudier-Brzeska to Raymond Buildings for dinner. His sleepover guest that weekend was Stanley Spencer. Spencer and Currie, it turned out, got along – Spencer even told Marsh he thought one of Currie's paintings 'is the best thing you have'. He even wanted Currie to come down and spend a day in Cookham sometime.[17]

The following night it was the turn of Gertler and Paul Nash to visit. Spencer and Gertler now made up after their falling out over Cézanne the previous summer, with Spencer informing the Raverats, 'I am very glad that Gertler agreed to be friends again, we agreed *un*conditionally'. Gertler, meanwhile, told Carrington, 'The evening with "Cookham" was most successful and inspiring. We got on very well together and had a long talk on art. He talks remarkably well about it.'[18]

• • •

Like Currie and Gertler, Nash was also initially rejected by The London Group (though his brother was admitted). In February 1914, however, he was invited to join the Omega Workshops. Fry had recognised that Paul had 'imagination of some kind', but felt he had to 'find the way in which to use it.'[19] Fry found that Nash was 'sympathetic' to the aims of Omega. Indeed, Nash was interested in the idea of artists establishing themselves in business, 'producing drawings, paintings, decorated furniture, etc.'[20] He was cautious of Fry, wary of his potential influence over his work. Nash was all for going his own way. He assisted Fry in his restoration of Mantegna's *Triumphs of Caesar* at Hampton Court Palace, but made little contribution to Omega.

With Marsh's generous hospitality Nash was able to visit London more often, and he frequently stayed overnight, rising for the lavish breakfasts Eddie provided before going to his office at the Admiralty. These would be leisurely affairs which, Nash wrote, 'from time to time turned into a breakfast party. It was not unusual to find a poet or two' had also been invited.[21] In fact, Nash was sleeping over at Eddie's only a few weeks after Rupert Brooke's return to London. On the morning of 9 July one of Marsh's breakfast parties assembled to dine on fried bacon and kidneys with toast and honey. The guests were Nash, Rupert Brooke, the poet W. H. Davies, and Siegfried Sassoon, a young and idling Cambridge graduate who had recently taken rooms in Raymond Buildings. Sassoon had glimpsed Brooke visiting Marsh's apartment a few days before and

was both wildly excited and nervous to be meeting this already famous young man. He later recalled Brooke's appearance at breakfast that summer morning:

> He was wearing an open-necked blue shirt and old grey flannel trousers, with sandals on bare feet, and hadn't bothered to brush his gold-brown hair, which was, I thought, just a shade longer than it needed to be. Seen in the full light as he sat beside the window, his eyes were a living blue and his face was still sunburnt from outdoor life on a Pacific Island.

At first Brooke was 'rather aloof and uncommunicative', but 'with honey on his toast he brightened up'. Sassoon had the 'assured perception that I was in the presence of one on whom had been conferred all the invisible attributes of a poet.'[22]

The day after Nash and Sassoon met Brooke, Marsh introduced the young poet to Stanley Spencer. They got on well. Brooke was also friends with the Raverats (they had all been undergraduates together at Cambridge) and he had admired Spencer's *John Donne Arriving in Heaven* at the Second Post-Impressionist exhibition.* To Spencer, Brooke seemed the very image of an English gentleman: 'He is a good man & I think he must be an English man, must be', he told the Raverats afterwards, 'you can't get away from it.'[23] There was something inspirational about him, and Spencer subsequently told Marsh that Brooke had provoked in him 'a desire to do some great work', explaining to Marsh his philosophy of friendship: 'As St Augustine says (or something like it) "One flaming heart sets the other on fire." I think that true friendship is

* Like Nash, Brooke did not care to have Spencer's *Apple Gatherers* hanging over him in the spare bedroom. He asked Marsh how he expected him 'to sleep in a room with all those bogies.' Not wishing to offend his most treasured guest, Marsh moved the painting.

Variation on a Spencerian theme: Paul Nash, Apple Pickers, *1914.*

a wonderful thing... I mean a close friendship the exact purpose of which is to cause one another & encourage one another to bring forth the joy of Heaven.'[24]

In this exhilarating rush of companionship, Gertler and the Nash brothers became properly acquainted. In April 1914 Gertler visited Iver Heath, writing to Carrington that he enjoyed his visit 'very much indeed. What a splendid way to live. What beautiful surroundings. How beautiful the country is. It will be my ultimate aim to live in the country.' Paul had taken him to see a nearby lake, and after tea their sister had played the piano. Then 'a wonderful rainbow' appeared: 'It started with a blaze of different colours from one field,' Gertler told Carrington, 'made a complete and most accurate semi-circle and finished up with another blaze in another. The sky in the meantime was blue-black. In the garden there was a little tree full of brilliant white blossoms which stood out strong and light against the sky. The whole effect was divine!'[25]

Gertler was touched by the family's kindness to him, and the visit stimulated his growing love of the countryside. And Paul found that he liked Mark's 'outlook': 'I have always been rather repulsed by his manner hitherto', he told Carrington, 'but I think he is really nice and rather amusing often. I hope to know him better – it is curious you have never talked of him – but I suppose not – everything hath its reason'.[26] It is curious indeed, and quite telling to see how Carrington kept different parts of her life in such separate boxes.

Another new friendship gave Gertler his opportunity to spend more time in the country. In January, Marsh put him in touch with a twenty-nine-year-old Cambridge lawyer-turned-writer, Gilbert Cannan. Cannan (who was soon to be named by Henry James in *The Times* as one of four up-and-coming authors, alongside D.H. Lawrence, Compton Mackenzie and Hugh Walpole) worked in a converted windmill at Cholesbury, Buckinghamshire. He shared the neighbouring Mill House with his wife, Mary, and their two large dogs. Mary, who was some twenty years older than Cannan, had been married to the playwright James Matthew Barrie, author of *Peter Pan*. Following a brief affair, and against the advice of friends, Cannan had married her in 1910; it was not a happy match. Cannan – who was prone to depression and long, introspective silences – distanced himself from the disappointing relationship by inviting a stream of friends to Cholesbury.

Gertler, though initially fearful of the sort of intellectual conversation he had so hated on his trip to Cambridge with Marsh, enjoyed his visit to the Mill House. As he wrote enthusiastically to Brett, 'I told them all about myself. They were so interested in my life, I told them all about where I came from & all about my people. Cannan thought I was extremely fortunate to live in the East End amongst *real* people.' The two men discovered a shared enthusiasm for Jewish theatre and the music halls, and held similar opinions on modern art, both dismissive of 'the milk and water outlook of Roger Fry & his followers & most of the so-called

"advanced" people.'[27] Perhaps for the first time in his life, Gertler felt that his humble background was actually interesting to other people.

Though Mary Cannan privately considered Gertler 'egotistical and unrestrained', dirty (he still washed only once a week) and 'too much of the back street Jew to be a wholly agreeable companion', he was soon a frequent guest.[28] He sat up late in the windmill with Gilbert talking, listening to Beethoven and reading poetry. With Currie still abroad with Dolly, Cannan was Gertler's new 'greatest friend'. During these visits he started painting *The Fruit Sorters*, a country scene in which a man and two women carry baskets laden with apples and lemons. Spencer's *Apple Gatherers* was one influence, whilst the female figures bore a close resemblance to those in Duncan Grant's 1910 oil painting, *Lemon Gatherers*, which was exhibited that year in the *Twentieth-Century Art* show at the Whitechapel Gallery. Gertler, of course, had seen Spencer's picture hanging in Marsh's flat; but the bright colouring of greens, blues and orange of his painting were inspired by the rainbow he had seen on his recent visit to Iver Heath.

In fact, Gertler was now writing about the countryside with emotions similar to Paul Nash. On a visit to Cholesbury in April 1914, he told Carrington: 'Coming down here in the train was wonderful. The sunshine, the fields and trees of the country fill me with vague longings. It makes me long, long, for something I don't quite know what. It made me feel that to live in town was decadent.'[29] Gertler would tell her later that year, 'My heart is in the trees!'*[30] A home in the country now became a burning ambition.

Cannan started looking out for an empty cottage for his new friend. For the past year, he had been assembling something of an artists' community around Cholesbury: John Middleton Murry and his lover, the young New Zealand writer Katherine Mansfield, had a place only a few miles away,

* Spencer was experiencing similar sentiments. 'Trees mean a lot to me', he would tell the Raverats in July 1914, '*some* trees.'[31]

whilst D.H. Lawrence, whose *Sons and Lovers* had recently been published to critical acclaim, had taken a cottage in nearby Chesham with his German wife, Frieda von Richthofen. Lytton Strachey and Bertrand Russell were also looking for somewhere nearby to live. Cannan would introduce Gertler and Carrington to this wide circle of literary talents, with dramatic results.

Another friend of Cannan's was the hostess and artistic patron Lady Ottoline Morrell. A kind-hearted but complex woman, she ran a weekly salon for writers and artists at her home in Bloomsbury's Bedford Square. She was also a buyer for the Contemporary Art Society, established on Roger Fry's initiative in 1909 as another way of supporting young painters and placing their work in public collections.* In April, Cannan asked if the CAS might buy one of Gertler's works: 'you would be helping him both materially and spiritually', he wrote, as the artist was desperately poor and again struggling to be noticed. 'London is so absurd a place that one little voice can raise echoes to breach the appalling silence which out of the hubbub can descend upon an artist. A genuine artist must come to a fight through a period of isolation, but Gertler's too young for it.'[32]

Lady Ottoline agreed to visit Gertler at his Whitechapel studio. She would have cut a curious figure in the East End slums: almost six feet tall, with striking red-gold hair, turquoise eyes, and an odd, horse-like face, she wore heels to accentuate her height, huge feathered hats and odd, colourful clothes copied from medieval and Renaissance patterns. Ridiculed and resented by many – but loved by others – she would later be described as 'the bohemian ancestor of all that is most adventurous in modern design'.[33]

From Liverpool Street Station Lady Ottoline made her way to what she described as 'the mean, hot, stuffy, smelly, little street' where Gertler

* After meeting Fry to discuss the project, Ottoline had written, 'I feel strongly now that every penny one can save ought to be given to young artists. At least, we who really feel the beauty and wonder of art ought to help them, young creators have such a terrible struggle.'[34] Lady Ottoline's house became the Society's headquarters.

worked.[35] The Cannans were there too, and the twenty-two-year-old artist proudly showed off his pictures. Ottoline was dazzled by the 'intense, tangible, ruthless, hot quality' that seemed to mark them out as part of 'the Jewish tradition, the Jewish mark'. This gave them what she considered 'a fine, intense, almost archaic quality'. Gertler impressed her, too – 'passionate and ambitious and exceedingly observant and sensitive.'[36] Her visit (and the flowers she sent afterwards) thrilled the young artist. Cannan was equally pleased: 'nothing for a long time has given me so much happiness,' he told Ottoline, 'and I thank you for it'.[37]

Lady Ottoline invited Mark to tea at 44 Bedford Square, hoping to find out 'what he was really like'. She asked him 'if he didn't find it hard reconciling his home life with the life he lived at the Slade, and with Mr Eddie Marsh'. Gertler confessed 'that he could not but feel antagonistic to the smart and the worldly, while at the same time he felt depressed by the want of cultivation in his own people.' Lady Ottoline admired 'the persistence and resolution that dwelt in this apparently fragile body.' She invited him to her Thursday salon, where he showed *The Fruit Sorters* to Walter Sickert, head of the Camden Town Group. Ottoline wrote of Mark 'standing by his picture, thin, erect and trembling internally, if not externally, at the excitement of having his work looked at and discussed by anyone like Sickert, whom he so respected.'[38]

It was probably Gertler who recommended that Ottoline should seek out Spencer's work, too. One hot, sunny summer's day Ottoline and her husband Philip, a Liberal MP, took the train to Cookham. Just as Marsh had been, she was amused and impressed by the Spencer family. Stanley and Gilbert looked like 'two, healthy, red-faced farm labourers', though she quickly realised 'how remarkable' they both were. 'I felt that they had sprung from the soil and were, what is very rare in England, two real painters.' Stanley, Gilbert and the Morrells strolled down the Thames path with Par and their brother Sydney, all talking animatedly about art

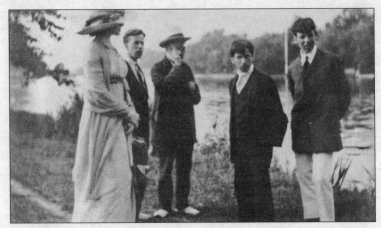

Ottoline Morrell visits Cookham, summer 1914, with (from the left) Sydney, Par, Stanley and Gilbert Spencer

and music. Ottoline thought Stanley was 'more of a genius, more intense' than Gilbert, and 'more like Blake than anyone I knew.'[39]

Stanley was then working on a large painting, *Zacharias and Elizabeth*, another biblical event, this time set in a Cookham garden. Lady Ottoline bought a drawing from each of the brothers, to add to Gertler's painting *The Fruit Sorters* which she had purchased on behalf of the Contemporary Art Society. Stanley was particularly pleased that she had liked what he called Gil's 'big picture'. 'It could be used as a very good anti-septic after being poisoned by futuristic stuff', he joked. 'It makes me feel hopeful about New English Art.'[40]

With Lady Ottoline's friendship, Gertler again enjoyed a social whirl of concerts, theatre trips and expensive restaurants. He even turned down a night at the opera with Marsh to meet with Ottoline. 'Everybody is being very nice to me just now', he told Carrington. 'This makes me very happy.'

Yet the contrast between his two lives troubled him. 'I shall always be unhappy if I try to get away from this class to which I belong', he told Carrington during a holiday to the south coast in July. 'This place makes me hate London... and it is with horror that I look forward to going

back.' But he felt there was no escaping it. 'I must go on in the *East End*. There lies my work, sordid as it is.'[41]

• • •

Whilst Nash, Spencer and Gertler were busy making new friends, Nevinson was almost as quickly losing them. In March he had exhibited with his Rebel colleagues at the Goupil Gallery, displaying his latest semi-abstract, Futurist-style paintings. These attempted to capture the bustle of London crowds and the rush of the Underground. *Tum-Tiddly-Um-Tum-Pom-Pom* was his attempt at a Futurist masterpiece, representing on a monumental scale the Bank Holiday crowds on Hampstead Heath enjoying a funfair. He received some favourable notice, but Sickert was largely critical of the young artists, writing to the press: 'If these meaningless patterns are all they have to show for what has passed since their scholarships, they will have considerable leeway to make up to convince neutrals that they take their own talents seriously.'[42]

Futurist poetry performances, such as that at the Rebel Art Centre in May when Richard imitated the sound of cannon fire on two huge drums, might have impressed his father, but for much of the public they were simply absurd. Marinetti's Grand Futurist Concert of Noises at the Coliseum, with its team of ten 'noise tuners', was no better received. *The Times* wrote disappointedly that Nevinson 'used to be a painter with a modest talent; but now he is like a singer with a small voice who has taken to shouting. Futurism, we are sure, is merely poison to him; and, if he has not lost his talent altogether, it will take him some time to recover it.'[43]

As Nevinson became increasingly involved with the Futurists' performances, Wyndham Lewis grew increasingly uneasy. The Italians, it appeared to him, were hijacking the English avant-garde. What, anyway, was so *Italian* about the modern age? Had not the Industrial Revolution happened in England? Was not England the first industrialised nation, and London, not Rome, its capital? With it huge manufacturing industries, its vast iron, steel and coal works, Britain was the workshop

of the world. British artists, not Italians, should be showing the world how to be Modern.

The break came on 7 June 1914, when Marinetti and Nevinson issued a joint declaration written on Rebel Art Centre notepaper and titled *A Futurist Manifesto: Vital English Art*. The prologue declared, 'I am an Italian Futurist poet, and a passionate admirer of England. I wish however to cure English Art of that most grave of maladies – passé-ism. I have the right to speak plainly and without compromise, and together with my friend Nevinson, an English Futurist painter, to give the signal for battle.'

The Manifesto listed the things the 'English Futurists' were 'Against': 'The worship of tradition and the conservatism of Academies'; 'The pessimistic, sceptical and narrow views of the English public... Aestheticism, Oscar Wilde, the Pre-Raphaelites, Neo-Primitives and Paris'; 'The perverted snob who ignores or despises all English daring, originality and invention, but welcomes eagerly all foreign originality and daring'; 'The sham revolutionaries of the New English Art Club'; 'The English notion that art is a useless pass time, only fit for women and school-girls, that artists are poor deluded fools to be pitied and protected'; 'The sentimentality with which you load your pictures'. In its place they wanted an English Art that was 'strong, virile, and anti-sentimental' with 'a fearless desire of adventure, a heroic instinct of discovery, a worship of strength and a physical and moral courage, all sturdy virtues of the English race'. They called on the 'English public to support, defend, and glorify the genius of the great Futurist painters or pioneers and advance forces of Vital English Art'.[44]

Published in the major daily newspapers and distributed by Nevinson around London's theatres and galleries, the Manifesto claimed as its co-signatories many of the Rebel artists, including Jacob Epstein, William Roberts, David Bomberg, Edward Wadsworth and Wyndham Lewis. Though Nevinson claimed the Manifesto stirred up the art world, it was a

blunder: none of the other Rebels had been consulted, and in attempting to fuse Futurism's ideals with those of the English avant-garde, Nevinson succeeded only in alienating himself from his former friends.

Lewis's response was almost immediate. With a £100 loan from Kate Lechmere, he was already working on a new magazine to promote the Rebel cause – Nevinson himself had provided its title, *Blast*. Now it was turned into a launching pad for yet another artistic movement. In what Lewis termed a 'putsch', on 12 June he, Gaudier-Brzeska, Wadsworth, T.E. Hulme and 'a determined band of miscellaneous anti-Futurists' appeared at one of Nevinson's Futurist performances at the Doré Gallery. They heckled from the back, and announced the launch of their new group.[45] They were the Vorticists, they declared, their named coined by Ezra Pound as an expression of the Great English Vortex 'from which, and through which, and into which, ideas are constantly rushing'.[46]

Just as the Slade Coster Gang had fought a couple of years before, so the avant-garde artists now fought with each other – and since the Futurists loved nothing better than a good scrap, the Doré Gallery 'putsch' ended in violence, and the police were called. Lewis wrote that during these hot, heady months of the summer of 1914, 'Life was one big bloodless brawl'.[47] Ostracised from the Vorticist experiment and his former Rebel colleagues, Nevinson was bitter, uncomprehending – and once more alone.

The first edition of *Blast: A Review of the Great English Vortex*, appeared at the beginning of July, and contained Lewis's 'Vorticist Manifesto'. The Futurists had taught the English artists the power of theatrical, eye-catching propaganda, and in brash, black, oversized type Lewis 'blasted' the things the Vorticists professed to hate. They started with England: 'Curse its climate for its sins and infections' and that 'Victorian vampire, the London cloud'. And they 'blessed' the things they loved: 'Bless England, Industrial island machine', 'Bless all Ports', 'Bless these Machines'.[48]

According to Lewis, he quickly 'shot into fame as the editor of *Blast*.' As he later explained, the radical young artists were the best show in town: 'The Press in 1914 had no Cinema, no Radio, and no Politics: so the painter could really become a "star". There was nothing against it. Anybody could become one, who did anything funny. And Vorticism was replete with humour, of course; it was acclaimed the best joke ever.' To be a modern artist was suddenly to be newsworthy. 'Exhibitions were reviewed in column after column', Lewis declared with pride.[49]

Coming as it did only a few weeks after the Whitechapel Gallery's major exhibition *Twentieth Century Art: A Review of Modern Movements*, which included works by Gertler, Nash, Currie, Wadsworth, Bomberg and Rosenberg, it showed that the Slade's crop of young artists were making unignorable reverberations. It seemed that nothing could now halt their irresistible rise.

• • •

By mid-July it was holiday season, and many of the young artists and writers were escaping London. Carrington and Gertler went to the seaside: Carrington with her family to Devon, Gertler to a bed-and-breakfast near Hastings in East Sussex. Epstein was living nearby, and Mark found the Vorticist sculptor's presence so 'worrying' that he was unable to work for the whole first week of his holiday.[50] 'Epstein has a filthy mind', he complained to Carrington, 'and he always has some girl living with him, *including* his wife'.

Nevertheless Mark managed to paint *Black and White Cottage*, one of his finest works from this period. He described to Carrington his joy in successfully completing the portrait of this building, which he had 'so long pined to paint.' In a not-too-subtle analogy, he explained: 'I should imagine the pleasure akin to that of a lover embracing, for the first time, the girl he for so long loved and longed to embrace. Just as he would passionately and lovingly linger over parts until then forbidden, so I lovingly lingered over those beautiful greens, greys and whites I knew so

well but never before had the opportunity to paint.' He also responded to her comments on Spencer's recent work: 'I do not agree with you about "Cookham" being the *only* individual artist,' he wrote, aggrieved. 'That is rather unfair on some of us other artists who work.'[51]

Spencer, of course, was spending *his* summer in Cookham, with occasional trips to see Eddie Marsh and friends in London. He also joined Gertler and Gilbert on a Slade picnic, and they walked back to Cookham together.[52]* His brother Will was coming home from Germany for the August Bank Holiday weekend, and Henry Lamb was another guest at Fernlea. After their disastrous first meeting in London the previous year, in March Lamb had visited Cookham. He told his friend Lytton Strachey afterwards, 'I understood his origins & genre much better this time and he was much less nervous and trying; so that I really got to like him tremendously.'[53] Even though Spencer did not find Lamb's work 'interesting', they shared a passion for music, and became firm friends.

Nash, meanwhile, was in Lancashire with Margaret, visiting Gordon Bottomley and his wife. The cost of their holiday – kept secret from their parents, who would not have approved of the unmarried couple travelling alone together – had been generously funded by Marsh. Paul wrote to him gratefully, and explained that his sketches 'are promising for later development but individually rather nice and gentlemanly. Still, I feel I have given a jump right away from "Nash trees".'[54]

It was Nevinson who ventured furthest afield, heading to the south of France with his mother. They were in Marseilles when news came that a Serb nationalist in Sarajevo had assassinated Archduke Franz Ferdinand, heir to the Austro-Hungarian Empire. In England, where sectarian civil war

* In his biography of Stanley Spencer, Gilbert plays down his brother's friendship with Gertler, stating, for example, that Gertler never visited Cookham. But as Stanley's letters from the period reveal, this was not the case.[55] 'I have always been a tremendous admirer of Gertler's work,' Stanley recollected towards the end of his life, 'and we were good friends [from] before the war to the end'.[56]

in Ireland looked more worrying than hostilities in Europe, the news was hardly noticed. The complex web of treaties and alliances that linked the Slavic states, Russia and France on the one side, and Austro-Hungary and Germany on the other, were too Byzantine for most people's interest. But in France rumours circulated: 'The machines are starting; there is no hope of peace, it is a question of days', the guests at the Nevinsons' hotel murmured.

Then one evening Richard and Margaret returned to find the hotel deserted. '*C'est la guerre*,' their host informed them, 'mobilisation has already begun...'[57]

Richard and his mother left Marseilles by train the following morning, a 'long, terrible journey across France in the burning heat with neither food nor drink, jammed in like cattle with the soldiers.' All non-nationals were fleeing the country, and cross-Channel boats were packed. Back in England, 'instead of the clear knowledge and decision in France' the Nevinsons found 'stupefaction'. People were too busy enjoying the Bank Holiday weekend to fuss over a continental fracas: 'surely to God we were not going to fight over such a trifle,' was the impression they encountered.[58]

A trades union rally in Trafalgar Square attracted ten thousand anti-war protestors. They made a resolution 'in favour of international peace and solidarity, calling upon his Majesty's Government to take every step to secure peace on behalf of the British people, and upon the workers of the world'.[59] International events, however, had turned the tide against the forces of peace.

Germany's Schlieffen Plan, devised in anticipation of a simultaneous war with France and Russia, entirely depended upon a quick victory on the Western Front. By invading through Belgium, German forces would evade the heavily fortified defences on the French border and be in Paris within six weeks. Then, with France conquered, they could turn their attentions to the more distant armies of Russia. But there was a weak

point in this strategy: Germany would have to violate Belgian neutrality. The Kaiser thought this would not be enough to bring Britain into the war. He thought wrong, and when German troops marched into Belgium Herbert Asquith's Liberal government felt duty-bound to honour its long-standing treaties.

At 11pm on Tuesday 4 August, after Germany had ignored a call to withdraw its forces, Britain declared war. *The Times* recorded that, as the bells of Big Ben chimed the appointed hour, 'a vast cheer burst out' from crowds gathered in the streets around Whitehall, and it 'echoed and re-echoed for nearly 20 minutes.'[60] 'We are going into the war that is forced upon us as the defenders of the weak and the champions of the liberties of Europe', wrote the newspaper's editor. 'We are drawing the sword in the same cause for which we drew it... against NAPOLEON. It is the cause of right and honour, but it is also the cause of our own vital and immediate interests.'[61]

Henry Nevinson was in Berlin covering the story, and a belligerent crowd attempted to break the windows of his hotel.[62] 'The nation acquiesced,' wrote his wife, 'still half-stunned, but knowing we must keep our pledged word to a little State, trampled already under foot by a great Power thirsting for the blood of France.'[63] An Expeditionary Force was quickly dispatched to join in the defence of Belgium and France. When Nash heard the news he wrote to Marsh in a letter dated 'Bloody August': 'God bless my soul, what a horrible state of things is come to pass... really the whole business is most bloody stupid.'[64]

Nash later described the last few happy months of 1914 as 'the lights going down over the horizon, the voices dying away, the transformations of the last scene of a drama one might call The End of a World.'[65] For more than forty years, Western Europe had been at peace; despite recent German sabre-rattling, few in Britain had ever really expected war. Wyndham Lewis admitted that it dawned on him only slowly 'that something overwhelmingly unsuitable had come to pass; and that my

friend, Life, was somehow treacherous and not at all the good sport and "square-shooter" I had supposed him to be... I'd never hidden anything from him, and he'd never hidden anything from me. Or so I thought... He was an awfully intelligent companion, we had the same tastes (apparently) and he was awfully fond of me. And all the time he was plotting mass-murder.'[66]

Eddie Marsh's friend Siegfried Sassoon, at home at his parents' house in Kent, was equally bemused by the sudden twist of events: 'I had lived my way to almost twenty-eight', he later wrote, in 'an unquestioning confidence that the world had arrived at a meridian of unchangeableness... I had, indeed, sometimes wished that I were living in more stirring times. No one could have been more unaware that he was in for one of the most unrestful epochs in human history, and that the next twenty-five years would be a cemetery for the civilised delusions of the nineteenth century.'[67]

It was a strange new dawn for Europe. The next four years, as Margaret Nevinson observed, stretched out 'in long-drawn horror, dwarfing all the rest of life in their concentrated misery.'[68]

Chapter 13

'No Ordinary War'

Paul Nash was the first of the Slade artists to enlist, though his initial reaction had been to do something outside the military such as the Red Cross, or 'gathering in the harvest or guarding the Railway'.[1] He sympathised with Carrington, whose three brothers had immediately enlisted. 'Yes isn't this an abominable business', he told her. 'Jack and I are not rushing off as yet. Personally I am more in favour of mending men than killing them'.[2]

The war, quite simply, was an intrusion. Margaret Nash later wrote that its initial impact 'seemed quite unreal to both of us, and it interrupted a new and lovely life which we had planned during that year, a life which was to be devoted to an intensive research and development of his work as an artist.'[3]

It was the same for all the Slade artists – the same for everyone, of course, in what Gertrude Stein famously dubbed the 'lost generation'.[4] The war spilt apart Eddie Marsh's band of young writers and artists. What about 'the Book', Nash asked him: 'I suppose it goes onto the shelf – for a time?'[5] But *Georgian Painters* went 'onto the shelf' for longer than that. It would in fact never be published, and Marsh's group fragmented. Rarely after August 1914 would more than two of them be found in company together. One peaceful path that might have been had vanished. Another, unlike anything any of them could have imagined, had materialised, seemingly from nowhere.

Two options faced the Slade men: to fight, or to continue their pursuit of life in the service of Art. 'Do not be unhappy about the war', Gertler told Carrington in August. 'The best way we can help is to *paint*.'[6] It was never going to be so simple. The commonplace impression is of men volunteering in droves at the outbreak of War; but for many there was a hard decision to be made, one they would have to face on their own terms, and then live with forever. Gilbert Spencer described it as a miserable period 'of fears, doubts, and distressing inconsistencies of character'.[7]

In a way the young men of Britain were lucky. In France, Germany, Austro-Hungary and Russia most able men could be conscripted into the armed forces immediately. Britain, however, had long depended upon a volunteer army, supplemented by Territorials. There was no legal force to make *anyone* enlist; there was only moral and patriotic pressure. Of both there was plenty. Newspapers reported accounts of German atrocities in Belgium, and the invaders were demonised *en masse*, raising jingoistic fervour feverishly. It was a disturbing time for any Germans in England – such as D.H. Lawrence's wife, Frieda. She told the stiffly nationalistic Eddie Marsh in September how distressed she had been 'when Mark Gertler told me your views of the war – It is not *true* that the Germans and the Allies "hate" each other – As individuals they *don't* – And this abstract hate of a fairytale German ogre... it's mostly an artificial thing.'[8]

But the propaganda worked. By the end of August half a million British men had volunteered, and thousands more soon joined them from the Empire – Africa, Australia and New Zealand, Canada, India. Others arrived from the USA to serve in the Allied armies even before their government declared war on Germany and her allies at the end of 1917.

Despite the propagandising, the question of whether to enlist remained difficult and personal. As Nash felt he would get 'dragged in' sooner or later, on 10 September he enlisted for home service as a private in the 2nd Battalion Artists' Rifles, part of the 28th London Regiment of Territorials. Ironically, Nash was one of the Battalion's few

actual artists – the name derived from its original foundation in 1859–60, when Rossetti, Lord Leighton, and Millais had all been volunteers. One of the first friends Nash made was an eighteen-year-old volunteer, Lance Sieveking. He memorably described the young painter at their first meeting as 'a superlatively elegant dandy... When I met his large, extra-ordinarily intelligent eyes I felt myself to be in the presence not merely of another chap a little older than myself but of an experienced, completely grown-up person: an urbane man of the world, with a slight air of the man-about-town.'[9]

Paul's enlistment for home service was a compromise that pleased Margaret. Though he would have little or no time to paint or draw, he would not go to the Front. Instead, he took on the domestic military duties of the regular soldiers now being sent to France. 'I hate the War', he told Mercia Oakley, 'never was there such world-amazing nonsense, may it gasp itself lifeless before two years are out.'[10]

Yet at the same time he felt he was missing out on something important. In October he bumped into Rupert Brooke, who had joined the Royal Naval Division as a junior officer at the outbreak of the war and had already experienced brief action in Belgium. Brooke had seen Antwerp in flames, filled with refugees and retreating soldiers, describing it to an American friend as 'like several different kinds of hell'. Yet he told Nash that 'it was marvellous'. Nash reported excitedly to Gordon Bottomley: 'I should hate the slaughter – I know I should but I'd like to be among it all, it's no ordinary War.'[11]

Gertler was all against fighting. Arriving back in London from his holiday he told Carrington, 'The war is indeed terrible, but how ludicrous!... Isn't it strange that such a thing as war should still exist?'[12] Gertler simply wanted to paint. But the immediate economic effects of the war had forced his father to close his furrier business, and Mark worried that if the war continued long, 'the working classes will starve.'[13] Although he had been born in England, the rest of his family were Austro-Hungarian

nationals. They were in danger of being repatriated, and his brothers of then being conscripted. Mark told Carrington, 'My brothers do not want to fight for Austria as they like England better. But they do not, if they can help it, want to fight at all, as they are of a peaceful disposition.'[14] The threat of expulsion hung over the family until the following May, when they successfully registered themselves as Galician Poles.

When at the end of August Dorothy Brett suggested Mark should enlist, he wrote back raging against the 'wretched sordid Butchery!!' He told her he was moving to the countryside, 'to rot away my life until the Butchery is completed'.[15] Finding London 'so full of war', he fled to Cholesbury and the pacifist companionship of Gilbert Cannan and D.H. Lawrence. In a letter oddly out of step with events, Gertler told Marsh (who was now busy helping Churchill with the mobilisation of the Navy), 'I am glad I am leaving London, for I love the country more and more now. I hope in the future to be able to live more among trees.'[16]

• • •

Nevinson was uncertain how to face the war. He considered himself 'as having no patriotism... Brass bands, union jacks, and even "Kitchener Wants YOU" had no power to move me.'[17] He also quickly came to abhor the position of his Futurist friends. Marinetti and his colleagues had hastened back to Italy with the intention of provoking Italy to join the conflict: Marinetti duly announced 'We wish to glorify war – the only health giver of the world – militarism, patriotism, the destructive arm of the Anarchist, the beautiful ideas that kill.'[18] However, Henry Nevinson, back home from reporting on the first weeks of action, wrote in late October that Richard was 'much disturbed about the war & the Futurist support of its horror. Declares he will abandon Futurism'.[19]

Spencer was also uncertain what to do. His brother Percy had immediately enlisted, hoping this would mean his younger brothers would not feel obliged to go (though Sydney, now up at Oxford University, soon joined the Officer Training Corps). A week after the start of hostilities,

Spencer told Lady Ottoline that he and Gilbert were 'very bothered about this war: we certainly ought to help but...... It is not the fact that we might have an unpleasant time; it is that it means a complete disorganization of our work & perhaps ruination to it.' Furthermore, he did not feel he would 'be of much use', though it seemed 'so utterly selfish for young boys like ourselves to stay at home in absolute comfort while others are denying so much for us.'[20] He told Henry Lamb that if he did go to the Front, it would only be on condition that he could take his little Gowans & Gray art books with him: 'Giotto, The Basilica of Assisi... & Fra Angelico in one pocket & Massaccio, Masolino & Giorgione in the other.'[21]

Though he could joke about it, the question of what to do was agonising. He wrote to Gwen Raverat, seeking guidance: 'My conscience is giving me no peace', he groaned: 'advice from you would greatly relieve me, even if you said I ought to go to the Front.' Joining the army might be the ruin of his work, but he could hardly paint now anyway: 'I have been so disturbed that I have not been able to concentrate.'[22] He found it impossible to explain to his mother the significance of what was happening in Flanders, or for her to understand 'the necessity of men joining'. 'My dear', Mar told him in September, 'it's brutality. I hope none of *my* sons will ever kill a man.'[23] So he and Gilbert lingered on in Cookham, whilst one by one the other young men in the village left for the war.

In fact, aside from Nash, none of the artists from the Slade circle showed any urgency to enlist – neither Allinson or Wadsworth or Bomberg, nor Lewis, Roberts or Currie joined the ranks in 1914. It was Currie who would be the Slade's first casualty of these war years. But the bullets that ended his short life that October were not fired at the Front.

• • •

Currie had enjoyed his escape to Brittany with Dolly Henry in spring 1914. In fact, as he told Marsh, 'The presence of "Cookham" or Paul Nash in Town was sufficient to make me think of living in the Country

for a time – I mean they really do look well on country life. And it really is fine. It is most beautiful here – especially in the evenings – A feeling of exaltation I've not felt enough of lately.'[24]

But Dolly had soon bored of rural France and she returned alone to England. 'Difficult to tell you why', Currie told Marsh: 'She has gone away friendly, but she was very much out of place here. Peasant life made her long for cafés & clubs in Town. This is so much finer to my mind that I couldn't stand any mention of London.' Currie hoped Dolly's departure would mark the conclusion of their relationship: 'There are many good things in her, but all my recent trouble in various ways might have been avoided had she better sense. The emotional and sexual horror and beauty of the whole damned thing – the months of torment and waste of energy, my loss of control, seems like a hell to me now.' Immersed in the simple, devout life of the Breton peasants, he felt that there was 'great love and tenderness in everything'.[25]

Eventually, though, he too tired of the solitude. With his mind 'in a whirlwind' he moved to Paris, then Cannes. But when Dolly wrote 'declaring her unceasing love' he returned to England, joining her at Newlyn in Cornwall. Though the original break-up of their relationship had been 'a source of terrible suffering', he was glad to be back with Dolly. He told Marsh of his hope that the experience would bring forth new vigour in his painting: 'I've had a long spell of chaos. I think its Nietzsche, isn't it, who says something about one must have chaos to give birth to a dancing star.'[26]

Filled with confidence, a solo exhibition was organised for October at the Chenil Galleries. He would soon be back in London, and was looking forward to catching up with Gertler. He wrote telling his old friend, 'I have much to say concerning work that will interest you.' He added, poignantly, 'I always have the deepest feelings of friendship for you.'[27]

Then Currie and Dolly's impossible relationship collapsed once more. Their former conflicts resumed, and during a cliff-side walk they erupted

into a violent argument, Currie threatening to push her off into the sea. Alarmed by his furious passion, Dolly fled to London, eventually taking a flat in Paultons Square, just off the Kings Road. But Currie had heard rumours – that Dolly had modelled for lewd photographs, that she had taken up with another artist, that she was attempting to blacken his name and ruin his career.

He returned to London and visited Dolly's flat repeatedly. After a brutal row early in October, he wrote her a final letter:

A very fury of remorse and love and sorrow is raging in me. I blame myself for everything. I am over-whelmed with self-disgust… As the days go on the feeling of all I have lost in you becomes so frightful I cannot breathe. I am looking for a place I can bury my heart and forget.[28]

But Currie could not forget. He was, as Gilbert Cannan later wrote, compelled 'to smash the clotted passion of his life'.[29] The end of the affair was reported in *The Times* on 9 October 1914:

A young woman, whose name is said to be Dorothy or Eileen O'Henry, was found fatally shot in a house in Chelsea… At a quarter to eight yesterday morning shots and screams were heard. The other occupants of the house ran upstairs and found the woman on the landing in her nightdress bleeding from wounds. In the bedroom a man partly dressed was discovered with wounds in the chest. He was taken to Chelsea infirmary, but the woman died before the arrival of a doctor.[30]

According to Augustus John, Currie had shot himself *four* times.[31] A suicide note read, 'My motive is that Henry deserves death for her

damaging untruths and the ruin of my career... Although it means my going too, I had rather that than this everlasting trouble with her.'[32]

Gertler was at home, working on a portrait of his father, when he received the news. Two years later, on half a dozen scraps of paper, he recalled the moment. It was a dreary day; his father gazing out of the window; his mother beating eggs. He went on in hurried detail:

> The sound of the beating eggs only emphasized the oppressive stillness in the room & the dreariness outside & even the oppressive sadness that was weighing on my soul. Oh! How unhappy, unhappy I am I thought... Oh! the hardness of our lives, our three lives. So my thoughts ran on as I painted. To my people it must have seemed that I was lost in work was only thinking of my painting. But in reality when I would be painting I would have moments of intense suffering especially at that dark period when I was so lost in the maze of life & when my painting seemed so meaningless to me.
>
> I was indeed just in the right mood that day to receive ugly news & the ugly news came. I had been painting for about two hours when the telephone bell rang. So shrill & sharp did it sound that I almost jumped out of my chair. For you I suppose said my father. For who else agreed my mother. Its always for him, we pay for the telephone & he has all the calls. But by this time I had dropped the receiver & was standing pale & helpless with tears in my eyes. Whats the matter gasped both my parents. Currie has killed Henry & then shot himself he is not quite dead. He is in hospital, Chelsea, dying. I am going to him...
>
> The journey to Chelsea I thought would never end. In the train I [had] difficulties in stopping my tears. I want to cry so

much for pity & love of humanity, for hatred of the terrible demon that was, for no apparent reason, torturing us all. Yet I could not help noticing that some people were quite happy in the trains as if nothing had happened. I disliked & despised them for being happy & the fact destroyed the harmony of my thoughts. Then I felt really wretched and my body felt helpless with misery, but I did not want to cry any more – I was too wretched.

On coming out of the train I became Philosophic again & the tears came to my eyes once more, but I could not help smiling through my tears when I pictured Currie lying in a hospital dying, having at last done something real a thing he had ached to do all his life. I wondered if [he] would ly in a heroic attitude as he used to do formerly, what heroic words would he have to say to[o]! Ah! & what would I not say to him. Currie, I at any rate still love you. I understand you if nobody else does. Then he would squeeze my hand & turn away his head with emotion. My tears would fall on his face. What interesting stuff to tell my friends about. Heavens I am glad it happened. What a hero I am, what a wonderful person. What extraordinary things happen to me.

I was just beginning to feel very happy & comforted when I remembered that it was all true & that I was nearing the beastly hospital. What a nuisance! Why did he do it, why did he kill her & then himself?! Have I not got enough trouble of my own. Is not my own life sufficiently sordid? But why should he have killed her. If he loved her why not live with her peacefully & if he could not live with her peacefully why not try really to break away from her. It would need strength of course, what a nuisance. What a nuisance. By that time I had reached the hospital. Why

should I go in I wondered. Why you should go in, why you ask? Don't go to see your greatest friend dying said a voice in side me. Was he my greatest friend I had not seen him for six months & besides I somehow feel I know all about it, that I have already seen him there was no need to go in. However I had already rung the bell & the door was opened & I was let in.[33]

Just two years before, Gertler had told Carrington there were only 'two kinds of actions: – ugly & beautiful. I can forgive murder or any crime as long as it is done "bigly".'[34] But could he really forgive Currie? Had his friend's actions been 'big'? According to Gilbert Cannan, Currie had brought 'baseness and folly' into Gertler's life, but he also believed that Currie's legacy continued 'as a powerful force in his work'.[35]

When Eddie Marsh arrived at the Chelsea Infirmary, he found Gertler, 'broken down completely'. He wrote and told Michael Sadler that Currie 'was in a dreadful state of exhaustion – but very peaceful and gentle, not seeming quite to realise what he had done.' What surprised Marsh was that Currie had been unable to live without the 'vain and quite empty-headed' Dolly. 'Isn't it a dreadful wasteful business?' he told Sadler. 'I did think his love for his work would keep him from what he has done. I am sure he would have become a fine painter if he could have freed himself from that disease of heart and will.'[36]

Currie's only dying remarks were: 'It was all so ugly'. Marsh wrote much later that 'by a queer mercy he seemed to have no sense of his position, for he talked of nothing but what he would do when he came out of hospital. He died a day or two later, in the early springtime of his powers.'[37]

Everyone blamed Dolly. In Augustus John's opinion she had 'deteriorated into a deceitful little bitch'.[38] 'Of a truth Dolly drove Currie mad,' Michael Sadler's son wrote, 'and deprived the world of a genuine

artist and a devoted worker. He was a man who, had circumstances been a little kinder, would have made a great reputation and lived a full an happy life.'[39] For Sadler, Currie's 'best epitaph' was penned by Gaudier-Brzeska: 'He was a great painter, and a magnificent fellow.'[40]

On the day Currie died, the German army captured Antwerp. Despite this success, the Schlieffen Plan was going awry. With stiff resistance from the Belgian army, and the unexpected resources of the British Expeditionary Force, almost eight weeks into the war the Germans were still largely stuck in Belgium. As autumn approached and the weather worsened, the fighting became bloodier than anything ever known before.

As a British artillery gunner recorded in his diary: 'Heard that the enemy's infantry were attacking very fiercely... Our battery fires all day. The news is that we are slaughtering them.'[41] It was true: in a final bid for speedy victory the German generals committed their raw, barely-trained Volunteer Divisions – mostly young, idealistic students, the *Kindermord*, who went into battle with arms linked, singing, only to be mown down in droves. But Britain's finest regulars and territorials were being slaughtered, too. Tens of thousands on both sides were already dead. This was the way it would continue for more than four years, an average of over 5,000 combatants dying *every day* of the war.

The German advance on Paris and the Channel ports slowed. Near Ypres, in the wetlands of Flanders, seven miles from the French border, the German invasion was halted.

• • •

In 1909 W.B. Yeats wrote that Henry Nevinson 'has been in more danger than any man I know, in practically every European war for years.' An experienced reporter, Nevinson had told Yeats that 'no European army would fight again even as well as those of France and Prussia fought in 1870', because today we 'have realized that the worst thing that could happen to us would be to be dead'.[42] Nevinson was wrong, and on 11 November the Germans launched their last great offensive of

1914. The following day, and in spite of his disgust with the war, his son became the first of the Slade circle to pull on a uniform and leave for France.

Richard had been under contract for a one-man show at the Doré Gallery but, overwhelmed by a sense of futility in the face of what was now happening, he had been released by his dealer. Whilst in France at the start of the war, Richard's father had seen the appalling state of wounded soldiers left to die in railway sheds at Dunkirk, and he was determined to do something about it. Richard took a crash course in motor engineering and first aid, and he joined the Friends' Ambulance Unit, a Quaker organisation Henry had helped to establish.[43]

Arriving in Dunkirk in heavy rain and to the distant roar of guns, Richard and his father set to work in a railway shed known as 'the Shambles'. It was packed with 3,000 dead, wounded and dying French soldiers, crying pitifully for their mothers. Nevinson later recalled how they lay 'on dirty straw, foul with old bandages and filth, those gaunt, bearded men, some white and still with only a faint movement of their chests to distinguish them from the dead by their sides.'[44]

A German veteran observed that the 'whole misery of the war' was concentrated into the operating theatres of

Richard Nevinson in uniform, Friends Ambulance Brigade, 1914.

these sickening, makeshift field-hospitals: 'The soldier who after such a sight goes back under fire with ardour unquenched has indeed withstood a test of nerve: for every fresh and terrible impression claws itself into the brain, and is added to the prostrating complex of imaginings that make the moment between the rush and the burst of a shell ever more frightful.'[45]

For Nevinson, the experience was 'a sudden transition from peaceful England, and I thought then that the people at home could never be expected to realise what war was.'[46] One person who shared Nevinson's realisation was Henry Tonks. He too had volunteered for hospital service, and as he wrote back to a friend in England in October 1914: 'Most of [the wounded] are in a most broken down condition as far as their nerves are concerned... Modern war is so horrible owing to the artillery fire that it simply shatters people... and I doubt if many will be the same after.'[47]

Those back home never would come to understand the full horror of the Great War, and those shattered by it would never be the same again. How could they? Only the men and women who served and saw and survived could understand – if never quite tell – the whole story.

At the 'Shambles' Nevinson worked as 'nurse, water-carrier, stretcher-bearer, driver, and interpreter'. As he later recalled, gradually 'the shed was cleansed, disinfected and made habitable, and by working all night we managed to dress most of the patients' wounds.' After a week, Nevinson's former life seemed 'years away'. After a month he felt he had been 'born in the nightmare. I had seen sights so revolting that man seldom conceives them in his mind'. But there was no shirking. 'We could only help, and ignore shrieks, pus, gangrene and the disembowelled.'[48]

After the Shambles, Nevinson worked briefly as an ambulance driver. Near Ypres a shell passed clean through the back of his vehicle. Grim sights included a dead child in a Dunkirk street, killed during one of the first ever air raids. With his rheumatism worsening, however, Richard found the driving hard going, and he soon returned to nursing duties. After some ten weeks he was sent home as medically unfit. By the end of January 1915 he was back in Highgate, and refused to return to France.

Though brief, Nevinson's first taste of war had been appalling. Yet once in London again he rediscovered his Futurist loyalties: he sent a photograph to Marinetti of himself posing in uniform by his ambulance, and wrote up his Front line experiences for a series of newspaper articles.

Wyndham Lewis was busy preparing another, war edition of *Blast*. Nevinson was now one up on Lewis, however. Playing up his experiences in France, he gave journalists a posed photograph of himself in military cap, goggles and leather trench coat, and wrote an article, 'A Futurist's View of War', published in the *Daily Express* on 26 February 1915. He declared: 'All artists should go to the front to strengthen their art by a worship of physical and moral courage and a fearless desire of adventure, risk and daring and free themselves from the canker of professors, archaeologists, cicerones, antiquaries and beauty worshippers.'

Though he explained that unlike his 'Italian friends', he did not 'glory in war for its own sake,' and could not 'accept their doctrine that war is the only health-giver', he did not publicly renounce his allegiance to the movement. War was 'a violent incentive to Futurism' and 'there is no beauty except in strife, no masterpiece without aggressiveness.' He believed the 'Futurist technique' was 'the only possible medium to express the crudeness, violence and brutality of the emotions seen and felt on the present battlefields of Europe.'[49] Having announced his intentions in print, he next had to show how it could be done in paint.

The fate of art during wartime, and how exactly such a grotesquely mechanised and modern conflict would be represented in paint, troubled critics. To some, this war was the logical solution to the decadent threat Max Nordau had written of in the 1890s; to others it was merely its unnatural culmination.* Many hoped the war would bring an end to the period of experimentation and radicalism in both culture and politics that had characterised the previous few years. One critic even suggested the war would usher in 'a masculine new age, with no feminist

* John Nash told Carrington that the Germans' devotion to Nietzschean philosophy had made them 'a truly atheistical crew which seems to make the Allies' cause almost a Holy one; certainly civilization cannot advance until it is wiped out.' Not long after, however, he lamented how sick he was of the war: 'I wish it were a day of miracles and that God would strike down all peace-breakers.'[50]

politics, more masculine literature, and a reversion to traditional art'.[50] Others spoke of the need for art that would take people's mind off the carnage. Some thought the 'lunatic' antics of the avant-garde, whilst providing entertainment in peacetime, were inappropriate to these more sombre days.

It was certainly true that wars of previous centuries had produced works of great beauty, such as Paolo Uccello's fifteenth-century masterpiece *The Rout of San Romano* in the National Gallery. Lady Elizabeth Butler, who had memorialised British military episodes of the nineteenth century, was still alive and still painting. But hers were popular representations of former times, when men had marched or rode into battle in scarlet and blue uniforms behind flags and banners. Even the more recent Boer and Zulu Wars had produced their share of picturesque imagery. This first great European conflict of the twentieth century was, however, unlike anything anyone had ever experienced before. How was it to be represented in art?

An article published in the *Athenaeum* in September 1914, 'Art after Armageddon', offered an answer: 'In an age of brutal strife, the art, if any, will be brutal also, the extremes of Futurism being alone suitable to express its spirit.'[51] But the following April *The Times* wrote of 'The Passing of the Battle Painter: No Inspiration in the Trenches'.[52]

It was this conundrum that Nevinson would set out to solve: to find an authentic, modern way to represent this new, brutal, unpicturesque and machine-like war. Michael Sadler had put forward the theory that the Great War was 'the outcome of the same restlessness and seething discontent that led to the expressionist and futurist revolution'.[53] If this were true, then it would take a Futurist to do full justice to it in paint.

Chapter 14

'A Valuable Man'

Whilst Nevinson was busy working out how to paint the conflict, Stanley Spencer was still struggling with his moral response. Rupert Brooke had told Spencer at the end of July that he was 'depressed' about this 'war business', but if Britain joined the fighting it would be 'Hell to be in it; and Hell to be out of it'.[1]

By November it was clear the conflict was not going to be the short affair many had first expected, and late in the month Spencer wrote to Henry Lamb, explaining that he and Gilbert were seriously thinking of enlisting. Stanley accepted what he called the 'necessity' for the war, and added that he was finding it difficult to paint under the circumstances: 'to work at our job one has to enjoy things & I find that impossible, at least I can enjoy, but then there is the constant shock of realising what is [going] on.' The atmosphere in Cookham, so long the happy inspiration for all his art, and a place of so much joy, was 'sickly'. Gilbert was walking about 'like a lump of lead', and finding it harder to work than Stanley was.[2] Up at the Slade, Gilbert felt that even Tonks 'would almost have accepted a bad drawing as a good one, in wartime.'[3]

Though at five foot two Stanley was beneath the statutory peacetime height for an infantryman, special 'Bantam' battalions were being raised for smaller men. His conscience pricked by accounts of German atrocities in Belgium, he was considering joining one. He told Lamb that he was 'quite sure' he was 'as strong as thousands who are fighting & the more beastly

the stories become, the more I feel I ought to go or do something.' Even the monotony of training would be better than being in Cookham and 'trying to work'.[4] He joked to Lady Ottoline that he doubted he would be taken as an officer, but 'I could go as a brave little bugle boy.'[5] In the meantime, he and Gilbert joined the Maidenhead branch of the Civic Guard and the St John's Ambulance. But so long as Mar was against her two youngest sons enlisting, there was little else they could do.

Increasingly, though, it was hard for a young man to remain in civilian clothes. In May 1915 Stanley had an awkward encounter in Cookham's barber's shop. A man who had served in the Boer War and had re-enlisted told him that he ought to have joined up.

'Here am I, a married man with children,' he declared, 'but I am going tomorrow, yes, tomorrow.'

Spencer told the Raverats that he had felt 'like an idiot & a lout & the fact that the barber had parted my hair made me feel more so.' The veteran soldier asked him why he had not joined up, and – feeling foolish – Stanley answered, 'I hope you will believe me that there is some honour in a civilian & when he says he cannot [go], it is because he cannot.'

He strode out of the barber's 'feeling I had made a thorough mess of myself. My walk seemed guilty & my trousers flapped in an annoying way... It is terrible to be a civilian. God says: "You must go, but I give you the power to obey or disobey this command." If you do not go, then you feel something has gone from you.'[6]

He had expressed a similar sentiment to Eddie Marsh the previous month: 'I feel that something has gone out of me; something I had 2 years ago that I shall never have again'.[7] It was the war that had taken it from him, and the sudden loss of two of Marsh's circle in the spring and summer of 1915 could only have worsened his dejection.

For Marsh, the most devastating blow was the death in April of Rupert Brooke. He was *en route* for the Dardanelles as a junior officer with the Royal Naval Division, engaged in Churchill's brilliantly conceived

but hopelessly mishandled campaign to knock Turkey out of the war. Brooke had succumbed to blood poisoning from an insect bite, and was buried on the Mediterranean island of Skyros, aged only twenty-seven. The publication later in the year of *1914 and Other Poems* brought him perpetual fame as the beautiful fallen hero, for whom a corner of a foreign field would be 'forever England'.

No less a patriot, Henri Gaudier-Brzeska had returned home to enlist in the French army. On 5 June 1915 he was killed in action at Neuville St Vaast. It was another bitter loss for Marsh and his circle. It might be thought that these trying circumstances would dull Spencer's ability to paint – as he had feared that they would. In fact, between August 1914 and spring 1915, he completed two of his finest early paintings, and started work on a third. The first, *The Centurion's Servant* (or 'the bed picture' as Spencer fondly called it), was set in the attic of Fernlea. This was the room where the family maid slept, and where sometimes Stanley overheard her in conversation when he knew she was alone, 'and felt it might be the maid was talking to some angel.' In fact, she was talking through the thin dividing wall to the servant next door in Belmont's attic. But Stanley recalled that when she came back downstairs, 'I would not have been surprised to see her face shine as Moses did when he came from Mount Sinai.'[8] The resulting painting represented a story in the Bible, where Jesus miraculously heals a Roman centurion's servant, without actually entering the house in which he lies.

As Spencer later pondered: 'The people praying round the bed may have something to do with the fact that in our village, if anyone was very ill, the custom was to pray round the bed, and I thought of all the moments of peace when at such moments the scene might occur'.[9] *The Centurion's Servant* was his first painting of an interior scene, and has often been taken as a representation of his inner struggle over the war (he himself appears twice in it – as the servant on the bed, and as one of the praying figures beside it). When it first appeared in public, it would

confuse – but also impress – the critics. As he told the Raverats the following year, everything to do with the picture had been perfectly clear in his mind before he started, so that 'it was done in no time, it was done like clockwork.'[10]

Mending Cowls, painted in spring 1915, did not come so easily. A view of the oast house roofs at the back of Fernlea, Spencer found the picture depressing him. 'I wanted it to look like somewhere,' he moaned, '& it looks as if it might be somewhere else.'[11] Dark storm clouds loom on the horizon, and like the 'bed picture' it is an ominous work. The war's lengthening casualty list was clearly hanging heavily on his mind, and he asked the Raverats to send him a photo of Brooke.[12]

The third major painting he began, however, was a lighter work. It portrayed Turk's Boathouse beneath Cookham Bridge, with villagers in punts busy 'swan upping', one of the traditional summer events on the Thames. Sitting in church during service one day, Spencer had heard the sounds of people working nearby. It had seemed then that Cookham life was 'as much a part of the atmosphere prevalent in the church as the most holy part of the church', and the thought of the people outside was 'an extension of the church atmosphere'.[13]

Through June he stuck 'manfully' at the new picture. But from the common came the sound of recruits training, and the distraction of what he felt he *ought* to be doing became overbearing. He saw that *Swan Upping* had the potential to be a truly great painting, and wondered 'if only there was not this war, what could I not do?'[14]

By then, Gilbert had passed his St John's Ambulance exam and had joined the Royal Army Medical Corps in Bristol, whilst Sydney had been commissioned 2nd Lieutenant in the Royal Warwickshire Regiment. Now, Stanley told Lamb, 'Mar's attitude has altered'. Seeing that 'she can do without us, without dying, as she thought she would, & also Cookham having been completely stripped of its youth, I feel I can no longer stick living here, but must exist somewhere else, suspend myself till after the war.'

He wanted to join the infantry, but for the sake of his parents was joining Gilbert in the RAMC. 'Wherever I go,' he told Lamb, 'it is bound to be vile, but I am prepared for anything. I expect my duties will be cleaning out lavatories, & taking the "Pan" round the ward'.[15]

Before leaving Cookham, Spencer invited Gertler, Marsh and Lamb down to see his latest work. Lamb expressed an interest in buying *The Centurion's Servant*, but Spencer was posted before any sales could be agreed: in July he passed his St John's Ambulance exam and almost immediately was sent to Bristol. The completed recent works, together with the half-finished *Swan Upping*, remained in his bedroom to await his return.

• • •

Spencer's departure was a melancholy day. Always awkward with goodbyes, he slipped out of Fernlea without saying goodbye. The day had started hot and a thunderstorm was brewing over Cliveden Woods as he walked to Maidenhead railway station. A 'positively vicious' rain burst soon upset his already 'very shaky' mental equilibrium. As he wrote later,

> this storm gave me a kind of pre-vision of what I was to see & experience, & my thoughts became wretched & I felt very harrowed. My straw hat was all wet & sticky: why God should have put a dampner on my patriotic ardour, I couldn't understand.

And then 'the very thing happened' that he did not want to happen – his father had cycled over from Cookham and appeared on the platform to wave him off. As Stanley sat with the other recruits and the train started off, his father called through the carriage window to the man in charge, 'Take care of him he's valuable', which made Stanley 'feel very awkward... I felt so horribly like the curly-haired little boy going out into the wide, wide world, & all by himself.'

From Bristol railway station they were bussed to Beaufort War Hospital, a vast, ivy-clad Victorian building that in peacetime had been a lunatic asylum. Its massive iron gates reminded Spencer of the gates of Hell.

His patriotic ardour, which he had struggled hard all day to retain, withered. Instead, 'A great clawing death seemed to be sitting or squatting on all my desires & hopes... The day did not seem like day to me, the men did not belong to day. I felt that these things, should they journey to where my home is, would evaporate into nothingness long before they got there.' The Regimental Sergeant Major, a 'gigantic man' who strutted around the Asylum grounds with his dog, paralysed him with fear. The strict nursing sisters from the Queen Alexandra's Imperial Military Nursing Service were no less intimidating. And there were still a few of the lunatics who had not been sent to asylums in the countryside, kept on to do odd jobs. There was one who never understood there was a war on at all, whilst another delighted in saluting anyone in uniform.

Sitting in the oddly homely bedroom he was to share with the other orderlies, Spencer was oppressed by a sense of unreality. He and the other volunteers realised, too late, that they had 'made some awful mistake and were in a trap, and the stupefied expression on each of our faces proclaimed this.' Spencer recalled that, rather than forming friendships, 'It was a case of every man for himself, and this instinctive feeling produced an atmosphere at once of unfriendliness between us. We each became to each other a symbol of our own helplessness.'[16]

As he sat at a mess table for dinner that evening, his food served by one of the lunatics, the contrast with home could not have been more complete. The future would be a monotonous military routine of mundane, repetitive and menial tasks around the hospital, caring for wounded soldiers returned from France and the Dardanelles, with a mere thirty-six hours' leave a month. It appeared to be the end of his joyful life as an artist.

With the War, Ottoline Morrell wrote of how Bloomsbury's 'old interests had been swept away and there seemed no spot that one touched that didn't fly open and show some picture of suffering, some macabre dance of death.' Everywhere there was evidence of the conflict: recruitment posters, soldiers training in the parks, a constant procession of ambulances overflowing with 'tortured, maimed, human bodies'.[17] Most young men were in uniform. Those who were not were looked down on, their cowardice assumed. Veterans brought back hellish accounts of the fighting.

'The other day I met Nevinson in uniform!' Gertler wrote excitedly to Carrington in February. 'He had come back from the Front! Told me in five minutes *all* about it, and you can imagine how ghastly it sounded in "Nevinsonian" language, God etc. etc.'[18]

Carrington heard enough about it from her brothers. When the eldest was wounded she visited him in hospital, listening to his 'gory and sanguine accounts of the battles. It sounds so like Goya,' she told John Nash. The only thing keeping her from getting 'too depressed amongst these people who talk so constantly of war' was a Dürer exhibition at the British Museum.[19]

Gertler was still adamantly resisting having anything to do with it all, and remained focused on his painting. But public interest in art – and *avant-garde* art in particular – had, for the time being, evaporated. Paul Nash's father was of the opinion that 'art must go to the wall', and John told Carrington, 'truly I think it will do so for all Lady O's entreaties'.[20]

Eddie Marsh recognised this, and did his best to keep his circle of friends afloat. In December 1914 he bought one of Nash's tree drawings; Nash knocked the price down from ten guineas to eight so Marsh would have more funds available: 'you are one of the very few men who collects honestly,' he explained, '& about the only one who is going on buying during the war. You are a valuable man Eddie, but at the moment your money is more valuable, since you can't keep artists going by any other

means. I admire you enormously.' He told him to save his money 'for the more "hard-up" painters.'[21]

The 'hard-up' painter whom Marsh did most to 'keep going' was Gertler. He firmly believed that Mark was 'born to be a great painter', and considered it 'a proud thing in my life' to be able to assist his young friend's development.[22] Late in 1914 he arranged to pay him £5 a month 'pocket money' for the duration of the war, and to fund the cost of a studio. Mark would repay him in paintings and drawings, giving Eddie first refusal on all new works. Mark was deeply touched by this arrangement.

'It isn't the actual money that pleases me,' he told his new patron, 'but the generous and friendly feelings that prompted you to help me. I feel that you are a real friend and that makes me very happy.'[23]

In January, after a Christmas spent at Cholesbury with Gilbert Cannan, D.H. Lawrence and their wives, Gertler moved in temporarily with Marsh. Then, with Brett's help, he started hunting for a studio. He knew he had to get out of the East End, but his attempts to settle in the countryside, which would always eventually bore him, had failed. Hampstead, however, offered a compromise. With happy memories of his walks on the Heath with Nevinson, and with friends, family, theatres and art galleries only a bus ride away, it seemed the ideal location.

In the meantime, life with Marsh was rosy. Raymond Buildings was a great step up from Whitechapel, and Marsh and his kind-hearted housekeeper, Mrs Elgy, waited on him hand and foot. He told Carrington that he had 'never been so comfortable before in my life... Every morning at nine o'clock Eddie comes and says, "Mark! Bath ready!" and helps me into a PURPLE SILK DRESSING-GOWN! OH! How good a thing is comfort!'[24] Carrington was amused: 'You are indeed leading the life of the idle rich at Eddie's.'[25]

For a brief time Gertler was happy. It did not last long. After the Cannans' drunken Christmas party, where he sparked a row by kissing Katherine Mansfield, he decided to have nothing more to do with women

for a while.* He attempted another of his periodic breaks with Carrington. 'I wonder why life should be so ghastly', he told Brett. 'I mean why one should have to chuck the one person one really loves!'[26]

Eventually he found a room to live *and* work in at 13 Rudall Crescent, Hampstead. Penn Studio had two small rooms, a high roof with skylights, and a kindly landlady who was soon offering to cook his meals. Resuming his inevitable contact with Carrington, he wrote her a letter filled with optimism. At last he would be free from his former life:

> I shall be neither Jew nor Christian and shall belong to no class. I
> shall be just myself and be able to work out things according
> to my own tastes. I was beginning to feel stifled by everything
> in the East End, worried by the sordidness of my family, their
> aimlessness, their poverty and their general wretchedness. I used
> to get terribly depressed also by my father, in whose face there
> is always an expression of the sufferings and disappointments
> he has gone through. I keep wondering why they are alive and
> why they want to live and why nature treated then so cruelly...
> It'll be good to get all that change and yet be in London. Yes,
> I'm excited about it. It feels like the beginning of chapter one
> of the second book of my life.[30]

* Gertler told Lytton Strachey on New Year's Day that he had got so drunk at the party 'that I made violent love to Katherine Mansfield! She returned it, also being drunk. I ended the evening by weeping bitterly at having kissed another man's woman and everyone was trying to console me.' He added that the party 'was altogether an extraordinary one. So interesting was it that all the writers of Cholesbury feel inspired to use it in their work.'[27] Frieda Lawrence records that Mansfield declared to Lawrence that she was in love with Gertler; Frieda accused Mansfield of leading the younger man on, and threatened never to speak to her again.[28] The day after the party Cannan wrote to Lady Ottoline that he was 'groping out of the strangest and most astonishing evening I ever spent.... It was like a chapter out of a Dostoievesky novel. The mill is still very queer with it & I have been out in the woods all day shaking it off.'[29]

He completed *The Creation of Eve*, and in February received a formal letter from Wadsworth inviting him to join the London Group. He accepted. The sheer fact of the war had eventually prevented Spencer from painting; for Gertler, it had the opposite effect. With the war, he *had* to paint. It was his only way of escape. He continued working enthusiastically, brimming over with an ardent, nervous energy.

• • •

A regular visitor to Gertler's studio through the early months of 1915 was Lytton Strachey. They had met at Ottoline Morrell's Thursday salons, and though Strachey was a Cambridge intellectual of the type Gertler had disparaged, they had become friends. A gifted raconteur and witty essayist – and homosexual – the thirty-five-year-old Strachey cut an odd figure. Lady Ottoline described him as 'always absurdly English'. Before the war he had affected an Augustus John look, with long hair, earrings and a cape. But he discarded this Bohemian attire after 1914, for, as Ottoline wrote, 'in those times of intolerance and suspicion any eccentricity was liable to attract persecution as a foreigner and spy.'[31] His appearance, though, was still more than a little strange: a long straggly beard, bookworm spectacles and a 'delicate body... raised on legs so immensely long that they seemed endless, and his fingers equally long, like antennae'.[32] Strachey was a conscientious objector, but his delicate constitution would be enough to keep him out of the War. 'He seemed entirely without vitality', a fellow author would observe: 'Sad merriment was in his eye, and about him a perpetual air of sickness and debility.'[33]

Strachey's friends included Henry Lamb, who, shortly to head off to the Front with the Royal Army Medical Corps, was completing an immense portrait of the writer at his Vale of Health studio. Strachey had for many months been infatuated with Lamb. He had eventually overcome his lust, however, and the two men were now close companions, enjoying competitive and often bawdy banter, and frequently holidaying together. Strachey was attracted to Gertler, too, but at first Mark was

completely unaware of Strachey's sexual interest, and they got along well. They walked together on Hampstead Heath, intently discussing art and literature: 'He is splendid to talk to', Mark told Carrington, who had not yet met the writer.[34]

In February Gertler spent a weekend at Strachey's cottage, The Lacket, in Wiltshire, where Strachey was busy working on his biography of 'eminent Victorians'. He encouraged Mark in his own creative endeavour, and sympathised with his financial difficulties: 'you *are* an artist,' he declared, 'and being that is worth more than all the balances at all the banks in London.'[35]

In May, however, Strachey made a pass at Gertler, and so he started avoiding him, making excuses not to meet for tea. He told Carrington that though he liked Strachey, 'you can't think how uncomfortable it is for a man to feel he is attracting another man that way... to any decent man to attract another physically is simply revolting!'[36]

The friendship with Strachey marked Gertler's increasing acceptance into Lady Ottoline's wing of the Bloomsbury Group. Following Currie's suicide, he had become a regular visitor at her salons, sharing the pacifist sentiments of the group.[*] In May 1915 one focal point of this intellectual social circle moved from Bloomsbury to the countryside, when the Morrells bought the Jacobean manor house in Garsington, a village a few miles outside Oxford.

On 1 June 1915 Lady Ottoline recorded in her journal: 'I dread anyone coming and spoiling, breaking, this lovely spellbound existence, but yet I feel it is selfish to enjoy it all alone – the garden is full of flowers and

[*] In early August 1914 Ottoline's husband, Philip, had been one of the few MPs to question Britain's declaration of war. But when he had stood up in the House of Commons to state his case he had been drowned out by cries of 'Sit down! Sit down!'[37]. The pacifists' leading light was Ottoline's sometime lover, Bertrand Russell. In 1917 he would serve six months' solitary confinement in Brixton Prison for an article written against the war. Rather incongruously, the Prime Minister, Asquith, was also a friend of the Morrells, and he too would sometimes appear at Garsington.

the trees are just in leaf now. I have promised the Lawrences and the Cannans and Gertler and his friends that they shall come.' Her London salons now seemed pointless:

> Any delicate creative effort is blasted and seems trivial, for the War is so real and terrible, it blots out anything else, and makes any other work seem valueless, except that of passionate resistance, and that at times seems quixotic and futile.
>
> But I should like to make this place into a harbour, a refuge in the storm, where those who haven't been swept away could come and renew themselves and go forth strengthened.[38]

Garsington Manor became a retreat for an array of young artists, writers, students and idealists. They made the most of the Morrells' hospitality in their grand old house, which, as one regular visitor recalled, reeked of pot-pourri and scented oranges, with silk and Persian furnishings of 'an almost oriental magnificence'. Over time, paintings by Grant, Gertler 'and a dozen other younger artists' came to fill the walls.[39] Ottoline later wrote how her many guests would rush down for the weekend, to swim in the pond, to lounge on the lawns 'endlessly talking', and then games of charades and dancing in the evening. With the exception of the sickly Lytton Strachey, 'most of them were all young, full of vitality and indignation against the War... it seemed good to gather round us young and enthusiastic pacifists.'[40]

Gertler was one of Ottoline's most entertaining guests. Though he usually worked hard during the day, in the evenings he seemed incapable of resting. His loud laughter, his love of theatricals and his talent for imitation all went down well. As Ottoline's friend Beatrice Glenavy later recalled, Mark would go out of the room 'and return as Lady Ottoline Morrell, then as one of the Stracheys or Sitwells or Maynard Keynes or

some other, making himself fat or tall, short or thin, while we all laughed helplessly.'[41] He did a grand impression of the earnest, argumentative Lawrence, pressing his hands to his head and shouting, 'You lie! You lie!'

For Glenavy, 'Gertler's laugher was a glorious thing. It seemed to bend him and shake him till all the curly hair above his forehead was jumping and bobbing about.'[42] Such descriptions of Gertler amongst his friends are in sharp contrast to the depressed loner who emerges from his letters to Carrington. But Glenavy also wrote that Mark 'seemed always to be saying, "Don't touch me. Leave me alone."'[43] Ottoline felt the same about him 'and all these modern artists' like Katherine Mansfield and John Middleton Murry. Unlike nineteenth-century writers such as Keats or Tolstoy, they 'don't know what it means to have a love for humanity. They can understand a personal selfish love, but that is only an extension of themselves.' She felt their 'hunger for praise' was 'stronger than the hunger for friendship or the desire to work for an ideal.'[44]

Yet Ottoline's eccentricities put people off her. Her most complained-of faults were insincerity and nosiness, and many visitors secretly resented her. Carrington (who was in the habit of leaving her personal letters lying around) was annoyed that they were constantly being picked up and read. It was said that Gertler treated Ottoline as a joke, and that at the sound of her approaching voice her house guests would scatter. Stanley Spencer felt that there was 'an unpleasant atmosphere in being in her presence'. Though he thought 'she would like to be good', it was 'the atmosphere that goes against her more than all the wicked things she is supposed to have done.'[45] Gilbert Spencer became a closer friend, and for a while after the war lived in a house on the Garsington estate. Gilbert felt that at times Ottoline 'was as silly as some of her guests, but never, like Strachey, sinister.' It was 'wretched', Gilbert thought, how her friends 'exploited her hospitality when she was so good to them.'[46]

When Carrington was invited by Duncan Grant and Vanessa Bell to visit them in Sussex, she was shocked by the way they talked about the

Morrells and Cannans behind their backs. 'What traitors all these people are!' she told Gertler. 'I think it's beastly of them to enjoy Ottoline's kindnesses & then laugh at her.'[47]

Nonetheless, more and more often it was with the Morrells and the Cannans that Gertler spent his time when he wanted to escape London. He was concerned about his health – he was suffering periodical but severe headaches, and worried about his emotional state. His friends too were anxious. The previous July Cannan had told Ottoline that Mark was 'fretting and tearing himself into bones and nerves.'[48]

Despite these troubles, during the summer of 1915 at Cholesbury Mark worked on a portrait of Gilbert, standing in front of the Mill with his two dogs. But he worried about his future. In July he told Carrington, 'I expect I shall be dragged into this wretched war, before it's over, but

Mark Gertler, photographed by Ottoline Morrell, 1917.

I shall keep out of it as long as I possibly can. How hateful it all is... How hateful it would be to lose one's life, or even be maimed for life, through a purpose in which one has no sort of belief. How unfortunate it is to have been born just in time of war and such a war.'[49]

Conversations with Lawrence, who in January had told a friend that since the war's start his soul had lain in a tomb, 'not dead, but with the flat stone over it, a corpse, become corpse cold',[50] could not have helped. Increasingly Lawrence exerted his powerful influence over Gertler, who was busy studying philosophy – Spinoza, Kant, Bertrand Russell. Lawrence recognised Gertler's great potential: the

previous September he had told Marsh, who had just purchased Mark's flower painting *Agapanthus*:

> When Gertler does a good figure composition... then, if it comes off, it should be very good – much better than the flowers, which are not extraordinary. I think he may do something valuable – he's the only man whose work gives me that feeling. But it will be those semi-realistic pictures that get some *awe* in them.[51]

By August 1915 Gertler was writing to Marsh in Lawrentian terms, explaining how his thoughts about his work were 'becoming more and more mystical': 'Ideas for future pictures come to me very often, and these ideas are so mysterious and wonderful that when they come over me – they come in waves – I get so excited and feel so physically weak that I can scarcely stand. It is almost too much to bear.'[52]

The influence of the intense, idealistic Lawrence, who encouraged strong expression of all emotions, is clear. Ottoline described Lawrence, the son of a Nottinghamshire coal miner, as like 'someone who had been under-nourished in youth making his body fragile and his mind too active'.[53] The parallels with Gertler are clear: two men of passion, ambition and genius hailing from tough working-class backgrounds, physically weak but mentally strong, totally devoted to their work. Their attraction was mutual, and Gertler subsequently inspired characters in some of Lawrence's novels and short stories.

Indeed, Lawrence, who shared a passion for Nietzschean philosophy, saw them as both working toward the same purpose. In September 1916 he would tell Gertler, 'Nothing matters, in the end, but the little hard flame of truth one has inside oneself... I hope we can add our spirit together, unite in essential truthfulness, in the end, and create a new well-shapen life out of the smashed mess of the old order – I do believe we can, in time.'[54]

In August 1915, Gertler headed off to Cholesbury, and more conversations with Lawrence and Cannan. The upshot was dramatic. In July he had told Carrington that he felt 'depressed' taking Marsh's money. Now the final break came. Returning to London in October, he sorrowfully penned his loyal and generous patron – who believed so strongly in his talent – another letter:

Dear Eddie,

I have come to the conclusion that we two are too fundamentally different to continue friends. Since the war, you have gone in one direction and I in another. All the time I have been stifling my feelings. Firstly because of your kindness to me and secondly I did not want to hurt you. I am I believe what you call a 'Passivist'. I don't know exactly what that means, but I just hate this war and should really loathe to help in it...

As long as I am not forced into this horrible atmosphere I shall work away. Of course from this you will understand that we had not better meet any more and that I cannot any longer accept your help. Forgive me for having been dishonest with you and for having under such conditions accepted your money. I have been punished enough for it and have suffered terribly. I stuck it so long, because it seemed hard to give up this studio which I love. But now rather than be dishonest I shall give it up and go to my cottage in the country. I have still a little money of my own from the Sadler portrait.* On this I shall live. In the country I can live on £1

* Gertler had been commissioned to paint Michael Sadler's portrait in Leeds, but had not enjoyed the experience. 'Frankly I am no good at all at any *commissioned* work', he had explained to Marsh. 'I simply *can't* do it.' There were just too many of his own ideas 'fighting in me to come out'. [56]

a week. I shall live there until there is conscription or until my money is used up.

Your kindness has been an extraordinary help to me. Since your help I have done work far, far better than before. I shall therefore never cease to be thankful to you. Also if I earn any money by painting I shall return you what I owe you. I shall send you the latchkey and please would you get Mrs Elgy to send me my pyjamas and slippers.[55]

Chapter 15

'Ever Busy Yet Ever at Rest'

Carrington had completed her fourth and final year at the Slade in the summer of 1914, returning home to live with her parents. Later that year they left Bedford for a large farmhouse in the Hampshire village of Hurstbourne Tarrant. Carrington had her own studio, and was soon exploring the neighbouring countryside by foot and on long bicycle rides. The beauty of the North Downs filled her 'with a curious longing & much amazement, that the world can be made so wonderfully.'[1] The local inhabitants were equally intriguing – bronze-skinned ploughboys and big-boned gypsies. Augustus John, who had helped to establish an appreciation amongst artists for the Romany way of life, introduced her to his gypsy companions. She would later tell a friend that these were 'the happiest people... without reputation or possessions, and no houses to live in.'[2] That freedom was deeply attractive.

With the Hampshire countryside to inspire her, Carrington was soon painting sensitive landscapes in oils and watercolour, and was mastering her portrait technique, too. Yet it was often a struggle: 'My work disappoints me terribly', she complained to Gertler: 'I feel so good, so powerful before I start & then when its finished, I realize each time, it is nothing but a failure.'[3] But the privacy of Hurstbourne Tarrant was better than Tonks's strict classroom regime. 'I wouldn't go back to the Slade for anything', she told her friend Christine Kühlenthal, who was still studying there. 'Oh, this freedom is wonderful!

And nobody who cares whether I work or not, or if I do whether it is good or bad.'[4]

Nonetheless, she was frequently lonely. Each day amongst her family seemed exactly like the one before. Her brothers were away at the war, and in May 1915 her sister married – a transaction of such middle-class convention it disgusted her. Her family's bourgeois outlook continued to jar: 'They are so commonplace and material', she moaned to Gertler. 'This morning I just longed to run away from them all, and escape to London.'[5] She found herself 'a beautiful dog' as a companion: 'He would have made me happier here', she told Christine. 'But I had to leave him with a friend whilst I went to the Nashes and they lost him in London.'[6] Worse, her mother disapproved of visits from friends. Christine Kühlenthal even had to disguise her Germanic name when she came to stay. Carrington later wrote how she 'could not stand the few years of loneliness and isolation' she lived through after leaving the Slade.[7]

Gertler remained her closest confidante, but their relationship continued hopelessly troubled. He demanded a degree of love she was incapable of giving, and her physical detachment left him angry and frustrated. 'Affection does not seem to come easily from you at any time', he complained early in 1915.[8] A few months later, when she criticised his numerous sexual affairs, he responded that she was 'apt to misunderstand that sort of thing' because she was 'young and inexperienced and rather, if I may say so, cold and sexless.'[9]

'I want *all* of you or nothing', he declared in another letter: 'I want your body as well as your mind. Whenever I've said anything else, I've been insincere or hysterical'.[10] Sex, he explained, would be the physical expression of his love for her, as painting was the physical expression of his love for art.

'You must know one could not do, what you ask, sexual intercourse,' Carrington replied, 'unless one does love a man's body. I have never felt any desire for that in my life... I do love you, but not in the way you

want.'[11] He couldn't understand. 'Why is it?' he asked. 'Am I repulsive to you?' Or was it 'simply perhaps because you don't want children?' In that case, he told her, 'we should not have them, like many other couples.'[12] Noel Carrington believed that her upbringing had left his sister with 'a repugnance for family life as such', and he thought she viewed marriage as a 'lapse from grace', and maternity as 'an inevitable but none the less deplorable sequel for a person of intelligence.'[13] Even Brett called her 'puritanical', a trait she claimed to notice in Carrington's art.[14]

Unable to consummate his strongest feelings, Gertler sought – and found – sexual release elsewhere. He boasted to Carrington of his sexual attractiveness, and occasionally her coldness thawed. In the summer of 1915, during a visit to Cholesbury, Gertler found her manner 'completely altered':

> You seem to have suddenly grown up into a woman... I am
> wondering if it's permanent or only temporary. I could not
> bear you to go back again and become indifferent again. Oh!
> I like your present warmth... Heavens! How near I felt to
> you! Nearly, nearly, all there![15]

Then, almost as suddenly, her attitude changed. She would distance herself, casting him into fearful depressions. He sought faults in himself. He worried about his appearance and mental state: 'I have a small wretched skinny body', he lamented to her, 'worn out by continual nervous strain. All my limbs speak of my wretched life... I feel now so tired and ill that I can't think how I will go on living.'[16] Knowing she was in many ways responsible, Carrington vacillated, but found that she could still not commit herself sexually. Though she was now twenty-two, she was still not ready.

Then, late in 1915, Noel was shot by a German sniper. With a badly injured arm, he was sent to a convalescent hospital in Hove,[17] and Carrington and her parents went to be near him. Carrington wrote to Christine Kühlenthal how they had 'some good times' walking on the

South Downs, 'and some fine talk with Noel, who is so beautiful, and so unlike all the Slade people.'[18] Whilst at Hove she received an invitation from Vanessa Bell to visit them at nearby Asheham House. This was the country home in the midst of the South Downs belonging to Vanessa's sister, Virginia Woolf.[19] Carrington had met Vanessa at the World's Fair in Islington back in February, but was surprised by the invitation since she was not intimate with the influential artists and writers of the Bloomsbury Group. Other guests at the house included Duncan Grant and Lytton Strachey. Carrington was at first unimpressed by Strachey 'with his yellow face and beard' and his intellectual friends: 'What poseurs they are really!' she told Christine.[20]

Carrington knew from Mark that Strachey was homosexual (even if she was uncertain of exactly what this meant), and so she was surprised when, during a walk on the Downs, he suddenly kissed her. Strachey – who had once, rather improbably, proposed to Virginia Woolf – had probably been attracted as much by Carrington's androgynous appearance as her compelling personality. Seeking revenge, the following morning Carrington planned to cut off Strachey's wiry beard whilst he slept. But, with her scissors poised, he had woken and beguiled her with his alluring eyes. Though his homosexuality initially disgusted her, a life-long friendship blossomed that would perplex Strachey's sometimes caustic Bloomsbury friends.

Gertler was surprised – but pleased – that Carrington had got on with the Bloomsbury 'crew'. With no suspicion of what was to come, he was immersed first in his own misery, and then in the sudden, almost scandalous success which followed the London Group's exhibition at the Goupil Gallery that November.

• • •

The London Group's third exhibition, in November 1915, included numerous works by the young Slade artists, including Gertler, Nevinson, Nash and Allinson. Nevinson had already exhibited some of his first war paintings at the Group's earlier exhibition in March, including the

Futuristic paintings *Returning to the Trenches* and – in an early and innovative representation of the aerial war – *Taube Pursued by Commander Samson*. Both works had impressed at least some critics, with the *Sunday Times* praising the latter for its 'beauty of colour', and the impressive way it 'conveyed movement with such imaginative power'.[21]

In June 1915 Nevinson had, like Spencer, volunteered as a private in the RAMC, and had been sent to the 3rd London General Hospital. He found most of the Army nurses 'repulsive', and resented the 'dullness and squalor' of the work. This included emptying bedpans, road-building, helping equip huge new wards, and cooking; he also met the hospital trains that arrived daily at Charing Cross, and assisted in the operating theatres. Later he worked with the hospital's 'mental cases': some were simply 'mad', he observed, others shell-shocked, and some mere 'nit-wits'. For many, their horrific experiences at the Front had 'sent them completely into a world of hallucination and persecution'.[22]

It was Richard's parents who arranged for his war paintings to be shown with the London Group in November – among them *Flooded Trench on the Yser*, *Bursting Shell* and *La Guerre des Trous*. That he was in the Army 'made a good story for the newspapers', and his work was well received in the press. For the *Standard*'s art critic, the toned-down Futurism of *A Deserted Trench* was 'as convincing a picture of the conditions of modern warfare as one could wish to see'.[23] But Nevinson later complained that his war paintings were dismissed by what he called 'the Clive Bell Group' as 'merely melodramatic'. The stinging rebuke from Bloomsbury, who favoured form over subject, was, he wrote, 'my first real taste of the jealousy of artists and the nastiness of the intellectuals'.[24]

But Gertler was also unimpressed by his fellow London Group exhibitors. 'What a rubbishy show!' he complained to Carrington. 'All the pictures except my own, were composed of washed out purples and greens, and they matched so well that it seemed almost as if the artists all collaborated in order to create harmony'.[25]

Gertler's paintings included *The Fruit Stall* and *Creation of Eve*. The latter grabbed the press's attention: he told Carrington it 'created a tremendous uproar! The critics are quite mad with rage.'[26] Many of them, like a large part of the public, associated contemporary art with the Continent, and now placed the 'blame' for this type of work on Germany in particular. For Sir Claude Phillips, such art was an 'infection' and Gertler's works 'a deliberate piece of eccentricity'.[27] Nevinson's Futurist descriptions of the war were admired – or at worst, tolerated – because they spoke eloquently of current events. But to many, Gertler's new works in their 'crude', expressionistic colours seemed irrelevant, and even unpatriotic – his Germanic-sounding name did not help. Someone stuck a label on the belly of his Eve with 'Made in Germany' written across it. The critic for the *Morning Post* called the painting 'Hunnish indecency'.[28]*

Nor did Augustus John think much of these pictures. 'Mark Gertler's work has gone to buggery and I can't stand it', he told a friend. 'Not that he hasn't ability of a sort and all the cheek of a Yid, but the spirit of his work is false and affected.'[29]

Duncan Grant and Clive Bell, however, responded enthusiastically. Bell, who visited the show with Fry, wrote to Mark declaring, 'I don't know when last I saw an English picture that seemed to me so much the real thing.'[30] Grant, meanwhile, told him that they were 'much the best work of yours I have seen. I should like to talk to you about it one day – perhaps I can come to tea one day soon?'[31] And as Mark told Carrington, the wealthy society hostess Lady Cunard was

> furiously excited, says she '*loves*' my pictures, and carts me
> about in her motor car to Lords, Ladies and Baronesses who
> want to meet me, and would you believe it all these people

* There had been a similar response to works by Wadsworth, Roberts and Lewis exhibited at the London Group's second show in March, *The Times* critic writing that they were 'Prussian in... spirit.'[32]

pretend that they like my pictures!... I expect my fame to last quite four days, but these four days may be long enough for me to get some money out of these titled wretches, so that I can go on quietly again for a while and paint what I want to.[33]

For a while, at least, he was well off again, and was able to retain his Hampstead studio. For the moment the loss of Marsh's patronage did not cut too deeply. With Gertler's tendencies towards self-destruction, however, it could not last.

• • •

Whilst Gertler and Carrington could enjoy the relative freedom of civilian life, Spencer, Nevinson and Nash were tied to the strict routines and discipline of military service. Private Spencer's experience of the RAMC was even tougher than Nevinson's. Life at Beaufort War Hospital began at 5am, and he worked through until 6, 7 or even 8 in the evening. He woke and washed the patients, brought them their meals, carried laundry, cleaned and scrubbed and laboured to keep the hospital clean. He also attended military parades, church services and training exercises.

Off-duty, he could sometimes obtain an evening or half-day pass to go into Bristol. His brief allowance of leave was spent in Cookham. It was never long enough for him to work on his paintings – had he wanted to: the rigidity of military life, and the bullying and discipline dampened any sense of creativity. Occasionally he slipped away from hospital duties to steal a few moments alone with his precious Gowans & Grays. But he was no longer an artist, nothing more than a minute cog in the immense, impersonal war machine.

'I have had something to get used to here Eddie', he wrote to Marsh in October. 'Nothing but drudgery & patients & lunatics.' It was 'all very loathsome', and he longed for news from London: 'I should like to hear from you or Gertler any time you can write.' He urged Eddie to help him transfer: the Territorials or the Artists' Rifles would be better than this.[34]

Then one day at the end of November 1915 a one-legged patient hobbled up on crutches and poked a copy of *The Times* under his nose. 'Is that you, you little devil?' the soldier demanded, pointing

Home leave: Stanley, Percy and Sydney Spencer, Cookham, 1916.

at the paper. '*Mr Stanley Spencer's Vivid Work*', the headline read. To Spencer's amazement it was an enthusiastic review of his work at the New English Art Club's winter exhibition: 'The most interesting picture' in the whole show, the paper declared, was *The Centurion's Servant*, 'so simple, so unusual, and yet so unaffected'.[35]

'I had almost forgotten my fading past' as an artist, Stan recalled later. He'd had no idea his painting was even in the exhibition, and reading this account of his former life as an artist made a 'strange impression... I had become completely lost & it was extraordinary to see even a newspaper & then all of a sudden this.'[36]

Unknown to him, Tonks had written to Par, asking if there were any of Stanley's paintings that could be shown at the NEAC. Without asking Stan's permission – or even informing him – Par had sent *The Centurion's Servant*. Stanley was cross with his father, but had to accept that the positive reviews 'were very welcome'.[37] Before this sudden revelation of his talent, the public and critics had had little opportunity to see his work. With only a few notable exceptions, all Spencer's work had either been bought by the Slade or sold virtually straight off the easel to private collectors such as Eddie Marsh.

Word spread quickly through Beaufort Hospital that they had a famous artist in their midst. The Matron 'came down through the wards with a veritable sheaf of dailies over her arm determined to track down

this great "unknown".' Suddenly even she 'looked a little less grim & gaunt.'[38] This transformation was like one of Spencer's 'resurrection' paintings: patients and staff started asking this former 'utter nonentity' to draw their portraits. He agreed, and began working again – and he even started to see ideas for possible paintings in the quotidian activities of the Hospital.

The glowing reviews of *The Centurion's Servant* also brought a new friend. One day a young man appeared at Beaufort as Spencer was scrubbing clean one of the hospital's long corridors. He was amazed to see 'that this youth in a beautiful civilian suit was walking towards me as if he meant to speak to me; the usual visitors to the hospital passed us orderlies by as they would pass a row of bedpans. The nearer he came, the more deferential his deportment, until at last he stood and asked me with the utmost respect whether I was Stanley Spencer.'[39] The young gentleman was Desmond Chute. Just before the war he had been at the Slade, where he had known Gilbert; now he was living with his mother in Bristol. He too had read the newspaper reviews, and discovered that Spencer was a near neighbour. Four years younger, Chute was a devout Roman Catholic with a keen interest in literature and music. His weak, nervous constitution ruled him out of military service, and he helped his mother run a local theatre.

Chute's sudden appearance was 'a godsend'. Generous and kind-hearted, he appreciated 'the mental suffering' Spencer was going through.[40] A close friendship quickly formed, and Spencer was soon spending much of his free time with Chute, either on 'wonderful walks' round Bristol, or talking and listening to music in Chute's bedroom, or reciting Homer. Most importantly for his future career, Chute helped Spencer find spiritual meaning in his mundane war work. He showed him St Augustine's autobiography, *Confessions*, and in particular lines that appealed to Spencer: 'Ever busy yet ever at rest', he recalled them. 'Gathering yet never needing, bearing, filling, guarding, creating, nourishing, perfecting, seeking though thou hast no lack.'[41]

Nevertheless, when the opportunity came for Spencer to leave Beaufort, he took it. Henry Lamb was due to qualify the following summer as an RAMC doctor, and asked Stanley to be his batman. But Stanley could not wait that long. Gilbert had already volunteered to serve in Salonika, and when early in December 1915 a notice appeared in the hospital requesting volunteers, Stanley was the second man to put his name down. It was, he later recalled, 'a foolish & wildly romantic' act.[42] Of 41 volunteers, he was among 14 passed fit for foreign service.

In May he went to a training camp at Tweseldown, Hampshire, in preparation for attachment to an RAMC field ambulance unit. Escaping Beaufort was, he told Marsh, 'like rebirth'. He loved drill training and the long marches through spring countryside.[43] Released from the hospital, he began thinking of it in pictorial terms: of the differences between the wards, the daily tasks he had performed, the convoys arriving in dead of night with wounded soldiers. He realised what 'real valuable work' he had done.

'I itch to get back to painting', he told the Raverats.[44] 'I am looking back on Beaufort days, and now that I am away from it I must do some pictures of it – frescoes. I should love to fill all the hundred square spaces in this hut with hospital work'.[45] It was a grand ambition. But for now, as he prepared for despatch abroad, it was also an impossible one.

• • •

For Paul Nash, military service in London was neither so debilitating to his art nor so tedious to his spirit. Nash did not need Spencer's sense of encompassing calm or spiritual repose in order to work; in the gaps between soldiering he could draw and paint, and even exhibit new work. He and Margaret had decided against a long engagement, and at the beginning of December 1914 Gertler, coming to breakfast at Eddie Marsh's, announced that Paul was getting married to 'a very nice and rather remarkable young woman'.[46] The service, on 17 December, was

held at St Martin-in-the-Fields, Trafalgar Square, and the reception afterwards at Bunty's club in Grafton Street.

Paul moved into his wife's flat at 176 Queen Alexandra Mansions, Judd Street, at the north end of Bloomsbury. It was not an ideal life, but it was neither as dangerous as active service nor as monotonous as Spencer's incarceration in Bristol. Nor did he suffer the opprobrium Gertler endured for his pacifist beliefs. There were regular parties, and weekly teas at Brett's, where they met up with old Slade friends. Gertler and Carrington, however, did not warm to Bunty. No doubt meaning well, she commissioned Carrington to paint a picture. But Carrington moaned to John Nash that his new sister-in-law

> gives me bad postcards of painted fruit or photographs of terrible eighteenth-century still-lives, and then I have to compose a still-life from these and paint entirely out of my head with great detail and highlights everywhere. Significant form! Not much... May she die in the night.[47*]

Though home service was a relatively easy situation, London was not without its dangers. In early 1915 huge gas-filled 'Zeppelin' airships began raiding England, and one day Margaret watched one fly over the Tower of London, where Paul was on guard duty, and drop its load of bombs. They missed the Tower, but the raids left her frightened and upset, and they worsened as the war advanced. Though it was nowhere near as devastating as the Blitz of 1940–41, thousands of civilians were killed or injured, and anti-aircraft guns and bomb blasts regularly shattered the night.

The raids, however, offered a thrilling new subject for Nevinson. He had seen their effects in Dunkirk at the start of the war, and at the Friday Club in February 1915 he exhibited a Futurist-style painting of

* In May 1916 Gertler would ask Carrington to tell Brett 'that on my knees I implore her just this one Tuesday *not* to have Nash and Binkie [sic]'[48].

searchlights puncturing the night sky over London. He returned to the theme in 1916, with an even more forceful evocation of the subject. But Gertler found the attacks horribly disturbing. 'It is ghastly here', he told Ottoline on returning to his studio after a stay at Garsington:

> I have been miserable since the moment I stepped out of the train into London. You have no idea how awful these Air Raids are... For two hours every night one sits huddled in some basement or other listening to the almost continuous shriek and booming of guns. It is really dangerous too in the streets because the shrapnel falls and bursts... making huge holes. This morning almost finished me, I was just coming away from my surgeon, when Boomb, Boomb, the Guns again!

It was all so awful, and the interruptions to his work so frustrating, that he was thinking of returning to Garsington. 'In the meantime I am desperately depressed and all shaky and ill.'[49]

Occasionally the Royal Flying Corps or the Army's anti-aircraft guns hit back. One Sunday night in 1916, Gertler and Carrington were dining at Beatrice Glenavy's house in Hampstead. Late on, a little after Gertler had left and Beatrice was undressing for bed, 'the whole outside world seemed to burst into a roar of fierce, terrible, savage cheering.' Pulling back the curtains, Beatrice 'saw the whole sky was crimson and all the houses and trees lit up'. She dashed down the stairs, gasping, 'Zeppelin coming down – burning.'

Carrington shot out of her room, and they clawed at the hall-door and dashed into the street: 'There it was, creeping and dripping down the sky, head first, mighty and majestic, a great flaming torch, and away up above it the little light of the plane, signalling to the guns.' Great roars of applause came from an artillery barracks at the end of the street and

'it sounded as if all London was cheering'. Carrington, however, could not bear to watch the death fall of the machine and its helpless crew. She 'burst into terrible sobbing and rushed back to her room', crying 'so bitterly she could not speak'.[50]

The war was making her deeply miserable, as her letters to Noel reveal. Their brother Teddy was also in the trenches, and 'Very sad about the beastliness of it all.'[51] She attacked politicians such as Churchill and journalists who opposed peace negotiations, and was critical of those who supported the naval blockade in the belief that it would give the German population 'a taste of war, & what it means':

> as if the logic of giving people back what they give you had
> any effect. We give the German soldiers back underground
> explosions, gas fumes, hand grenades, & every horror that
> they give us. & yet is has not altered their state of mind –
> what idiots these press people are... But I doubt if you agree.[52]

She argued too with Paul Nash, who (like Noel) annoyed her with his support for the war. He apologised for having trodden on her 'pacifist corns' after showing her some pictures in a newspaper, but warned, 'don't get narrow minded, you might be able to look at drawings in a paper without becoming contaminated by the tone of the other contents.'[53]

• • •

In the summer of 1916 Carrington escaped her 'bird-cage' life at Hurstbourne Tarrant and returned to London, staying at a studio at 16 Yeoman's Row, Brompton Road, which she shared sometimes with Christine Kühlenthal. She was reliant on a small annual allowance of £50 from her parents. She supplemented this by making bookplates for friends, private art classes, and occasional work for Omega, but much of the time she was penniless, living off two-penny soups and walking miles when she was unable to afford the bus or tube. Often she borrowed

money from Noel, and regularly returned home to her parents, where there were servants to cook and clean. She was determined, however, to live as independently as possible. She mocked the conventionality of family life, and escaped it to live as she pleased. 'My studio is incredibly dirty and I sit knee-deep in crockery, and old letters', she told her new friend, Lytton Strachey, in June, 'and everywhere drooping flowers, with pools of deep-red petals'.[54]

She learnt to ride a motorcycle and tore round Regent's Park, 'leaving gaping faces of city clerks behind on either side'.[55] But it was far from perfect. Following another air raid she told Gertler that London was 'a beastly place after the country, crowded with hideous people, prostitutes, & debased soldiers, & so grey & gloomy, & then the beauty of the night torn to pieces by these guns & bombs. I long to rush away!'[56]

Gertler's obssessional interest continued unabated. In January 1916 D.H. Lawrence had advised him: 'If you could only really give yourself

The only person to whom I never needed to lie, because he never expected me to be anything different to what I was': Carrington and Lytton Strachey, around 1917.

up in love, [Carrington] would be much happier. You always want to dominate her, which is no good. One must learn to relinquish oneself, not to bother about oneself, but to love the other person. You hold too closely to yourself, for her to be free to love you.'[57] Lawrence was giving good advice, yet Mark did not – or could not – heed it.

Carrington's growing relationship with Strachey was a complication of which Gertler remained ignorant – in fact, the two kept their increasing intimacy a secret from everyone. Mark was 'the Jew' in their correspondence: 'the Jew would slay you, if you lured me from him', Carrington warned playfully when Strachey suggested a rendezvous in London on a day she had already arranged to spend with Mark.[58] Though she was falling in love with Strachey, she would not abandon Gertler.

And there were other suitors, too – including the persistent John Nash. He and Carrington had spent a few weeks holidaying together in the summer of 1915 at a farmhouse in Dorset. She swam each morning, then spent the day drawing Nash-like subjects: 'Binding machines, barns, houses, thatchers, landscapes, cows, anything in fact'. She ended the day with a long walk, taking a gun to shoot rabbits. With her own studio to work in, it was all 'So un-Slady and un-arty.'[59]

John enlisted in the Artists' Rifles shortly afterwards. By November he was in France, looking back wistfully on their holiday. The previous year Carrington had told Christine Kühlenthal, 'I like Jack Nash so much. He passes the examination almost above everyone.'[60] But like Gertler, he loved her in a way that was never fully reciprocated. She resisted any suggestions of marriage, and was pleasantly surprised when Christine and John announced in 1916 that they had got engaged.

• • •

Seemingly unaware of these goings on, Gertler invited the Slade 'cropheads' to Garsington. Lady Ottoline remembered them as 'a little group of girls in corduroy trousers, coloured shirts, short hair. They all seemed fresh and interested in life, and hated the war.'[61] For her part,

Carrington would describe Garsington as 'almost like a lunatic asylum at tea. Everybody equally enchanted.'[62]

Ottoline quickly became fascinated by Mark's relationship with Carrington. Aware that he had been 'deeply and tragically in love' for some five years, Ottoline felt that whilst Carrington 'seemed to enjoy his company and vitality, his good and amusing talk and devotion', she 'neither wholly responded nor wholly rejected him.' Nonetheless, Ottoline had the impression that 'they would inevitably sooner or later marry, as they were so bound up with each other.'[63]

Gertler was not so optimistic. As he wrote from Garsington to a new London friend, the Ukranian-Jewish émigré S.S. Koteliansky: 'It gets more and more complicated with C'. Their relationship, he explained, was 'like some terrible disease and incurable. We both put our heads together and try to end it, but we can't. It goes on despite our both being tired and worn out... it has neither beginning nor end.'[64]

Ottoline found it unbelievable that Carrington, now twenty-three, was still a virgin. Writing from Garsington in July 1916, Carrington told Strachey that her host was 'trying her best to get my state of virginity reduced'. Ottoline had told her husband, and one evening Philip Morrell declared 'without any preface... how disappointed he had been to hear I was a virgin!'

Philip, who like his wife enjoyed numerous affairs, told Carrington that her attitude to Mark was 'wrong... and then proceeded to give me a lecture for quarter of an hour! Winding up by a gloomy story of his brother who committed suicide.' Then Ottoline seized her and talked about sex 'for one hour and a half... Only she was human and did see something of what I meant... But this attack on the virgins is like the worst Verdun on-slaughter and really I do not see why it matters so much to them all.' Yet when the next morning Mark suddenly announced that he was leaving Garsington, 'complicated feelings' had immediately arisen inside her.[65]

This to-ing and fro-ing was 'torture' to him. 'Do you want to wait until you kill *all* my natural instincts', he demanded in September. 'How can you bear to let your beauty pass by when you know there is a man dying for it! Have you a Heart. There is only one period of Youth in our life time – Don't waste it!'[66] But for the time being she remained beyond persuasion.

Lawrence was similarly fascinated by the young couple's relationship. Carrington would inspire the character Minette Darrington and Gertler the German sculptor Loerke in *Women in Love*, the novel he started writing in 1916. Equally rapt was the aspiring young author Aldous Huxley, then an undergraduate at Oxford and another regular guest at Garsington. During the summer of 1916 he enjoyed long rooftop conversations with Carrington, and fell a little in love with her.[67] He subsequently cast her as the blue-eyed, gold-haired and virginal Mary Bracegirdle in his novel *Crome Yellow*, a withering satire of Garsington and its outlandish guests that was perhaps the greatest of all betrayals of Ottoline's hospitality. When published in 1921, Carrington told a friend it was 'a book which makes one feel very very ill. I don't advise you read it.'[68]

• • •

Whilst at Garsington, Carrington painted, but Ottoline (who described her to Gertler as being 'like some strange wild beast – greedy of life') felt she was not concentrating sufficiently on her work.[69] Carrington seemed to lack the self-discipline essential to her chosen career. Indeed, she moaned to Christine Kühlenthal in 1915 that she was fed up of going to London, where 'The drug of the Slade routine besets all one's friends. One goes to Brett's studio – not that I dislike Brett's studio more than any other place – but it seems annoying afterwards.'[70] Carrington envied her friends' dedication to their work, and was annoyed at their reluctance to put down pencils or paintbrushes as soon as she arrived.

Perhaps recognising her flightiness, Roger Fry counselled her against becoming a serious artist – advice that further undermined her

confidence.[71] But he took her on to work at Omega, and through the war years her attention turned increasingly towards more craft-like activities. These included ornamental tiles, wood- and lino-cuts and, as she became increasingly attracted to English folk and naive art, signboards for shops and inns.[72] She continued to paint 'seriously' too, but it remained a struggle. The end results never seemed as good as what she had set out to do.

In August 1916 she escaped the endless gossip and intrigues of Garsington and, despite a 'tremendous argument' with her parents, who refused to let her go, joined Strachey, Barbara Hiles and Barbara's fiancé on holiday in Wales.[73] They took long walks amongst the 'Cezanne landscapes of mountains' and bathed, as she told Gertler, 'in a wonderful pool with waterfalls'. 'I miss you,' she added: 'The intimacy we got at lately makes other relationships with people strangely vacant, dull.'[74]

Then the weather worsened and Strachey took ill, forcing them indoors. He sat with a blanket pulled over him, reading Shakespeare and Donne, whilst Carrington nursed him and sketched his portrait. Their friendship blossomed, and she overcame her earlier distaste of his homosexuality, telling Gertler that she thought 'one always has to put up with something, pain or discomfort, to get anything from a human being. Some trait in their character will always jar, but when one realises it is there – a part of them and a small part – it is worth while overlooking anything bigger and more valuable'.[75] Towards the end of the month she and Strachey took off alone for Somerset, and at the George Hotel in Glastonbury they shared a bed.[76]

That it was to the homosexual Strachey that Carrington very probably surrendered her virginity seems odd. But with her bobbed hair, the almost erotic thrill she found in wearing men's clothes, and her tormented, on-off relationship with Gertler, Carrington's sexuality was blatantly confused. Furthermore, there was an obvious strain of bisexuality

246

running through the wider Bloomsbury circle: Duncan Grant, Clive Bell, Maynard Keynes, Katherine Mansfield and Rupert Brooke all had male and female lovers at one time or another. Gertler himself was frequently a target of attraction for homosexual friends such as Strachey, Marsh and the collector Monty Shearman, and Lawrence had to struggle hard to uphold his heterosexuality. Carrington's friend Christine Kühlenthal had a female lover – a relationship that continued after her marriage to John Nash.[77] This circle was clearly not afraid to experiment with its sexuality, and gender laid down no clearly defined rules.

Although the physical side of Strachey and Carrington's relationship did not prosper, they hatched a plan that would last their lifetimes: they would find a cottage in the countryside where they could live together, a quiet home away from the world, where Lytton could write and Carrington paint. But how to pay for it? That was a question for which they did not yet have an answer. It remained, for the time being, nothing more than a dream.

Chapter 16

'Strident Lies and Foul Death'

During their long conversations in Gilbert Cannan's windmill, Gertler related his life story: the childhood struggle in Whitechapel, the years at the Slade, his long, unconsummated relationship with Carrington. Cannan was intrigued. Indeed, Gertler told Carrington that the writer 'thought our relations wonderful and worth much and he envied me for knowing you. He appreciates you very much and I love him for liking you.'[1]

The story was far too good for Cannan to waste. Early in 1916 he wrote a novel, *Mendel*, based on his new friend's life story, dashing it off in just a few months.[2] This *roman à clef* cast Gertler as the poor Jewish artist Mendel Kühler, with Carrington as his middle-class lover and Nevinson the public schoolboy who befriends him. John Currie is portrayed as an ardent young man who sweeps Gertler along with his 'torrential energy', but is slipping into insanity. The murder of Dolly Henry and Currie's suicide served as the dramatic climax.

The novel's publication at the end of the year would prove disastrous for Cannan's relationship with his two Slade friends – though it would be overshadowed for a time by darker events both in Cannan's life, and in the wider world.

Spring and summer 1916 was a period of national crisis, with the Easter Rising in Dublin only a bloody sideshow to the principal Continental theatre of slaughter. In February the German army launched a massive

assault on the French-held line at Verdun; by August, combined French and German casualties topped half a million. On 1 July, further north up the Line, the British launched a counter-attack. It was a disaster. By the close of the first day of the Battle of the Somme, almost 20,000 British soldiers were dead. The small stretches of enemy ground taken were meaningless. By 18 November 1916, when the Somme offensive was finally abandoned, there had been over 400,000 British casualties. Amongst them was Carrington's brother Teddy, missing in action in October. Hopes for his survival lingered on in to the following year, but his body would never be found – one of many soldiers with no known grave.

D.H. Lawrence ranted against this sustained madness. He told Ottoline Morrell that he no longer had *any* conscientious objections, mankind was simply beyond hope: 'I don't care much who is killed and who isn't, who kills and who doesn't.'[3] It did not help that Baron Manfred von Richthofen – the infamous 'Red Baron', who was now making his name for his airborne exploits – was a relative of Lawrence's wife. As Lawrence told Gertler in September, he was exhausted 'by all this fury of strident lies and foul death'.[4]

Cannan's response to the mass butchery was, on the completion of *Mendel*, to go mad. He stopped writing – the English language, he later reflected, 'became entirely inadequate even if I wished to express myself, which I did not.'[5] Words were useless tools to explain himself or the world; he became apathetic, motiveless. When in August Gertler, concerned, sat him down and quizzed the reticent writer for his life story, after a 'dreadful pause' Cannan told him everything 'in a dull dreary voice'.

'You see, it is just as I thought,' Gertler reported to Carrington: 'nothing ever *really* stirred him, nothing ever made a real impression. When he came, for instance, to the part of his life where a rich cousin comes as if from nowhere and adopts him, puts him into a rich home suddenly after his own sordid environments and then to Cambridge, he did not seem at all impressed or excited... He told it all in the same even bored voice!'[6]

Ottoline shared Lawrence and Cannan's anxieties. She later wrote that through these years 'there was always a haunting fear of something dark and terrible, a fear not for one's own safety, but for the safety of all that has made England so happy and so remarkable, so poetic.'[7] It was more than a fear of what might happen if Britain *lost* the war; it was what Britain might do to herself in the process of *winning* it. Would the price be too great? To the Bloomsbury pacifists, in whose company Gertler and Carrington were spending more and more time, it quite clearly already was.

• • •

In the face of horrifying losses, in 1915 the Government had proposed a Conscription Act: if passed, almost all young men could be forced into military service. It would be an unprecedented step. Despite the vast size of her Empire, Britain had traditionally kept only a small standing army: it was in the Royal Navy that her military strength lay, supplemented abroad by colonial forces. Such days were now past, however: men were urgently needed, and lots of them.

It was an action that smacked of militarism – exactly the thing Britain was supposed to be fighting *against*. Opponents of the Military Service Act included Cannan, Lytton Strachey and Bertrand Russell, who all contributed their literary talents to a vigorous anti-conscription campaign. Their efforts were futile. A first bill, conscripting single men aged eighteen to forty-one, was passed in February 1916; it was followed by a second in June that allowed the call-up of married and widowed men. At the end of that month Cannan received call-up papers. He registered as a conscientious objector, and in August went before a military tribunal.

The tribunals were often bigoted processes: few cared for conscientious objectors, who were roundly castigated as cowards. One of the few places they appeared to thrive was at the Slade: an article in the *UCL Magazine* in June spoke of the 'rather extraordinary' emergence among Slade students of 'the "cult" of the "Conscientious Objector"'. The student journalist declared that he had 'scarcely any tolerance for the kind of Objector who,

hailing from the precincts of South Kensington, lately told a City tribunal in effect, that he preferred chasing butterflies to any form of Military Service; while another said, it was against the artistic creed "to mutilate the human form!"'[8]

It was no doubt ex-Slade students such as Gertler, Allinson and Duncan Grant who had set the fashion for this 'cult'.* Grant – the son of an Army officer – refused to fight, and Allinson (whose mother was German) later recalled how the fact he 'could not share the Great Illusion driving the young men of Europe to mutual slaughter at the behest of their leaders' left him an outcast. Ostracised by friends and even family, he wrote that 'it hurt to realize that one lived in a world where the blindness of the masses permitted an equally blind minority to lead them to destruction in an ever increasing tempo.'

Allinson was sent before two boards 'of a farcical nature': 'My objection to killing Germans was considered invalid if I were prepared to destroy either fleas or butterflies.' The tribunals assumed that the enemy 'was vermin and to be treated as such'.[9] An atheist, Allinson laughed cynically at the murderous acts of so-called Christians. But he was lucky: he failed his medical examination and escaped imprisonment. Cannan was equally fortunate. He too was exempted on grounds of ill health, but was ordered to find a job of national importance within six weeks or face gaol.[10]

In February 1916 Gertler 'walked trembling in every limb into the local tribunal & recruiting office' to assess his options. To his relief, he was rejected – on account of his parents' nationality. 'You can imagine my delight,' he told Brett afterwards. 'What luck! Well now I am free & go

* Henry Tonks set a different example. Shortly after the outbreak of war he returned to his medical studies, and in March 1916 the *UCL Magazine* reported that he had 'left us for the Front... with a Commission in the RAMC. While regretting the absence of his guiding hand and inspiring counsel, we think it exceedingly sporting of him to have joined, and wish him the best of luck.'[11] Tonks would go on to produce what would prove to be his most enduring artistic works: pastel sketches of the faces of badly disfigured soldiers who were undergoing reconstructive surgery.

on with my work. Perhaps some day "My Country" will thank God for my Austrian Parentage which enabled me to sit quiet & paint... Artists are rarer than Tommies.'[12]

But he would soon again be living under fear of conscription. As he wrote to Carrington from Cholesbury later in the year: 'Lately the whole horror of the War has come freshly upon me. I can't help thinking that they will get me yet. They now stop people in the streets in London & ask them what they are doing. If that did happen, especially just now, it would be dreadful, as I am so full of work. God knows what I should do. Without my work, life would become a living Hell & especially under military authority. Yet I can hardly expect to escape.'[13]

The reaction of the owner of the Goupil Gallery to pacifists was not untypical. When William Marchant discovered that Allinson and Gertler would be exhibiting with the London Group, he sent an ultimatum: 'No enemy aliens, conscientious objectors or sympathizers with the enemy were permitted to exhibit in his galleries and should the Group contain any of these his walls would be closed to them.'

Members of the Group agreed unanimously 'that politics should be kept out of the domain of Art'.[14] They rejected Marchant's terms, and found an alternative venue at Ambrose Heal's new gallery in Tottenham Court Road. As Christine Kühlenthal observed, it was a much better venue for modern art than the Victorian ambiance of the Goupil.[15]

• • •

The war dominated everything. To the deaths at the Front and the air raids on London could be added food shortages and rationing. 'I am sure one will become so happy & light headed again when this nightmare is over', Carrington told Gertler.[16] For Gilbert Cannan, the events of 1916 proved simply too much. He had once told Lady Ottoline that his only successful relationships had been with children and dogs: now both his beloved dogs died. At the same time his affair with his wife's maid ended when she became pregnant. His long

silences developed into dangerous retreats from the outside world, and an inner vision coalesced into a strange, fiery symbol inside his mind. Out of this mental inferno seemed to project what Cannan called 'an endless succession of elusive characters – all kinds of men, women and children, dogs, horses, houses, cats, trees, churches, all marching round and round the circle and along the diameters, in and out and round about'.

Trying to capture these visions became a compulsion. He started drawing obsessively – what Gertler described as 'circular shapes and vortexes rather like those appearing in a life of Nijinsky, and Van Gogh's vortex, suns and stars in his later landscapes'.[17] Cannan was soon sent to a nursing home in London.[18]

By the following spring he was improving. 'I'm in a very queer condition,' he told Gertler, 'terribly weak physically, but with such mental and spiritual clarity as I never had', but that to others looked 'like sheer madness'.[19] It was later rumoured that Cannan had thrown a brick through the window of a London department store in protest at the war, and that he had treated his wife abysmally. But Cannan insisted to Gertler that the 'facts', though 'appalling', 'simply are not open to moral judgement. I have been right through the whole Hell of it and the story is more mysterious and terrible than anyone can guess'.[20]

In *The Release of the Soul*, Cannan's account of his mental breakdown, he explained: 'This was a bitter winter, bitter to the senses but more bitter to the soul: 1916, when the shouting and the eager idealism had withered away and all meaning had gone out of the words of war. So bitter was the agony that physical discomfort had become a small thing and men and women were like ghosts pathetically trying to remember the sensations of their life in the Flesh.'[21]

In the midst of what Cannan called this 'explosion of insanity', his novel based on Gertler's life was published. *Mendel* was dedicated to Carrington – it transpired that Cannan, too, had been in love with her.

(Once, guiltily, she had even let him kiss her, to Gertler's horror.) But Carrington hated the novel, which depicted her as the shy, forgetful, compulsive Greta Morrison.

'How angry I am over Gilbert's book!' she told Mark. 'Everywhere this confounded gossip, and servant-like curiosity. It's ugly, and so damned vulgar. People cannot be vulgar over a work of art, so it *is* Gilbert's fault for writing as he did'.[22] Gertler considered the novel 'a piece of cheap trash'.[23] 'Our love has been and is nothing less than classic, so wonderful is it', he told Carrington after reading *Mendel*. 'What a book it really could make!'[24]

Based as it is on long, intimate conversations with Gertler, Cannan's novel is fascinating for its insights into the artists' relationships. Nevinson was depicted as Mitchell, 'a fine young Englishman, pink and oozing rumbustious health, ease, refinement, and comfort', but living 'under his father's shadow'. According to Cannan, it was Gertler who had set off Nevinson's 'revolt against his Public School training', and it was Nevinson and his family who had 'shocked' Carrington 'into thinking and gave her a sense of liberation'. And it was Nevinson (as Mitchell) who introduced Gertler to John Currie, whose electric conversation makes the Slade seem like 'a girls' school'. Cannan depicted Currie as a brilliant rabble-rouser filled with 'furious energy', and in *Mendel* it is the Blake-like Currie who encourages Gertler to ditch Nevinson: 'He is a liar and a coward, and he will never be an artist, because he is too weak', are the words Cannan places in Mendel's lips. 'He is not true. He is not good... I wanted him to be my friend, but it is impossible.'[25]

Astonishingly close to life, *Mendel* caused a stir in literary circles. One reviewer was impressed by the author's rendering of the life of a struggling painter: 'We have always felt an artist's temperament must be an uncomfortable possession, but never has the belief been quite so irresistibly forced on us as after reading Gilbert Cannan's odd, brilliant study of a Jewish artist.'[26] The *Times Literary Supplement* thought that 'an exasperated consciousness' of sex pervaded the book – an opinion with

which Paul Nash concurred. He described the novel to his wife as 'an obsession of self-seeking, self-interest, self-aggrandizement, self-love. Hence misery. And of course the main cause of the two tragedies in the story is the attitude of the men to women – it is the lowest conceivable.' Yet he also considered it 'a hard discomfiting tale, charged with beauty and quite exciting pathologically.' He added, 'My darling let you and me be careful of our love, for the love of the body is a fearful tyranny & our most precious moments are not of the body.'[27]

The indiscretions of *Mendel*, his shoddy treatment of his wife, and his altered, post-breakdown personality, meant many of Cannan's closest friends, including Gertler, fell away. When Cannan started a relationship with a nineteen-year-old South African woman, Carrington wrote disappointedly to her brother Noel, reporting that Cannan's 'murky past' had now been 'disclosed for the first time': 'far from being the high up lifted pacifist, with noble sentiments too pure to live', he was in fact 'a dirtee liar, & raper of young females.'

This was harsh, but another of Carrington's 'tin gods' had fallen. 'True, I had suspected him sometimes', she wrote. 'But not so bad as all that. So poor Mary has sold her house & the mill, & has to start life again'.[28] It was the end of an era.*

• • •

Whilst the events of 1916 jolted Cannan from words, they provided Gertler with material for his most vivid and now most famous painting, *Merry-Go-Round*. This powerful satire on the relentless pointlessness of the War was inspired by the colourful bank holiday funfair on Hampstead Heath: 'Multitudes of people', he told Carrington, 'Bright Feathers, swinging in front of the clouds in coloured boats, coloured ropes a Blaze of whirling colour, the effect... something like a rainbow.'[29]

* Cannan's recovery was short-lived. He would be certified insane in 1924, and committed to an asylum. He spent the rest of his days in institutions, dying in 1955 at Holloway Sanatorium, Virginia Water, where Stanley Spencer's brother William had once been a patient.

The painting that resulted from this inspiration depicted a carousel of soldiers and civilians, fixed grins or screams on their faces, caught in an endless circus ride from which escape was impossible. It appeared to have a clear pacifist message – though the painting also owed a debt to Futurism: in his 'Initial Manifesto', Marinetti had praised 'aggressive movement, feverish insomnia, the double quick step, the somersault, the box on the ear, the fisticuff.'[30] Gertler's aggressively energetic painting displayed all these traits. (Indeed, another work from this period was of a boxing match.) It was an artistic progression well beyond his early still lifes and portraits, and exactly the 'aweful', 'semi-realistic' sort of picture in which Lawrence had seen such potential.

Gertler's friend, the lawyer St John Hutchinson (who represented a number of writers who were conscientious objectors), asked Mark if it was wise to exhibit the new painting publicly, given the reception *The Creation of Eve* had received. 'It will of course raise a tremendous outcry', he warned: 'the old, the wise, the professional critic will go mad with anger and righteous indignation'. Hutchinson worried 'that these symptoms may drive them to write all sorts of rubbish about German art and German artists in their papers and may raise the question acutely and publicly as to your position.'[31]

When Lytton Strachey saw the painting in Gertler's studio in July 1916, he called it 'his latest whirligig picture'. 'I admired it, of course,' he told Lady Ottoline, 'but as for *liking* it – one might as well think of liking a machine-gun'.[32] It was simply too good not to be exhibited, however, and Mark included it in the London Group's next show. When D.H. Lawrence eventually saw a photograph of the painting in October, he told Gertler: 'This is the first picture you have ever painted'. He went on:

> it is the best *modern* picture I have seen: I think it is great, and true. But it is horrible and terrifying. I am not sure I wouldn't be too frightened to come and look at the original.

If they tell you it is obscene, they will say truly... I *do* think that in this combination of blaze, and violent mechanical rotation and complex involution, and ghastly, utterly mindless human intensity of sensational extremity, you have made a real and ultimate revelation. I think this picture is your arrival – it marks a great arrival... I realise *how* superficial your human relationships must be, what a violent maelström of destruction and horror your inner soul must be. It is true, the outer life means nothing to you, really. You are all absorbed in the violent and lurid processes of inner decomposition... It is a terrifying coloured flame of decomposition, your inner flame.

Lawrence linked the painting directly to Gertler's heritage: 'It would take a Jew to paint this picture', he told him. 'It would need your national history to get you here, without disintegrating you first.' To Lawrence it was a real indication of who Gertler was, of the 'ecstasy of destructive sensation' that must be burning inside the young painter: 'I have for you, in your work, reverence, the reverence for the great articulate extremity of art.'[33]

Like Gertler, Lawrence suffered and struggled over the creative process – in February he had told Mark that writing 'used to be, as it is with you, a pure process of self-destruction.'[34] But now he worried that his friend was working *too* hard, sacrificing *too* much. He warned, 'take care, or you will burn your flame so fast, it will suddenly go out... You seem to me to be flying like a moth into a fire. I beg you, don't let the current of work carry you on so strongly, that it will destroy you oversoon.' He invited Gertler to come and visit them in Cornwall, and added in a postscript, 'Get somebody to suggest that the picture be bought *by the nation* – it ought to be – I'd buy it if I had any money. How much is it? I want to know how much do you want for it.'[35]

Of course it was impossible that the impoverished Lawrence could afford the painting. But it was forceful support for a vivid creation that would, sadly, go largely unrecognised in the painter's lifetime.

· · ·

Like Gertler, Nevinson was responding to the war with all his artistic strength. Late in 1915 he had been told that he was to be posted to the Mesopotamian Front with the RAMC. His mother recorded how one evening Richard suddenly informed her 'that, though not engaged, he meant to get married before he was killed.'[36] On 1 November, at six days' notice, he married Kathleen Knowlman at Hampstead Town Hall. His father was away covering the fighting in Gallipoli, and according to Richard the handful of relations who came 'behaved as though they were at a funeral'.[37] After their honeymoon at a Ramsgate hotel, Private Nevinson reported back for duty with the RAMC, faced with the prospect of imminent despatch abroad. But he took seriously ill, and was ordered to bed with his old ailment, acute rheumatic fever. In January 1916 he was invalided out of the service.[38]

Though forced for a while to walk on crutches, Nevinson was not too sick to paint; in March he exhibited with the Allied Artists Association at the Grafton Galleries. His works included his audacious representation of a French machine gun post, *La Mitrailleuse*, which he had painted on the last two days of his honeymoon. Taking his inspiration from a 1915 pencil drawing of the same title by Gaudier-Brzeska, Nevinson showed in this, one of his best-known paintings, how his Futurist, Cubist legacy was the ideal technique for representing modern warfare. Like the steely, screaming figures in Gertler's *Merry-Go-Round*, Nevinson's soldiers are cold-blooded automatons. It was the machine gun, dealing out blind, mechanised slaughter, which had more than anything changed the nature of warfare.

As the critic Lewis Hind wrote of *La Mitrailleuse* in the *London Evening News*: 'When war is no more this picture will stand, to the astonishment

and shame of our descendents, as an example of what civilised man did to civilised man in the first quarter of the twentieth century.'[39] Walter Sickert agreed. He declared in the *Burlington Magazine*: 'Mr Nevinson's "Mitrailleuse" will probably remain the most authoritative and concentrated utterance on the war in the history of painting.'[40]

How had Nevinson achieved this transition from pre-war ridicule and attack to fulsome praise? As Frank Rutter explained in the *Sunday Times*, *La Mitrailleuse* was 'sufficiently "futurist" to be piquant and distinguished, yet no so relentlessly futurist... as to be bewilderingly disintegrated.'[41] Furthermore, cultural critics at large were starting to accept the modernist vision of the avant-garde: it was young men who were making the greatest sacrifice in a war that could be compared to no other in history. Only they could be expected to depict it – and it had to be accepted on their own, modernist terms. Nevinson's picture was bought anonymously and presented to the Contemporary Art Society. They in turn gifted it to the Tate Gallery.

As Nevinson subsequently explained in 1937, 'My obvious belief was that war was now dominated by machines and that men were mere cogs in the mechanism.'[42] Today, the many painted representations of the conflict are so embedded in our consciousness that it is difficult to realise that Nevinson was the first person in England to represent the Great War as this hideous, corrupting, faceless mechanism for mass annihilation. As he claimed, he was the first fully to acknowledge in paint that the traditional opinion, 'that the human element, bravery, the Union Jack, and justice, were all that mattered', was plainly wrong in the face of the devastating, mutilating effects wrought by machine guns, aeroplanes and massed artillery batteries.[43] After the war Nevinson wrote: 'It was said I believed man no longer counted. They were wrong. Man did count. Man will always count. But the man in the tank will, in war, count for more than the man outside.'[44]

• • •

Following the critical success of *La Mitrailleuse*, Nevinson was 'astounded and delighted' to be offered a one-man show at the Leicester Galleries. He 'painted and painted and painted', borrowing earlier works he had sold to put in the exhibition. The private view in September 1916 of 'War' was, however, sparsely attended. Initial interest was slow. Then Michael Sadler bought *Marching Men* and three other pieces, whilst Arnold Bennett purchased *La Patrie*. This spurred public interest, and soon celebrities were coming through the doors, including writers – George Bernard Shaw, Joseph Conrad, John Galsworthy – and politicians – Ramsay MacDonald, Arthur Balfour, Winston Churchill: 'slowly but surely the exhibition sold right out.'[45]

The critical success of this breakthrough exhibition came, Nevinson explained, because 'I was the first artist to paint war pictures without pageantry, without glory, and without the over-coloured heroic that had made up the tradition of all war paintings up to this time.'[46] A student critic from the Slade concurred, reporting in the *UCL Magazine* that Nevinson's work 'is intensely expressive of a sort of mechanical brutality which seems a fit comment upon the pitiless science of modern warfare. The very form of his technique accentuates it.'[47]

Now, finally, Nevinson was a celebrity. His mother would recall how many young soldiers, amongst them Siegfried Sassoon and Osbert Sitwell, 'interested by my son's pictures, came to see us'. Occasionally they held parties for these guests, but such frivolities 'seemed horrible, almost blasphemous' at a time of increasing horror: 'always the men died,' wrote Margaret, 'existence seemed unendurable.'[48]

Though he had achieved fame painting the War, Nevinson had no wish to return to it. Lloyd George, who in December 1916 replaced the exhausted and disillusioned Asquith as Prime Minister, feared Britain was losing the conflict. Nonetheless, he felt obliged to press on. The public, he wrote privately, like his General Staff, 'still cherish the illusions of a complete victory.' The following year, as the situation worsened, he

reflected bitterly that if people really knew the truth 'the war would be stopped tomorrow, but of course they don't – and can't know. The correspondents don't write and the censorship wouldn't pass the truth. The thing is horrible, and beyond human nature to bear, and I feel I can't go on any longer with the bloody business.'[49] But he did go on.

Soon men released from military service on health grounds were being recalled for re-examination. In November, Henry Nevinson recorded his son's 'terror of being called up again'. Richard decided to escape with his wife to neutral Spain, but they were refused passports: he was suspected of being a conscientious objector, a claim Henry vigorously denied. A flight to the south of France was also stymied, and Richard, Henry recorded in December, was consulting a doctor for 'nervous apprehensions'.[50]

It seemed unclear what could be done to save him from the trenches. The war machine was too powerful. On the Western Front, French troops moving up the Line baaed like sheep, in cynical acknowledgment that they were little more than lambs to slaughter.

• • •

In the summer of 1916 the demand for more front line soldiers caught up with Paul Nash. Unlike Nevinson, however, he was keen to see action. In August he began officer training – though he told Mercia Oakley that, whilst he hoped 'to make myself something like an officer before the end, I shall never like soldiering or get any nearer to being a soldier.'[51] In December he was gazetted Second Lieutenant in the Hampshire Regiment; on 22 February 1917 he landed in France. He was soon with the 15th battalion on the Ypres Salient.

As ever, Nash was alert to the new world around him. Marching up to the Front he was still capable of discovering surprising sights amid the destruction – spring flowers blooming, green buds on the trees in a shell-destroyed wood still 'reeking with poison gas', where a nightingale sang. 'Ridiculous mad incongruity!' he wrote to Margaret. 'One can't think which is the more absurd, the War or Nature.'[52]

Luckily for Nash it was a quiet time in the Line, and at first he was happy. 'It sounds absurd, but life has a greater meaning here and a new zest, and beauty is more poignant,' he told Margaret in March.[53] He continued to draw, making sketches of the blasted woods, a ruined church, a scarred hill, and 'the trenches under a bloody sort of sunset, the crescent moon sailing above'. A month later he was writing, 'Oh, these wonderful trenches at night, at dawn, at sundown! Shall I ever lose the picture they have made in my mind?'[54]

He sent Margaret detailed descriptions of his nocturnal routine: 'I go round the slimy duck-boards down the trench with the sergeant, seeing that all is well, sometimes inciting a listless sniper to fire, or the Lewis gunner to play a burst to show the Huns we are really awake. At intervals we send up Very lights and the ghastly face of No Man's Land leaps up in the garish light, then, as the rocket falls, the great shadows flow back shutting it into darkness again.'[55]

But as his time in the trenches lengthened, and as he grew closer to the men under his command, his attitude changed. Like Carrington, he came to hate the journalists' jingoistic propaganda that only seemed to prolong the War – the Government vetted official war reporters, and left-wing 'troublemakers' like Henry Nevinson were refused easy access to the Front. The endless articles in the press about profiteers, together with Margaret's talk of the threat of armed insurrection at home (as there already had been in Russia, where the Tsar had recently been overthrown by the Bolsheviks) angered Nash. He gave full vent to his feelings:

> It is intolerable – I cannot read the papers – it's just humbug, from end to end. We need a spirit to stamp out cant and lies from England... You speak of a revolution that will come at home if war grinds us to famine; it would be a pity to nurse your sorrows and your wrongs until the men return, that is when revolution will come. Out here men have

been thinking, living so near to silence and death, their thoughts have been furious, keen, and living has been alive. Hammering in their minds are a hundred questions, festering in their hearts a thousand wrongs. The most insistent question is 'Why am I here?'[56]

There was strangeness to this 'monstrous land', he confided in Margaret towards the end of April. The Front was a 'nightmare' where nothing seemed real.[57]

In May he told his wife that he and his men were 'sad and sick with longing for the end of this awful unending madness. I cannot get things straight at all. What is God about?... The cause of war was probably quite futile and mean, but the effect of it is huge.' Yet, as if girding himself and his wife for the forthcoming 'Big Push' that was supposed to bring a quick end to the War, he quoted Tennyson, assuring her, "*I have felt that I am one with my native land.*" He added too that he felt 'lucky in joining the Company... I believe when the time comes, they will follow me over the top to a man.'[58] They waited, restlessly, for that decisive moment.

Then on the night of 25 May 1917, a week before the assault, in the darkness Nash fell from a parapet and into a trench, breaking a rib. By 1 June he was back in London. The war machine rolled relentlessly on: a few days later his regiment attacked Hill 60, where many of his fellow officers and men were duly slaughtered. As he acknowledged, his escape 'was a queer lucky accident', and one that quite likely saved his life.[59]

• • •

The year 1916 was proving one of change and extraordinary new experiences for Spencer, too. In July his RAMC company shipped out to Macedonia, where the Allies were opening a new front through Greece and Bulgaria to the Balkans. For the first time in his life, Spencer left England; it was an awe-inspiring experience. Steaming through the Straits

'I shall never like soldiering or get any nearer to being a soldier': Paul Nash in uniform, 1918

of Gibraltar their convoy passed Algeria. 'It looked very mysterious', he informed the Raverats: 'it was just like being in the Bible.'[60] Later, anchored in the Gulf of Salonika, he saw the old Ottoman-Turkish port in the distance, 'its lights at night & minarets just visible in the blue darkness.'

In a strange way, Desmond Chute's lyrical recitations from the *Odyssey* and the *Iliad* had prepared him for this. Disembarked and in the warm darkness of camp, amongst candlelight and the low hum of conversation, he heard the voice of a man arriving with news from the Front: 'If he had been Hermes straight from Olympus with messages from Zeus I should not have felt more moved.'[61]

Travelling on a Macedonian train to join his Field Hospital Unit, he sat 'entranced by the landscapes from the window. Low plains with trees & looking through trees to strange further plains... & here & there a figure in dirty white. It was not landscape, it was a spiritual world'. Heading up the line above Lake Ardzan he witnessed a grass fire 'like a huge dragon stretching the length of the lake & reflected in it.' There were the sights of oxen under yokes; men passing slowly on mules; distant, rugged mountains. At night, sleeping beneath the stars, he heard in the darkness 'wolfish dog's symposiums'.[62] A soldier

excited him with talk of old Maltese churches, 'full of frescoes'.[63]

Whilst Beaufort War Hospital had cast him down, here in this extraordinary, ancient land, amongst the family-like comradeship of an active service unit, Spencer's spirit was uplifted, sometimes to an almost joyful plane. Yet it was agony to be unable to paint it.

The following spring, French, Serb and British forces launched a joint offensive against the Bulgarians. But their army, dug in to defensive positions on high ground, could not be shifted. Once more, thousands died to little effect. Stalemate ensued.

In the long months of inactivity that followed, books were Spencer's lifeline: friends and family kept him well supplied. In a letter to Henry Lamb he listed his reading material: Chaucer, Shakespeare, Blake, Keats, Milton, Dickens, Marlowe, the Bible, as well as Ruskin's life of Giotto and various of his trusty Gowans & Grays. 'When it is possible, several chaps offer to carry one or two each', he explained to Lamb.[64] He described his books as 'Heavenly Armour', with Milton his 'Glittering Spear'.[65]

On top of this were regular letters from England. His sister Florence sent news that Sydney had earned his BA from Oxford: 'Bless his heart,' wrote Stanley, 'I would love to see him.'[66] And Lady Ottoline wrote enclosing photographs of life at Garsington. 'Everything is so different from my Slade days', he replied, 'that I think I must be on a new planet.' But he added that he was thinking of returning to the school for a term after the war, 'that is if Tonks is still master'. He had done a lot of drawings of heads for the other soldiers: 'I think they are better than any heads I ever did in England. I have got over a lot of my "Slade"ish ways, though not all.'[67]

And he received copies of the *UCL Magazine*, which 'contained a lot of real interesting news about a lot of my old Slade friends'.[68] Ottoline in turn passed round news of Spencer. Carrington reported to Gertler that she had heard that Spencer was 'drawing away in Salonika in the trenches,

& doing some good work. He is quite happy as he likes the climate. What a strange character!'[69]

But he missed Cookham. In July 1917 he told the Raverats how he longed 'for a peaceful English sunny afternoon, a walk across the causeway from the station to home', the sound of bread being cut for tea and 'the clock ticking on the high mantelpiece.'[70] To Ottoline he recalled the blissfulness of early morning plunges into 'the crisp cool swimming water at Odney Weir, & to see the sun rising above Cliveden woods & casting a long dazzling shaft of light along the surface of the water & to dive into that light & to feel all the glorious promise of the day... It is how I would like heaven to be.'[71]

Yet in a letter to his sister he admitted, 'I would not have missed seeing the things I have seen since I left England for anything'.[72]

Chapter 17

War Artists

In March 1917 Nevinson discovered that the new Military Service Act would soon mean his rheumatic discharge no longer automatically exempted him from call-up. With nearly half a million British men already killed, the prospect of rejoining the military machine hardly bore thinking about. He consulted a specialist about his nervous condition. The doctor announced that 'his nerve [was] all gone', that he was 'almost insane'. Richard told his father that he would 'never go back to the army alive', and a 'wretched sleepless night of terror' followed.[1]

Doing all he could to avoid conscription, Nevinson contacted a friend of his father's. C.F.G. Masterman had been a Liberal MP and a member of the Cabinet; he was now head of the War Propaganda Bureau. He and Richard met on 1 April. Richard also wrote to Eddie Marsh, seeking advice on how to get attached to a recently created army section 'that paints & disguises guns etc for invisibility from aeroplanes'. The word used for this new-fangled operation was 'camouflage': 'I think you agree with me', he told Marsh, 'that such knowledge as I may possess of colours, tones etc. would be of more use to the country in this section of the army'.

A phone call eventually came through from the War Office, proposing that he go to France as a private sapper working in camouflage. He was reluctant to return to the ranks, however: 'not from any snobbish reason', he explained to Marsh, 'but because of its hardships... & its loneliness

which breaks my spirit.' An officer's commission in the Artists' Rifles would be better – but it seemed that there was nothing more Marsh could do.[2]

Then, at the end of April, Richard's meeting with Masterman paid off: the Under-Secretary for War, 'in spite of his personal dislike of my work', had been persuaded to put Nevinson's name forward as an Official War Artist. Richard wrote to Marsh again, asking him to 'put in a word'. He feared he stood 'very little chance' of getting a position, but was pleased to hear that Marsh liked his recent paintings: 'it needed a little moral courage to come out of what I now consider the cul-de-sac of pure abstract painting', he explained.[3]

The Official War Artists scheme had received official backing in June 1916, largely through the efforts of the Scottish printmaker, Muirhead Bone, who almost single-handedly created the job as a way of avoiding conscription himself.[4] His suggestion that artists be sent to France to record the War met a need that had been noted in a wide number of circles, including the Slade. As a student had written in the *UCL Magazine* in March that year: 'What a pity it is that practically no pictorial records of the war have been made by competent eye-witnesses – except kinema productions, which live for the moment only: the Authorities apparently grant few facilities to experienced men to visit the battle line.'[5]

Things started to change in 1916. With the honorary rank of second lieutenant and an annual salary of £500, Bone was sent to the Front as the first Official War Artist; he arrived on the Somme in August and immediately set to work. Over the next two and a half years many more artists either asked, or were invited, to join the programme. Among the first were Bone's brother-in-law, Francis Dodd, followed by Eric Kennington and William Orpen.

Bone liked what he had seen of Nevinson's war work. Masterman, too, felt there was 'no doubt he has genius... I think he might do some work original in character but quite remarkable in substance'.[6] Masterman

was also impressed by Nevinson himself: 'He is a desperate fellow and without fear', he told the author, John Buchan, who was employed as the Director of the Department of Information, 'only anxious to crawl into the front line and draw things full of violence and terror.'[7] Nevinson's talent for imitation was remarkable: he could play the role of war hero, but this was hardly an accurate impression. With his father (and possibly Marsh) at work behind the scenes, at the end of June 1917 Richard was accepted into the War Artists scheme. He would not, however, receive either salary or rank. Dressed in his father's war correspondent uniform and with a press brassard on his arm, he arrived in France at the beginning of July, where he was provided with a car and driver.

As Masterman gave the Official Artists free rein, Nevinson was uncertain what exactly was expected of him. 'Nevinson and Kennington have continually asked me for instructions as to what they should draw', Masterman observed in October, 'but I have always taken the view that it is not for a Government Department to attempt to regulate artists in their work, art being so largely individual in expression.'[8] This was a commendable attitude. The Official War Artists were not simply producing propaganda; they were there to make historical records, too. It was hoped, furthermore, that this independence would highlight British traits of autonomy, in distinction to what was considered the authoritarianism of Prussian *Kultur*. This, if anything, was one of the high-minded British ideals behind the war.[*] The British avant-garde would storm the moral high ground.

Based first near Caen, Nevinson soon moved closer to the Front, driving and drawing, as he explained to Masterman, 'all about the line North &

* This would not always work in practice. An official in the War Office, who considered its subjects to be of 'degenerate' appearance, attempted to censor Nevinson's 1917 painting, *A Group of Soldiers*, on the grounds that it might be used by the Germans as propaganda. But, as Masterman told him, 'If we judge of its ugliness or beauty as censors we are "in the soup" at once!!'[9]

South in trenches, balloons, aeroplanes, batteries, dug-outs & most of the roads behind the lines'.[10] His first ascent in an observation balloon was interrupted by an attack by a German fighter plane, and on numerous occasions the front line positions he visited were being shelled or machine-gunned.[11] But at least he was there as an artist, not cannon fodder.

By early August, he was back in London. The month-long excursion to the war zone had done nothing for his nerves – and little for his art. Masterman

had told Nevinson 'to develop his own genius – however bitter and uncompromising!!' But he felt that the artist had actually 'abandoned his own metier in order to produce *official* (perhaps tame) pictures.'[12]

When the artist Thomas Derrick visited Nevinson at his studio in October, he, too, was concerned that he had self-censored in both style and subject matter. As Derrick explained in a report to Masterman, Nevinson

'I was the first man to paint in the air, and… I still think my aeroplane pictures are the finest work I have done': Richard Nevinson, Sweeping Down on a Taube, 1917

had 'avoided the more revolting aspects of the business', and had 'restrained himself – almost to

the point of dullness'. He added that when he next visited Nevinson, he would advise him that his 'unrestrained, savage self, can appear in subsequent work, without giving offence in official quarters.'[13]* Nevinson would heed this advice, though with problematic results.

* Claude Phillips, who had thrown the catalogue of Roger Fry's first post-impressionist exhibition down in the street and stamped on it, would be pleased to announce on viewing some of these paintings in 1919 that Nevinson was 'no longer [to] be counted among cubists, hardly indeed among the ultra-moderns'.[14]

Reproductions of Nevinson's new work were soon published as a propaganda magazine, *Modern War Paintings*. In his accompanying introduction, the art critic P.G. Konody wrote that it was

> inevitable that the painter who could successfully grapple with the unprecedented conditions of modern warfare should be an adherent of the modern school, an artist who has assimilated the theories of Post-Impressionism, Cubism and Futurism... One solitary artist of the independent group has had the courage to undertake the inspiring task. C.R.W. Nevinson stands alone in England, as the painter of modern war.[15]

An exhibition, simply titled *War*, was held at the Leicester Galleries the following spring. It was hugely successful, with the opening attracting many important people. Still, it was not without a controversy – though Nevinson used this as excellent publicity. Despite Masterman's advice that he should paint whatever he liked, Nevinson was enraged to be told by officials at the War Office that *Paths of Glory*, which depicted two dead Tommies lying beneath a fence of barbed war, could not be shown. Rather than withdraw the offending picture, Nevinson obscured the corpses with a strip of brown paper, writing the word 'CENSORED' across it.

Nevinson designed this striking poster for the War Bonds Department in 1918

273

The subsequent controversy did nothing for his health, and Henry feared that his son was 'almost insane with anxiety'. Diagnosed by a neurologist as suffering from 'nerves and acute insomnia', Richard headed to Cornwall with his wife for a holiday. But he could not cope with having 'endless leisure for brooding', and they returned to London. Henry Nevinson would soon be writing nervously of his son's 'haunted mind'.[16]

Painting could not excise the ghosts of what Richard had witnessed in France. With the conscription laws constantly changing to keep up with the demand for more men, he feared that before long, he too would be called up to serve at the Front.

• • •

During his convalescence from the injury he had sustained in the trenches, Paul Nash had made a series of some twenty drawings in ink, chalk and watercolour of what he had seen in Flanders. Again he was painting landscape – but this was a landscape ravaged, brutalised, murdered by mechanised warfare. And his style had changed to meet this new experience. Nash had seen a copy of *Blast* in 1914, but neither Vorticism nor Futurism had then made much impact on his work. Futurism had held little relevance to his interest in the spiritual realms of the natural world. But once in Flanders, he had been struck by Nevinson's vision of the conflict. Towards the end of March 1917, whilst still in Flanders, Nash had asked his wife to send him a copy of Nevinson's etching, *Ypres After the First Bombardment*.

'I should like to have it if possible', he explained. 'It is part of the world I'm interested in.'[17] The sight of ruined houses behind the Line was 'wonderful', and he told Margaret. 'I begin to believe in the Vorticist doctrine of destruction almost.'[18]

The subsequent series of landscapes that Nash exhibited at the Goupil Gallery in June 1917 showed more modern influences, and were well received – Carrington recorded that he 'sold quite a number the first day',

'Only the black rain out of the bruised and swollen clouds... is fit
atmosphere in such a land': Paul Nash, Rain: Lake Zillebeke, *1918.*

and Nevinson was among those who bought a work (the Futurist-looking
Obstacle).[19] Nash was pleased with his success – and he and Nevinson
met up, no doubt to discuss art and the war. Nevinson started to teach
Nash lithography and, just as Nevinson was abandoning it, under his
guidance the pointed, zigzag style of Futurism and Vorticism started to
make an ever-greater impression on Nash's work. More importantly, in
July Nevinson told Nash that he should contact Masterman at the War
Artists Advisory Commission.[20]

Nash had a number of influential advocates to support his application
for a commission. They included Eddie Marsh, William Rothenstein,
Roger Fry and Henry Tonks. Marsh advised Buchan that 'it is safe to say
that Paul Nash is one of "les jeunes" who are generally considered as
"to be reckoned with".'[21] Some officials were not so certain. Campbell
Dodgson, Keeper of Prints and Drawings at the British Museum and an
advisor to the War Artists Advisory Committee, felt that drawings of the
Front by Nash 'would harmonize very well with Nevinson's paintings'.

But he added that Nash's work was 'decidedly post-impressionist, not cubist, but "decorative", and his art is certainly not what the British public generally will like'. It might, however, 'be welcomed by artists, and by connoisseurs who follow with interest the more modern developments, and the influence of recent French painting.'[22]

Francis Stopford, the editor of *Land & Water*, saw a propaganda opportunity, however. He told Buchan that Nash's exhibition at the Goupil Gallery was 'quite one of the best War Exhibitions that have been held... you come away from it with a much better understanding of German brutality and of the needless havoc and destruction which German armies are committing'.[23]

Though Masterman agreed with Buchan that he was 'not very struck with Paul Nash's productions', since there was 'a tremendous consensus of opinion about his work', the Director of Propaganda decided to commission him.[24] Nash was with a reserve battalion near Portsmouth, about to ship out to France, when his alternative call-up arrived at the end of August. He was soon back in Flanders – this time not as a combatant, but as a uniformed observer, with a batman and chauffeur-driven car.

Nevinson's artistic vision had been softened by his official appointment, but Nash's would be angrily, vigorously emboldened. There had been a certain detachedness to the war pictures he had exhibited in the summer. They remained largely unmarked by the real tragedy of the conflict. His experience in the trenches had been too limited, too uneventful. General Headquarters wanted Nash to operate from behind the Lines, but this would not have given him the direct experiences he needed – the experience of the horror of the war that Nevinson had witnessed first hand in 'The Shambles'.

Using 'nothing but brown paper and chalks' to make his sketches, Nash insisted on 'getting as near to the real places of action as it was possible to go'. By the time he returned to the trenches it was mud-soaked winter, and the Third Battle of Ypres – better known as Passchendaele

– had been struggling hopelessly through the quagmire for three bloody months. With mustard gas recently used for the first time, it was even more of a hellhole than the one he had escaped from in March. It was an abomination that the jingoistic British press was still failing to represent in all its awful truth.

On 16 November 1917, a day after he was 'damn nearly killed' by German shellfire, Nash recorded his impressions of the slaughterhouse in a long, impassioned letter to his wife:

'The roads and tracks are covered in inches of slime, the black dying trees ooze and sweat and the shells never cease': Ypres, 1917

I have seen the most frightful nightmare of a country more conceived by Dante or Poe than by nature, unspeakable, utterly indescribable. In the fifteen drawings I have made I may give you some vague idea of the horror, but only being in it can ever make you sensible of its dreadful nature and of what our men in France have to face. We all have a vague notion of the terrors of a battle... but no pen or drawing can convey this country – the normal setting of the battles taking place day and night, month after month. Evil and

the incarnate fiend alone can be master of this war, and no glimmer of God's hand is seen anywhere. Sunset and sunrise are blasphemous, they are mockeries to man, only the black rain out of the bruised and swollen clouds all through the bitter black of night is fit atmosphere in such a land. The rain drives on, the stinking mud becomes more evilly yellow, the shell holes fill up with green-white water, the roads and tracks are covered in inches of slime, the black dying trees ooze and sweat and the shells never cease. They alone plunge overhead, tearing away the rotting tree stumps, breaking the plank roads, striking down horses and mules, annihilating, maiming, maddening, they plunge into the grave which is this land; one huge grave and cast up on it the poor dead. It is unspeakable, godless, hopeless. I am no longer an artist interested and curious, I am a messenger who will bring back word from the men who are fighting to those who want the war to go on forever. Feeble, inarticulate, will be my message, but it will have a bitter truth, and may it burn their lousy souls.[25]

With this furious objective, Nash returned to England with more than '50 drawings of muddy places'.[26] He began working them up for a one-man exhibition, held at the Leicester Galleries in May 1918. It was titled 'Void of War'.

As *The Times* reported, Nash's war-torn landscapes depicted a world of 'utter chaos... You feel that it has been seen with frightened eyes, eyes frightened at the inhumanity of it. It is waste – the waste of worlds, of ages, which looks as if it had been made by some indifferent will of nature. And then we remember that it has been made by man in his babyish will to power.' The critic added that Nash's drawings might be used 'in the propaganda of a league of peace.'[27]

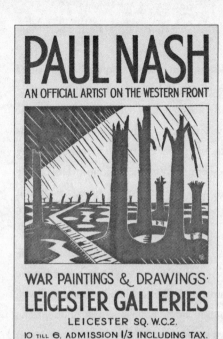

PAUL NASH

AN OFFICIAL ARTIST ON THE WESTERN FRONT

WAR PAINTINGS & DRAWINGS·
LEICESTER GALLERIES
LEICESTER SQ. W.C.2.
10 TILL 6. ADMISSION 1/3 INCLUDING TAX.

Nash's stark woodcut poster for his 1918 exhibition clearly reveals the influence of both Nevinson and Vorticism

The *Daily Telegraph* was critical of Nevinson's recent influence on Nash;[28] but in contrast to Nevinson's interpretation of the War as a pitiless, murderous machine, Nash – through his love and almost mystical appreciation of the natural world – had achieved a curious thing: Nature, not Man, became his emblem of suffering. With his devastated woods and disembowelled hillsides, Nash made the Great War seem fathomable through what it had done so destructively to an innocent landscape.

With the success of this exhibition, Nash was commissioned by the WAAC to paint a major canvas. Before now, he had worked almost entirely in pen and ink, embellished with chalk and watercolour. Oil was an entirely new medium. Nash chose as his subject the Menin Road, the chief thoroughfare east out of Ypres, and scene of some of the heaviest shelling during the Passchendaele offensive; it would be a huge painting, some sixty square feet of canvas. Broken trees play an important role, with thick shafts of sunlight penetrating the gloom. In the middle ground, among zigzagging trenches, there are soldiers, dwarfed by the dismembered landscape surrounding them. In July, Nash told Gordon Bottomley that his first attempts at oil painting had been 'a complete experiment you know – a piece of towering audacity'.[29] As he would add the following year, when the

painting was finally completed, *The Menin Road* was 'by far the best thing I have yet done'.[30]

Other works painted at the same time, such as the ironically titled *We Are Making a New World*, were equally successful. In this painting, a mass of cloud is illuminated blood red by the dawn sun, starkly silhouetting the stumps of broken trees. It is as if Nature bleeds over the shattered land – with trees, of course, representing living personalities for Nash. It is a scene of pitiable emotion. Devoid of human figures, but overflowing with the impact of human action, it is an unmerciful evocation of the devastation and pointlessness of the War.

We Are Making a New World appeared on the front cover of the third part of *British Artists at the Front*, and was soon purchased for the nation. The critics were again impressed. Herbert Read, who served with distinction on the Western Front and would emerge as England's leading post-war critic, wrote that on first seeing Nash's work, 'I was immediately convinced' that he 'could convey, as no other artist, the phantasmagoric atmosphere of No Man's Land.' For Read, Nash revealed the war's 'outrage on Nature – the Nature which had been so delicate and sensuous to New English eyes.'[31]

As John Salis observed in the 1918 magazine *British Artists at the Front*, Nash's images were 'a full record of what war means to Nature.' They seemed as though they were 'torn from the sulphurous rim of the inferno itself.'[32] In Salis's opinion, only a man like Nash could have produced such work, a man whose 'comprehension of nature is a thing born in him as his skeleton'.[33]

• • •

Whilst in France Nash had searched for his brother, who was still at the Front with the Artists' Rifles. In November he found John, 'miraculously spared' and 'looking very well – a bronzed and tattered soldier, with incredible hands overgrown with cuticle'; they spent 'a jolly day' motoring

through the French countryside.[34] Back in England, Paul immediately did all he could to get his brother out.

'Can you by any fair or foul means help Jack home for a commission?' he asked Eddie Marsh. 'It is unnecessary to speak of Jack's worth & his real value as an English artist and it's a damned shame if nothing can be done to extricate him from a position in which he is in utmost danger.' He added, 'All my own success & happiness turns bitter while I think of Jack in the trenches.'[35]

Then, on 30 December 1917, John's luck nearly ran out when his Battalion were ordered over the top. It was a bitterly cold day, and as they advanced across No Man's Land the Artists' Rifles were stopped dead in the snow. It was 'pure murder', John later recalled, 'and I was lucky to escape untouched.'[36]

John Nash was doubly fortunate: Eddie Marsh was soon able to pull the necessary strings to get him home on leave, though he still had to wait nervously for confirmation of his appointment as an Official War Artist. Carrington visited the brothers at Iver Heath: she had already found Paul 'much less bumptious' since the War had taken its effect, but told Noel that 'Jack seemed rather nervy. He has been having a very bad time of it and nearly all his company was killed... I think he may get one of those artist's jobs and so get transferred home. I hope so. He deserves it more than Nevinson or Paul Nash.'[37]

Carrington, now in her mid-twenties, was increasingly asserting her independence. In September 1916 she had moved into the attic rooms of 3 Gower Street, just around the corner from the Slade. She was to share the house with Brett and Katherine Mansfield, and two of Strachey's Cambridge friends – one being the economist John Maynard Keynes. She busied herself with visits to Museums and the opera; to make money she sometimes taught private art classes, worked occasionally for Roger Fry at Hampton Court, and she made woodcut illustrations for Leonard and Virginia Woolf's fledgling Hogarth Press.

Her growing self-determination asserted itself in other ways, too. Having surrendered her virginity – or at least some part of her physical innocence – to Strachey, Carrington at last succumbed to Gertler's insistent attentions. Despite considering it 'vulgar', she consented to what she coyly called 'sugar in her coffee': sexual intercourse. After a few days in December spent alone at Gilbert Cannan's Mill House making love, she cautioned Mark that his supply would be strictly rationed to 'three lumps a month. You've had more than three for this month', she told him, 'So no more till next year, you sugar eater you!'[38]

Mark was so pleased at the prospect of *any* sex with Carrington that he did not feel concerned about rationing: 'I shan't worry you for much "sugar" if only I can see you and talk – I must, I must... Give me time – give me at any rate a year or so of happiness. I deserve it – you have tortured me enough in the past.' The Morrells, though, had succeeded in their advocation of 'free love'. The idea that she could have many lovers appealed to Carrington. It was an argument Mark refused to accept. 'Don't believe those "advanced" fools who tell you love is free. *It is not* – it is a *bondage*, a beautiful bondage. We are bound to one another – you must love the bondage.'[39]

Despite her talk of 'free love', sex would never come easily to Carrington, and the thought of pregnancy filled her with 'absolute horror'.[40] She warned him that they could never live together: 'You are too possessive, & I too free... If I wasn't such a damned egotist, it would be simpler.'[41]

But she was his inspiration: 'you stimulate me in a way that no person or idea can, without this stimulation, I would not paint or live', he told her.[42] Yet he believed it was her devotion to work that stood between them: 'You think that by living with me you will not be able to carry on your work. It is not that you don't love me. You *do* love me & even sex would not hinder you, it's your work. That's what I hate about you

because I *know* that we could work *better* together.' He even suggested that they could live together '*without sex*. It's your constant companionship that I want so frightfully.'[43*]

Their sexual relationship lasted only a few fraught months. She grew tired of his constant pleas to live together, and at Easter 1917 finally confessed to her relationship with Strachey. He was appalled and disgusted. Sacheverell Sitwell – who acknowledged that with her 'distinctive yet classless appearance' there was 'certainly an aura attaching' to Carrington – wrote that Gertler could not understand her 'devotion to the freakish and anything but kind-tongued Lytton Strachey'.[44]

John Nash had told Carrington that he had 'always been repelled' by Strachey's 'outward appearance'.[45] Yet Carrington, too, felt an outcast from her body. 'Today I have been suffering agonies because I am a woman', she had told Mark in 1915. 'All this makes me so angry, & I despise myself so much.' On another occasion she told him, 'It is a mystery to me that my bulk & size should ever move anyone!'[46] This shared discomfort with their physical appearance was one of the things uniting her with Strachey. She also appreciated his great intellect; the opportunity to learn from him, and for life to be exciting yet at the same time calm and regulated. Gertler, she told Strachey, had 'wanted each day to be wildly chaotic. I hated it because it had no connection with one's life, & was so devastating.'[47]

At the end of 1917 Carrington's parents left Hurstbourne Tarrant. Going back to sort out her things, she discovered many old love letters. She wrote to Mark that she had found 'all those very early ones of yours & Nevinson's. And then I suddenly remembered how long it had been. And felt this end didn't justify such a struggle on your part.'[48] By then it

* Gertler had once told Brett, 'There is my Art that is greater than woman & more infinite & when I die I shall be more pleased if my work shall be such, that will give pleasure to many after I have gone. I say that will please me more than if my love affairs have been successful.'[49]

was the end. Though they continued to correspond and meet from time to time in London (and even briefly to resume sexual relations), Gertler was nauseated by her relationship with that 'half-dead creature', Strachey: 'you prostitute yourself to his lust', he told her. 'I hate you for it'.[50]

A far stronger, but unsent, letter declared, 'You have by your love for that man poisoned my belief in love, life and everything; you by that love turned everything that I once believed in and thought beautiful into ridicule. I laugh bitterly the whole time now at this wretched rigmarole we call life.'[51]

Had Carrington ruined Gertler's life? Perhaps – certainly she had (as Nevinson had warned long before) kept him hanging on, clawing him back whenever she seemed in danger of losing him. Yet she had long feared that, even with her, Gertler would never be happy. Certainly he would never love anyone else with the same intensity, devotion or twisted pleasure. As he told Koteliansky in December 1917: 'I sometimes think my real life will not commence before my passion for Carrington ends. But God knows when it will end.'[52]

• • •

Though loath to lose her friendship with Gertler, Carrington was devoted to Strachey. When he stayed a few nights at her Frith Street studio, she wrote to a friend afterwards, 'I've never been so happy in my *life* before.'[53] In August she would tell him, 'Every moment, when something definite is not being done – I am thinking of you.'[54]

The portrait she painted of him during the early part of 1917 captures the intimacy they shared in contemplative study, the reading of books, and a friendship that contrasted with the passion and urgent sexuality that characterised Gertler's relationships with women. Privately, she considered her portrait of Strachey 'wonderfully good', but she dreaded showing it to any one. As she told the subject of what would become her most famous painting, it was 'marvellous' simply having it all to herself to work on, free from public appraisal or comment.[55]

Strachey was still busy working on his collection of four brief Victorian lives,* and was not yet equally committed to Carrington. 'That woman will dog me,' he told Virginia Woolf in December 1917. 'She won't let me write, I daresay.' Virginia responded that, in Ottoline Morrell's opinion, he would end up marrying Carrington.

'One thing I know', Strachey countered, 'I'll never marry anyone.'[56]

Yet he and Carrington were already talking about finding somewhere in the country, where they could live together and work, and which could also provide an occasional retreat for wealthy Bloomsbury friends such as Keynes, who would help to finance it. Carrington had explored the countryside on her bicycle for months trying to locate the ideal place. Then, in October 1917, it was Carrington's mother, ironically, who showed her an advert for the Mill House at Tidmarsh, near Pangbourne in Berkshire. It had six bedrooms, three large living rooms, electric lighting and an acre of garden and orchards. It was, she told Lytton, 'very romantic and lovely... I'm wildly excited. Hooray!'[57]

Carrington, who told her mother that the house was to be a rural retreat for female students from the Slade, moved in in November. She set to work making it habitable for Lytton's arrival. In time, paintings by Duncan Grant, Vanessa Bell, John Nash, Augustus John and Gertler lined the walls, along with shelves and shelves of Lytton's books.

Strachey's Bloomsbury friends remained suspicious of Carrington. Virginia Woolf was unsure whether to judge her as an artist or not ('She seems to be an artist', she wrote, uncertainly, in her diary), and found her 'mixture of impulse & self consciousness' odd – and possibly contrived. 'I wonder sometimes what she's at', she wrote in June 1918, 'so eager to please, conciliatory, restless, & active. I suppose the tug of Lytton's influences deranges her spiritual balance a good deal... but she is such a

* The subjects of the biographies were General Charles Gordon, Florence Nightingale, Cardinal Henry Manning and Dr Thomas Arnold.

bustling eager creature, so red & solid, & at the same time inquisitive, that one can't help liking her.'[58]* Lytton, she thought, was a father figure to her – undoubtedly an accurate assessment of the couple's unconventional relationship.[59]† Gertler – with whom Carrington continued to correspond – warned her that the 'Bloomsburies' were 'capricious and vicious... they all back-bite the supposed love and best friend! It is all so small – so hateful – and *you* will *not* see it...'[60]

Virginia Woolf found Gertler – whom she met for the first time that summer – almost as puzzling as Carrington. Her husband, Leonard, was Jewish, and she felt there was 'something condensed in all Jews'. Gertler's mind, she observed when he and Koteliansky visited them for dinner, 'certainly had a powerful spring to it.' He was, furthermore, 'an immense egoist' who thought himself 'very much cleverer than most painters... He means by sheer will power to conquer art.' When she visited his studio the following month, he told her of the 'agony' of his work, and of his obsession since childhood with shape, form and colour. Everything, she found, was 'tight curled, tense, muscular about him'. She advised him, 'for art's sake, to keep sane; to grasp, & not exaggerate, & put sheets of glass between him and his matter.'[61]

Gertler was well aware of the danger. As he had told Mary Hutchinson two years earlier, 'I want to do so much. But I must take care, I must go slowly, I must learn to have patience & control or I shall destroy myself.'[62] His struggles continued. 'No one knows what my inner life is like,' he told Ottoline, who was one of his chief emotional props during the war years,

* Even Gertler felt there was sometimes something two-faced about Carrington. 'I used to get so irritated with Carrington,' he told Brett in 1918, 'who would show much enthusiasm before my work, & then, behind my back, she would find fault and not breathe a word of it to me, & I had to find out from other people what she really thought.'[63]

† Strachey and Carrington shared a similar family background: Lytton's father was an army officer who spent much of his career in India, whilst his mother was thirty years younger than her husband. Sir Richard Strachey was in his early sixties when Lytton, his eleventh child, was born.

'no one knows what big price one has to pay for painting *real* pictures & *living real* life!'[64]

In February 1917, Gertler's father died suddenly of bronchitis. It proved a difficult time, and much of the early part of that year he spent working on a wooden sculpture of acrobats that he exhibited at the London Group: it received little notice. He struggled for a long time on a painting of bathers at Garsington. It, too, was a failure of both form and function. By early 1918 his health was poor, and a severe cold, he told Ottoline in February, had succeeded in 'thoroughly depressing' him. 'I see everything in the Blackest possible light, especially the War, which I don't think will ever end!'

Only his commitment to painting kept him physically and emotionally afloat. Yet even this was not always enough. As he told her,

> some times in the evenings when my work is over, the light goes out, and everything seems as black as death, I fight hard, I try to be brave, but it is terribly hard... Painting alone is so terribly hard, you have no idea. Sometimes my head whirls round, over the problem of it all, so much, that I feel I shall go mad. All this hard struggle tells on my health, and I am constantly verging on complete break down. Only every now and then do I see a brilliant light in the dim distance – for a moment – and these moments keep me going.[65]

Early in March he appealed against his conscription, citing both 'conscientious grounds' and his Austrian parentage. He consented, however, that he was prepared to do 'work of national importance'.[66] He told Ottoline that what he wanted most was to be accepted as a conscientious objector and given work on Philip's Garsington farm, where he could then also paint. The prospect of the Army was appalling: he told Brett the only consolation was, 'I shall have at least

a gun, which I can use to end it all, if the position becomes really unbearable!'[67]

Slade colleagues who had joined up were suffering terribly. David Bomberg, who was serving with the Royal Engineers in Flanders, shot himself in the foot. An officer at the army hospital where he was treated tried persuading him to say that it had been an accident. But, as Bomberg's wife recalled, 'David insisted that he had fired the shot deliberately, because he had found life too hard to bear – and must make some protest, whatever punishment it brought'.[68] In January 1918, Isaac Rosenberg, who was serving at the Front in an infantry regiment, wrote to Eddie Marsh: 'Christ never endured what I endure. It is breaking me completely'.[69]

Then – almost inevitably – at the end of March Gertler failed his medical. He was rejected outright for military service. The experience had done nothing for his nerves. He left the Recruitment Office in London 'somehow stunned by the whole affair'. Clutching his rejection papers, he felt 'bewildered and unsettled... very unnerved and ill'.[70]

• • •

As spring 1918 wore on, news from the Front became increasingly ominous. On 21 March, having put Bolshevik Russia out of the war in the east, the Germans launched the first of a huge three-pronged attack in a final bid to win the war in the west. It almost succeeded. On 12 April General Sir Douglas Haig issued an 'order of the day': 'There is no other course open to us but to fight it out!... With our backs to the wall, and believing in the justice of our cause, each one of us must fight on to the end.'[71]

'London seems overshadowed by a huge very ominous Cloud,' Gertler told Lady Ottoline, 'there is an almost frightening Dead Calm over everything. I have never felt London like this before.'[72] But, at the cost of thousands more Allied lives – British, ANZAC, Indian, African, Canadian, French, American – the crisis was overcome: Germany and

Austria simply did not have the manpower or the morale to win the war. The tide had turned. By early August their armies were in retreat.

It was in May, at the height of the Allied crisis, that John Nash finally received the news of his artist's commission. He did not return to France, and the following month he and Paul set up studio in an old herb-drying shed in the Buckinghamshire village of Chalfont St Peter. Their wives came with them, and the peacefulness of the countryside was in curious contrast to all that had gone before. As Paul told Bottomley in July: 'How difficult it is, folded as we are in the luxuriant green country, to put it aside and brood on those wastes in Flanders, the torments, the cruelty & terror of this war. Well it is on *these* I brood for it seems the only justification of what I do now – if I can rob the war of the last shred of glory, the last shine of glamour.' He felt very serious about the 'big picture' the War Artists Advisory Committee had commissioned, and planned to give it all he could muster.[73]

In these last months of the war, the WAAC's programme was taken over by a newly established British War Memorial Committee, founded in March 1918 under the initiative of Lord Beaverbrook and the Ministry of Information. The Canadian Government had orchestrated a similar scheme in 1916 – and the commissioning of modern young artists to paint the war sprang into overdrive.[74]

Slade artists called into these programmes over the following months included Henry Tonks, Philip Wilson Steer, Gilbert and Stanley Spencer, Augustus John, Wyndham Lewis, William Roberts, David Bomberg, Darsie Japp, Henry Lamb and Edward Wadsworth. In late April 1918, even Gertler was the recipient of a surprising invitation. The WAAC's secretary, Alfred Yockney, wrote to him that they would like to commission a war painting. He would have to sign on for at least six months, and would have to paint at least one large picture on a subject chosen for him. 'Air Raid Night in the Tube' had been suggested, Yockney explained, and he would be paid £300, plus expenses. This was a huge amount of money

for a man who, only two years earlier, had calculated that he could live in the country on a pound a week, and who was dependent on loans from his brothers, supplemented by occasional sales.

As Gertler told Ottoline, 'If this is given me I shall certainly accept – firstly because of the £300 which would save me, secondly on principle, because it is so wonderful, that only young and modern painters have been chosen!' Not a single Royal Academician had been selected for the scheme, and Gertler saw this 'as something very significant':

> I mean, that a more or less official committee, representing the Government, should do this! And so strong is it, that they are actually withdrawing people like Spencer and 'Bobby' [William Roberts] from the front to do this work! This is excellent! There is a good time coming for Art yet in England, no it shan't always be French, French, French. What will Clive Bell jaw and write about then?!! This Idea – I mean this War Memorial Committee, has somehow excited me very much! Because I see so much, that is significant in it. I am ambitious about having a really good school of painting in this country. I am sick of it always being *French*. Yes, about painting I am *patriotic*! What's more, I have a feeling that we *are* going to have good painting, after the War – there are good times coming if only we can hold out. This War is not the end.[75]

Yet his enthusiasm quickly waned. He was soon telling Brett that he would 'in some ways' be glad if he did *not* get the commission. Though he would welcome the money, he hated working to order, and anyway, it would distract him from his own projects. He was busy working on a self-portrait, he explained, 'a very complex subject and very interesting and unusual', and now 'at a very important and critical and interesting stage'.[76]

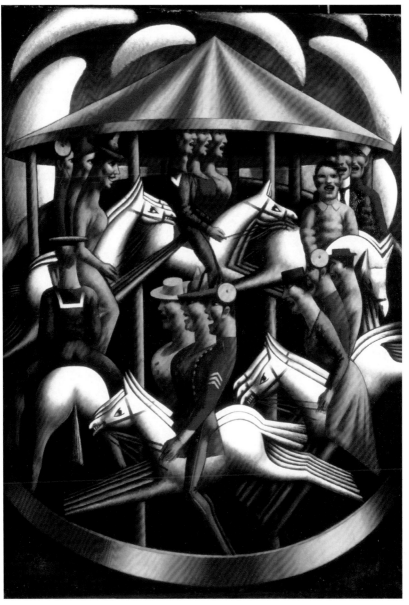

'It is the best modern picture I have seen ... in this combination of blaze, and violent mechanical rotation and complex involution ... you have made a real and ultimate revelation' D. H. Lawrence

Mark Gertler, The Merry-Go Round, *1916*

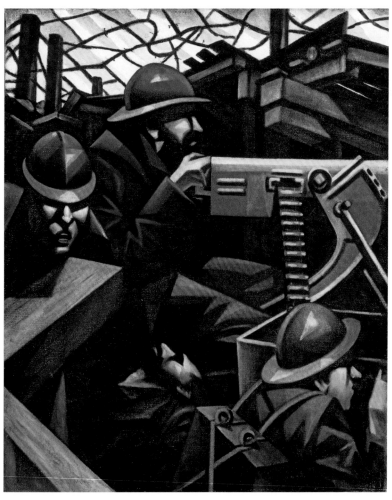

'Mr Nevinson's "Mitrailleuse" will probably remain the most authoritative and concentrated utterance on the war in the history of painting' Walter Sickert
Richard Nevinson, La Mitrailleuse, *1916*

'No one will ever know the utter happiness of our life together'
Dora Carrington, Giles Lytton Strachey, *1916*

Mark Gertler, Gilbert Cannan and his Mill, *1916*

Dora Carrington, The Mill House at Tidmarsh, *Berkshire, 1918*

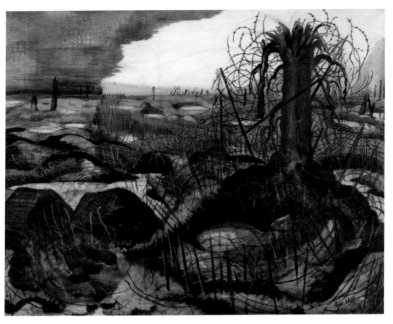

Paul Nash, Wire, *1918*

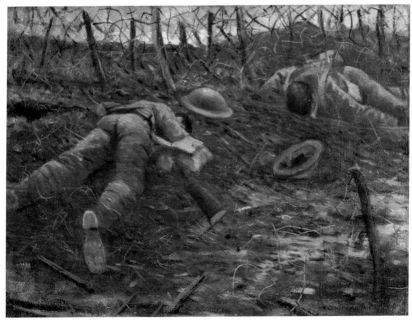

Richard Nevinson, Paths of Glory, *1917*

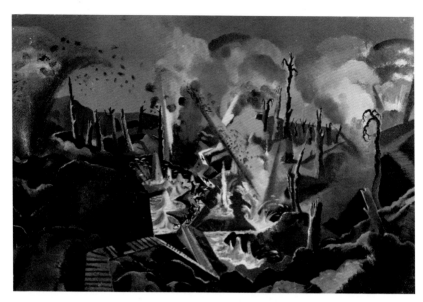

Paul Nash, The Mule Track, *1918*

Stanley Spencer, Travoys Arriving with Wounded at a Dressing-Station at Smol, Macedonia, September 1916, *1919*

'I have a picture at home & I just want to finish it before going into attack'
Stanley Spencer, Swan Upping at Cookham, *1915—19*

Overleaf: *'It is unspeakable, godless, hopeless. I am no longer an artist interested and curious, I am a messenger who will bring back word from the men who are fighting to those who want the war to go on forever'*
Paul Nash, The Menin Road, *1918—19*

In June the Ministry of Information contacted him, asking for a drawing for their approval. Gertler was angry to discover he did not have the 'free hand' he had been led to expect. 'The whole thing bores me frightfully', he now told Ottoline: 'I am not a machine, and cannot paint a stroke to order. I may never even start this sketch in spite of how much I should like the money... I am afraid it is quite impossible to paint ones best if one has to earn ones living from it.'[77] He told another friend that it would 'take too long' to explain why he turned the War commission down: 'I should have to explain all the peculiarity of Psychology'.[78]

But turn them down he did – the War, ultimately, was not important to him as an artist. The world would recover; time would heal the wounds. As he told his friend Richard Carline, who was now serving as an official artist with the Royal Air Force: 'The war cannot change anything for us as artists. As you say, the Guns do not change the shape of the hills & when one tree is mashed down another grows up in its place.'[79]

Gertler may not have seen Paul Nash's exhibition of paintings of the Front, but these remarks were a total rejection of his former colleague's perspective on the War. And as for Nevinson's artistic impressions of the Great War, Gertler appears to have taken no notice of them at all.

Chapter 18

Armistice

Whilst Nash and Nevinson were already painting their visions and experiences of the war, Stanley Spencer was longing for the chance to work. Gertler was wrong. Spencer had *not* been withdrawn from the Front. His war was not yet over.

In August 1917, Spencer had volunteered to join the infantry, and he was transferred from the RAMC to the 7th battalion, the Royal Berkshires. It was an odd decision, as it took him from the safety of a Field Ambulance Unit into the constant dangers of Front Line service. That safety, though, had been relative. He had already experienced shelling, had brought back wounded from the Front, and had helped to bury the dead. Joining the infantry, however, put him among his fellow Berkshire men, and it returned him (as he knew it would) to the Vardar Hills, a sector where he had been posted on his arrival in the Balkans – a sector where he longed to return, for he had experienced 'Cookham' feelings there.[1]

Then, the following May, he received an oddly formal letter from Alfred Yockney, Secretary of the War Artists Advisory Committee. Would he be interested, Yockney enquired, in accepting a commission to paint an official record of the War? Muirhead Bone, the letter explained, held 'a great interest' in Spencer's work, and had suggested that Spencer 'could paint a picture under some such title as "A religious service at the Front".'[2] Bone's grand plan was for a series of large paintings that would

form part of a Hall of Remembrance in London. In the event of the scheme maturing, the letter politely asked, would Spencer 'be disposed' to undertake such artistic work?

Spencer replied enthusiastically: yes he would! As he had told Lamb the previous summer, 'I am a thousand times more determined to do something a thousand times greater than anything I have done before when I get home, & am storing up energy all the time'.[3] He was, as he now told Lamb, 'aching to paint ideas', reckoning that he had been 'as much influenced by this particular Sector as I was by Cookham in peace times'.[4] Then he heard nothing. He wrote again to Yockney, fearing his first letter had gone astray; still there was no reply. It was agonising to have been offered this chance to paint, and then be answered by silence.[*]

The only news was of the offensive. For the two years Spencer had been in Macedonia, the British Army had hardly moved. Now 'we were going to suddenly tread over our wire & over the Bulgar lines right bang in amongst them'.[5] This was no time for the War Office to release a soldier (not even if he *was* wanted by London as an official artist), and Spencer's battalion was moved up to the Front. The men were surprised to have their mail delivered; in the midst of such 'inhuman happenings', he later recalled, 'this need to supply all the supposedly human needs' seemed 'ominous'.[7]

By moonlight he read a letter from Gwen Raverat, congratulating him on his commission from the WAAC. In the circumstances, it felt like fruitless praise – for where was that commission? An earlier assault had left two thousand men from his Regiment dead, and Private Spencer's chances of survival, advancing towards machine gun posts in entrenched positions across bare, open ground, did not look good.

As they waited in the darkness Spencer 'felt a very disagreeable

* Paul Nash was among those keen to get in touch with Spencer in 1918, telling Yockney it was 'rather important'. The WAAC supplied him with his address in Salonica but, as Yockney explained, 'Unfortunately we have not been able to secure his services. The matter is hung up at the War Office.'[7]

gloominess & taciturness' settle upon him; it was the first time he would be going 'over the top'. Two o'clock, the planned hour of attack, came – and went. Three o'clock approached, '& no-one seemed to be preparing for anything.' As the sun rose his spirits revived. During the night the Bulgars had cleared their positions and had fallen back. The Berkshires left their trenches, crossed No Man's Land unopposed, and set off in pursuit of their retreating enemy.

The seasoned infantrymen of his Company were unsure what to make of Spencer. He had made few friends; he stood out as odd, unreliable. He neither drank nor smoked, he read the Bible and Shakespeare, and had no sexual experiences to talk of. He was a misfit, as he had been at the Slade – except that here his artistic genius meant little to his fellow soldiers. He felt 'estranged', he told his parents, his conversation 'reduced to "yea" or "nay".[8] When a man pointlessly shot a dog during the advance, Spencer asked angrily, 'What did you do that for?' His question was 'met by much abuse'.[9] When he got entangled in a roll of ribbon wire, a Sergeant called him 'a confounded nuisance'.[10]

Eventually a chance came for him to prove himself. As they approached a point overlooking the new Bulgarian positions his unit was pinned down by machine-gun fire. Their captain called for volunteers to advance with him up a hill. Only Spencer followed. From the top of a ravine the captain surveyed the enemy below with binoculars, then sent Spencer back with a report for the artillery and aeroplane spotters. Spencer did as instructed, then returned.

'I did not expect you back', the captain told him, impressed. Then – unwisely in Spencer's opinion – the officer fired a round at an enemy machine-gun post, before deciding to turn back. They had gone only a few yards when the captain was hit by return fire. Spencer held him as he fell, and discovered a gaping wound in his neck. He bandaged it and called for stretcher-bearers. As he was taken away, the dying captain told another officer, 'Spencer is not a fool, he is a damned good man.'

Spencer, as he later recalled, 'thought that was very kind & not really deserved as I was quite unreliable & it just happened I was alright for this affair.' At the same time he wondered, 'What's all this; who has been saying otherwise?'[11]

Spencer was trying his hardest, but perhaps did not realise just how little suited he was for this role. Henry Tonks, when asked to write to the WAAC with a character reference, observed 'Spencer is, I should think, not much good as a private soldier, although I am sure very willing. A genius pitched in the mud.'[12] In the hope of getting his son sent home to work on his artist's commission, Par Spencer told the Ministry of War: 'he is such a midget that... he can never be of any value as a soldier'.[13]

As the British advance continued – and in spite of the machine gun and shell fire – it became apparent that the war in the Balkans was drawing to a close. Spencer was increasingly anxious that he might not survive to see the peace: 'Apart from greed for life I felt I had got a lot up my sleeve that I wanted to produce before I died, & every day I was being detailed off for worse & worse dangers.' He kept thinking of *Swan Upping*, the unfinished painting waiting for him back in Cookham. But what could he do? 'As an infantryman what would have been the use of this insignificant fragment of gun fodder that I was if I had said to the sergeants "I have a picture at home & I just want to finish it before going into attack"?' The sudden appearance of fresh supplies of ammunition and orders for another offensive were 'insupportable to the spirit'.[14]

Then, on 30 September, the Bulgarians agreed to an armistice; all fighting in the region ceased. The war, for Spencer, was suddenly, abruptly, over. By early October he was in a field hospital, suffering from malaria – and nervous exhaustion, as his letters to Eddie Marsh reveal. He had told Marsh how he wished his 'nerves were like steel', and that he was 'braver', like other men in his Regiment: even the sound of gunshot put him into 'a state of melancholy depression'. News from home had not

been good either. Percy had been seriously wounded, and there had been nothing but silence from Sydney and Gilbert.

In October he confessed to Marsh that it was impossible to describe 'the most trying experiences' of recent months. With news of the German Army's collapse, however, it was 'wonderful' to realise that the war – which he now told Marsh he had regarded 'as a Crusade' – was 'drawing to a successful conclusion'. To be kept away from his painting was giving him 'greater pain every day... I am a complete stranger in this world without a brush, & it makes me feel terribly lonely & empty & meaningless.' He apologised for his unusually melancholy mood, 'but recent experiences seem to have un-manned me.'[15]

• • •

On the Western Front, German and Austro-Hungarian morale was collapsing – their armies were retreating in the face of the Allies' counterattack. Yet by early November Carrington was heavy inside, remembering her brother Teddy, dead two years before on the Somme, at 'the very place where they are shooting now.' Her parents had recently moved again, this time to Tatchley, where her father had lived as a boy. Now she hated coming home and seeing Teddy's belongings: 'in my rooms all his school books, the queer boxes, and carved things he made, old chemistry jars, boats, and in the drawers his note books, drawings of engines, and frigates.'[16]

She laid her soul bare to Strachey, who was now enjoying the almost overnight success that had followed the recent publication of *Eminent Victorians*.* She told him how she could not forget one of the last days her brother had spent at Hurstbourne Tarrant: 'In the afternoon I found

* After the publication of Strachey's irreverent book, and the one that made him both independently wealthy and a well-known public figure, Gertler told Koteliansky that 'conversations and discussions' about it raged at Garsington. 'Personally I've lost all sense of judgement. I am dazed into apathy by all the wonderful and "exquisite" books and other kinds of masterpieces that seem to come out every day like mushrooms in season – I am stunned like a drunken wasp in an apple with the immensity of modern production.'[17]

him fast asleep on the sofa, curled up. His dark brown face, and broad neck, the thick black shiny hair and the modelling on his face, like some chiselled bronze head.' She apologised for all these feelings coming to the surface, 'But it's been so heavy inside lately.'[18] Of her three brothers, Teddy had been killed, Sam was 'badly shell-shocked', and her beloved Noel had almost lost his arm.[19]

At its start, it had been widely believed the war would be over quickly. Even by late 1918 it seemed that it might never end: 'none of us will live to see the end of the war', the newspaper magnate Lord Northcliffe declared in October.[20] Yet, almost unbelievably, the end *was* imminent. As its origins had been many, so the causes of its resolution were various. Ground down by the endless casualties, with the Royal Navy blockading their ports and the United States recently joined in the conflict against them, German and Austro-Hungarian resolve collapsed. The stalemate of trench warfare had been broken; German forces were in retreat, the Allied armies pressing eastwards. With defeat on the Western Front now inevitable, and a socialist revolution brewing at home, in early November the German Emperor abdicated and fled to neutral Holland. With the Kaiser gone, a ceasefire could be brokered, and four years of slaughter brought to an end. Between ten and fifteen million had died in the process – and for what? An end to the war was, perhaps, victory enough.

On 5 November Carrington wrote to Lytton, 'I suppose Peace will be nothing like what [one] imagines... I think at least the old order of things ought to collapse. And a July Summer should break upon the world, and all the trees burst out into new leaves.'[21] By 8 November she was in Hampstead, staying with Lytton's sister-in-law, Alix Strachey. She went to shows at the Omega Workshop and the London Group, where she admired some of Gertler's new work. On Sunday 10 November she dined at the Grand Café, with Gilbert Cannan and his new wife seated at the next table.

Late the next morning she heard guns firing. At first she thought it was an air raid, before realising that it was the eleven o'clock signal for the Armistice. The war was over. She leapt on a bus, joining the crowds that spilt out of shops and offices, all heading into London. The scenes of triumph, joy and relief became increasingly wilder, she wrote to her brother the next day, '& more & more frantic' as they approached Trafalgar Square. There were slum girls and office boys, officers piled into taxis, and soldiers in vans driving round and round waving flags. By the time she reached the Strand 'the uproar was appalling'.[22]

A *New York Times* reporter recorded how someone in the immense crowd shouted, 'Who won the war?' The throng roared back, 'We won the war!' And again the cry, 'Who won the war?' '*WE* won the war!'[23]

Carrington had arranged to meet Monty Shearman at the Adelphi, and she struggled through the mass of people to get there. Monty took her to the Café Royal where they met his 'rejoicing friends', young men (with the most to celebrate) drunk on whisky. Somewhere there was Nevinson – he was in his studio when he heard the news, and with his wife had also rushed to Trafalgar Square to celebrate, before going on to the Café Royal, to drink champagne and clamber up its decorative pillars in joyful celebration. Two decades later he would recall it as 'the most remarkable day of emotion in my life'.[24]

That evening Monty threw a party. 'Everyone was there', Carrington told Noel: 'The halt, the sick, & the lame.' Even 'old Lytton' had rushed up from his 'death bed' in Sussex '& joined in the merriment'. Gertler was there, and Augustus John and Clive Bell, together with dancers from the Russian ballet, Café Royal outcasts and a miscellaneous crowd of ladies and officers. She danced non-stop for hours. Her only worry was the threat of Spanish Flu: 'I am very well', she told her brother. 'But as yesterday's gay crowd probably breed a thousand more microbes, I doubt if anyone will live Long.'[25] Millions died in the Spanish Flu epidemic that swept the world in 1918 and 1919. Carrington succumbed, but survived.

Though he joined in the celebrations, Gertler soon felt the need to escape to London. 'I have been in a sort of continuous mental whirl', he told Brett. 'Peace seemed to complete my unsettlement – I had to fly at last to Garsington'.[26] Paul Nash, meanwhile, celebrated the end of the war with Margaret in the rural tranquillity of Chalfont St Peter. John and Christine were there too, the brothers working diligently on their commissions for the WAAC.

They enjoyed the first months of peace after over four years of fighting, remaining at Chalfont St Peter until early 1919, when Paul became embroiled in an affair with another man's wife. This first infidelity established a pattern of short-lived relationships and philandering that continued well into the late 1930s. Like many artists and bohemians who rejected the strait-laced manners of Victorian and Edwardian England in the first decades of the century, he would find married life difficult. He later acknowledged what had been his prenuptial unease in the observation: 'We should be tied up, we should be tied down, fidelity was impossible, boredom inevitable.'[27]

Perhaps things would have been different if it had not been for the War – and especially those last experiences of it in Ypres? Nash would later recall how, up to the close of 1917, and in spite of the war, his life 'had run a more or less smooth and happy course; but with the last phase of the war and my participation in it as an official artist on the Western Front, a change began to take place. Thenceforth the whole savour of living, and the nature of my work seemed directly affected.' After 1918 Nash became more serious, more driven in his career as an artist, sometimes to the exclusion of his wife and his friends, and he suffered increasingly from periodical bouts of depression, what John called 'the Nash blackness'.[28]

Though no longer the carefree man he had been in 1914, Paul was a successful, nationally recognised artist. Ezra Pound had written in August that Nash's 'Void of War' had probably been 'the best show of war art...

that we have had'. And now, only a few days after the Armistice, a critic in the *Saturday Review* reported: 'Mr. Paul Nash suffers under the disability of being a genius. He is a poet in paint as he was in words.'[29]

• • •

Spencer was still in Macedonia when the Great War ended. However his WAAC commission had finally, belatedly, been confirmed. To get him back to England quickly, the War Office placed him on a list for repatriation of malarial cases. He soon took ship to Italy, then a train to northern France, crossing the Channel to Southampton on 12 December. As England approached, Spencer thought to himself, 'I am going to marry that land'.[30] It was a joyful return. Another train took him to the Royal Berkshire Regimental Depot at Reading. He was not yet officially demobilised, but he was given a month's leave, and he caught a train to Cookham.

Walking home across Cookham Moor, he saw the distant cowls of the malthouse glistening in the late afternoon sun. 'Only a few weeks ago I was saying to myself I would have to go three thousand miles if I wanted to see them. So far removed, the cowls looked like huge white moths settled on some twig of wall with wings closed in the midst of the trees of Cliveden Woods and the houses and the smoke of the hamlet.' When he heard the sound of the blacksmith's hammer on his anvil 'it was as if I had been hearing it when away.'[31] Stumbling into Fernlea, he surprised his parents, who were not expecting him home. Stanley knew that Gilbert was still in Egypt, but he hoped he might find Sydney back from the trenches.

Instead, he discovered that his brother was dead – killed during a German barrage just six weeks before the War's end: Sydney had been the battalion's last casualty. 'I had so many things I wanted to speak to him about', Stanley wrote and told Eddie Marsh the next day.[32] His brother had been recommended for the Military Cross, and the medal was awarded posthumously. Henry Lamb received the same decoration, but told Spencer that 'it only added absurdity to feelings of despair.'[33]

Spencer would soon have heard the news that Isaac Rosenberg had also been killed in action earlier that year.

Going up to his bedroom, he found *Swan Upping*, unfinished where he had left it in 1915. 'Well there we were looking at each other', he later recalled; 'it seemed unbelievable but it was a fact.' The war was like a dream; yet looking at his hands, he saw the yellow cordite stains from artillery shells on his fingernails.[34] He *had* been there, and he really *was* home. It was hard to believe, for so little seemed different: his mother sitting up in bed, revelling over village gossip, his father downstairs at the piano, playing Mozart. He told the Raverats, 'I begin to think that I have been killed & that now I am in Heaven'.[35] It seemed 'an awful privilege to be spared to see my Mother & Father & to see England & Cookham again.'[36]

Walking around the village the next day it was 'as if I were performing a miracle every time I beheld the familiar spots.'[37] Now he could see Cookham 'not as I did in 1914 when I felt disturbed about the war and not as when every month at Bristol I had a day and a half's leave, but as I did in the 1910–1913 years'.[38] He walked to Odney Common, to Cliveden Woods, and to a spot in the trees where he and Sydney had sat together reading the Bible. He recalled 'the marguerite field of softness just as it was, with Syd walking along the path between it... he was a peace-loving person, and he seemed like some Esau or Jacob or Zacharias.'[39]

The guilt of the survivor welled up. A few days after his return he told Lamb, 'I feel all sort of dazed & expect God to leap down & snaffle me with "no you don't though: I knew I had made a mistake somewhere."'[40] To Desmond Chute he wrote, 'You can't imagine what I feel like. I thought I had gone beyond recall: too far removed, an awful feeling.'[41] The worst thing was that his religious convictions had been undermined by his war experiences. The following year he would tell Chute how, in some of his worst moments in Macedonia, 'I found myself asking the question: "Is Christ adequate in this?"... It is an awful shock to find how little my faith stood in my stead to help me.'[42]

Despite the mixed experiences of returning home, Spencer's commission for the WAAC progressed quickly. Though he had lost one of his sketchbooks in Macedonia, he told Marsh that everything was still 'very clear' in his mind.[43] He had already seen some of the work of other Slade artists in the scheme. William Roberts's *The First German Gas Attack at Ypres* moved him 'very much', and he considered Paul Nash's *Chaos* 'a good picture'.*[44] He started work on his own painting at Fernlea, but as it was to be some 7 feet by 8 in size he needed more room. Eventually he rented the stables at nearby Moor Hall. All the horses had been requisitioned for the War, and the building was cold and empty, but there was space and light.

The painting he created in this makeshift studio, *Travoys Arriving with Wounded Soldiers at a Dressing Station at Smol, Macedonia*, illustrated an early experience during his overseas service, when he was still with the 68th Field Ambulance. During an Allied attack, an old Greek church was used as a makeshift hospital, and injured soldiers were brought in on mule-drawn stretchers. Preparing to start work on the painting in March 1919, he told Marsh, 'It will be rather wonderful to get that dead stillness of the operating theatre right bang against the terrific swiftness of this mule coming out of the darkness from Machine Gun Hill.'[45]

Spencer acknowledged that this could have been considered a 'sordid... terrible scene, but I felt there was a grandeur about it'. Like Christ on the cross, the wounded men (who he later recalled as being like 'so many crucified Jesus Christs'[46]) 'belonged to a different world than those attending them.' There *is* a strange tranquillity to the finished painting, which is by no means a site of fear or pain. The painting almost answers Bone's original suggestion of 'a religious service at the front': the brightly lit interior of the operating theatre inside the church is like a glimpse into the stable of an early Renaissance nativity scene.

* The only work of Nash's with this title was his ink and watercolour painting, *Chaos Decoratif*, which had been exhibited at the Goupil Gallery in 1917 and bought by Charles Rutherston.

Spencer received £200 for the painting, and Muirhead Bone was keen to commission further work. After finishing *Travoys*, however, he reached the same conclusion Gertler had: that he could not work to order. The independence to paint *what* he wanted, in the way *he* wanted, was paramount – never mind if that meant having to struggle financially. He started work on two smaller paintings, but soon gave them up. In one of his characteristically colourful but blunt letters, he informed Yockney that he had 'lost the thread' of his '"Balkanish" feelings', and could not work on any more war pictures. 'The thing is', he explained, 'as artists we can do just what we like (that sounds very nice) BUT WE MUST NOT DO WOT WE DON'T LIKE, woe unto us if we break this law. I am "sickening" for the Ministry.'[47]

At the same time as painting *Travoys*, Spencer completed *Swan Upping*. Although it was the moment for which he had waited a long time, as he later recalled, it was 'a very difficult matter getting back to this painting'. He admitted that though 'here & there' it was hard to notice the difference, other parts, painted in 1919, clearly stood out as inferior work. In particular, the sun-speckled river beyond Cookham Bridge, which he had been 'doing so well' in 1915, became muddy and clumsy. He had changed, and the War was to blame: 'Oh no,' he later wrote, 'it is not proper or sensible to expect to paint well after such experiences.'[48]

Though he would search for it for the rest of his life, the mood and the inspiration of those innocent Cookham years before the War, when everything and anything had seemed achievable, would never quite be recaptured, however hard he tried.

• • •

Lord Beaverbrook and Muirhead Bone's proposed Hall of Remembrance, for which so many spectacular paintings had been commissioned, would never be built. But many of the works were exhibited in a large show, *The Nation's War Paintings*, held at the Royal Academy over the winter of 1919–20; many were acquired by the recently established Imperial War Museum.

The reviewer for *The Times* described this extensive exhibition as 'Art's Fresh Start'. Before the war, he wrote, artists had 'had nothing momentous enough to paint'. The war, however, 'has supplied a momentous theme, while it is an event in itself so large, and so shattering of continuity, that even the dullest of us expect all things to be different after it.' This collection of war pictures, commissioned by the Ministry of Information and the Canadian Government, was, he explained, 'wildly different from anything that any official body could conceivably have countenanced before the war.'[49] Whereas only a few years before modern art had been derided and dismissed, now it was seen as being amongst the finest and most forceful official images of the conflict.

Much of their work was not so radical as it had been in 1914. That which was, such as David Bomberg's rather abstract first version of an official commission for the Canadian Government, *Sappers at Work*, was rejected. But those who had absorbed the vision of the *avant-garde* without being overwhelmed by it, deployed it to incredible effect, and to the satisfaction of most critics.

Many of the largest war works on show at the Royal Academy were displayed in Gallery 3. They included Stanley Spencer's *Travoys*, Paul Nash's *Menin Road*, John Nash's *Oppy Wood*, Gilbert Spencer's *New Arrivals, F.4 Ward... Sinai*, William Roberts' *A Shell Dump, France*, Henry Tonks's *An Advanced Dressing Station*, Henry Lamb's *Irish Troops in the Judaean Hills Surprised by a Turkish Bombardment*, and John Singer Sargent's *Gassed*. All of these artists, aside from John Nash and Sargent, were Slade men. It was the most remarkable testament to the School's achievement.*

There was one Slade name missing from the Gallery, however: Richard Nevinson. Seventeen of his works were on display elsewhere in

* In the opinion of the *Burlington Magazine*, the exhibition was a mixed bag. The 'general level of excellence' was 'high', but their reviewer felt there were 'no really great pictures'. Spencer's *Travoys* was 'one of the best' pictures there.[50] Spencer, however, was disappointed that at the official opening Tonks had passed by it 'without comment'. 'I suppose he does not like it', he concluded.[51]

the exhibition (including *Paths of Glory*, *Swooping Down on a Hostile Plane*, *A Group of Soldiers*, and *The Harvest of Battle*), but in the artist's opinion all had been poorly displayed. This, he believed, had been the deliberate and vindictive action of the hanging committee – a committee that included Tonks and the man he now dubbed 'Bonehead Muir'.

According to Nevinson's father, people were queuing up to see Richard's *Harvest of Battle*, the epic panorama of dead and wounded men he had painted earlier that year. The only other painting attracting such public attention, he wrote, was *Gassed*.[52] Nonetheless Richard, as Henry recorded in his diary after seeing his son the following day, was 'almost insane with rage'.[53] It was in this mood that Richard penned a letter to the WAAC, expressing the 'contempt' he felt 'for the ungenerous and unsporting way you have flung my altruistic efforts at cooperation into the cesspool of artistic intrigue, and the cynical lack of appreciation you have shown throughout'.[54] Another – no doubt similarly worded – was sent to Tonks, and he raged when Bone called his paintings 'potboilers'. Henry feared for Richard's mental state: it was a sorry (but perhaps not surprising) result of the severe demands Nevinson had experienced over the previous four years.

All the Slade artists, in their own way, had been changed by the War. Gilbert Spencer, returning to the Slade to resume his studies, even found Tonks 'a little less aggressive' and 'kindlier', awed as he had been by the sacrifices made by the young men he had once so chastised.[55] For some, the years 1916–18 would be the highpoint of their artistic careers. When John Rothenstein reviewed the art that had been produced in these long, terrible months from the safer distance of 1931, he would observe that of the artists selected for the WAAC scheme, many 'revealed depths of emotion and technical powers they had not hitherto been conscious of possessing, and, stranger still, which they now possess no longer. Two of the artists... tell me that they despair of equalling the work they did under the spell of the War.'[56]

Epilogue

'Another Life, Another World'

The Armistice of November 1918 brought a new world – but not, perhaps, a better one. Though Britian had won the War, and its Empire was even larger in 1919 than it had been in 1914, it was an Empire in slow, terminal decline. As an economic and industrial powerhouse, Britain was spent. A new superpower had emerged, continuing its own inevitable rise: the United States. Post-war Europe – like its post-war art scene – was in difficult and uncertain times. Furthermore, the 1919 Treaty of Versailles, which dictated extensive and punitive peace terms on Germany, served only to sow the seeds of future discord.* When Margaret Nevinson reflected on the state of affairs in 1926, she saw herself surrounded by the legacy of the War: 'everywhere, there is terrible unrest, crimes of violence, murder and suicide, dishonesty and immorality,' she wrote, 'a general loss of honour and self-control and a callousness produced by the long spectacle of pain and suffering. In England especially, we have industrial dead-lock, widespread unemployment and increasing class-hatred.'[1] The winning of the vote for women in 1918 was little recompense.

At the Slade, Tonks privately expressed his bemusement at the anarchic Dada movement, which had emerged in Zurich in 1916: 'the Art

* John Maynard Keynes, who acted as a member of the British delegation to the Paris peace talks, resigned in protest at the harshness of the terms. He went on to write a bestseller, *The Economic Consequences of the Peace* (1919), explaining why they were so disastrous.

to end Art', he called it. 'I have finally decided that I am quite unable to appreciate modern art,' he told a friend, 'so please look upon me as completely an old man comfortably stowed away on the shelf'.[2] Group X – Wyndham Lewis's attempt in 1920 to revive the pre-war avant-garde in London – failed. In Britain, at least, there would be a movement away from modernism, a return to tradition and the pastoral and an understandable desire for tranquillity, at least in the painted arts. And the Slade group, whatever was left of it, dissipated.

Even without the Great War's blunt and sudden intervention, the Slade friends would, no doubt, have separated sooner or later, scattering wherever their careers and personal lives took them. It was already happening in 1914 – though Eddie Marsh, till then, had held at least some of them together in his loose assemblage of 'Georgian Artists', whilst the Omega Workshop and the Rebel Art Centre had provided meeting points, for a time, for many of the young avant-garde artists.

Such youthful relationships, which are lived so intensely at the time, often grow apart. Friendships that were close can grow stale. Or, as in the case of Gertler and Nevinson, they can be too close and fierce to last long. Like Gertler's love for Carrington, they can eventually smother the object of their desire. Mere distance can separate, with new and more immediate friends taking the place of old. Or what had seemed like exciting and novel strengths can become irritating flaws – as in Gertler's friendship with D.H. Lawrence. Gertler had, by August 1918, become bored by the writer's 'bitter intolerance of the whole world. Perhaps the whole world & everybody in it *is* bad,' he told Lady Ottoline, 'but even then – what good is it to spend hours cursing & cursing.'[3]

Yet, for long afterwards, those friendships of our early youth can be the best remembered, and the most treasured. Certainly, new friendships are made; new influences upon our ideas appear and help mould our thoughts. But in those callow years, our minds are more malleable; they are more open to influence and the intensity of early, shared experiences.

Everything feels original and exciting, as we discover our place in the world, our way of experiencing and recording it. In achieving that, we are not alone; we draw upon those around us whose temper seems closest to our own. From those friends, we forge our adult tastes in art, music, literature, politics. We fall in romantic love for the first time, and experience relationships that remain defining and unforgettable – relationships that are both sexual and platonic, with our teachers and – most importantly – with our peers. That, at least, has been the argument of this book, and what I have hopefully shown in the relationships between these five particular artists.

For all of them, no doubt, the time before the War was another life, another world: a time more innocent, and freer. 'Youth is wasted on the young', wrote Oscar Wilde. He was right, though only growing old ourselves proves him so. But we cannot leave them there, these five artists. In fact, 1919 was not entirely the end of their contact with one another – they would continue over the years to drift in and out of each other's lives. It is necessary therefore to chart in brief the remainders of their careers.

• • •

Noel Carrington considered his sister's early years at Tidmarsh, between 1917 and 1921, as 'the happiest of her life and also the most productive, for emotional fulfilment always stimulated her as an artist.'[4] For a while her friendship with Strachey seemed to provide almost everything she required. She told him in January 1918 that 'the bridge is finally broken between Mark and me',[5] and their life at the mill was, for a time, relatively uncomplicated. As she would write in her diary in 1919, meals divided up their day; Lytton read in the morning, followed by lunch and a siesta; then a walk to Pangbourne, more reading, a French lesson with Carrington, and then dinner, followed by reading aloud, bed and hot water bottles – 'and every day the same apparently. But inside, what a variety, and what fantastic doings.'[6]

Carrington continued to paint, when she had the time, and the confidence, and she was glad to be free of London and the 'intrigues, & squabbles' of its artists.[7] Her love of this new life can be seen in her oil portrait of the Mill House, painted in 1918, with its two black swans added fancifully to the mill-stream.

Gertler saw it, though he did not rate it highly. 'Yes, I have seen Carrington's picture of the Mill', he told Brett. 'I am afraid I did not like it at all. I was very disappointed. It has a sort of determination & obstinacy which expresses her character very well.'[8]

Yet a friend of Carrington's would later observe that her oil paintings 'were much influenced by Gertler in their careful, smooth technique, three-dimensional effects, and dense, rich colour.'[9] This is not untrue of the *Mill House*; perhaps Gertler saw that, and felt it somehow compromised Carrington's individuality – or what he actually saw in it was his *own* characteristics of determination and obstinacy reflected. Carrington exhibited the painting at the London Group's show in the autumn of 1920, but only two pictures were sold.[10] She rarely exhibited again.

The death of Carrington's beloved father late in 1918 distanced her further from her family. Though her mother expected 'Dora' to care for her in her widowhood, Lytton was her priority now, and Tidmarsh her home. It all slowly started to unravel, however – and it was love, and sex, that was their undoing. Despite their closeness, Carrington and Strachey spent regular periods apart. Following the success of *Eminent Victorians*, Strachey became a popular figure on the post-war literary and social scene. He enjoyed frequent trips away from Tidmarsh; he entertained occasional male lovers, and told friends he feared Carrington would become too dependent on him, 'a permanent limpet'.[11]

So Carrington had to look elsewhere for more physical relationships. In the summer of 1918 she had met a young man. He was an Oxford and Army friend of Noel's named Reginald Partridge. She found 'the

Major' romantic and exciting – though he was rather shocked by her radical, Bloomsbury opinions, describing her as 'a great Bolshevik'. Tall, handsome and athletic, he was not the expected Bloomsbury type.

After surviving the Western Front, Partridge returned to Oxford, and became a regular visitor to Tidmarsh. He soon fell in love with Carrington – whilst Strachey fell in love with *him*, rechristening him 'Ralph', as he would thereafter be known. It eventually transpired that the only way to keep this improbable *ménage à trois* intact was for Carrington to marry Ralph. She was reluctant to 'join the hordes of the respectable'. 'Let us cling to wickedness as long as we have breath in our bodies', she told Noel.[12] Though she did not love Ralph, she finally relented in 1921. According to Beatrice Campbell, when Gertler heard the news, 'He was so shattered that he felt that nothing but a revolver could end his pain. He went out to buy one, but found it was Saturday afternoon and all the shops were shut.'*[13]

Carrington (she refused to change her name) still had no desire to start a family – 'One cannot be a female creator of works of art & have children', she had observed the previous autumn.[14] Partridge was neither a faithful nor an affluent husband, and the marriage (though not their friendship) failed within a couple of years. Carrington did not lose the capacity to have men fall madly in love with her, nor to act deceitfully, and she would have a string of lovers – the most important being with Ralph and Noel's old army friend, the writer Gerald Brenan. Then in 1924 she embarked on her first known lesbian relationship – an expression of physical feelings that had been emerging for many years. In 1929 she would become pregnant by another lover, Bernard Penrose;

* Gertler told Ottoline Morrell that he was 'not surprised' by the news, and was only 'thankful' that Carrington had not married Strachey: 'Somehow I could never bear that relationship'.[15] Gertler went out again to buy a revolver in 1929, so that he would always have to hand 'an easy means of ending my life'; but as he had neared the shop his tongue had gone dry 'with horror' and he had 'turned away in disgust'.[16]

there were fears she might kill herself, and Ralph arranged an (illegal) abortion. Through it all, however, she and Lytton and Ralph remained close friends.

Lytton's newfound wealth from his books, and the renewed freedoms offered by the end of the war, allowed Carrington to travel abroad. She visited Spain and France regularly, honeymooned in Italy, and made trips to Austria, Tunis and Holland. Wherever possible she painted. At heart, though, she remained very much an English artist, albeit one who almost never exhibited: 'It never seems anything like as good as what I conceive inside', she told Lytton, who appreciated her work and did his best to encourage her. 'Everything is a failure when it's finished. They start off so full of hope.'[17]

As such, she would not be widely known as an artist in her lifetime. Yet ironically, her work was probably more widely seen than many of her Slade contemporaries. In 1921 she started painting signboards for local pubs and shops, and reported that it was 'a greater honour than becoming a member of the London Group'.[18] Her finest commission was to paint a sign for *The Spreadeagle* at Thame, an inn that had been bought by the former Slade student John Fothergill.

In 1924, with the proceeds from his books, Strachey bought a large country house, Ham Spray, in a village near Hungerford in Berkshire. Over its extensive garden loomed the beautiful, bare green hills of the North Downs. Carrington moved with him, and once more busied herself redecorating – her painted interiors inspired, in part, by what she had seen of Duncan Grant and Vanessa Bell's home at Charleston.

The romantic problems that dogged her life did not go away, but she continued to work, and remained devoted to Strachey. Yet he was frequently absent from Ham Spray, and though he bought her a pony, she was often lonely, and could find herself seized by sudden despair. She resented growing old, found no real confidence in her art, and was troubled by ill-health, nightmares and depression.

Then, late in 1931, Lytton grew increasingly ill. He had long been troubled by digestive problems, but this was something more serious. His doctors were unable to diagnose his ailment, and by January it became clear that he was dying. A few days before he died of what transpired to be cancer, he suddenly declared, 'Darling Carrington I love her. I always wanted to marry Carrington, & I never did.'

Carrington admitted that she would never have accepted him, 'But it was happiness to know he secretly had loved me so much, & told me before he died.'[19]

Lytton passed away at Ham Spray on 21 January 1932. Carrington was devastated. As she recorded in her diary, Strachey 'was, and this is why he was everything to me, the only person to whom I never needed to lie, because he never expected me to be anything different to what I was... No one will ever know the utter happiness of our life together.'[20] Going on without him seemed pointless: 'the loneliness is unbearable', she wrote, 'no future interests me... I see my paints, & think it is NO use for Lytton will never see my pictures now'.[21]

Even before Lytton died, she had attempted suicide. On 11 March, the day after a visit from Leonard and Virginia Woolf, Carrington dressed herself in Lytton's old dressing gown. Then she shot herself; she died a few hours later. She was thirty-eight years old.

Lady Ottoline Morrell, on rereading Carrington's letters after her death, reflected on the enigma that her short life had been:

> I realize what a strange, uncertain, rudderless creature she was; very attractive by her odd way of expressing herself and her disjointed perceptions of life, with patches of intense enjoyment, but I also feel in them her own uncertainty and her fear of criticism and want of frankness. She was so anxious to be a success with numbers of people that her life became a tangled and matted skein.[22]

It would only be much later that Carrington gained the public recognition she deserved as an artist in her own right.[*]

• • •

For Gertler, the War had been a failure: as his ideas had become more powerful, more personal and idiosyncratic, the public interest in his experimentation and expressionism had waned. His pacifism, his family origins in the land of the great enemy, and the rapid decline of interest in 'Germanic', expressionist painting had all further undermined his chances of prospering in an already harsh artistic climate. His relationship with Carrington, too, had floundered, and he had found consolation in a string of affairs.

He maintained irregular contact with Carrington, however – she even invited him to Ham Spray, though illness prevented his visit. It was 'curious', he told her shortly after Strachey's death, to hear that she had been reading some of his old letters, 'because I went through all yours a few months ago... It certainly made most moving reading. It must have been an extraordinary and painful time for both of us. But we were both very young and probably unsuited. And it is over now and nobody's fault.'[23] A few days later, Carrington shot herself.

By 1932 Gertler was no longer the impoverished artist he had been during the War. In 1918, some £1,000 in debt, he had decided to totally renew his approach to his work. As he told Koteliansky: 'I am starting from the ABC again. Right from the beginning as though I have never painted before.' It remained arduous work, 'and terribly exhausting. I am ill and worn out with it all. Why should it be so painful and difficult? I don't know – sometimes I feel that perhaps one ought to paint more lightly, gaily, but if this is possible to some people it is not to me. *I* can't work without desperate seriousness.'[24]

[*] Particularly influential were Michael Holroyd's biographies of Lytton Strachey, and subsequent biographies of Carrington, together with exhibitions of her work and, in particular, the eponymous 1995 feature film, in which Emma Thompson played Carrington.

In 1920 he returned to Paris, where he saw Auguste Pellerin's extensive collection of works by Cézanne. 'Heavens!' he told Brett, 'what a sensation it was, seeing them in the "flesh" at last!' Renoir also made 'an enormous impression' during this French trip. 'About the more modern stuff I am really not at all sure; there is nothing that takes one's breath away like those giants.'[25]

Though hard won, the results of this return to the 'ABC' – with subjects ranging between landscapes, still lifes, and female portraits and nudes – received considerable interest. Aldous Huxley accompanied Carrington to a show at the Omega Workshop in December 1918, where he saw 'what I thought an admirable Gertler'.[26] And Carrington told Gertler that Roger Fry 'liked your work very much. He is one of the *best* people I think, as he really cares so much for good work'.[27] Carrington, too, liked what she saw. She told her brother Noel in December 1919 that she had been to visit Gertler's studio, and that 'He has done some frightfully good paintings lately.' She added, 'I am always more impressed by him than any one when I talk about painting to him.'[28]

The Burlington Magazine, reviewing a solo show at the Goupil Gallery in 1921, judged that here was 'a consummate artist' with 'a vast store of genuine originality' who was 'after long labour getting the upper hand of a stubborn but beloved medium of expression'.[29] Another fan of this early post-war work was Stanley Spencer. After visiting Gertler's 1923 solo exhibition, he told Ottoline Morrell that he was

> very much impressed, though I did not expect to be. I feel that what he paints is something he has spiritually experienced; there is a sort of romantic atmosphere pervading the things; there is something ordained & auspicious about what he does; it was not just something that 'amused' him. And of course Gertler has got passion, which means almost everything to me.[30]

When William Marchant (the man who had banned Gertler from exhibiting in his gallery because he was a conscientious objector) saw the new work in 1921, he liked it so much that he arranged to pay Mark £300 annually in advance of sales. When Marchant died, the Leicester Galleries made a similar offer. Since Gertler's outgoings remained frugal, and though these were hard years for artists to make a living, between 1921 and 1932 he was financially secure.

Gertler's poor health, which had kept him out of the army, worsened. In late 1920 he was diagnosed with tuberculosis – the disease that would kill his old friends Katherine Mansfield in 1923 and D.H. Lawrence in 1930. Given his impoverished upbringing in the East End, and the years of struggle during the war, it was not a surprising diagnosis. Gertler was only thirty years old, and it was obviously a serious blow – though not necessarily a fatal one. He went to a sanatorium in Scotland to convalesce, and for a period was forced to stop painting. He recovered, but there would be relapses, and these – together with the regular need to rest – impinged upon his ability to work.

Furthermore, there was no improvement in his mental health; a modern doctor would probably diagnose bipolar disorder (what was once commonly called manic-depression). His largely self-imposed isolation did not help. He lived alone, kept strict hours of work in his small studio, and sacrificed virtually everything to his painting. This was the only way he could impose order on his life.

After Carrington, there were many brief, even passionate, affairs; but no one came close to replacing that obsessive relationship. In 1926 Brett had emigrated to America with D.H. Lawrence and his wife. Gertler wrote to her two years later, 'I am not yet married – I have nothing against marriage – I approve of it, in fact. But one does not somehow come across the right woman.'[31] In 1930, however, he married a former Slade student, Marjorie Hodgkinson, whom he had met through his Hampstead friend, Richard Carline. She was eleven years

his junior, and since she was not Jewish, his brothers did not approve of the match.

In 1932, six months after Carrington's death, their only child was born – a boy they named Luke. Mark did not embrace the idea of fatherhood: as he told Ottoline Morrell, the thought of 'being so suddenly plunged into being a "family man"... sometimes terrifies me – I love living a quiet retired studious life – really – but perhaps it won't be too harassing'.[32] The marriage would not be a success, however. Marjorie later described her husband's depressions as being 'really part of his nature, something to do with his race, & the fundamental difficulties between us are, I am convinced, racial ones. He would have been better with a Jewish wife. I am English, & his world is too melancholy, cruel & bitter not to be terribly oppressive to me.'[33]

Through the 1930s Gertler continued to struggle with illness and depression. With the demands of a family, and the worsening economic climate of the Great Depression, he became less financially stable.[34] There were further visits to sanatoria, together with long trips to the south of France, where he was advised that the warmer weather would help his health. He continued to work, and between 1932 and 1939 held five solo shows at the Leicester Gallery, exhibiting female figures and still lifes in a highly coloured and semi-stylised manner.

By the middle of the decade he was increasingly living apart from his wife and son. In 1936 he returned to a sanatorium. 'I still feel bruised by my last year's experience', he told Ottoline Morrell from there, 'and have considerable apprehension of returning to that all-in wrestling match we call "Life".'[35] In 1939 he held his last exhibition. It was not a great success – though this was due partly to the looming threat of another world war. As he wrote to his former patron Eddie Marsh (now knighted for his services to the country, and a trustee of the Tate Gallery): 'I'm afraid I am very depressed about my show – I've sold only one so far!... it's very disheartening.'[36]

Marsh replied in a now lost but clearly critical letter. Mark responded that 'obviously a number of other people feel as you do about my recent work.' But, as he explained, the trouble was:

> I can never *set out* to please – my greatest *spiritual* pleasure in
> life is to paint just as I feel *impelled* to do *at the time*... But to *set
> out* to please would ruin my process – and you know me well
> enough to realize that I am sincere – and to paint to the best
> of my capacity is and has always been my primary aim in life –
> I have sacrificed much by doing so... You must remember that
> many works by artists of the past were considered unattractive
> during their life time – there is just a chance that some of my
> works may be more appreciated in the future.[37]

A few weeks later, still depressed at the apparent failure of his exhibition and his life's work, at the breakdown of his health and his marriage, at radio broadcasts of Hitler's vilification of the Jews, on 23 June 1939 Gertler gassed himself in his studio. He was buried four days later at Willesden Jewish cemetery, in the rough grass among the unmarked graves of the unorthodox. One of his greatest artistic achievements, *The Merry-Go-Round*, would be discovered rolled up in his studio, unsold.

Gilbert Spencer would subsequently write that, in his opinion, Gertler's 'early gifts were not sustained... I do not believe his tragic death was for domestic reasons, but because he could not bear falling behind.'[38] John Rothenstein, who had opened the door as a young boy when Gertler had come to seek the advice of his father in 1908, had gone on to become Director of the Tate Gallery. He too felt that Gertler's work had not progressed, observing:

> something of an impressive and even a startling rarity
> died gradually away as his art conformed more and more

closely to the accepted canons of Post-Impressionism...
It therefore seems to me that in spite of the indisputable
aesthetic qualities of his later work, it was the work of his
youth that expressed what was finest in him and was most
intimately his.[39]

• • •

Gertler's obituary in *The Times* described his death as 'a serious loss to
British art. Opinions of his work are likely to vary,' it conceded, 'but it is
safe to say that a considered list of the half-dozen most important
painters under fifty working in England would include him.'[40] Who might
the other five have been? Certainly Stanley Spencer and Paul Nash would
have to be included; and Ben Nicholson was now a leading light of British
modernism, with his flat, spare canvases. But what of their other Slade
contemporary – Richard Nevinson? Perhaps surprisingly, his reputation
was, by 1939, not what it had once been.

'The relief that the war was over was tremendous,' Nevinson recalled
in 1937, 'yet this turned out to be for me the most repulsive time of
my life.'[41] Given his great success as a war artist, Nevinson now had the
problem of what Paul Nash – who was facing the same predicament
– called the 'struggles of a war artist without a war'.[42] At first, Nevinson
appeared to know exactly what to do. He would have no more to do
with groups or movements, and he turned his back on Bloomsbury and
Fry and Grant's obsession with French art. As P.G. Konody observed in
1919 (with a mixture of amusement and confusion), Nevinson 'insists
upon being a rebel, and if there is nothing else to rebel against, he rebels
against his own rebellion'.[43]

In the winter of 1918/19 Nevinson returned to Paris, but he was
not impressed by the post-war city. Perceptively, he saw that the future
of modern art lay elsewhere – across the Atlantic, in New York City.
And it was there he immediately went. In April 1919, on the eve of his
departure, he threw a dinner at which he gave a powerful, rambling

speech in which he attacked the 'narrow cliques & little sets' who, he believed, were trying 'to scorn him and reject him as successful'.[44] 'An artist cannot be too aggressive', he declared. 'As I have often said, an artist should be a bellicose Jesus Christ: a man convinced of his mission and unashamed, with a song to sing impossible to repress, and determined to be heard.'[45]

As Nevinson sailed into New York harbour, the sight of the morning skyline of skyscrapers overjoyed him. Here was a city and a subject he could paint! And the city embraced him, welcoming him as war hero and victimised genius of modern European art, come to discover the USA and reveal it to itself. 'There is no other living artist who is so equipped as he is to show the inhabitants of this city what an interesting place they are living in', gushed *The Herald*.[46] Unfortunately, this promising relationship soon soured. For Nevinson, attack was always the best form of defence, even though it made him many enemies. Now, in New York, Nevinson inexplicably went on the offensive.

In lectures at the Waldorf-Astoria and the Kevorkian Gallery he accused the Americans of being 'splendid painters, but no artists', and declared that his impression of the American public was one 'of mental sterility'. At the same time – as he would throughout his life – he exaggerated and embellished his war experiences. Did he fancy himself as a new Marinetti, who had made his name in pre-war London by attacking the English? It seems possible, as, although he had by now fully rejected Futurism, he read out in New York the manifestos of old.[47]

Not surprisingly, America turned on him. Some saw his words as bluster, or window dressing by an artist whose star had been eclipsed. One observer, the New York lawyer John Quinn (whose collection included early works by Nevinson, as well as paintings by Picasso, Matisse, Kandinsky, and Gertler), had the feeling that Nevinson 'knows that he has not the real stuff but that he wants to cash-in and make big sales now while there is a market for war stuff.'[48]

In fact, Nevinson worked on some excellent views of the Manhattan skyline – as he would continue to produce evocative portraits in paint and lithograph of London and Paris. His output, however, was increasingly patchy, and to the frustration of more intellectually-minded critics, he refused to settle on a style. As he liked to reiterate, he saw no point in using the same technique to paint a concrete skyscraper or a nude. To the popular press this was admirable versatility; but to powerful critics like Fry, Nevinson's art was little more than journalism.

His return to London was not a happy one. Kathleen, pregnant, had remained in England, but the baby died a few days before Nevinson reached home. At the same time, the 'intelligentsia' – by which he meant the Bloomsbury critics Fry, Bell and Grant, his Vorticist antagonists Wyndham Lewis and Ezra Pound, and his old art teacher Henry Tonks – continued to display what he called 'every form of hostility and contempt'.[49] Tonks, he would claim, even led a campaign to have *La Mitrailleuse* removed from the Tate. Nevinson responded by claiming that he did not even like the painting himself.[50] To Nevinson, Tonks was an old woman, whilst Bloomsbury was snobbish, effete and anti-English.

This belief that he was being persecuted and his career deliberately sabotaged was not entirely paranoia, though sometimes he feared it was. As the critic Lewis Hind observed in his catalogue introduction to an exhibition of recent work in 1920: 'It is something, at the age of thirty-one, to be among the most discussed, most successful, most promising, most admired and most hated British artists.'[51]

Through the 1920s Nevinson 'boiled with rage', a 'black pessimism' engulfed him, and he thought at times of suicide.[52] Yet he continued to battle his corner, lambasting and lampooning society with regular articles in, or letters to, the national press. They were frequently rude, opinionated, bombastic or self-serving. For instance one, sent to the *Daily Express* in September 1930, observed:

> I think it was Picasso who once told me I was the greatest
> painter since Cimabue. I could be greater still if I wanted to
> but I am proud enough of being as great as I am... 'You are
> our greatest painter' Paul Nash is always saying to me, and I
> have the highest respect for his opinions.[53]

If some critics slated him, others were happy to lavish praise. The novelist Ethel Mannin considered him 'the most essentially modern artist' in England (though she added that he had 'a perfect genius for being misunderstood').[54] And it is true that, of the five artists in this book, Nevinson is the one who, post-war, engaged most closely with modern subjects: the Wall Street stock exchange, London crowds by night, the clubs and bars of the jazz age. If his days as a rebel in style and interpretation were long over, he was not alone. It has been pointed out that, in a response to the carnage of the Great War, British painters in general retreated from the vigorous modernism that had characterised the four or five years before 1914.[55]

Richard's own father felt that he had lost touch with his subject. As he wrote in his diary in 1920, he was 'fearful' that his son might 'have lost the kind of inspiration given him by the war'; in 1925 he added that Richard's 'imagination seems to be failing for the time & he lives in imitation'.[56] Indeed, he worried sometimes for his son's sanity. This was not without foundation, since Richard's mother became increasingly mentally disturbed as she grew older. By 1932, Margaret Nevinson was suffering from the delusion that Wyndham Lewis and the Director of the Tate Gallery were poisoning her and her son. She attempted suicide, and Richard suggested that she be sent to an asylum.[57] She died at home soon afterwards.

Yet in spite all the personal attacks, by the end of the Great War Nevinson was one of the most famous artists in England. Gertler and Carrington inspired characters in works by Gilbert Cannan, D.H.

Lawrence and Katherine Mansfield, but Nevinson appeared in various guises through the fiction of the period. He was even name-dropped in an early draft of T.S. Eliot's masterpiece *The Waste Land*, before Ezra Pound excised him. Writing from a sanatorium in 1920, Gertler told Carrington, 'I find that in the world I live in now there is only one chance of distinction for me and that is to shelter under the wing of such men as John, Epstein, [and] Nevinson... My own poor self counts as nothing here!'[58]

In this sense, Nevinson the self-publicist had succeeded – brilliantly. His studio parties became famous social occasions, filled with artists, actors and writers. Spencer wrote that Nevinson's parties were 'like a wonderful love affair',[59] and the two painters would be delighted at being reunited at one in the late 1930s. As Richard declared: 'Stan, I would like you to know how glad I am that we have met again. My gratitude to you is boundless. As you know, I consider you the only man with indefinable touch of genius. I felt it for Picasso years ago.'[60]

Gertler was less charitable, moaning to a friend that one of Nevinson's parties 'was crammed with fourth-rate celebrities, including all the critics and dealers.'[61] John Rothenstein, however, would recall the 'eagerness' with which he awaited them, and Nevinson 'stout, portentuous, talking loudly – about himself.'[62] Perhaps like many of those who surround themselves with the famous, Nevinson acknowledged that in the midst of it all he was 'intensely lonely'.[63]

As the 1930s advanced, Nevinson grew increasingly fearful of what lay ahead. In 1934 he co-wrote a novel, *Exodus AD: A Warning to Civilians*, in which a fleet of enemy aeroplanes drop gas, plague and chemical bombs on London.[64] A number of large-scale paintings, including *The Twentieth Century* and *The Unending Cult of Human Sacrifice*, encapsulated his anxiety, and the threat of warfare and mass destruction. In 1937 he published his autobiography, *Paint and Prejudice* – a hugely entertaining but

wildly unreliable memoir.* He wrote there that he was glad never to have brought another child into the world, 'cursed as I am with apprehension of torments and degradations yet to come'.[65]

His warnings, he felt, went unheeded, but they were realised when the Second World War broke out in 1939. In the ensuing Blitz, bombs hit both his studio and the family home in Hampstead. Nevinson raged when a new War Artists Advisory Committee refused to employ him; he volunteered in a hospital, and went up in RAF planes to work on pictures of the air war. When he gifted a painting to Winston Churchill, the Prime Minister responded: 'I am sure the young men who are fighting regard you as part of the England they defend.'[66]

Nevinson's health had never been good, and in 1942 he suffered a stroke that disabled his right arm. He wished it had killed him; but he lived on to see the end of the war, dying, aged only 57, in October 1946.

When in the early 1950s John Rothenstein came to write his biographical history of modern British art, for a time he considered omitting Nevinson entirely, because he felt such 'little sympathy... with the greater part of his work'. Taken in its entirety, Nevinson's career, he felt, had been 'productive of little of outstanding merit'.

Yet in the end he decided to include him, since

> the two first years or so of the First World War were years passed in a theatre of action so magnificent, apprehended with such an intensity of feeling and expressed with a power so worthy of the feeling which it conveyed, that they were able to produce as many paintings of outstanding merit as other subjects of these studies produced in their entire lives.[67]

* His only mention of his relationship with Carrington was the observation: 'I coquetted with a girl with whom Gertler was violently in love. Poor girl, she killed herself on the death of Lytton Strachey years later.'

Those remarkable war paintings would, ultimately, be Nevinson's enduring legacy.

• • •

Coincidentally, Nevinson's old Slade colleague and (apparently) great fan Paul Nash had died only a few months earlier. Unlike Nevinson, Nash had been invited by the War Artists' Advisory Committee to provide official images of the new conflict – a world war that was, in many ways, simply a second round of the one that he had recorded two decades earlier. The enemy was the same, and in time the Allies would be identical: Britain and its Empire, France and, in due course, the USA. Nash rose successfully to meet this new challenge. Critics hold his work from the Second World War in as high esteem as those from the Great War, a situation in marked contrast to Nevinson's record.

But then, Nash's career and talent had developed in ways that Nevinson's had not. He had faced the same crisis in 1919 of what a war artist without a war was to do. And inevitably, the horrors of Ypres had marked him. After visiting his sickly father in 1921, he collapsed and, as his wife told Eddie Marsh, was 'dangerously ill' and 'very nervy'.[68] He was taken to a London hospital specialising in nervous disorders, where a doctor told him that he was suffering from emotional shock 'starting from the period of his work as a War Artist'.[69] He was told to rest, and avoid any strenuous effort. In due course he suffered increasingly from asthma, which he blamed on his exposure to the lingering effects of gas attacks at Ypres in 1918.

Like Nevinson, who also suffered physically in the first years after the War, Nash was cast adrift by his return to life as a peacetime artist: what should he do now? What kind of a life could he make for himself and for Margaret, how would they live? Though they had a reasonable private income, and would never have children, they had middle-class expectations; money would be a struggle for much of the rest of Nash's life.

The next decade was thus an unsettled story of peripatetic ramblings, mostly between London and the south coast of England, with occasional journeys abroad. It was a sometimes cloudy picture of a life lived on the move, of health worries, and of Nash's struggle to accommodate the European avant-garde whilst still retaining the tenets of an English landscape tradition. This was the troubling conundrum he now sought to answer: was it possible to be British, and still be *modern*? He was not alone in his dilemma. The War had caused a crisis in European culture and society: what were the values that had been fought for, what was the future to hold? Where could modern art go now? This was the decade that saw publication of literary works revealing a fractured, radical reinterpretation of time and space: James Joyce's *Ulysses* (1922), T.S. Eliot's *The Waste Land* (1922) and Virginia Woolf's *To the Lighthouse* (1927). How would the pictorial arts respond – and in the light of what had gone before, did they want to respond at all?

Nash attempted to find an answer, though his early supporters, in particular Bottomley and Sir William Rothenstein, became increasingly uneasy about the new direction he was taking. Bottomley had always believed Nash should never have dropped figures from his pictures, though this was never his strong point. Rothenstein, meanwhile, felt Nash was moving away from the direct representation of nature, though Nash denied this. Perhaps more correctly, both men felt their friend was leaving behind his English Romantic roots, with its origins in the Renaissance tradition. In late 1919 Bottomley wrote that Nash 'thinks he can more quickly get to where he wants to be if he uses new traditions from France instead of old ones from Italy. And he won't; and he doesn't need to.'[70]

This, then, was a difficult period. Should he follow his own vision, as he had at the Slade? Or should he continue further down the path of continental modernism? Either way, he was largely going it alone. The Bloomsbury critics did not care much for his work, and his former

ally Roger Fry became hostile, attempting to have him excluded from the London Artists' Association. Nash was alienating old friends in his ambition to follow his own course.

Once again, he found inspiration in nature. In 1919 he made his first visit to Dymchurch, on the southern Kent coast. The long sea wall there became one of his new 'places'. At Dymchurch, as on the Western Front, Man met in conflict with Nature, the two fighting it out together, and neither side ever quite able to overpower the other. Over the next few years Paul and Margaret spent much time living near Dymchurch, the region becoming the scene for a whole series of paintings.[71] Some, such as *Winter Sea*, begun in 1925, would be the most powerful and successful he would produce in these two decades of experiment and uncertainty.

Like the rest of the Slade artists, Nash travelled in Europe in the 1920s, and visits to France and Italy were influential. He was particularly intrigued by the work of the Italian painter Giorgio de Chirico, and the Surrealist movement, but he also experimented, albeit unsuccessfully, with abstraction. A visit to New York in 1931 made little impact on his work – nor did he especially impress the US. A press release in the *Pittsburgh Sun-Telegram* explained that he had first come to attention through his war work. Since then, however, 'his peace-time paintings have been logical performances but anti-climax to that dread picture "The Menin Road".' Whilst his still lifes and beach-scenes 'command respect', they were, this critic thought, 'utterly divorced from life.'[72] This was harsh criticism, and it stung Nash; but it was not wholly without truth, as he must have realised.

No more successful was his involvement in the foundation in 1933 of a new group of allied artists, Unit One. This included his old Slade colleagues Ben Nicholson and Edward Wadsworth, as well as Edward Burra, Henry Moore and Barbara Hepworth. It appeared to them that a combination of artists, one for all, and all for one, was the only way modernism could become a legitimate force in English art. The group crumbled the following year.

In 1936, however, Nash displayed his work at the first International Surrealist Exhibition, which took place in London. Participants included André Breton, Max Ernst, Salvador Dalí and Joan Miró – but yet again, Nash's works under the influence of this group were not especially successful. In fact, his consciously surreal works were far less fantastic or disturbing than his pre-War fantasies. More inspiring was his encounter with the strange stone circles of Avebury, and the 'found objects' with which he began to people some of his paintings.

It was the new war with Germany that saw him reach a final pinnacle in his artistic career. At the start of hostilities he asked Sir Kenneth Clark, Director of the National Gallery and Chairman of the new War Artists Advisory Committee, if he 'could be given official facilities for recording monsters. I believe I could make something memorable.'[73] Clark recognised Nash's potential to represent aerial scenes, and commissioned him to work with the Air Ministry. The best of his works included *Battle of Britain* (1941) and *Totes Meer* (1940–41), in which a dump of wrecked German bombers seems to come to life beneath a haunting moon.

Nash's health was failing. In some of his last and finest paintings he returned to a youthful subject: Wittenham Clumps. He was consciously looking back over his life, but was struggling to complete the autobiography, *Outline*, that he had been working on for some years. He could not get beyond the end of the Great War. As he told Bottomley in July 1945, 'When I came to look into the early drawings I lived again that wonderful hour. I could feel myself making those drawings – in some ways the best I ever did to this day. And because of this I suddenly saw the way to finish my "life"... I feel I could make a complete thing by taking it up to 1914 – just up to the war. After that it was another life, another world'.[74]

Nash died in his sleep – from heart failure – on 11 July 1946.

• • •

The longest-lived, and most successful, of the five Slade artists was Stanley Spencer, though he, too, was irrevocably changed by his experiences during the War. His hopes that he might be able to reclaim his pre-1914 'Cookham feelings' were dashed. The failure to complete *Swan Upping* to his satisfaction had been a warning. He found that he could not settle into his old routines at Fernlea, as he had no room in which to work, and the house was too noisy. These things had not bothered him much before the War, when he had got by with rudimentary studios around the village. Now, when wealthy new patrons, Margaret and Henry Slesser, offered him the use of a room across the river at Bourne End, he jumped at the chance.

The Slessers also offered him a major new commission: a series of religious scenes for their private chapel. During the war, Spencer had conceived of a plan to build a church with Jacques Raverat, its walls decorated with paintings, 'all about Christ. If I do not do this on earth,' he had told his sister Florence, 'I will do it in Heaven'.[75] The idea would remain his life's ambition. As he explained to Lady Ottoline Morrell, he wanted to develop what he called 'some definite *scheme* of pictures. It is so difficult to get people to see that I want to do big pictures to appear bang next to each other cheek to cheek, & *nothing* in between.'[76]

A more important event occurred before he could start work on this dream. Late in 1919 he met Hilda Carline. She lived in Hampstead with her artistic parents and brothers Sydney and Richard. Sydney had studied at the Slade with Stanley (though he had advised Richard against going), and both brothers had been official war artists. Their wide circle of writer and painter friends included Gertler and Nevinson, and they held regular salons at their studios. Hilda immediately captivated Stanley. She was an artist (she was studying at the Slade) and, as a Christian Scientist, was deeply religious.

'I felt sure that she had the same mental attitude towards things that I had', Spencer later recalled. 'I could feel my real self in that extraordinary person. I saw life with her'.[77]

Spencer would later write how, during the Great War, 'when I contemplated the horror of my life and the lives of those with me, I felt that the only way to end the ghastly experience would be if everyone suddenly decided to indulge in every degree and form of sexual love, carnal love, bestiality, anything you like to call it. These are the joyful instances of mankind'.[78] His fear that marriage might break the very personal vision of the world on which his art depended resulted in a long and indecisive courtship. In 1922 his mother died, and in 1923 he returned to the Slade for a term. When he finally married Hilda early in 1925, the discovery of sex, at the age of thirty-three, was explosive – as his subsequent erotic drawings and paintings would reveal.

It caught his old friends unprepared. 'I am somehow astonished to hear that Hilda is going to have a baby', Gertler wrote later that year: 'for some reason I thought that queer couple would be incapable of manufacturing such an article – or even have the desire to do so.'*[79] Yet sex for Spencer was both a spiritual and religious experience. He would explain that he could 'feel reverence in the contemplation of Christ on the Cross, and I can feel reverence through sexual desire for a woman walking down the street.'[80]

During these years, Spencer continued to pursue his dream of a large-scale scheme of pictures. Unsettled in Cookham, he wandered from place to place. He lodged for a while with Muirhead Bone, then with the Carlines in Hampstead, before moving into Henry Lamb's old studio in the Vale of Health. Then in 1924 he started painting a subject that had been fascinating him for years: the Resurrection. This was no ordinary painting, however: it was to be some eighteen feet wide and nine feet high, with the bodies of the resurrected rising from the graves in all their physical perfection. The setting, of course, was Cookham churchyard.

The Resurrection, Cookham took almost three years to complete. He exhibited it in 1927 in a solo show at the Goupil Gallery, to immediate

* Shirin Spencer was born in 1925; a second daughter, Unity, followed in 1930.

acclaim. *The Times*'s critic called it 'the most important picture painted by any English artist during the present century... What makes it so astonishing is the combination in it of careful detail with modern freedom in the treatment of form. It is as if a Pre-Raphaelite had shaken hands with a Cubist.'[81] The description could hardly have been better put.* *The Resurrection* was bought for the considerable sum of £1,000, and presented to the Tate Gallery.

This, together with another major work then underway, would be Spencer's apotheosis. In 1923 Lamb had introduced him to two wealthy potential patrons, Louis and Mary Behrend. Mrs Behrend's brother, Lieutenant Henry Willoughby Sandham, had died at the end of the War. To Spencer's joy, they commissioned him to decorate a purpose-built memorial chapel to him at Burghclere, Hampshire. Spencer moved to Burghclere with Hilda in 1926, and worked at the chapel until its completion in 1932. The paintings[†] were a detailed record of the everyday experiences of his war service – from Beaufort Hospital and the training camp at Tweseldown to his time in Macedonia. The altar wall of the chapel was dominated by another Resurrection scene, in which dozens of British soldiers lay the white wooden crosses that had marked their graves at the feet of a distant Christ.

When the art historian R.H. Wilenski saw the recently completed sequence of paintings, he wrote of his sense 'that every one of the thousand memories recorded had been driven into the artist's consciousness like a sharp-pointed nail'.[82] Though admitting that the Burghclere scheme was 'epic', Wilenski nevertheless felt that after the war

* Others noticed this link between Spencer and the Pre-Raphaelite tradition: as Gordon Bottomley told Paul Nash in 1945, 'You for a long time and Stanley Spencer for a minute were the only true heirs of the Pre-Raphaelites, for you carried Something forward from where they left off.'[83]

† Like Giotto in the Arena Chapel at Padua, Spencer wanted to record his cycle in fresco, but in the end his murals were painted on canvas.

Spencer had lost contact with his spiritual home, Cookham. His *Christ Carrying the Cross*, set in Cookham, 'really records a sense of frustration, a sense of failure to recapture the old contact with the village'.[*84]

Spencer had realised this, and in 1932, in an effort to recapture his Cookham feelings, returned there with his family, purchasing a large house a short distance from Fernlea. But things were still not right. His relationship with Hilda was strained, and she was spending increasing time back in Hampstead. Spencer seemed to rediscover some of his lost Cookham feelings, however, in an attractive artist he met in the village. Patricia Preece had studied at the Slade, and was now living a somewhat impoverished life in Cookham with her lover and fellow artist, Dorothy Hepworth.[†] What followed was a love triangle almost as complicated and bizarre as that which embroiled Carrington.

Hilda refused the *ménage à trois* that her husband proposed, and in 1937 they divorced. Spencer immediately married Patricia. Her motives were almost entirely material, however, as Stanley lavished her with elegant clothes, dainty underwear and expensive jewellery. He even signed the deeds of his Cookham home over to her. Though she posed nude for his paintings, she had no interest in a sexual relationship, and refused to

* Others, too, felt that he had lost his way. In 1922, Paul Nash told Gordon Bottomley: "I am afraid I am a little unsympathetic about S[tanley] Spencer, I used to admire him inordinately & believed him to be the real thing with all the right inheritance of the fine qualities of the mighty & something perfectly his own which caught one by a strange enchantment, and then and then – and now – Did you ever see his Slade competition pictures & the Apple gatherers...?'[85] Nash may have been resentful of Spencer: in 1920 William Rothenstein and Michael Sadler had started plans for a mural scheme at Leeds Town Hall. The artists involved included John and Paul Nash, Spencer, and Edward Wadsworth. It never reached fruition, and Paul blamed Spencer for its failure.

† Preece had been born in 1894, but always maintained that her year of birth had been 1900. She had studied under Roger Fry and, according to Virginia Woolf, was 'much admired' by Fry and Vanessa Bell, and Duncan Grant helped to promote her work.[86] Stanley would tell Hilda that Patricia 'was the first and only time this Cookham image which had always haunted me came to me in the flesh.'[87]

332

cohabit. With a wife, an ex-wife, and two young children for Spencer to support, and with income tax bills going unpaid, it soon became necessary for his dealer, Dudley Tooth, to supervise the artist's financial affairs to save him from bankruptcy.

It was a far cry from Spencer's pre-War days when he had told Henry Lamb that his outgoings were so minimal, 'I do not worry about money'.[88] He was forced increasingly to paint the 'potboiler' landscapes that sold well, but which he hated, since they kept him from his more serious (but less popular) religious subjects, and his dream of another great chapel project. Works such as *St Francis and the Birds* and *Love Among the Nations*, with their oddly formed figures and idiosyncratic subjects, were met with perplexity and sometimes laughter. The Royal Academy, to which Spencer was elected in 1934, saw fit to reject two paintings from its Summer Exhibition the following year.

Hilda, though sympathetic to Stanley's romantic problems, refused to be reconciled, whilst Patricia rejected proposals for a divorce. Though Stanley would have affairs with other women, his heart remained with Hilda. A list made in 1942 headed 'Times when I liked my life & been my self' had as number one, 'My self before the War'. All the other periods in the list were times spent with Hilda. An additional list of 'other times' when he had been happy on his own was headed, perhaps surprisingly, 'Macedonia by myself, 1915–19'.[89] He was devastated by Hilda's death from cancer in 1950, and continued to write her loving letters until the end of his own life.

In 1938, Patricia forced Stanley out of his Cookham home. Exiled and alone, he suffered a nervous breakdown. A period of wandering ensued, though the Second World War brought opportunity when he was commissioned by the War Artists Advisory Commission to paint scenes of shipbuilding at Port Glasgow. In 1945 he returned to Cookham, moving into the small house where his sister Annie had lived. He continued to paint, and though his brother Gilbert felt that he had gone into a decline, he enjoyed considerable success. In 1955 the Tate held a

major retrospective, and in 1959, in a final and splendid recognition of his life's achievement, he was knighted.

By then he was seriously ill with cancer, and Sir Stanley Spencer died in hospital on 14 December 1959. His last great work, *Christ Preaching at Cookham Regatta*, was left unfinished at home. His body was cremated, and the ashes buried in the churchyard at Cookham, near the banks of the Thames.

Where this story began, so it ends.

Abbreviations

Allinson MS	Adrian Allinson, 'A painter's pilgrimage', McFarlin Library, University of Tulsa, Oklahoma
BL	The British Library, London
Bod	The Bodleian Library, Oxford
HRRC	The Harry Ransom Research Center, University of Texas, Austin
IWM	The Imperial War Museum, London
NYPL	New York Public Library
ODNB	*The Oxford Dictionary of National Biography* (Oxford University Press, 2004)
TGA	Tate Gallery Archive, London
DB	Dorothy Brett
GB	Gerald Brennan
RB	Rupert Brooke
GC	Gilbert Cannan
DC	Dora Carrington
MG	Mark Gertler
CK	Christine Kühlenthal
DHL	D.H. Lawrence
HL	Henry Lamb
EM	Edward Marsh
LOM	Lady Ottoline Morrell
JN	John (Jack) Nash
PN	Paul Nash
RN	Richard Nevinson
LS	Lytton Strachey
SS	Stanley Spencer

Endnotes

Preface

1 Schwabe (1943), 6: by the time he wrote these words, Schwabe was Professor of
 Drawing at the Slade.
2 Schwabe (1943), 9.
3 Rutter (1922), 14.
4 PN to GB, late July 1945, Abbott & Bertram (1955), 219.

Chapter 1

1 Jerome K. Jerome, *Three Men in a Boat* (Penguin: Harmondsworth, 1962), 117.
2 Pople (1991), 10.
3 Spencer (1961), 30.
4 Ibid., 34.
5 Spencer (1974), 12.
6 Spencer (1961), 34.
7 TGA 8116.8, Glew (2001), 20.
8 Spencer (1961), 40–1.
9 Ibid., 11.
10 Rothenstein (1957), 'Stanley Spencer', 406–41.
11 Spencer (1974), 14.
12 Spencer (1961), 69.
13 Ibid., 68–9.
14 Ibid., 51.
15 Ibid., 36.
16 SS to the Raverats, 23 December 1914, TGA, Pople (1991), 25.
17 Rothenstein (1957), 410.
18 Spencer (1961), 55.
19 Rothenstein (1979), 14.
20 Spencer (1961), 48.
21 TGA 733.2.51, Glew (2001), 26.
22 Spencer (1961), 45.
23 Spencer (1974), 13.
24 Schwabe (1943), 141.
25 *Made at the Slade* (1979), 4.
26 Spencer (1961), 102–3.
27 Carline (1978), 25. Spencer would tell Eddie Marsh in 1913, 'I *hate* coming to

London it is the journey upsets me'. SS to EM, 7 November 1913, NYPL.
28 Spencer (1974), 28.
29 Quoted in Ackroyd (2000), 679.

Chapter 2

1 Carrington (1965), 19.
2 Ibid., 20.
3 Charles Booth, *Life and Labour of the People of London* (Macmillan & Co: London, 1896), 33.
4 Carrington (1965), 21
5 Ibid., 22.
6 Ibid., 17, 25.
7 Ibid., 23.
8 James Cantlie, *Degeneration Amongst Londoners* (London: The Leadenhall Press, 1885), 32–3, 39.
9 Woodeson (1972), 36.
10 'Jack the Ripper', *ODNB*.
11 Carrington (1965), 25.
12 Woodeson (1972), 46
13 A member of the Gertler family, Woodeson (1972), 36
14 Woodeson (1972), 43.
15 Cannan (1921), Woodeson (1972), 22.
16 Ackroyd (2000), 682.
17 Rothenstein, (1957), 449.
18 Woodeson (1972), 49.
19 Ibid.
20 Morris (1985), 8.
21 Moore (1924), 118.
22 Spencer (1974), 31.
23 George Charlton, 'The Slade', *Studio*, October 1946.
24 Tonks (1929), 224.
25 Ibid., 224–9.
26 Ibid., 235.
27 Ibid., 230.
28 Morris (1985), 8.
29 Tonks (1929), 223.
30 Rothenstein (1932), vol. 166.
31 Woodeson (1972), 57.
32 Spencer (1974), 20.
33 Morris (1985), 8.
34 Allinson MS, f. 17.
35 Nash (1949), 90.

Chapter 3

1 M. Nevinson (1926), 113–4.
2 Ibid., 114.
3 Ibid.

4 DC to NC, 8 January 1921, HRRC.
5 M. Nevinson (1926), 201.
6 Ibid., 130.
7 Walsh (2008), 19—20; John (2006).
8 M. Nevinson (1926), 146.
9 Letter to Jacques and Gwen Raverat, in Glew (2001), 41.
10 M. Nevinson (1926), 224.
11 Ibid., 146.
12 R. Nevinson (1937), 18—19, my emphases.
13 M. Nevinson (1926), 117.
14 Ibid., 118.
15 Ibid., 119.
16 Ibid., 117.
17 Ibid., 118.
18 Ibid.
19 Ibid., 120.
20 Walsh (2002), 6,
21 H. Nevinson (1923), 309—10.
22 Walsh (2002), 7.
23 RN to DC, August 1912, HRRC.
24 R. Nevinson (1937), 14.
25 Ibid.
26 Allinson MS.
27 R. Nevinson (1937), 14.
28 Ibid., 15.
29 Ibid.
30 Walsh (2002), 11.
31 Nevinson to Carrington, 14 Aug 1912, HRRR, 10; R. Nevinson (1937), 15—16.
32 R. Nevinson (1937), 20.
33 Ibid., 16; John (1952), 76—83.
34 R. Nevinson (1937), 16.
35 Ibid.
36 Walsh (2002), 11.
37 R. Nevinson (1937), 17—18.
38 *The Times*, 3 December 1907.
39 R. Nevinson (1937), 18. For John's drawings in *The Slade*, see Fothergill (1907), 1—19.
40 R. Nevinson (1937), 19.
41 Ibid., 20—21.
42 Henry Nevinson to Gilbert Murray, 18 January 1909, Walsh (2008), 31.

Chapter 4

1 R. Nevinson (1937), 23.
2 Ibid.
3 Carpenter (1989), 114.
4 R. Nevinson (1937), 23—4.
5 Ibid. The Slade's signing-in book confirms that Gertler, Spencer, and Fothergill
 Were all there on Nevinson's first day.
6 R. Nevinson (1937), 25.
7 Ibid., 25—6.

8	Ibid., 26.
9	MG to William Rothenstein, 1910?, Carrington (1965), 33.
10	M. Nevinson (1926), 121.
11	R. Nevinson (1937), 26–7.
12	Ibid., 27.
13	Allinson MS, f. 18.
14	RN to DC, undated, HRRC.
15	S. Spencer (1955), 4.
16	G. Spencer (1961), 107.
17	G. Spencer (1974), 197.
18	Allinson MS, ff. 20–21.
19	Carline (1978), 29.
20	Rothenstein (1979), 16.
21	G. Spencer (1961), 106–7.
22	Carline (1978), 26.
23	G. Spencer (1961), 79.
24	Hyman & Wright (2001), 77.
25	SS to EM, 7 November 1913, NYPL.
26	William Rothenstein to MG, 12 May 1909, Carrington (1965), 30.
27	MG to William Rothenstein, 1909, Carrington (1965), 30.
28	William Rothenstein to MG, 12 May 1909, Carrington (1965), 30.
29	MG to William Rothenstein, 1909?, Carrington (1965), 31.
30	Woodeson (1972), 75.
31	Ibid.
32	MG to William Rothenstein, 1910, Carrington (1965), 31.
33	MG to William Rothenstein, 1910?, Ibid., 33.
34	Walsh (2002), 18.
35	To Dorothy Brett, September 1913, in Carrington (1965), 55.
36	Nevinson (1937), 41.
37	R. Nevinson (1937), 28–9.

Chapter 5

1	Nash (1949), 90. Nash arrived at the Slade on 20 October, over two weeks after the start of term. The Slade's signing-in book confirms that Gertler, Nevinson, Spencer, and Roberts were all there that day.
2	Nash (1949), 46.
3	Ibid., 41.
4	Ibid., 32–3.
5	Autobiographical fragment, IWM; file 267A/6, ff. 18–19.
6	Nash (1949), 74.
7	Ibid.
8	Ibid., 73–6,
9	PN to GB, late April 1910, Abbott & Bertram (1955), 4.
10	Nash (1949), 78.
11	Nash (1947), 3.
12	PN to Mercia Oakley, 29 March 1909, Boulton (1991), 21.
13	Nash (1949), 79–80.
14	Blythe (1997), 14.
15	Blythe (1997), 14.

16 Abbott & Bertram (1955), xi.
17 PN to GB 9 April 1910, Abbott & Bertram (1955), 1.
18 GB to PN, 2 August 1910, Abbott & Bertram (1955), 8.
19 Nash (1949), 81.
20 Ibid., 87.
21 PN to Mercia Oakley, 21 July 1910, Boulton (1991) 31.
22 Nash (1949), 87–8.
23 Nash (1949), 89.
24 Nash (1949), 89.
25 PN to GB, 15 Nov 1910, Abbott & Bertram (1955), 13.
26 PN to Mecia Oakley, undated, 1911, Boulton (1991), 38.
27 Nash (1949), 89–90.
28 Ibid., 91.
29 Ibid., 91–2.
30 Ben Nicholson to John Summerson, 6 May 1944, Checkland (2000), 20.
31 See PN to Margaret Nash, 21 March 1917, and King (1987), 43.
32 Ben Nicholson to John Summerson, 6 May 1944, John Summerson Archive,
 TGA, Checkland (2000), 21.
33 Nash (1949), 92.
34 PN to GB, 16 April 1911, Abbott & Bertram (1955), 92; Nash (1949), 92
35 PN to DC, c.1914, John Nash Trustees papers, TGA. See also Nash (1949), 104–5.
36 Nash (1949), 104–5.
37 PN to DC, 26 March 1912, Blythe (1997), 15.
38 Nash (1949), 104.
39 PN to DC, c.1913, John Nash Trustees papers, TGA.
40 NC, 'Carrington's Early Life', Garnett (1970), 501.
41 DC to GB, 6 October 1920, HRRC.
42 DC to LS, 1 January 1919, Gerzina (1989), 8.
43 Quoted in Garnett (1970), 504.
44 DC to GB, 26 December 1920, HRRC.
45 DC to GB, 21 July 1925, HRRC.
46 DC to Gerald Brenan, 21 July 1925, HRRC.
47 DC to Gerald Brenan, 21 July 1925, HRRC.
48 Carrington (1978), 18–19.
49 Ibid., 18.
50 DC to LS, 23 September 1926, Garnett (1970), 341.
51 DC to GB 6 October 1920, HRRC.
52 DC to NC, 26 December 1916, HRRC: Noel understandably found it hard to call
 his sister by her surname, and she suggested he call her 'Doric' instead.
53 Carrington (1978), 21.
54 Ibid.

Chapter 6

1 Fry to G. B. Shaw, Woolf (1940), 56.
2 Nash (1949), 162–3.
3 Bell (1956), 64.
4 Woolf (1985), 197; Henry Nevinson, diary, Bod. MS Eng. Misc. e. 617/2, 12 July 1912.
5 Woolf (1985), 197.
6 Helen Tongue, *Bushman Drawings*, in *Burlington Magazine* (May 1910): see Spalding (1980), 129.

7	Spalding (1980), 129.
8	Hill (1994), 31.
9	Rothenstein (1957), 257.
10	MacCarthy, "The Art-Quake of 1910", *Listener*, 1 Feb 1945.
11	Woolf (1940), 152.
12	RF to G. L. Dickinson, 15 October 1910, Sutton (1973).
13	*Pall Mall Gazette*, 10 November 1910.
14	Robert Ross, *Morning Post*, 7 November 1910, Bullen (1988), 100–104.
15	Nash, (1949), 93.
16	*The Times*, 7 November 1910.
17	W. B. Richmond, *Morning Post*, 16 November 1910, Bullen (1988), 114–16.
18	W. S. Blunt, Bullen (1988), 113–4.
19	Fry, *Vision and Design*, 192–3, Spalding (1980), 139-40.
20	*University College Union Magazine*, V/2, June 1911, 242.
21	Nordau (1895), vii, 3, 317, 536.
22	Karl Pearson, *The Scope and Importance to the State of the Science of National Eugenics* (1907), Jay and Neve (1999), 41.
23	Alice Comyns Carr (ed.), *J. Comyns Carr: Stray Memories* (1920), 60, Spalding (1980), 139.
24	Nash (1949), 93.
25	Ibid.
26	Moore (1924), 135–7.
27	Ibid., 131.
28	Rothenstein (1957), 90.
29	Nash (1949), 93.
30	Richard and Mark were accompanied by Henry Nevinson, who ran into his friend Charles Lewis-Hind, critic for the *Art Journal* and *Daily Chronicle*. Henry recorded in his diary afterwards that 'The ribald scorn of the fatted rich who knew nothing of art even stirred Hind's rage.' Bod. MS Eng. Misc. e. 616/2, 26 November 1910.
31	*University College Union Magazine*, V/2, June 1911, 242.
32	William Rothenstein to Fry, 19 March 1911, Spalding (1980), 155.
33	*Saturday Review*, 10 December 1910, 747.
34	Nevinson (1937).
35	Ibid., 33.
36	Woodeson (1973), 335.
37	Ibid, 336.
38	RN to DC, nd, HRRC.
39	*The Times*, 20 February 1914.
40	MG to DB, August 1913, HRRC.
41	Woodeson (1973), 337.
42	RN to DC, July 1912, HRRC.
43	Bell (1992), 26.
44	G. Spencer (1974), 99.
45	SS to the Raverats, 12, 15 and 17 July 1914, Glew (2001), 49.
46	Carrington (1980).
47	*University College Union Magazine*, vol. VI, No. 1, December 1912.
48	MG to DB, nd, HRRC.

1	Spencer (1961), 105–6.
2	Woodeson, 67–8.
3	H. Nevinson, Bod. MS Eng. misc. e.617/1, 1 December 1911.
4	Walsh (2002), 22; R. Nevinson (1937), 40.
5	R. Nevinson (1937), 55.
6	RN to DC, 17 September 1912, HRRC.
7	R. Nevinson (1937), 29.
8	RN to DC, June 1912, HRRC.
9	Allinson MS, ff. 24–5.
10	RN to DC, May 1912, HRRC.
11	G. Spencer (1961), 105.
12	Allinson MS, f. 21.
13	*The Times*, 2 October 1911, 9.
14	R. Nevinson (1937), 41.
15	'Death of M.G. Lightfoot', TGA 8221.5.24.
16	RN to DC, 12 June 1912, HRRC.
17	RN to DC, 8 April 1912, HRRC.
18	RN to DC, 28 March 1912, HRRC.
19	RN to DC, 9 September 1912, HRRC.
20	Carrington (1980), 22.
21	RN to DC, 28 March 1912, HRRC.
22	RN to DC, April 1912, HRRC.
23	Nevinson (1937), 30.
24	RN to DC, nd, HRRC.
25	RN to DC, April 1912, HRRC.
26	RN to DC, April 1912, HRRC.
27	MG to DC, Woodeson (1972), 85.
28	Quoted by Gertler's friend Sylvia Lind, MacDougall (2002), 66.
29	MG to DC, 15 April 1912, HRRC.
30	RN to DC, 10 June 1912, HRRC.
31	RN to DC, May 1912, HRRC.
32	Carrington (1980), 23.
33	MG to DC, 13 July 1912, Carrington (1965), 41.
34	MG to DC, 13 May 1912, Woodeson (1972), 90.
35	Woodeson (1972), 90.
36	MG to DC, December 1912, Carrington (1965), 49.
37	Carrington (1980), 23.
38	MG to DC, 19 June 1912, Carrington (1965), 36.
39	RN to DC, 21 June 1912, HRRC.
40	M. Nevinson (1926), 217–8.
41	MG to DC, undated, HRRC.
42	MG to DC, 2 July 1912, Carrington (1965), 37.
43	MG to RN, July 1912?, HRRC.
4	MG to DC, 7 July 1912, Gerzina (1989), 34.
45	MG to DC, 2 July 1912, Carrington (1965), 38.
46	RN to DC, 5 July 1912, HRRC.
47	MG to DC, August 1912, Carrington (1965), 44.
48	RN to DC, 1912, HRRC.

49	RN to DC, 11 July 1912, Gerzina (1989), 38
50	MG to DC, ? July 1912, Carrington (1965), 41.
51	MG to DC, 19 July 1912, ibid.
52	MG to DC, ? July 1912, ibid., 42.
53	Carrington (1980), 26, 22.
54	RN to DC, 19 July, HRRC.
55	RN to DC, 5 July 1912, HRRC.
56	Hamnett (1932), 36.
57	RN to DC, ? 1912, HRRC.
58	RN to DC, ? 1912, HRRC.
59	RN to DC, July 1912, Gerzina (1989), 38.

Chapter 8

1	Sadleir (1949), 254.
2	Ibid.
3	Ibid.
4	MG to DC, July 1912, Carrington (1965), 43.
5	Nevinson (1937), 41.
6	Allinson MS, ff. 21–2.
7	Woodeson (1972), 102; see Schwabe (1943) for this reference.
8	Sadleir (1949), 253.
9	SS to the Raverats, 15 December 1913, Glew (2001), 47.
10	RN to DC, August 1912, HRRC.
11	RN to DC, 8 September 1912, HRRC.
12	RN to DC, 14 August 1912, HRRC.
13	RN to DC, August 1912, HRRC.
14	RN to DC, 17 September 1912, HRRC.
15	RN to DC, 17 September 1912, HRRC.
16	PN to DC, July? 1914, Blythe (1997), 78.
17	RN to DC, August 1912, HRRC.
18	MG to DB, August 1912, HRRC.
19	MG to DC, August 1912, Carrington (1965), 44.
20	MG to DC, July 912, Carrington (1965), 43.
21	Ibid.
22	MG to DC, 2 September 1912, Carrington (1965), 44.
23	MG to DC, 12 September 1912, ibid., 45.
24	MG to DC, 15 August 1912, HRRC.
25	MG to DC, 12 September 1912, HRRC.
26	MG to DC, 24 September 1912, Carrington (1965), 47.
27	Nash (1949), 110.
28	Parsons (1979), 301.
29	Nash (1949), 96–7.
30	Ibid., 97
31	Ibid., 105.
32	Ibid., 106–7.
33	Ibid., 110.
34	Ibid., 121.
35	Ibid., 122.
36	Nash to MO, undated, Bertram (1955), 45.

37	Nash (1949), 111.
38	PN to GB, August 1912, Abbott & Bertram (1955), 42.
39	Nash (1949), 200.
40	PN to MO, 23 September 1911, Boulton (1991), 39—41.
41	Bertram (1955), 69; Nash (1949), 122—3.
42	Nash (1949), 111.
43	PN to MO, 12 May 1912, Boulton (1991), 79.
44	*The Times*, 15 November 1912.
45	Nash (1949), 125, 129.

Chapter 9

1	Nash (1949), 129—30.
2	Obituary, *The Times*, 26 June 1939; G. Spencer (1974), 100.
3	SS to Jacques Raverat, May? 1911, in Glew (2001), 34.
4	From 'Sermon LXVI', Pople (1991), 25—6.
5	G. Spencer (1961), 110.
6	Hyman & Wright (2001), 79.
7	SS to Sydney Spencer, 18 May 1911, Glew (2001), 34.
8	SS to the Raverats, July/August 1911, TGA 8116.4.
9	Pople (1991), 32.
10	TGA 733.2.85, in Pople (1991), 35.
11	SS to the Raverats, 7 August 1911, TGA 8116.6.
12	Hyman and Wright (2001), 87.
13	SS to the Raverats, 13 June 1911, Glew (2001), 35.
14	See Hyamn and Wright (2001), 83—4.
15	G. Spencer (1961), 113—15.
16	SS to the Raverats, 18 July 1912, TGA 8116.10.
17	SS to the Raverats, 15 December 1913, Glew (2001), 47.
18	SS to Richard Carline, 2 May 1915, Glew (2001), 53.
19	See Hyman and Wright (2001), 87.
20	Bullen (1988), 367, 407. Hind's review appeared in the *Daily Chronicle* on 5 October 1912, and Brooke's in the *Cambridge Magazine* in November.
21	The *Connoisseur* (November 1912), Hyman and Wright (2001), 79.
22	Clark Library, UCLA, MS Gill G384L R 8465, October 1912.
23	Nash (1949), 93.
24	Walsh (2002), 51.
25	*University College Union Magazine*, V/2, June 1911, 242.
26	Margaret Nevinson, *Vote* (3 December 1910), Walsh (2002), 45.
27	*Evening News*, 4 March 1912, Walsh (2002), 45.
28	EM to RB, 1914, Hassall (1959), 254.
29	Roger Fry, *Nation*, 9 March 1912, Spalding (1980), 153.
30	Boccioni to Vico Baer, 15 March 1912, Walsh (2002), 47.
31	Wees (1972), 96.
32	Glenavy (1964), 58.
33	RN to DC, 22 August 1912, Walsh (2002), 38.
34	RN to DC, September 1912, HRRC.
35	Allinson MS, ff. 35—8.
36	John (1952), 72.
37	RN to DC, 12 October 1912, HRRC.

38	Nevinson (1937), 45–6.
39	RN to DC, 13 October 1912, HRRC.
40	M. Nevinson (1926), 238–9.
41	Nevinson (1937), 35.
42	Ibid., 45, 47–8.
43	Ibid., 34–53.
44	RN to DC, 16 January 1913, HRRC.
45	RN to DC, 20 January 1913, HRRC.
46	RN to DC, 26 March 1913, HRRC.
47	MG to DC, October 1913, Carrington (1965), 57.

Chapter 10

1	Nevinson (1937), 56.
2	RN to DC, 14 January 1913, HRRC.
3	Nevinson (1937), 41.
4	Ibid., 56.
5	Ibid.
6	Rothenstein (1957), 270–1.
7	*The Times*, 16 October 1913.
8	Clive Bell, *Nation* (25 October 1913), Walsh (2002), 61.
9	Walsh (2002), 62.
10	Nevinson (1937), 56.
11	Cork (1985) 216.
12	Nicholson (2002), 266.
13	Allinson MS, f. 41.
14	Blythe (1997), 77.
15	Ibid.
16	PN to GB 27 December 1913, Abbott & Bertram (1955), 68.
17	Nash (1949), 162.
18	Ibid., 166–7.
19	PN to William Rothenstein, c. December 1913, Bertram (1955), 76. On this exhibition, see Bullen (1988) 467.
20	Blythe (1997), 45; Rothenstein (1983), 35.
21	DC to JN, 1913, Blythe (1997), 38.
22	JN to DC, no date given, 1914? Blythe (1997), 84.
23	JN to DC, no date given, Blythe (1997), 62.
24	MG to DC, 1 January 1914, in Carrington (1965), 61.
25	MG to DC, 2 January 1914, HRRC.
26	Hamnett (1932), 44.
27	See Nash, *Outline*, and Boulton (1991), 9, and in particular PN to Mercia Oakley, 1912 or 1913, Boulton (1991), 88–9.
28	PN to Mercia Oakley, March 1912 and undated, 1912, Boulton (1991), 62–3, 64.
29	PN to Mercia Oakley, undated, spring 1912, Boulton (1991), 68.
30	Ibid., 73.
31	Nash (1949), 130–1.
32	Ibid., 140–1.
33	Sieveking (1957), 50.
34	Nash (1949), 147.
35	Ibid., 145; Sieveking (1957), 54–5.

36	PN to MO, December 1910, Boulton.(1991) 36: 'once I was vaguely a Socialist but I have never been a Radical and I think at present as a matter of fact I am a Unionist'.
37	Nash (1949), 154.
38	Ibid., 147–8.
39	Sieveking (1957), 61.
40	PN to DC, no date given, Blythe (1997), 32.
41	DC to JN, no date given, Blythe (1997), 21.
42	PN to GB, March 1913, (1955), 54–5.
43	GB to PN, 18 March 1913, (1955), 55–6.

Chapter 11

1	Fry to William Rothenstein, 28 March 1911, Spalding (1980), 155.
2	Taped interview with Prof. Quentin Bell, 1960s, University of Sussex Library, Watney (1980), 3.
3	Nicolson (1953), unpaginated.
4	Marsh (1939), 355.
5	Shone (1993), 62.
6	Marsh (1942), 97.
7	Marsh (1939), 356.
8	Hassall (1959), 552.
9	Nevinson (1937), 63.
10	EM to RB, August 1913, Hassall (1959), 241.
11	MG to DB, June 1913, Carrington (1965), 54.
12	MG to DC, June 1913, ibid., 53.
13	MG to DC, Christmas 1913, Carrington (1965), 58.
14	MG to DC, October 1913, ibid., 57.
15	MG to DB, July 1913, HRRC.
16	Ibid.
17	MG to DB, June and September 1913, Carrington (1965), 54, 55.
18	EM to RB, August 1913 and 26 August 1913, Hassal (1959), 241, 244.
19	MG to Brett, September 1913, Woodeson (1972), 108.
20	MG to DB, September 1913, HRRC; MG to DB, August 1913, HRRC.
21	MG to DC, December 1913, Carrington (1965), 59–60.
22	DC to JN, no date, Blythe (1997), 12.
23	MG to DC, 1 January 1914, Carrington (1965), 61.
24	MG to EM, ?
25	MG to DC, December 1913, Carrington (1965), 60.
26	MG to EM, 1913, Carrington (1965), 57.
27	MG to DB, July 1913, HRRC.
28	Woodeson (1972), 114.
29	Ibid., 125.
30	EM to RB, August 1913 and 26 August 1913, Hassall (1959), 241, 244.
31	SS to the Raverats, 1913, Glew (2001), 44–5.
32	SS to LOM, 17 July 1914, HRRC.
33	Ibid.
34	MG to EM, October 1913, NYPL.
35	JC to EM, 21 October 1913 and 25 August 1913, NYPL.
36	SS to the Raverats, 15 December 1913, in Glew (2001), 46.

37 MG to DC, nd, HRRC.

38 MG to DB, 1913, HRRC.

39 MG to DB, September 1913, HRRC.

40 MG to EM, 1913, NYPL.

41 JC to EM, 1914, NYPL.

42 MG to DC, January 1914, Carrington (1965), 63.

43 SS to EM, 21 October 1913, NYPL; in 1913 and 1914 Gilbert Spencer won the
 Slade's first prize for figure drawing, and first prize for cast drawing in 1915.

44 SS to HL, 24 October 1913, Glew (2001), 45.

45 HL to LS, March 1914, Clements (1985), 207.

46 SS to the Raverats, 15 December 1913, Glew (2001), 47.

47 SS to the Raverats, Pople (1991), 52.

48 EM to RB, Hassall (1959), 252.

49 William Spencer to EM, 23 November 1913, NYPL.

50 EM to Seabrooke, Hassall (1959), 258.

51 Clements (1985), 210.

52 Spencer (1961), 90.

53 EM to RB, Hassall (1959), 254–5.

54 MG to EM, 1913, NYPL.

55 RB to EM, September 1913, Woodeson (1972), 111.

56 Pople (1991), 50.

57 Hassall (1959), 258.

58 Woodeson (1972), 110.

59 Hassall (1959), 258.

Chapter 12

1 Nevinson (1937), 64.

2 SS to EM, 14 March 1914, NYPL; Hassall (1959), 280.

3 Causey (1980), 51.

4 PN to GB, late October 1913, Abbott & Bertram (1955), 65–6.

5 PN to EM, NYPL; see Causey (1980), 51.

6 Nash (1949).

7 Ibid., 137.

8 Ibid., 138.

9 Ibid., 139.

10 SS to the Raverats, 15 December 1913, Glew (2001), 47.

11 Carline (1978), 45–6.

12 JC to EM, 1914, NYPL

13 Sadler (1949), 255.

14 Woodeson (1972), 134.

15 EM to MG, in Hassall (1959), 265.

16 JC to EM, 1914, NYPL.

17 SS to EM, 31 March 1914, NYPL.

18 SS to the Raverats, 19 April 1914, in Glew (2001), 48; MG to DC, 1 April 1914,
 Carrington (1965), 64.

19 Fry to R. C. Trevelyan, 16 January 1914, Sutton (1972), 377.

20 Bertram (1955), 75.

21 Nash (1949), 138.

22 Sassoon (1942), 223–4, 231.

23 SS to the Raverats, July 1914, Glew (2001), 49–50.

24 SS to EM, 10 October 1918, NYPL.

25 MG to DC, 9 April 1914, Carrington (1965), 66–7.

26 PN to DC, 1914, TGA 8910.13.2.123.

27 MG to DB, January 1914, HRRC.

28 Farr (1978), 111.

29 MG to DC, April 1914, Carrington (1965), 67.

30 MG to DC, August 1914, Carrington (1965), 75.

31 SS to the Raverats, 12 July 1914, TGA 8116.39.

32 Farr (1978), 104.

33 ODNB.

34 Seymour (1998), 122.

35 Gathorne-Hardy (1963), 253.

36 Ibid., 253.

37 Farr (1978), 104.

38 Gathorne-Hardy (1963), 253.

39 Ibid., 254–6.

40 SS to LOM, 15 July 1914, HRRC.

41 MG to DC, July 1914, Carrington (1965), 71–2.

42 Walsh (2002), 69.

43 Ibid., 74.

44 Ibid., 76–7.

45 Lewis (1992), 33.

46 Ezra Pound, 'Vorticism', *Fortnightly Review*, 1 September 1914.

47 Lewis (1992), 39.

48 See Wilson (2000).

49 Lewis (1992), 35–40.

50 MG to DB, postmarked 18 July 1914, HRRC.

51 MG to DC, July 1914, Carrington (1965), 71–4.

52 SS to EM, 2 July 1914, NYPL.

53 Clements (1985), 207.

54 PN to EM, nd, NYPL.

55 G. Spencer (1974), 99–100.

56 Stanley Spencer to Christopher Hassall, TGA.733.1.671, quoted in Causey (1980), 22.

57 M. Nevinson (1926), 243–4.

58 Ibid., 245.

59 'War protest meeting', *The Times*, 3 August 1914; Harold Frederick Bing, IWM, sound catalogue 358/11, reel 1.

60 'London and the coming of war', *The Times*, 5 August 1914.

61 'The Declaration of War', editorial, *The Times*, 5 August 1914.

62 H. Nevinson, Bod. MS Eng. Misc. e.618/3, 4 August 1914.

63 M. Nevinson (1926), 245.

64 PN to Eddie Marsh, August 1914, Abbott & Bertram (1959), 85.

65 Nash (1949), 158.

66 Lewis (1992), 63–8.

67 Sassoon (1942), 274.

68 M. Nevinson (1926), 245.

Chapter 13

1	PN to GB, August/September 1914, (1955), 72.
2	PN to DC, August 1914, Blythe (1997), 81.
3	Nash (1949), 177.
4	Ernest Hemingway, *A Moveable Feast* (Penguin: Harmondsworth, 1975), 28.
5	PN to EM, August 1914, NYPL.
6	MG to DC, August 1914, Carrington (1965), 75.
7	G. Spencer (1961), 134.
8	Frieda Lawrence to EM, c.13 September 1914, Zytaruk and Boulton (1981), 214.
9	Sieveking (1957), pp. 48–9.
10	PN to MO, 4 December 1914, Boulton (1991), 93.
11	RB in Marsh (1942), cxxix; PN to Emily Bottomley, October 1914, Abbott & Bertram (1959), 76.
12	MG to DC, August 1914, Carrington (1965), 74.
13	Ibid.
14	Woddeson (1972), 150.
15	MG to DB, 6 September 1914, HRRC.
16	MG to EM, 17 August 1914, Woodeson (1972), 149.
17	Nevinson (1937), 70.
18	Walsh (2002), 105.
19	Diary, 25 October 1914, Walsh (2008), 94.
20	SS to LOM, 11 August 1914, HRRC.
21	SS to HL, 12 August 1914, Glew (2002), 50.
22	Pople (1991), 58.
23	SS to the Raverats, September 1914, Glew (2001), 51.
24	JC to EM, 1914, NYPL.
25	Ibid.
26	Ibid. This famous quote attributed to Nietzche, though not found in his writings, goes: 'One must have a chaos inside oneself to give birth to a dancing star'.
27	JC to MG, 1914, Woodeson (1972), 152.
28	JC to Dolly Henry, ibid.
29	Cannan (1916), 263.
30	*The Times*, 9 October 1914, 9.
31	Holroyd (1976), 437.
32	Woodeson (1972), 155.
33	Mark Gertler MS, in the private collection of Luke Gertler.
34	MG to DC, 15 August 1912, HRRC.
35	Cannan (1916), 263.
36	Sadleir (1949), 254.
37	Marsh (1939), 361–2.
38	Holroyd (1976), 437.
39	Sadleir (1949), 254.
40	Marsh (1939), 361–2.
41	MacDonald (1987), 363.
42	W.B. Yeats, *Memoirs*, transcribed and edited by Denis Donoghue (London: Macmillan, 1972), p. 140.
43	H. Nevinson, Eng. Misc. e.618/3, November 1914; ODNB.
44	Nevinson (1937), 71–2; H. Nevinson, Eng. Misc. e.618/3, November 1914.
45	Jünger (1941), 116.

46 Nevinson (1937), 71–2.

47 Tonks to Mary Hutchinson, 28 October 1914, HRRC.

48 Nevinson (1937), 74; H. Nevinson, Eng. Misc. e.618/3, 14 November 1914.

49 Walsh (2002), 98.

50 JN to DC, no dates given, Blythe (1997), 81, 83.

51 *New Age*, 29 October 1914, 635.

52 *Athenaeum*, 12 September 1914, 269.

53 *The Times*, 30 April 1915, 15.

54 Cited by Konody (1917), 14.

Chapter 14

1 RB to SS, 31 July 1914, in Keynes (1968), 601.

2 SS to HL, 23 November 1914, Glew (2001), 51–2.

3 G. Spencer (1961), 138.

4 SS to HL, 23 November 1914, Glew (2001), 51–2.

5 SS to LOM, 11 August 1914, HRRC.

6 SS to the Raverats, 8 May 1915, TGA 8116.49.

7 SS to EM, 8 April 1915, NYPL. Spencer added the caveat, 'But 2 years ago I uttered the same words & in 2 years time I shall do the same... *perhaps*.'

8 Carline (1978), 41.

9 Pople (1991), 63.

10 SS to the Raverats, May 1915, Glew (2001), 56.

11 SS to the Raverats, 8 May 1915, Glew (2001), 54.

12 Ibid.

13 Hyman & Wright (2001), 99.

14 Pople (1991), 81.

15 SS to HL, 19 July 1915, Glew (2001), 57.

16 Glew (2001), 57–60; Carline (1978) 49–52; Spencer's notebook/diary, TGA 733.3.83.

17 Gathorne-Hardy, (1974), 31.

18 MG to DC, 1915, Carrington (1965), 85.

19 DC to JN, no date given, Blythe (1997), 66.

20 JN to DC, 1915?, in Blythe (1997), 104.

21 PN to EM, nd, NYPL.

22 EM to MG, 8 August 1915, Carrington (1965), 101.

23 Woodeson (1972), 161.

24 MG to DC, January 1915, Carrington (1965), 81.

25 DC to MG, 29 January 1915, HRRC; MG to DC, Woodeson (1971), 166.

26 MG to DB, January 1915, Carrington (1965), 78.

27 MG to LS, 1 January 1915, Carrington (1965), 77.

28 Frieda Lawrence, *Not I But the Wind*, 75.

29 Farr (1978), 115.

30 MG to DC, January 1915, Carrington (1965), 81.

31 Gathorne-Hardy (1974), 49–50.

32 Clements (1985), 197.

33 Holroyd (1967–8), 2.251. This was Frank Swinnerton of Chatto and Windus, who first met Strachey in January 1917.

34 MG to DC, 3 March 1915, Woodeson (1972), 208.

35 MG to LS, 12 May 1916, Woodeson (1972), 210.

36 MG to DC, c.May 1915, HRRC.

37 MG to EM, 17 August 1915.

38 Gathorne-Hardy (1974), 34—5.

39 David Garnett, Holroyd (1968), 596.

40 Gathorne-Hardy (1974), 49.

41 Glenavy (1964), 79.

42 Ibid., 162.

43 Ibid., 75.

44 Gathorne-Hardy (1974), 234.

45 SS to the Raverats, 8 May 1915, Glew (2001), 54

46 G. Spencer (1974), 74—5.

47 DC to MG, December 1915, HRRC.

48 GC to LOM, 6 July 1914, Farr (1978), 108.

49 MG to DC, 1 July 1915, in Carrington (1965), 97.

50 DHL to Lady Cynthia Asquith, 31 January 1915, Zytaruk & Boulton (1981), 268—9.

51 DHL to EM, 13 September 1914, Zytaruk & Boulton (1981), 215.

52 MG to EM, 17 August 1915, Carrington (1965), 100.

53 Farr (1978), 112.

54 DHL to MG, 27 September 1916, Zytaruk & Boulton (1981), 657.

55 MG to EM, 19 October 1915, NYPL.

56 MG to EM, 17 August 1915..

Chapter 15

1 DC to MG, 1915, HRRC.

2 DC to CK, 1915?, Blythe (1997), 92.

3 DC to MG, 1915, HRRC.

4 DC to CK, 14 February 1915, Blythe (1997). 89.

5 DC to MG, May 1915, Garnett (1970), 19.

6 DC to CK, no date given, Blythe (1997), 61.

7 DC to Gerald Brenan, 1 June 1923, Garnett (1970), 253

8 MG to DC, 23 January 1915, Carrington (1965), 81.

9 MG to DC, 4 March 1915, ibid. 87.

10 MG to DC, 1915, Woodeson (1973), 210—211.

11 DC to MG, 1915, ibid. 211.

12 MG to DC, 1 July 1915, Carrington (1965), 98.

13 Garnett (1970), 505.

14 MG to DC, June 1915, Carrington (1965), 96.

15 MG to DC, June 1915, ibid..

16 MG to DC, 30 May 1916, ibid.

17 Gerzina (1989), 80.

18 DC to CK, December 1915, Blythe (1997), 105.

19 DC to MG, December 1915, HRRC.

20 DC to CK, December 1915, Blythe (197), 105—6.

21 Frank Rutter, *The Sunday Times*, 21 March 1915.

22 Nevinson (1937).

23 Charles Marriott, *Standard*, 3 December 1915, in Walsh (2002), 130.

24 Nevinson (1937), 78—9.

25 MG to DC, November 1915, Carrington (1965), 104—5.

26 MG to DC, December 1915, ibid., 106.

27 *The Daily Telegraph*, Woodeson (1972), 185.

28 Woodeson (1972), 186.

29 Augustus John to John Quinn, 16 February 1916, Holroyd (1976), 436n.

30 Clive Bell to MG, December 1915, Carrington (1965), 106.

31 Duncan Grant to MG, in Woodeson (1973), 203.

32 *The Times*, 10 March 1915.

33 MG to DC, December 1915, Carrington (1965), 106–7.

34 SS to EM, 12 October 1915 and nd, NYPL.

35 *The Times*, 30 November 1915.

36 Glew (2001), 65.

37 Ibid.

38 Ibid.

39 Pople (1991), 110.

40 Ibid., 111.

41 Glew (2001), 63.

42 Ibid.

43 SS to EM, nd, NYPL.

44 SS to the Raverats, 12 June 1916, Glew (2001), 71.

45 SS to the Raverats, 1916 Pople (1991), 122.

46 Hassall (1959), 302.

47 DC to JN, no date given, Blythe (1997), 67.

48 MG to DC, 20 May 1916, Carrington (1965), 113.

49 MG to LOM, 2 October 1917, HRRC.

50 Glenavy (1964), 104.

51 C to MG, July 1916, HRRC.

52 C to NC, nd, HRRC.

53 N to DC, nd, Blythe (1997), 103.

54 C to LS, June 1916, Gerzina (1989), 79.

55 DC to LS, 13 June 1916, Garnett (1970), 29.

56 DC to MG, November 1917, HRRC.

57 DHL to Gertler, 20 Jan 1916, Zytaruk & Boulton (1981), 508.

58 DC to LS, July 1916, Gerzina (1989), 82.

59 Blythe (1997), 96–7.

60 DC to CK, 14 February 1915, Blythe (1997), 89.

61 Gathorne-Hardy (1963), 277.

62 DC to MG, September 1916, HRRC.

63 Gathorne-Hardy (1974), 52.

64 MG to Koteliansky, no date or source, Gerzina (1989), 82.

65 DC to LS, 30 July 1916, Garnett (1970), 33.

66 MG to DC, 4 September 1916, HRRC.

67 Gerzina (1989) 87: see Huxley's letter to Brett, 1 December 1918, Smith (1969), 172.

68 DC to Brenan, 18 December 1921, HRRC.

69 LOM to MG, 8 August 1916, Carrington (1965), 117.

70 DC to CK, 1915?, Blythe (1997), 90.

71 Gerzina (1989), 68–9.

72 Hill (1994) 41, 66.

73 DC to MG, August 1916, HRRC.

74 Ibid.

75 DC to MG, August 1916, Carrington (1965), 120–21.

76 Gerzina (1989), 90. See Garnett (1970), 37, and Garnett, *Great Friends*, 152–4.

77 Nicholson (2002), 45.

Chapter 16

1 MG to DC, June 1915, Carrington (1965), 95.
2 See MG to LS, May 1916, ibid., 111.
3 DHL to LOM, 5 May 1916, Zytaruk and Boulton (1981), 603.
4 DHL to MG, 27 September 1916, Carrington (1965), 129.
5 Farr (1978), 145.
6 MG to DC, 14 August 1916, Carrington (1965), 116—17.
7 Gathorne-Hardy (1963), 281.
8 Geo. C. Dixon (Slade School), 'The Art Student, "The Conscientious Objector",
 and the War', *University College Union Magazine*, VII/6, June 1916, 280.
9 Allinson MS, f. 50—2.
10 Farr (1978), 136
11 *University College Union Magazine*, VII/5, March 1916, 232.
12 MG to DB, 10 February 1916, HRRC.
13 MG to DC, nd, HRRC.
14 Allinson MS, f. 53.
15 CK to JN, 1916, TGA.
16 DC to MG, nd, HRRC.
17 Farr (1978), 145—8.
18 MG to DC, January 1917, Woodeson (1973), 239.
19 GC to MG, 1917, Carrington (1965), 137—8.
20 Ibid.
21 Farr (1978), 148—9.
22 DC to MG, 1 November 1916, HRRC.
23 MG to William Rothenstein, 3 July 1918, in Carrington (1965), 255.
24 MG to DC, 2 November 1916, Carrington (1965), 132.
25 Cannan (1916), 57, 78, 102—3, 105, 108, 121—2.
26 Farr (1978), 140.
27 Alice Sedgwick, *Times Literary Supplement*, 19 October 1916; PN to MN, c. January
 1917, King (1987), 77. TGA.
28 DC to NC, postmarked 2 March 1918, HRRC.
29 MG to DC, nd, HRRC.
30 Wilson (2000), 25.
31 St John Hutchinson to MG, Carrington (1965), 128.
32 LS to LOM, 3 July 1916, Levy (2005), 307.
33 DHL to MG, 9 October 1916, HRRC.
34 DHL to MG, 10 February 1916, Boulton & Robertson (1981), 531.
35 DHL to MG, 9 October 1916, HRC.
36 M. Nevinson (1926), 246.
37 Nevinson (1937), 81.
38 Ibid., 81—2; Walsh (2002), 123—4.
39 Hind, *London Evening News*, 27 September 1916.
40 Sickert, *Burlington Magazine,* April 1916.
41 Sunday Times, 5 March 1916.
42 Nevinson (1937), ??
43 Ibid.,, 87.
44 Ibid., 85
45 Ibid.
46 Ibid., 87.

47 *University College Union Magazine*, VIII/1 (December 1916), 29.
48 M. Nevinson (1926), 248–9.
49 Manchester (1983), 626, 613.
50 Walsh (2002), 152–3; H. Nevinson, Bod. MS Eng. Misc. e.620/1, 9 November to 26 December 1916.
51 PN to Mercia Oakley, after 16 August 1916, Boulton (1991), 95.
52 PN to MN, 7 March 1917, Nash (1949), 187
53 Ibid.
54 PN to MN, 6 April 1917, ibid., 194.
55 PN to MN, Good Friday 1917, Blythe (1997), 121
56 PN to MN, 18 April 1917, ibid., 121–2.
57 PN to MN, 26 April 1917, Nash (1949), 198.
58 PN to MN, 12 May 1917, Blythe (1997), 122.
59 PN to GB, August 1917, Abbot & Bertram (1955), 85.
60 Pople (1991), 128; SS to the Raverats, 1916, Glew (2001), 76.
61 SS, notebook, 1945–7, Glew (2001), 76.
62 SS, notebook, 1945–7, Glew (2001), 77.
63 SS to Chute, 28 October 1916, Glew (2001), 77.
64 SS to HL, 17 July 1917,Glew (2001), 87.
65 SS to Will Spencer, 24 February 1918, Glew (2001), 91
66 SS to Florence Spencer, 17 May 1917, TGA 733.1.731.
67 SS to LOM, 9 June 1917, HRRC.
68 SS to Florence Spencer, 24 February 1917, Pople (1991), 142.
69 DC to MG, November? 1917, HRRC.
70 SS to the Raverats, 15 July 1917, Glew (2001), 87.
71 SS to LOM, 9 June 1917, HRRC.
72 SS to Florence Spencer, 24 Feb 1918, Glew (2001), 91.

Chapter 17

1 Walsh (2002), 154.
2 RN to EM, 1 April and April 1917, NYPL; R. Nevinson (1937), 93.
3 RN to EM, 24 and 26 April 1917, NYPL.
4 See Malvern (2004), 13–14.
5 *University College Union Magazine* VII/5, March 1916, 233.
6 Masterman to General Charteris, 3 May 1917, IWM 266A/6, ff. 238–9.
7 Masterman to Buchan, 18 May 1917, IWM 266A/6, f. 232.
8 Masterman to Edward Hudson, 29 October 1917, IWM 266A/6, ff. 181–2.
9 Masterman to Major Lee, 27 October 1917, IWM, Walsh (2002), 176.
10 Walsh (2002), 159.
11 Nevinson (1937) 103; Walsh (2002), 159–60.
12 Masterman to Edward Hudson, 29 October 1917, IWM 266A/6, ff. 181–2.
13 Thomas Derrick, report to Masterman on his visit to Nevinson's studio on 15 October 1917, IWM 266A/6, f. 192.
14 'Royal Academy. Canadian War Memorials', *Daily Telegraph*, 7 January 1919, quoted in Walsh (2008), 144.
15 Konody (1917), 14.
16 Henry Nevinson, diary, 15 March and 3 April 1918, Bod. MS Eng. misc. e. 620/3; RN to Masterman, 10 March 1918 and 7 April 1918, IWM 266A/6 f. 69
17 PN to MN, late March 1917, Nash (1949), 192

18	PN to MN, 21 March 1917, TGA.
19	DC to NC, June or July 1917, HRRC.
20	PN to EM, 7 July 1917, IWM 267A/6, f. 1.
21	EM to John Buchan, 1917, IWM 267A/6, f4. 4–5.
22	Dodgson to Masterman, 18 October 1917, IWM 267A/6, f. 16–17.
23	Stopford to Buchan, 16 August 1917, IWM 267A/6, f. 3.
24	Masterman to Buchan, 15 September 1917, and Buchan to Masterman, 14 September 1917, IWM 267A/6, f. 10–11.
25	PN to Materman, 16 November 1917, IMW, 267A/6, f. 34; PN to MN, 16 November 1917, *Outline*, 210–11.
26	PN to Masterman, 22 November 1917, IWM 267A/6, f. 39.
27	*The Times*, 25 May 1918.
28	See the *Daily Telegraph*, 11 June 1918, cited in Causey (1980), 73–4.
29	PN to GB, 16 July 1918, Abbot & Bertram (1955), 98.
30	PN to GB, April 1919, Abbot & Bertram (1955), 103.
31	Read (1948), 8–9.
32	Salis (1918), unpaginated.
33	Montague and Salis (1918), unpaginated.
34	PN to MN, 5 November 1917, Rothenstein (1983), 45–6.
35	PN to EM, January 1918, NYPL.
36	Rothenstein (1983), 48–9.
37	DC to NC, March 1917, HRRC; DC to NC, nd, Rothenstein (1983), 46.
38	DC to MG, December 1916, Garnett (1970), 50.
39	MG to DC, December 1916, Carrington (1965), 134.
40	DC to MG, May 1917, HRRC.
41	DC to MG, April 1917, HRRC.
42	MG to DC, nd, HRRC.
43	MG to DC, July or August 1917?, HRRC.
44	Carrington (1980), 48.
45	JN to DC, 1916, Rothenstein (1983), 39.
46	DC to MG, 1915 and May 1917, HRRC.
47	DC to LS, 21 January 1918, BL Add. MS 62889.
48	DC to MG, nd, December 1917?, HRRC.
49	MG to DB, nd, HRRC.
50	MG to DC, nd, HRRC.
51	Woodeson (1972), 246.
52	MG to Koteliansky, 26 December 1917, in MGSL, 154.
53	DC to Barbara Hiles, quoted in Gerzina (1989), 113.
54	DC to LS, 12 August 1917, quoted in ibid. 116.
55	Carrington (1980), 35.
56	Bell (1977), 89.
57	DC to LS, 20 Oct 1917, in Garnett (1970), 83.
58	Bell (1977), 152–3, 183–4.
59	Bell (1977), 171.
60	MG to DC, 13 November [1917?], HRRC.
61	Woolf (1977), 158–9, 18 June 1918, and 175–6, 29 July 1918.
62	MG to MH, 15 August 1916, HRRC.
63	MG to DB, 4 May 1918, HRRC.
64	MG to LOM, 22 June 1916, HRRC.
65	MG to LOM, February 1918, HRRC.

66 MG to DB, 2 March 1918, HRRC.

67 MG to DB, 2 March 1918, HRRC.

68 Cork (1988), 109.

69 Cork (1994), 229.

70 MG to Mary Hutchinson, 20 March 1918, HRRC.

71 Manchester (1983), 638.

72 MG to LOM, April 1918, HRRC.

73 PN to GB, 16 July 1918, Abbot & Bertram (1955), 99.

74 For an excellent detailed history of the programme, see Malvern (2004).

75 MG to LOM, 24 April 1918, HRRC.

76 MG to DB, 24 April 1918, HRRC.

77 MG to LOM, June 1918, HRRC.

78 MG to Mary Hutchinson, 18 July 1918, HRRC.

79 MG to Richard Carline, 14 August 1918, TGA 8212.1.10.

Chapter 18

1 Pople (1991),155–7.

2 Yockney to SS, 15 April 1918, IWM 290/7, 6.

3 SS to HL, 30 July 1917, Glew (2001), 89.

4 SS to HL, 3 June 1918, ibid., 92.

5 Pople (1991), 165.

6 Ibid.

7 PN to Yockney, nd, and Yockney to PN, 2 October 1918, IWM 267A/6, f. 152 and 139.

8 SS to his parents, 23–28 October 1918, Glew (2001), 97.

9 Glew (2001), 96.

10 SS to Yockney, 16 November 1919, IWM 290/7, 99.

11 Glew (2001), 95.

12 Pople (1991), 178.

13 William Spencer senior to Lord Milner, Minister for War, early September 1918, IWM 290/7, 21.

14 Glew (2001), 103.

15 SS to EM, 16 September, 5 October, and 10 October 1918, NYPL.

16 DC to LS, 31 October 1918, Garnett (1970), 107.

17 Quoted in Woodeson (1972), 264.

18 Ibid.

19 Gerzina (1989), 80.

20 Cork (1994), 217.

21 DC to LS, 5 November 1918, BL Add. MS 62889.

22 DC to NC, 12 November 1918, HRRC.

23 Manchester (1983), 655.

24 Nevinson (1937), 114–15.

25 DC to NC, 12 November 1918, HRRC.

26 MG to DB, November 1918, HRRC.

27 Draft of *Outline*, TGA 7050.2.

28 Ibid.

29 Ezra Pound (writing under the pseudonym B.H.Dias), *New Age*, 18 July 1918; *Saturday Review*, 16 November 1918: Causey (1980), 74, 78.

30	Glew (2001), 101.
31	TGA 733.3.128.
32	SS to EM, December 1918, NYPL.
33	Pople (1991), 194.
34	Glew (2001), 103.
35	SS to the Raverats, December 1918, Glew (2001), 103.
36	SS to EM, December 1918, NYPL.
37	Glew (2001), 102.
38	Pople (1991), 179.
39	Ibid.
40	SS to HL, 4 January 1919, Glew (2001), 104.
41	SS to DC, 10 January 1919, ibid.
42	Pople (1991), 185.
43	SS to EM, December 1918, NYPL.
44	SS to A. Yockney, 24 Jan 1919, File No. 290/7, fol. 45, IWM.
45	SS to EM, 7 March 1919, NYPL.
46	Causey (1980), 24.
47	SS to A. Yockney, 12 and 27 July 1919, IWM 290/7.
48	Glew (2001), 103.
49	*The Times*, 12 December 1919.
50	*The Burlington Magazine*, February 1920, 94–5.
51	TGA 733.3.7.
52	Henry Nevinson, diary, 12 and 13 December 1919, Bod. MS Eng. Misc. e.621/2.
53	Ibid., 14 December 1919.
54	RN to the WAAC, 15 December 1919, IMW, 266B/6, fol. 1497–9.
55	G. Spencer (1974), 62.
56	Rothenstein (1931), 22.

Epilogue

1	M. Nevinson (1926), 277.
2	Henry Tonks to Mary Hutchinson, HRRC,
3	MG to LOM 13 August 1918, HRRC. April 1920.
4	Carrington (1980), 33.
5	DC to LS, 20 January 1918, BL.
6	Hill (1994), 62, quoted from Garnett, p.129
7	DC to NC, 4 November 1920, HRRC.
8	MG to DB, November 1918, HRRC.
9	Frances Partridge, 'Dora Carrington', ODNB.
10	Gerzina (1989), 165.
11	DC to LS, 14 May 1921, BL.
12	DC to NC, 11 May 1921, HRRC.
13	Woodeson (1972), 282.
14	DC to Gerald Brenan, October 1920, HRRC.
15	MG to LOM, 1 June 1921, HRRC.
16	Notes in Gertler's hand, Rothenstein (1957), 463.
17	DC to LS, 8 May 1921, BL.
18	DC to GB, 5 July 1921, quoted in Hill (1994), 66.
19	DC, diary, BL MS 65159 fol. 67v.
20	DC, diary February 1932, Garnett (1970), 491.

21 DC, diary, BL MS 65159 fol. 68v–69v, 12 February 1932.
22 Gathorne-Hardy (1974), 257–8.
23 MG to DC, 1 March 1932, MGSL, 235.
24 MG to Koteliansky, 12 December 1918, Woodeson (1972), 263–4.
25 GB to DB, Woodeson (1972), 268.
26 Aldous Huxley to DB, 1 December 1918, quoted in Gerzina (1989), 141.
27 DC to MG, 8 December 1918, in Carrington (1980), 118–9.
28 DC to NC, 12 December 1919, HRRC.
29 *The Burlington Magazine*, vol. 38, no. 216 (March 1921), 150.
30 SS to LOM, 10 March 1923, HRRC.
31 MG to DB, 1 June 1928, HRRC.
32 MG to LOM, 24 September 1932, HRRC.
33 Marjorie Gertler to Thomas Balston, 22 July 1938, HRRC:
34 Marjorie Gertler to Thomas Balston, c.1931–39, HRRC.
35 MG to LOM, 15 September 1936, HRRC.
36 MG to EM, 8 May 1939, NYPL.
37 MG to EM, May/June 1939, NYPL.
38 Spencer (1974), 99–100.
39 Rothenstein (1957), 442–3.
40 *The Times*, 27 June 1939.
41 Nevinson (1937), 117.
42 Nash (1949), 218.
43 *he Observer*, 2 November 1919.
44 enry Nevinson, diary, 11 April 1919, Bod.
45 An artist's war cry', *The Observer*, 13 April 1919, quoted in Walsh (2008), 149.
46 Mr Nevinson, British Artist, thinks New York is too modest', *The Herald*, 18 May 1919, Walsh (2008), 151.
47 See Walsh (2008), 152.
48 John Quinn to Wyndham Lewis, 16 June 1919, NYPL, Walsh (2008), 152.
49 Nevinson (1937), 142.
50 Ibid., 162.
51 C. Lewis Hind, 'An Appreciation', *The Old World and the New* (Bourgeois Galeries, 10 November to 4 December 1920).
52 RN to Nancy Cunard, February 1921, HRRC; Nevinson (1937), 154.
53 *Daily Express*, 27 September 1930, Walsh (2008), 228.
54 Ethel Mannin, *Confessions and Impressions* (London, 1930), 197, Walsh (2008), 196, 199.
55 See Corbett (1997) for discussion of the inter-war art of Nash, Nevinson, Spencer, Gertler and Wadsworth.
56 Henry Nevinson, diary, 1 April 1920 and 15 February 1925, Bod.
57 John (2007), 30.
58 MG to DC, December 1920, Carrington (1965), 193.
59 Glew (2001), 210.
60 RN to SS, 15 June 1939, TGA, 733.1.1107.
61 MG to Marjorie Hodgkinson, 10 February 1928, Carrington (1965), 226.
62 Rothenstein (1957), 387.
63 Nevinson (1937), 216.
64 His co-author was the writer Princess Paul Troubetzkoy.
65 Nevinson (1937), 140.
66 Winston Churchill to RN, 7 October 1942, quoted in Walsh (2008), 298.
67 Rothenstein (1957), 388.

68 Margaret Nash to EM, 12 October 1921, NYPL.

69 King (1987), 102.

70 GB to PN, 12 December 1919, Abbott & Bertram (1955), 116.

71 PN to Percy Withers 15 May 1923, in King (1987), 109.

72 King (1987), 148.

73 PN to Clark, Clark Archive, TGA, uncatalogued.

74 PN to GB, late July 1945, Abbott & Bertram (1955), 219.

75 Quoted in Pople (1991), 194.

76 SS to LOM, nd, HRRC.

77 Glew (2001), 209, TGA 733.2.105.

78 Malvern (2004), 224.

79 MG to Catherine, 17 November 1925, HRRC.

80 Glew (2001), 175.

81 *The Times*, 28 Feb. 1927, 'Art Exhibition. Mr. Stanley Spencer.'

82 Wilenski (1933), 281.

83 GB to PN, 27 August 1945, Abbott & Bertram (1955), 265.

84 Ibid., 285.

85 PN to GB, September 1922, Letters, 154.

86 Pople (1991), 325.

87 Pople (1991), 329

88 SS to HL, October 1913, TGA 945.3.

89 TGA 733.2.135, reproduced in Hayman and Wright (2001), 247.

Bibliography

Abbott, Claude Colleer and Anthony Bertram (eds.). 1955. *Poet & Painter. Being the Correspondence Between Gordon Bottomley and Paul Nash, 1910–1946*. London: Oxford University Press.

Ackroyd, Peter. 2000. *London: The Biography*. London: Chatto & Windus.

Baron, Wendy. 2000. *Perfect Moderns: A History of the Camden Town Group*. Aldershot: Ashgate.

Bedford, Sybille. 1973. *Aldous Huxley: A Biography, ol. 1: 1894–1939*. London: Chatto & Windus.

Bell, Ann Olivier (ed.). 1977. *The Diary of Virginia Woolf, Vol. I: 1915–1919*. London: The Hogarth Press.

Bell, Clive. 1956. *Old Friends: Personal Recollections*. London: Chatto & Windus.

Bell, Keith. 1992. *Stanley Spencer: A Complete Catalogue of the Paintings*. London: Phaidon.

Bell, Quentin, and Garnett, Angelica. 1981. *Vanessa Bell's Family Album*. London: Jill Norman & Hobhouse.

Bertram, Anthony. 1955. *Paul Nash. The Portrait of an Artist*. London: Faber and Faber.

Blanche, J. E. 1939. *Portraits of a Lifetime*. London: J. M. Dent.

Blythe, Ronald. 1997. *First Friends: Paul and Bunty, John and Christine – and Carrington*. Huddersfield. The Fleece Press

Boulton, James T. and Robertson, Andrew (eds.) 1984. *The Letters of D. H. Lawrence: Volume III, October 1916–June 1921*. Cambridge: Cambridge University Press.

Boulton, Janet (ed.). 1991. *Dear Mercia: Paul Nash Letters to Mercia Oakley, 1909–18*. Wakefield: The Fleece Press.

Brenan, Gerald. 1962. *A Life of One's Own*. London: Jonathan Cape.

Bullen J. B. (ed.) 1988. *Post-Impressionism in England: The Critical Reception*. London: Routledge.

Campbell, Beatrice. 1964. *Today We Will Only Gossip*. London: Constable.

Cannan, Gilbert. 1916. *Mendel*. London: Lloyds.

Carline, Richard. 1978. *Stanley Spencer at War*. London: Faber and Faber.

Carrington, Noel. 1965. *Mark Gertler: Selected Letters*. London: Rupert Hart-Davis.

Carrington, Noel. 1980. *Carrington: Paintings, Drawings and Decorations*. London: Thames & Hudson.

Carpenter, Humphrey. 1989. *The Brideshead Generation: Evelyn Waugh and his friends*. London: Weidenfeld & Nicholson.

Causey, Andrew. 1980. 'Stanley Spencer and the art of his time', in *Stanley Spencer RA*. London: Royal Academy of Arts.

Causey, Andrew. 1980. *Paul Nash*. Oxford: Clarendon Press.

Chaplin, Stephen. 1998. 'A Slade School Archive Reader, 1868–1975: A Compendium of Documents in University College London Contextualised with an Historical and Critical Commentary, Augmented with Material from Diaries and Interviews.' Unpublished typescript, UCL Archive, London.

Checkland, Sarah Jane. 2000. *Ben Nicholson: The Vicious Circle of his Life and Art*. John Murray: London.

Clements, Keith. 1985. *Henry Lamb: The Artist and his Friends*. Bristol: Redcliffe Press.

Cohen, Joseph. 1975. *Journey to the Trenches: The Life of Isaac Rosenberg, 1890–1918*. London: Robson Books.

Corbett, David Peters. 1997. *The Modernity of English Art, 1914–1930*. Manchester: Manchester University Press.

Cork, Richard. 1976. *Vorticism and Abstract Art in the First Machine Age. Volume 1: Origins and Development*. London: Gordon Fraser.

Cork, Richard. 1985. *Art Beyond the Gallery in Early Twentieth-Century England*. New Haven and London: Yale University Press.

Cork, Richard. 1988. *David Bomberg*. London: Tate Gallery.

Cork, Richard. 1994. *A Bitter Truth: Avant-Garde Art and the Great War*. New Haven and London: Yale University Press.

Dodgson, Campbell, and Montague, C.E. 1918. *British Artists at the Front, 1: C.R.W. Nevinson*. London: Country Life.

Eates, Margot (ed.). 1948. *Paul Nash: Paintings, Drawings and Illustrations*. London: Lund Humphries.

Edwards, Paul (ed.). 2000. *Blast: Vorticism, 1914–1918*. Ashgate: Aldershot.

Engert, Gail. 1972. 'Introduction': *An Exhibition of the Works of the Liverpool Artist Maxwell Gordon Lightfoot (1886–1911)*. Liverpool: Walker Art Gallery.

Farr, Diana. 1978. *Gilbert Cannan: A Georgian Prodigy*. London: Chatto & Windus.

Fielding, Xan (ed.). 1986. *Best of Friends: The Brenan–Partridge Letters*. London: Chatto and Windus.

Fothergill, John (ed.). 1907. *The Slade: A Collection of Drawings and Some Pictures done by Past and Present Students of the London Slade School of Art, MDCCCXCIII–MDCCCCVII*. London: University College.

Garnett, David. 1955. *The Flowers of the Forest*. London: Chatto & Windus.

Garnett, David. 1970. *Carrington: Letters and Extracts from her Diaries*. London: Jonathan Cape.

Gathorne-Hardy, Robert (ed.). 1963. *Ottoline: The Early Memoirs of Lady Ottoline Morrell*. London: Faber and Faber.

Gathorne-Hardy, Robert (ed.). 1974. *Ottoline at Garsington: Memoirs of Lady Ottoline Morrell, 1915–1918*. London: Faber and Faber.

Gerzina, Gretchen. 1989. *Carrington: A Life of Dora Carrington, 1893–1932*. London: John Murray.

Glenavy, Beatrice. 1964. *Today We Will Only Gossip*. London: Constable.

Glew, Adrian. 2001. *Stanley Spencer: Letters and Writings*. London: Tate Publishing.

Hamnett, Nina. 1932. *Laughing Torso: Reminiscences of Nina Hamnett*. London: Constable & Co.

Hanson, Anne C. 1995. *Severini Futurista: 1912–1917*. New Haven: Yale University Art Gallery.

Harrison, C. 1981. *English Art and Modernism, 1900–1939*. London: Allen Lane.

Hassall, Christopher. 1959. *Edward Marsh: Patron of the Arts: A Biography*. London: Longmans, Green and Co.

Hassall, Christopher. 1964. *Rupert Brooke: A Biography*. London: Faber & Faber.

Haycock, David Boyd. 2002. *Paul Nash*. London: Tate Publishing.

Haycock, David Boyd. 2007. 'A crisis of brilliance: C.R.W. Nevinson, Henry Tonks, and the Slade School of Art, 1909-12', in Walsh (ed.), 36-46.

Hill, Jane. 1994. *Dora Carrington*. London: The Herbert Press.

Holroyd, Michael. 1968. *Lytton Strachey: A Critical Biography, Volume II: The Years of Achievement (1910–1932)*. London: Heinemann.

Holroyd, Michael. 1976. *Augustus John: A Biography*. Penguin: Harmondsworth.

Hone, Joseph. 1939. *The Life of Henry Tonks*. London: Heinemann.

Hyman, Timothy, and Wright, Patrick (eds). 2001. *Stanley Spencer*. London: Tate Publishing.

Jay, Mike and Neve, Michael (eds.). 1999. *1900: A Fin-de-Siècle Reader*. London: Penguin.

John, Angela. 2006. *War, Journalism and the Shaping of the Twentieth Century: The Life and Times of Henry W. Nevinson*. London: I.B. Tauris.

John, Angela. 2007. 'A family at war: The Nevinson family', in Walsh (ed.), 23–35.

John, Augustus. 1952. *Chiaroscuro: Fragments of Autobiography: First Series*. London: Jonathan Cape.

Jones, Nigel. 1999. *Rupert Brooke: Life, Death & Myth*. London: Richard Cohen Books.

Jünger, Ernst. 1941. *The Storm of Steel: From the Diary of a German Storm-Troop Officer on the Western Front*. London: Chatto & Windus.

Keynes, Geoffrey (ed.) 1968. *The Letters of Rupert Brooke*. London: Faber and Faber.

King, James. 1987. *Interior Landscapes: A Life of Paul Nash*. London: George Weidenfeld and Nicolson.

Konody, P. G. 1917. *Modern War Paintings by C. R. W. Nevinson*. London: Grant Richards Ltd.

Lawrence, D. H. 1981. *Selected Essays*. Harmondsworth: Penguin.

Levy, Paul (ed.). 2005. *The Letters of Lytton Strachey*. London: Penguin.

Lewis, Wyndham. 1992. *Blasting and Bombardiering: Autobiography (1914–1926)*. London: Imperial War Museum.

Lewison, Jeremy (ed.). 1990. *A Genius of Industrial England: Edward Wadsworth, 1889–1949*. Bradford: Bradford Art Galleries and Museums.

Lipke, George Charlton. 1967. *David Bomberg: A Critical Study of his Life and Work*. London: Evelyn, Adams & Mackay

MacDonald, Lyn. 1987. *1914*. London: Penguin.

MacDougall, Sarah. 2002. *Mark Gertler*. London: John Murray.

Manchester, William. 1983. *The Last Lion: Winston Spencer Churchill: Visions of Glory, 1874–1932*. New York: Dell Publishing.

Marsh, Edward. 1939. *A Number of People: A Book of Reminiscences*. London: William Heinemann Ltd.

Marsh, Edward. 1942. *Rupert Brooke: The Collected Poems, with a Memoir*. London: Sidgwick & Jackson.

Malvern, Sue. 2004. *Modern Art, Britain and the Great War: Witnessing, Testimony and Remembrance*. New Haven and London: Yale University Press.

Martin, Christopher. 2000. 'C.R.W. Nevinson: The Artist and his Name.' *Nevinson News*, 5.

Moore, George. 1924. *Conversations in Ebury Street*. London: William Heinemann Ltd.

Morris, Lynda (ed.). 1985. *Henry Tonks and the 'Art of Pure Drawing'*. Norwich: Norwich School of Art Gallery.

Nash, Paul. 1947. *Aerial Flowers*. Oxford: Counterpoint Publications.

Nash, Paul. 1949. *Outline: An Autobiography and Other Writings*, with a preface by Herbert Read. London: Faber and Faber.

Nevinson, Henry W. 1923. *Changes and Chances*. London: Nisbet & Co. Ltd.

Nevinson, Henry W. 1925. *More Changes, More Chances*. London: Nisbet & Co. Ltd.

Nevinson, Margaret. 1926. *Life's Fitful Fever: A Volume of Memories*. London: A. & C. Black.

Nevinson, C. R. W. 1937. *Paint and Prejudice*. London: Methuen.

Nicholson, Virginia. 2002. *Among the Bohemians: Experiments in Living, 1900–1939*. London: Viking.

Nicolson, Harold. 1953. *Paintings and Drawings from the Sir Edward Marsh Collection*. London: The Arts Council of Great Britain.

Nicolson, Nigel (ed.). 1976. *The Letters of Virginia Woolf, volume II: 1912–1922*. London: The Hogarth Press.

Parsons, Ian (ed.). 1979. *The Collected Works of Isaac Rosenberg: Poetry, Prose, Letters, Paintings and Drawings*. London: Chatto & Windus.

Pople, Kenneth. 1991. *Stanley Spencer*. London: Collins.

Raverat, Gwen. 1952. *Period Piece*. London: Faber.

Rothenstein, John. 1957. *Modern English Painters, Sickert to Moore*. London: Eyre and Spotiswood.

Rothenstein, John (ed.). 1979. *Stanley Spencer, The Man: Correspondence and Reminiscences*. London: Paul Elek.

Rothenstein, John. 1983. *John Nash*. London: Macdonald & Co.

Rothenstein, William. 1932. *Men and Memories: Recollections of William Rothenstein, 1900–1922*. London: Faber & Faber.

Rutherston, Albert (ed.). 1925. *Contemporary British Artists: C. R. W. Nevinson*. London: Ernest Benn, Ltd.

Rutter, Frank. 1922. *Some Contemporary Artists*. London: Leonard Parsons.

Rutter, Frank. 1933. *Art in My Time*. London: Rich & Cowan.

Sadleir, Michael. 1949. *Michael Ernest Sadler: A Memoir by his Son*. London: Constable.

Salis, John, and Montague, C.E. 1918. *British Artists at the Front, 3: Paul Nash*. London: Country Life.

Sassoon, Siegfried. 1942. *The Weald of Youth*. London: Faber & Faber.

Schwabe, Randolph. 1943. 'Reminiscences of Fellow Students.' *Burlington Magazine*, 82, 6–9.

Schwabe, Randolph. 1943. 'Three Teachers: Brown, Tonks and Steer.' *Burlington Magazine*, 82, 141–6.

Shone, Richard. 1993. *Bloomsbury Portraits: Vanessa Bell, Duncan Grant and their Circle*. London: Phaidon.

Shone, Richard. 1999. *The Art of Bloomsbury: Roger Fry, Vanessa Bell and Duncan Grant*. London: Tate Gallery Publishing.

Sieveking, Lance. 1957. *The Eye of the Beholder.* London: Hulton Press.

Skipwith, Peyton. 1978. 'Adrian Allinson: A Restless Talent.' *Connoisseur,* 198, 264–73.

Spalding, Frances. 1980. *Roger Fry: Art and Life.* London: Granada Publishing.

Spalding, Frances. 1983. *Vanessa Bell.* London: Weidenfeld & Nicholson.

Spalding, Frances. 1986. *British Art Since 1900.* London: Thames and Hudson.

Spencer, Gilbert. 1961. *Stanley Spencer by his Brother Gilbert.* London: Victor Gollancz Ltd.

Spencer, Gilbert. 1974. *Memoirs of a Painter.* London: Chatto & Windus.

Spencer, Stanley. 1955. *Stanley Spencer: A Retrospective Exhibition.* London: Tate Gallery.

Sutton, Denys (ed.). 1972. *Letters of Roger Fry.* London: Chatto & Windus.

Tonks, Henry. 1929. 'Notes from "Wander Years".' *Artwork* 5 (20): 213–35.

Wadsworth, Barbara. 1989. *Edward Wadsworth: A Painter's Life.* Salisbury: Michael Russell.

Walsh, Michael J. K. 2002. *C.R.W. Nevinson: This Cult of Violence.* New Haven and London: Yale University Press.

Walsh, Michael J. K. (ed.). 2007. *A Dilemma of English Modernism: Visual and Verbal Politics in the Life and Work of C.R.W. Nevinson (1889–1946).* Newark: University of Delaware Press.

Walsh, Michael J. K. 2008. *Hanging a Rebel: The Life of C.R.W. Nevinson.* Cambridge: The Lutterworth Press.

Watney, Simon. 1980. *English Post-Impressionism.* London: Cassell Ltd.

Wees, William C. 1975. *Vorticism and the English Avant-Garde.* Manchester: Manchester University Press.

Wellington, Hubert. 1925 *Mark Gertler. British Artists of To-day, Number 1.* London: The Fleuron.

Wilson, Andrew. 2000. 'Rebels and Vorticists: "Our Little Gang"', in Edwards (2000), 24–39.

Woodeson, John. 1972. *Mark Gertler: Biography of a Painter, 1891–1939.*

London: Sidgwick & Jackson.

Woolf, Leonard, and Strachey, James (eds.). 1956. *Virginia Woolf & Lytton Strachey: Letters*. London: The Hogarth Press.

Woolf, Virginia. 1940. *Roger Fry: A Biography*. London: The Hogarth Press.

Woolf, Virginia. 1985. *Moments of Being*, edited by Jeanne Schulkind, 2nd edition. New York: Harcourt Brace Jovanovich.

Zytaruk, George J. and Boulton, James T. 1981. *The Letters of D. H. Lawrence, Volume II: June 1913–October 1916*. Cambridge: Cambridge University Press.

Acknowledgements

Over the course of writing of this book I have become indebted to numerous people for their advice and assistance. Emily Carlow kindly introduced me to David Inshaw, who shared with me his love of Stanley Spencer and Paul Nash; he in turn introduced me to Jerrold Northrop Moore, who proved to be a conscientious critic and genuine guiding light as *A Crisis of Brilliance* developed. In the latter stages of writing, Mike Walsh has been of particular assistance, and also Sarah MacDougall. Henry Howard read the final draft, and I am grateful for his numerous comments and corrections. I am particularly obliged to Luke Gertler for sharing his personal archive and memories, and for generously waiving any copyright charges for reproducing his father's work; likewise to Paul Sievking, for sharing his father's memories of his friendship with Paul Nash.

I am grateful for the assistance of the staff and librarians at the Tate Gallery Archive, the Imperial War Museum, the Bodleian and Sackler Libraries in Oxford, the British Library and the New York Public Library. My visit to the Harry Ransom Research Center at the University of Texas, Austin (where the librarians were remarkably helpful) was aided by a travel grant from the Paul Mellon Foundation. My agent, Anna Power at Johnson & Alcock, has been tireless in her support of this book, whilst Ben Yarde-Buller and the staff at Old Street Publishing have been notable for their enthusiasm in bringing it to press.

Finally, as always, my family have been invaluable in all their forms of support – but in particular, my wife and son, to whom this book is dearly dedicated.

Index

373

London Group, The 175, 177, 179, 220, 232-4, 253, 257, 287, 298, 310, 312